ONE WORLD TRADE CENTER

ALSO BY JUDITH DUPRÉ

ONE WORLD TRADE CENTER

BIOGRAPHY OF THE BUILDING

JUDITH DUPRÉ

LITTLE, BROWN AND COMPANY

NEW YORK • BOSTON • LONDON

Little, Brown and Company
Hachette Book Group
1290 Avenue of the Americas, New York, NY 10104
littlebrown.com

First Edition: April 2016

Little, Brown and Company is a division of Hachette Book Group,
Inc. The Little, Brown name and logo are trademarks of Hachette
Book Group, Inc.

The publisher is not responsible for websites (or their content) that
are not owned by the publisher.

The Hachette Speakers Bureau provides a wide range of authors for
speaking events. To find out more, go to hachettespeakersbureau.
com or call (866) 376-6591.

ISBN 978-0-316-33631-4
Library of Congress Control Number: 2015944039

10 9 8 7 6 5 4 3 2 1

APS

Printed in China

To my parents

*And in honor of the women
and men who built
the World Trade Center*

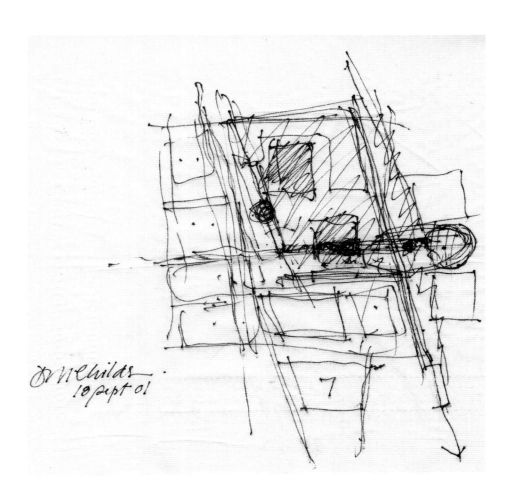

A sketch made a week after September 11 shows
architect David Childs divining how to organize the
newly devastated site. He drew as he discussed
potential solutions with Geoff Wharton of
Silverstein Properties. This prescient document
confirms the Twin Towers' footprints as the
site's center of gravity and the importance of
reinstating Greenwich and Fulton streets.
Seven World Trade Center, marked "7," is a given;
dark circles indicate where additional buildings
could be located in the future. Right: Childs's note
to his right hand, Jeff Holmes, imagines a tower
even taller than the one proposed.

Jeff Holmes

My weekend Chinese
fortune. I think it
was meant for both of us.
How about 2000+ feet?

David.

CONTENTS

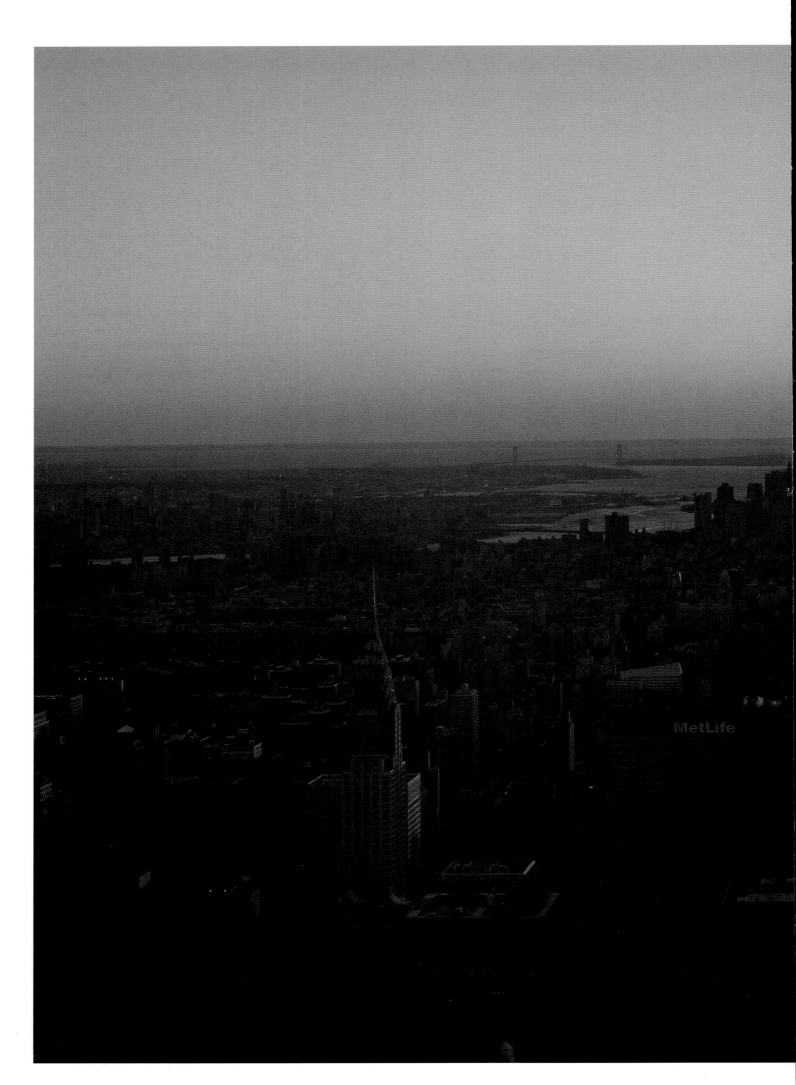

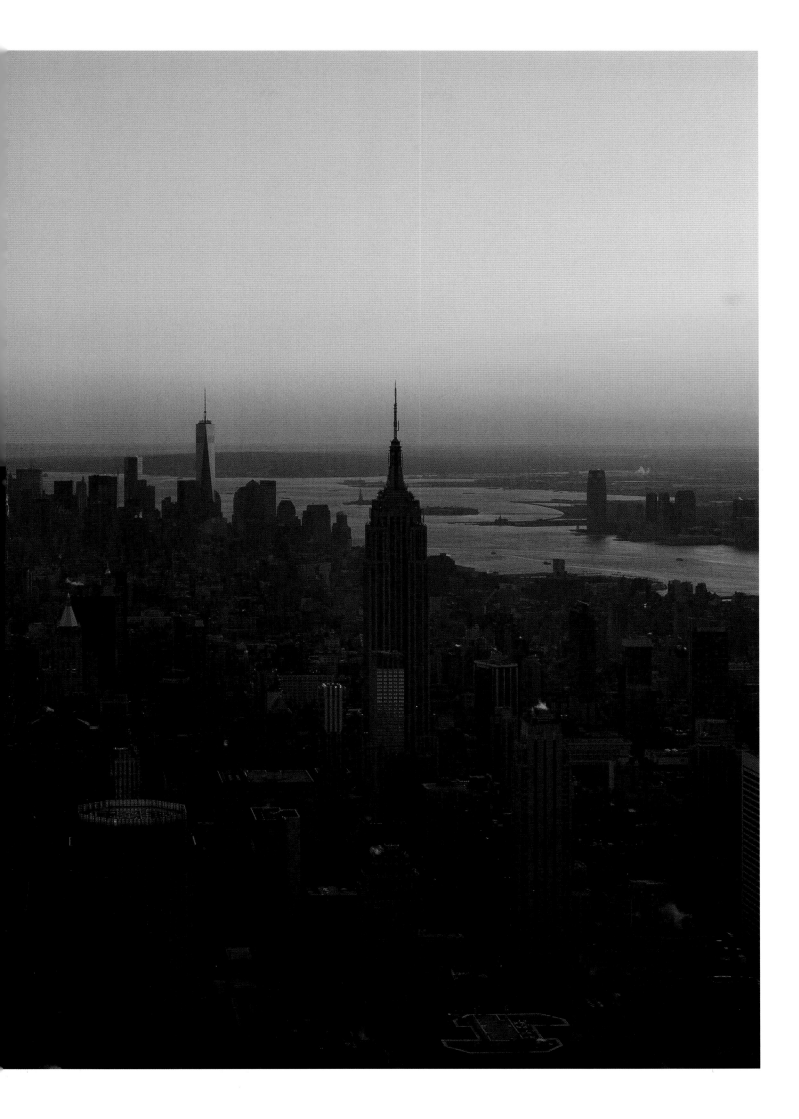

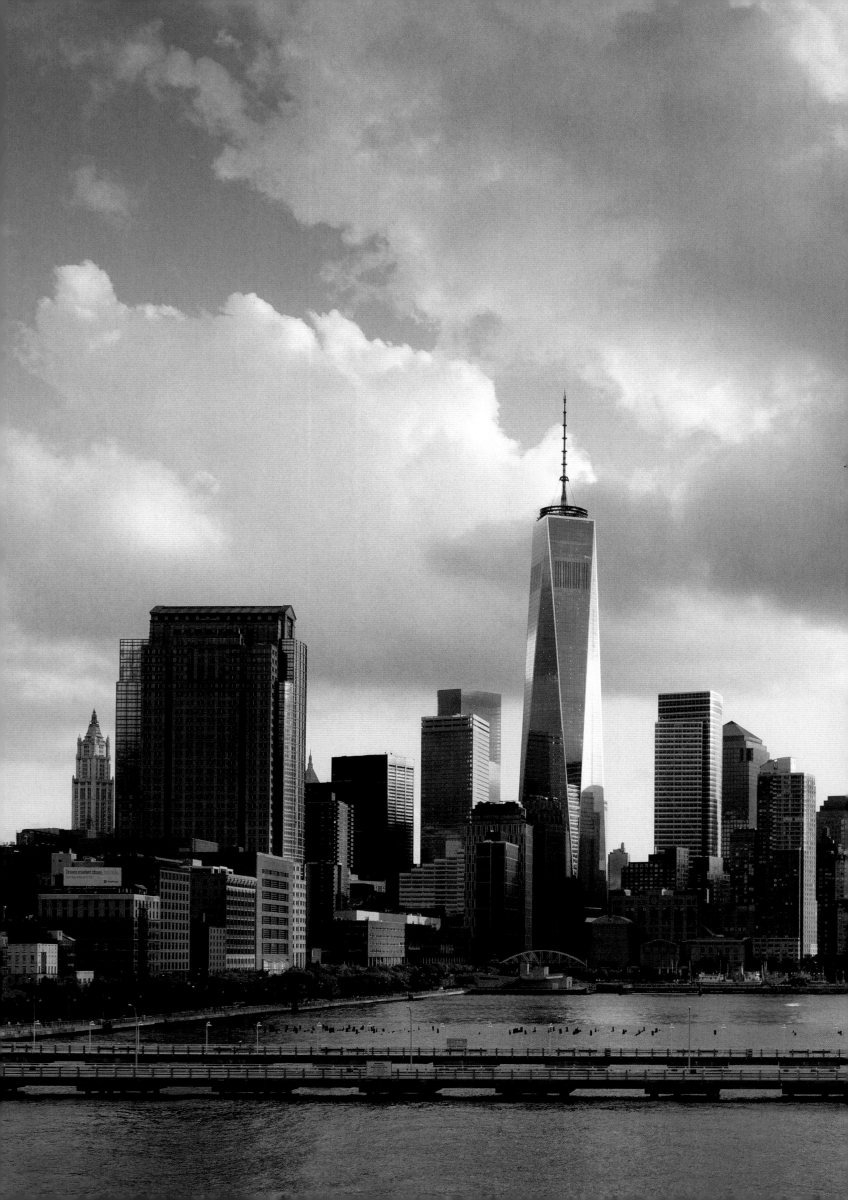

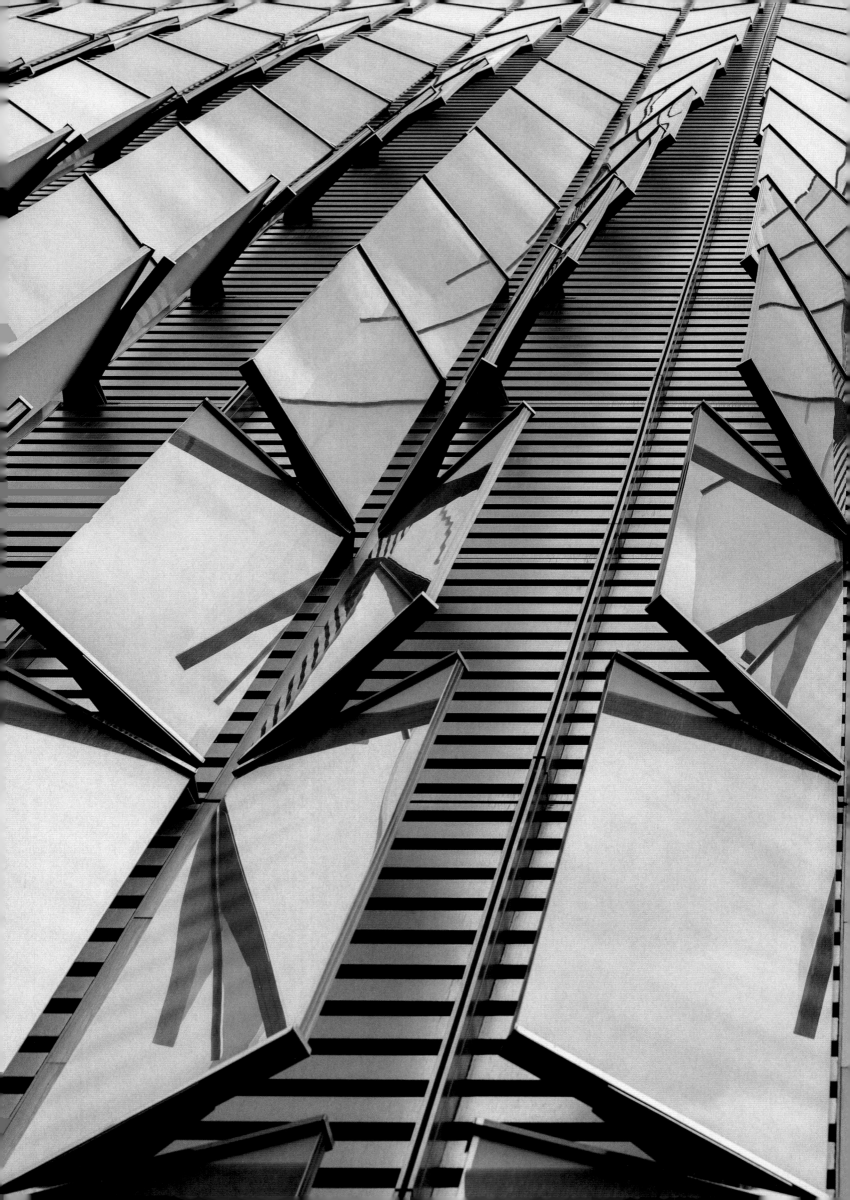

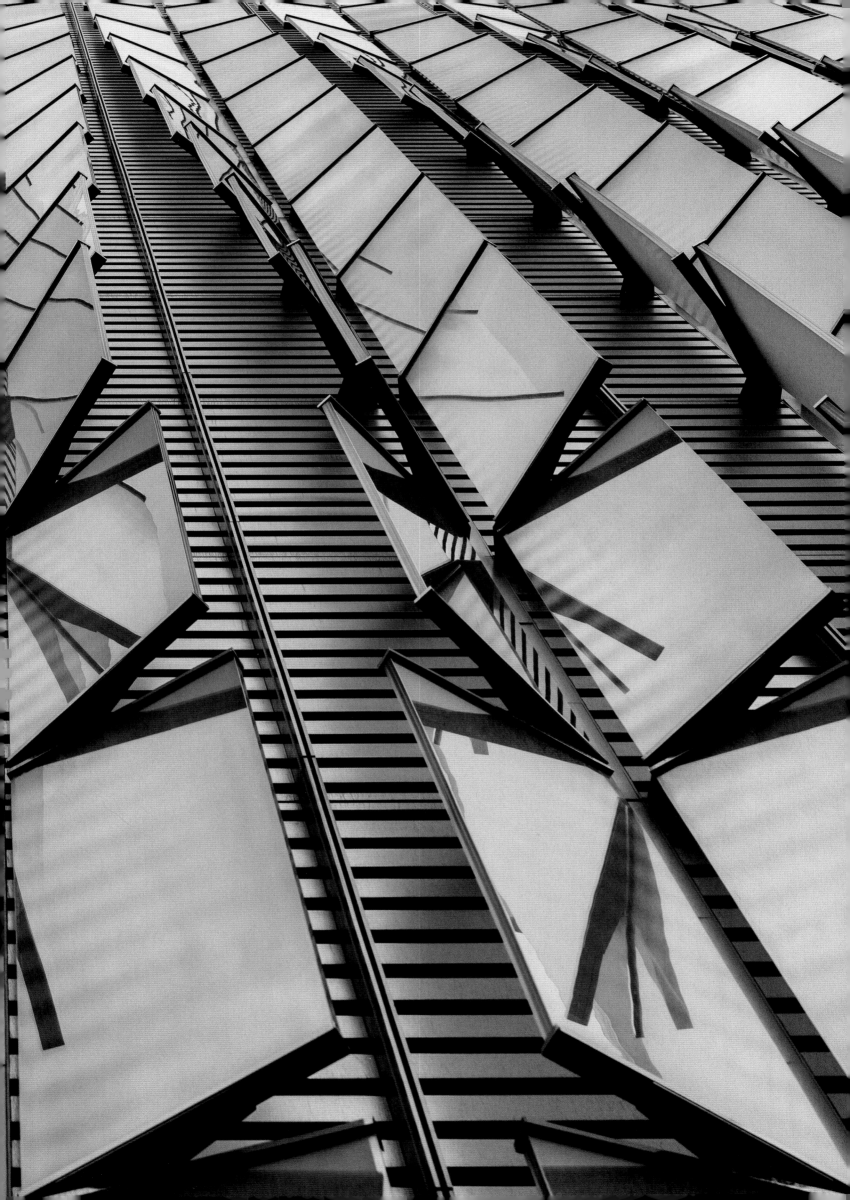

INTRODUCTION

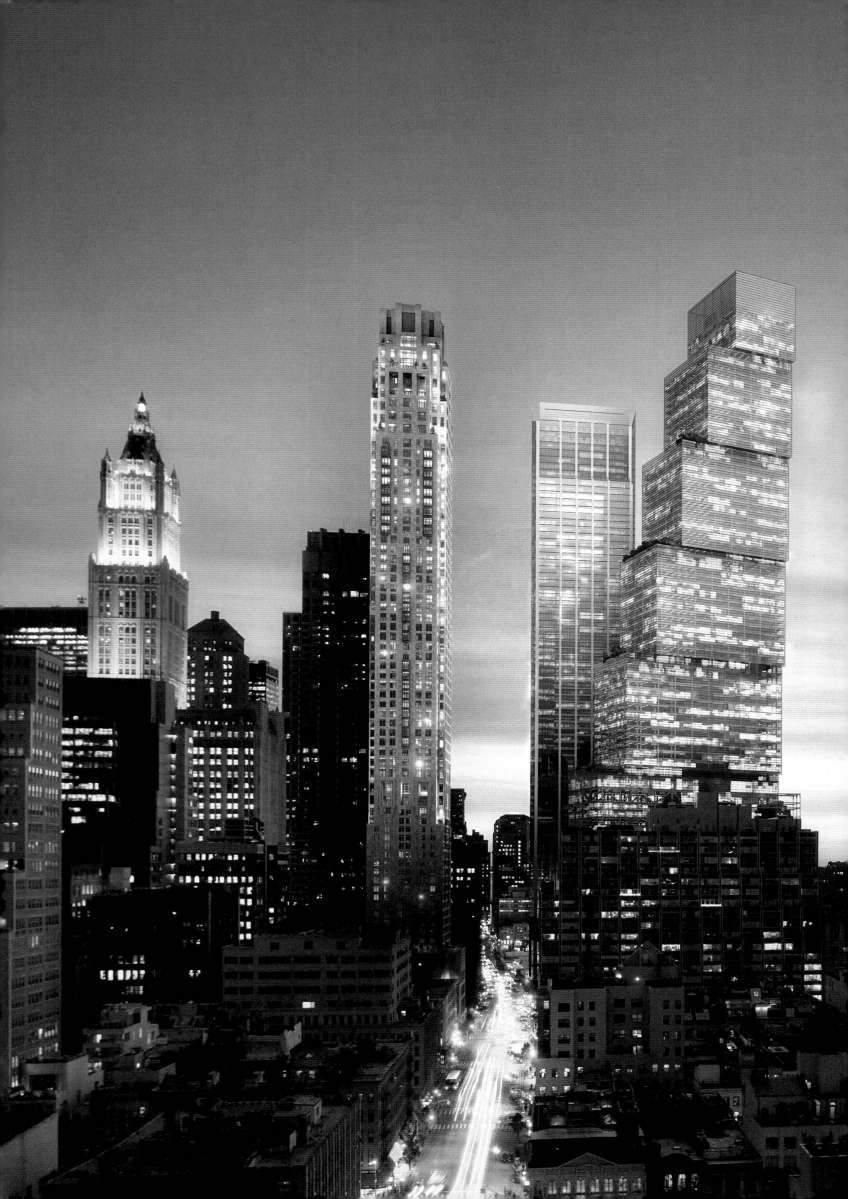

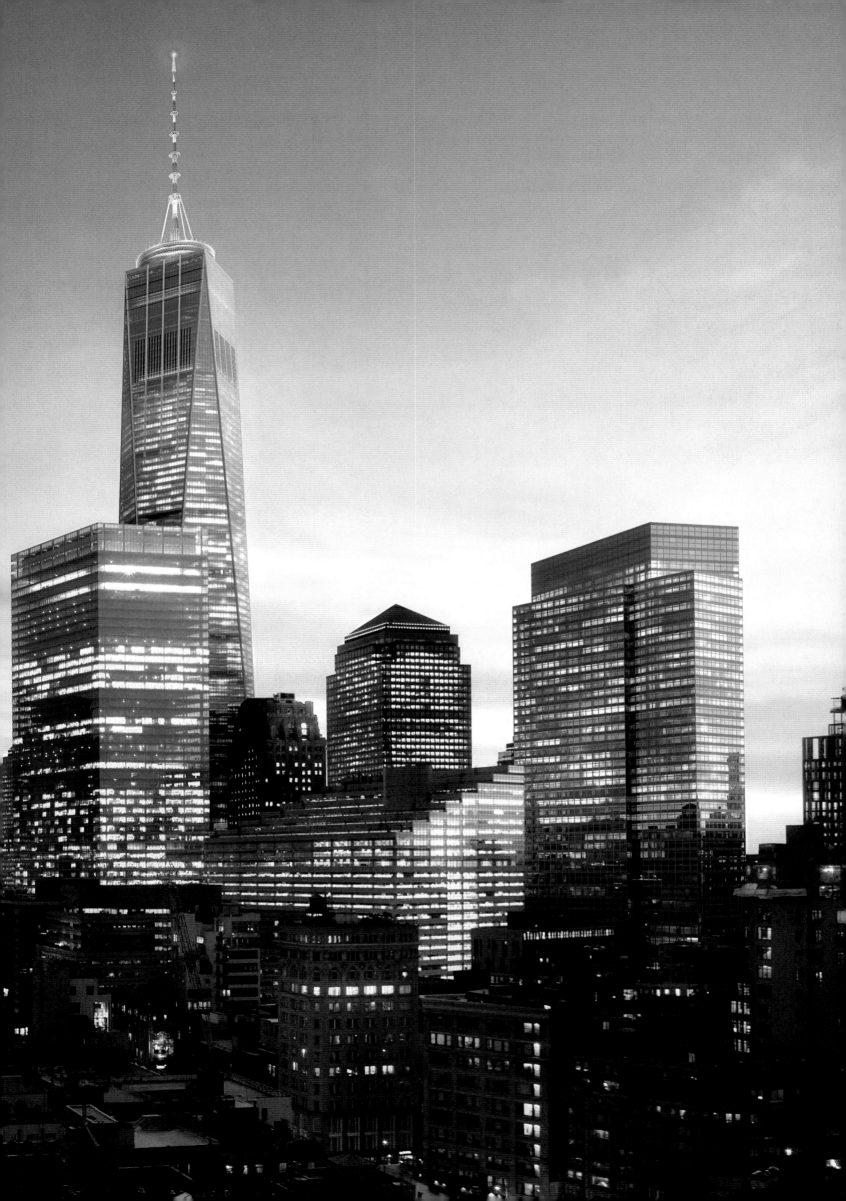

4

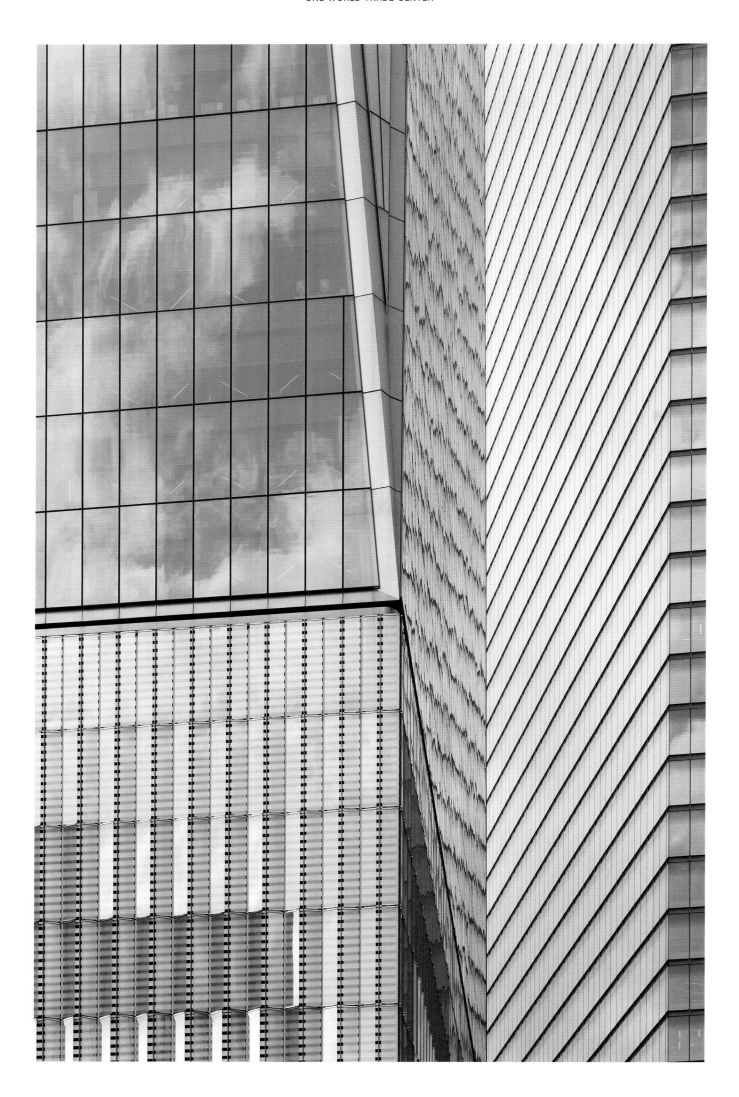

One World Trade Center, the tallest building in the Western Hemisphere, is the most advanced skyscraper ever constructed. A structural and political tour de force, it is the triumphant result of many demands, hopes, and visions that came together, improbably and at great cost. Now, as the new World Trade Center moves from a place of great debate to a great place, this book responds to the intense curiosity from around the globe about how this remarkable supertower was designed and built. The answers might surprise you and undoubtedly will inspire you.

The tower was a monumental undertaking, an outsized presence on the world stage and in the nation's collective psyche. After September 11's devastation and the warping disequilibrium and heartache that followed, simply deciding whether—and what—to build required the foresight of a dedicated few, the expertise of thousands, and the goodwill of a nation. These efforts can be understood only in the context of the larger site, where grief and contention have given way to enormous vitality. That liveliness is expressed in a plethora of building types—skyscrapers, certainly, but also a memorial, a museum, a church, a transit center, bridges, a plaza, a park, and stores. The World Trade Center is a new city within the city.

Nearly every state in the nation participated, contributing materials and skills to the rebuilding of the largest, most visible architectural project in memory. Each beam, rafter, and bolt was placed on behalf of the American people, and every construction milestone was accompanied by the raising of an American flag. One World Trade Center's staggering statistics reflect what it took to build it: Its superstructure consumed 45,000 tons (408,023.3 metric tons)—ninety million pounds—of structural steel, ninety percent of it recycled. Its central core was cast in concrete, some of it as strong as 14,000 psi (96.5 MPa), the strongest ever used in a skyscraper and just part of the 208,000 cubic yards (159,027.4 m³) of concrete that went into its making, enough for a sidewalk stretching from New York to Chicago. One million square feet (92,903 m²) of crystal-clear glass—the safest, most sustainable, and largest panels ever to clad a skyscraper—cover its upper reaches. Five of the fastest elevators in the Americas whisk visitors to its sky-high observatory. The project also took human effort, guzzling workers' talent, muscle, and willpower like a hungry animal. More than 26,000 workers—up to 3,500 of them daily, representing the expertise of forty-nine unions—have worked at the Trade Center since 2001. For many years, the Port Authority of New York and New Jersey "was the single largest contributor to construction spending," Patrick J. Foye, the agency's executive director, said. "That's a lot of jobs."

Exceptionally strong and secure, One World Trade Center is a nuanced response to security demands made

on cities everywhere since 9/11. It was designed by Skidmore, Owings & Merrill LLP (SOM), a firm with unparalleled expertise in skyscraper design. Pioneering building technologies and life-safety methods that were first developed for Seven World Trade Center, also designed by SOM, were refined and expanded at One. Innovations at both buildings helped rewrite the New York City Building Code, which had been essentially moribund since 1968. Long before tenants arrived, One was a working building, providing benchmarks for structural design, blast mitigation, and construction sequencing that are now used worldwide. Together, the designers, engineers, and owners even managed to change the way New York unions erect skyscrapers: the tower has a rigid structural steel perimeter as well as a reinforced concrete core. That core is the most significant technological leap forward in how buildings in New York City are designed today.

Taken as a whole, the anatomy of the World Trade Center represents one of the most profound collaborations in human history. The nine major buildings on its sixteen acres, along with the No. 1 subway line and four Port Authority Trans-Hudson

off their batons. While the influence of any one person might not be apparent, markers of these particular efforts have survived. Here too the scions of Manhattan's oldest real estate families — Durst, Silverstein, and Tishman — joined forces to rebuild their beloved city. Steven Plate, who directs construction at the Trade Center for the Port Authority, walks the site daily to keep massive egos in check and scheduling on track. He has reserves of Zen calm and a way of telling a story that is half anecdote and half adage. Whenever I called him, even before I'd ask for something, he'd say, "The answer is yes." You gotta love a guy like that. Apparently, he also says no, a lot, especially to those who did not adhere to his rigorous, mathematically precise construction schedules. His spirit and resolve are typical of all those who have been in the trenches for the past fifteen years, working first on Ground Zero's cleanup and then on the rebuilding. The project's metaphoric steel, they embody what has always been the city's treasure: a melting pot of individuals, willing to step into their greatness and get the job done — no matter what.

This is an illustrated record of the site's emotional, technically demanding reconstruction. Two

"There were many, many different layers of objectives. We took advantage of them to advance the science of our architecture. This is unique. There's no other building like One World Trade Center."

DAVID M. CHILDS, Lead Architect, One World Trade Center

6

(PATH) lines, form a Rubik's Cube of interdependent structures. To convey the ensemble's totality, this book examines each of these elements individually and within the context of the World Trade Center's larger story, from structural and construction challenges and the vicissitudes of the real estate market to the role of religion in a secular setting. Echoing the original World Trade Center's international focus, the chapter on Four World Trade Center delves into Japanese building philosophies, underscoring downtown's global sensibility. The National September 11 Memorial & Museum invites visitors to witness and interact with a still-unfolding history.

While the Trade Center offers a distinctive portrait of structural and political concerns at the opening of the twenty-first century, its buildings and commemorative elements also draw inspiration from historical structures such as the Washington Monument, Rockefeller Center, Grand Central Station, the Vietnam Veterans Memorial, and the Hagia Sophia.

As in a relay race, different individuals moved the project forward in significant ways and then handed

timelines reveal the project's extensive scope and pace. Diagrams and photographs suggest the intricacy of the considerations that shaped it. I conducted more than seventy interviews with those who were intimately involved. Some — like David Childs, Daniel Libeskind, and Santiago Calatrava — are boldface names, but others who are less well known, like Robyn Ryan, the woman who managed the logistics of installing the tower's glass curtain wall, brought fresh, no less valuable insights. Every single one said that this was the greatest project of their lives. All — starchitects and design veterans, ambitious young ones eager to make their mark, savvy insiders, political chieftains, and laborers whose sweat earned the knowledge that their hard work has value — were eager to share their stories with you.

As with any great endeavor, every inch of One World Trade Center's skyscraping height was contested, often bitterly. After terrorism experts questioned its vulnerability, its base and its topmost radome were reconfigured in the name of security and economic exigency. Other structures were modified for similar reasons. Designs changed; massive towers traded hands.

...the greatest project of their lives

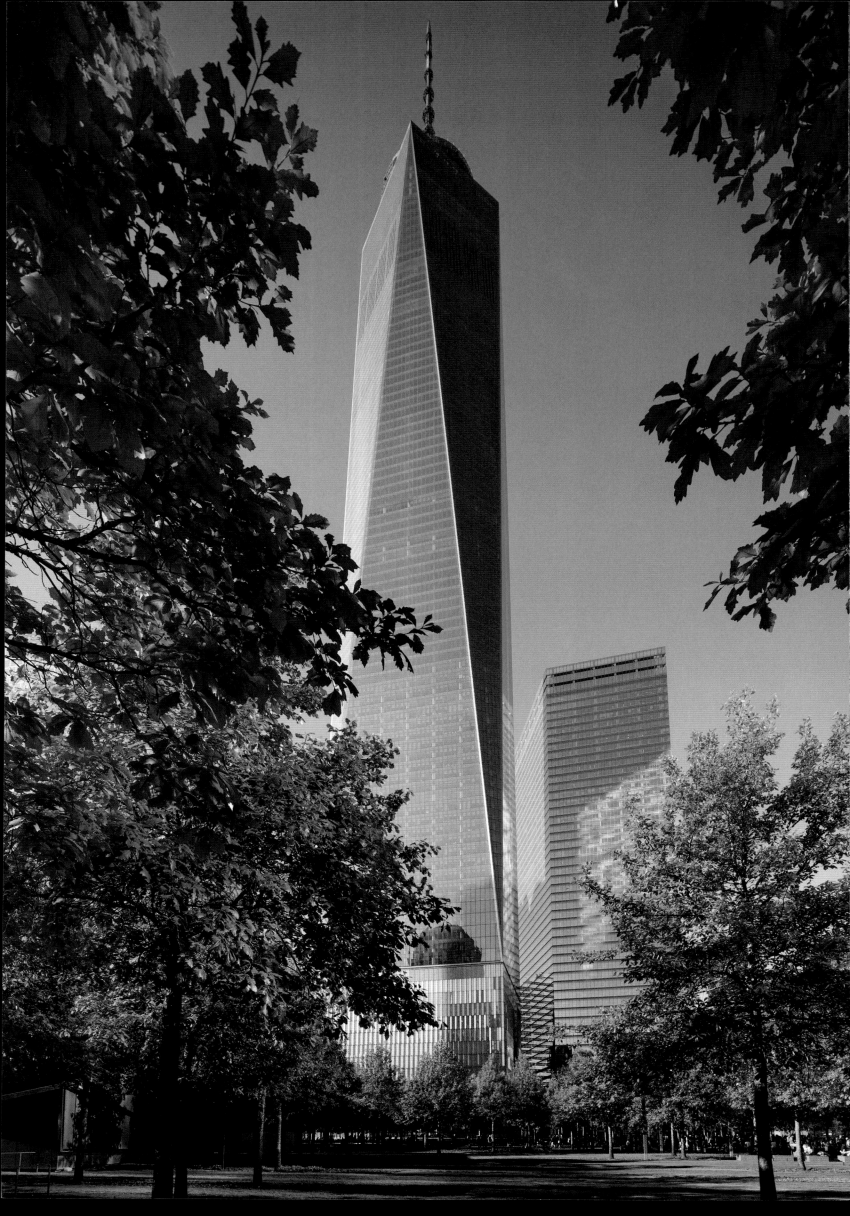

"A lot of people died. This building right here is a landmark for them. They had to put a building back up. They had to. And they put a great one up. And I'm blessed to be here to do it."

TOM HICKEY, Ironworker, *Rise*, 2014

Some remnants of the original site that were protected under federal law had to be preserved. Not one but two rail lines ran continuously through the site during construction.

But the project represents far more than the resolution of internecine battles: The push and pull of multiple agendas produced better buildings than a lesser struggle would have. The "to-ing and fro-ing and the conflicts and the resolution and the consensus are what makes the project real. It's not just some abstraction," said Daniel Libeskind, who created the site's master plan. These struggles provided the psychological means, critical to the mourning and rebuilding process, of reconciling the losses suffered there.

Did it take a long time to build? Yes, it did. Opinions were voiced and lengthy debates ensued. The project was uniquely bound and slowed by this preponderance of good will, a smothering of noble intentions, and hindered too by a few politicians who wanted to drape themselves in the project's glory. There were other hurdles. Despite One's minimal appearance, every single floor, and nearly every piece of steel, is different. Also, it went up in tandem with eight other buildings, an interconnected maze of below-ground structures, and a public memorial—all of it intensely scrutinized, controlled by dozens of owners, and subject to the tightest security measures ever implemented. Hovering like a black cloud was the 2008 recession, which stalled construction everywhere. From this

demanding framework, the World Trade Center emerged. Frankly, given all the challenges, it should not have, but it did because so many people cared so much.

Despite the finite amount of acreage on Manhattan island and its demand-driven market, the city needs buildings that make you stop in awe and reflect on what human beings are capable of. Not everything has to be utilitarian, or should be. And you don't have to be an architect to appreciate a great building. In fact, the public, with its questionable taste and unerring instinct, will decide what's great about the World Trade Center. Since its opening, people have voted with their feet—the place is so wildly popular that one reporter, previously vociferous in his criticism, had no choice but to quote Yogi Berra's zinger "Nobody goes there anymore. It's too crowded."

Cities everywhere are a compilation of good ideas and missed chances. Art will always be imperfect. That is the nature of making thought physical, and the nature too of human beings: People make mistakes and defend their turf. Money talks, and so does personal ambition. Even so, One World Trade Center soars. Along with the neighboring towers, it replaces almost eleven million square feet (1,023,000 m²) of commercial space, connects to dozens of commuter lines, and provides thousands with a place to work, eat, and pick up a pair of Jimmy Choos. The belief that all those things could be accomplished, backed up by more than a decade of strenuous labor, qualifies it as a masterpiece in my book. ▲

good ideas and missed chances...

The Port Authority of New York & New Jersey

The Port Authority of New York and New Jersey, the bistate entity in charge of the region's vast network of bridges, tunnels, marine terminals, and airports, owns and manages the World Trade Center. The agency is responsible for the entire site, which includes its own projects—One World Trade Center, the Transportation Hub, and the Vehicle Security Center—and the infrastructure that is shared among all World Trade Center structures. Hundreds of Port Authority staff, including builders, architects, engineers, landscape architects, surveyors, police, and security experts, rebuilt the Trade Center, their home for almost fifty years.

Created in 1921, the Port Authority is a government agency controlled by both New York and New Jersey. Its unique governance was intended to insulate it from the political powers and parochial views of either state and free it to focus on regional transportation. Having no taxing powers, the financially self-supporting agency raises revenues by collecting tolls, fees, and rents and by issuing bonds. Over the past century, the authority has built tunnels and bridges that are engineering landmarks, revolutionized the handling of cargo worldwide, and operated five airports that form the epicenter of the American aviation industry.

In 1962, the Port Authority took over the Hudson and Manhattan Railroad and renamed it the Port Authority Trans-Hudson, or PATH, line. In exchange for relieving New Jersey of the unprofitable H&M, the authority gained approval to develop a new center for international trade in New York. Originally designed by SOM and planned for the Lower East Side, the World Trade Center was moved west to accommodate New Jersey commuters. Construction of the Twin Towers began in 1965; then, as now, the PATH line had to remain operational while the new towers were being built. Designed by Minoru Yamasaki and Emery Roth & Sons, engineered by Leslie E. Robertson Associates, and built by Tishman Construction, the Twin Towers were the tallest buildings in the world when they opened in 1972.

After the towers were attacked, the authority shouldered the rebuilding of Ground Zero. "In addition to the national imperative to rebuild, the Port Authority had its own institutional imperative.... Eighty-four members of the Port Authority family were murdered on 9/11, and a significant investment was destroyed," said Patrick J. Foye, its executive director. Only the Port Authority had the financial and organizational heft to rebuild, but doing so took them out of their comfort zone. In the years that followed, the authority got "pummeled" for not being "a good player," said Christopher O. Ward, the agency's director from 2008 to 2011, even though it had "mortgaged its future to fill a financial gap that no other entity in this country could have ever been able to do. It wasn't that the Port said, 'We're going to bail everybody out'... [rather, Governor] Pataki turned to the Port Authority and basically said, 'You guys are going to do it.'"

Although the authority was not set up to conduct rebuilding on this scale after a disaster, they owned the real estate and, according to Foye, felt a moral obligation to do so.

The Port has the considerable clout and force of the states of New York and New Jersey behind it. But because it is a two-state agency, every dime spent in New York demanded that an equivalent dime be spent in New Jersey. The states' two governors oversee the entity, which has a budget larger than that of half the states in the country, so conflict is unavoidable. That's been true for much of the authority's history, but usually it would regroup and regain its equilibrium, said Scott H. Rechler, vice chairman of the Port Authority's Board of Commissioners. However, "9/11 was just such a shock to the system, and threw that all off," he said. "The New York side of the equation was, 'We've got to rebuild the Trade Center; it's a national mission.' On the New Jersey side, it was, 'Look at all this allocation of capital going to New York. We want our share.'"

Some thought the city should swap the city-owned land under Kennedy and LaGuardia airports, which the Port Authority operates, for the World Trade Center. The idea, floated in 2002, would have given New York City and State control over the rebuilding, but the discrepancy between the values of the airport land and the Trade Center was too great. Moreover, the city and state were not in a position to take over because of laws that govern how contractors and consultants are hired; developing the Trade Center would have required an entirely new bureaucratic structure, in addition to astronomical cash outlays.

The constant turnover in Port Authority leadership also made it difficult to achieve consistent direction. With every new governor came a new executive director. Since 2001, four New York governors have appointed five executive directors, and five New Jersey governors have appointed four chairmen. The governance structure is meant to safeguard the interests of both states; instead, according to a special evaluatory panel convened by New York governor Andrew Cuomo and New Jersey governor Chris Christie, that structure produced internal divisiveness and a lack of managerial accountability. Their 2014 report recommended that the agency "prudently divest itself" of its World Trade Center holdings and focus on its considerable, but aging, transportation assets. "The agency for the last couple of decades has lost its way," Rechler said. "It became politicized. We were doing small reforms, but it needed surgery, not therapy. There is still a need for the agency, but we need to refocus it for the twenty-first century. That starts with reinvigorating its corporate governance and organizational structure so that it once again is immune to politics and more focused on the region, its fiduciary duty, and its longevity."

In fact, the authority had already tried to extricate itself from the real estate business by selling the World Trade Center lease to developer Larry Silverstein, just weeks before

The Port Authority was established by the Compact of April 30, 1921, and one of the first interstate agencies created under a clause of the United States Constitution. The compact defined the Port District, an area centered on New York Harbor and covering about 1,500 square miles, where the agency builds and operates infrastructure critical to the region's trade and transportation network. In addition to the World Trade Center, its facilities include John F. Kennedy International, LaGuardia, and Newark Liberty International airports; marine terminals and ports; the PATH train; and six tunnels and bridges between New York and New Jersey.

ROCKLAND

CT

WESTCHESTER

Long Island Sound

NEW YORK

PASSAIC

BERGEN

MORRIS

BRONX

NEW JERSEY

ESSEX

MANHATTAN

HUDSON

NASSAU

SOMERSET

QUEENS

UNION

BROOKLYN

STATEN ISLAND

MIDDLESEX

Lower New York Bay

Atlantic Ocean

PORT DISTRICT

MONMOUTH

"It's a positive, self-reinforcing cycle — as different types of tenants arrive and people move downtown for the quality of life there, as public transportation attracts more people and companies, the workforce increases, which attracts still other companies and higher-quality retail — that has become unstoppable."

SCOTT H. RECHLER
Vice Chairman, Board of Commissioners, The Port Authority

Diplomat, taskmaster, and banker—**Patrick J. Foye**, the executive director of the Port Authority of New York and New Jersey since 2011, wears many hats. A native New Yorker, a first-generation American, and the first in his family to attend college, Foye worked summers as an elevator operator and doorman. He attended Fordham University on a scholarship from the Local 32BJ, his father's union; he later earned a law degree at Fordham. Foye was New York State's deputy secretary for economic development before Governor Andrew Cuomo selected him to head the Port Authority. He became a mergers and acquisitions partner at Skadden Arps, later managing the firm's offices in Brussels, Budapest, and Moscow. In the 1990s, Foye worked closely with former U.S. senator Alfonse D'Amato, helping to put together the Long Island Power Authority's takeover of the Long Island Lighting Company, which, at the time, involved the largest-ever issuance of municipal bonds. He was the executive president of AIMCO, a real estate investment trust and a component of the S&P 500. Foye served as president and chief executive of the United Way of Long Island, and serves on the board of the New York Metropolitan Transportation Authority.

"The World Trade Center and its tenant companies will directly and indirectly account for more than 128,200 jobs...with more than $13 billion in wages."

NYU Rudin Center for Transportation Policy and Management,
October 29, 2015

September 11. After Silverstein purchased the ninety-nine-year lease on July 24, 2001, he owned the rights to develop the Twin Towers, Towers Four and Five, and nearly a half million square feet (465,000 m²) of retail space. Earlier, in a different deal with the Port Authority, he had acquired the rights to develop Seven World Trade Center, which, like every other building bearing the World Trade Center address, also was destroyed on 9/11. Silverstein and the Port Authority, by necessity if not inclination, were thrust onto center stage. As the years passed, concerns grew about Silverstein's ability to complete the work. "However, he had a lease. He had legal rights. You're not going to unilaterally terminate that lease, because you'd be in court forever," Kenneth Ringler, director of the Port Authority at the time, said. The Port re-acquired their interest in One World Trade Center and Tower Five from Silverstein in 2006. According to Foye, "because of the site's importance on a national and international level, and because of the perceived lack of progress five years after 9/11, the consensus was reached that the Port Authority ought to take control of building One, and Silverstein agreed. The Port delivered on its part of the bargain, and so has Larry."

Over the past decade, the Port Authority has entered partnerships and selectively shed assets to more efficiently complete the Trade Center, reduce long-term financial risk, and generate investment capital for their transportation projects. To these ends, their moves have been deliberate, strategic, and quite successful. "While real estate development is not a core competency, building and designing and operating very complicated construction projects really is a core competency. By real estate development, I don't mean the construction and design or management of a construction site; what I mean is leasing Class A office space in a hyper-competitive market like Manhattan," Foye said. The Port Authority addressed that issue by bringing on the Durst Organization as a partner in One in 2010. In 2012, the agency entered into a joint venture with the Westfield Group, which paid $612.5 million for a fifty percent stake in the leasing and operation of shopping and dining space at the Trade Center; a year later, it sold its remaining interest to Westfield for $800 million. The authority's 2013 agreement with Legends to develop and operate One's observatory deck is worth $875 million over the term of the fifteen-year lease. They collect ground rent on towers Two, Three, and Four, which increases as tenants move in. They own, manage, and operate the Transportation Hub, along with the PATH line that runs through it, and the Vehicle Security Center, which all tenants use. The National September 11 Memorial & Museum and St. Nicholas National Shrine own their properties and help pay for shared infrastructure costs. "We lived through the hard times and pumped money into the project," Rechler observed, and "we've finally gotten to the point where it's earning. You don't want to throw that benefit away. The challenge of divestiture is finding the best way to monetize that and reallocate money to the region's transportation needs."

The Port Authority was determined to rebuild the Trade Center to the highest standards of quality, hospitality, and security, and it has done so. Over the course of fifteen years, it untangled myriad competing claims of private and public institutions and overcame innumerable aesthetic, structural, and financial challenges. The agency spared no effort or expense to realize its vision in a singular social and political climate that we can only hope to never see again.

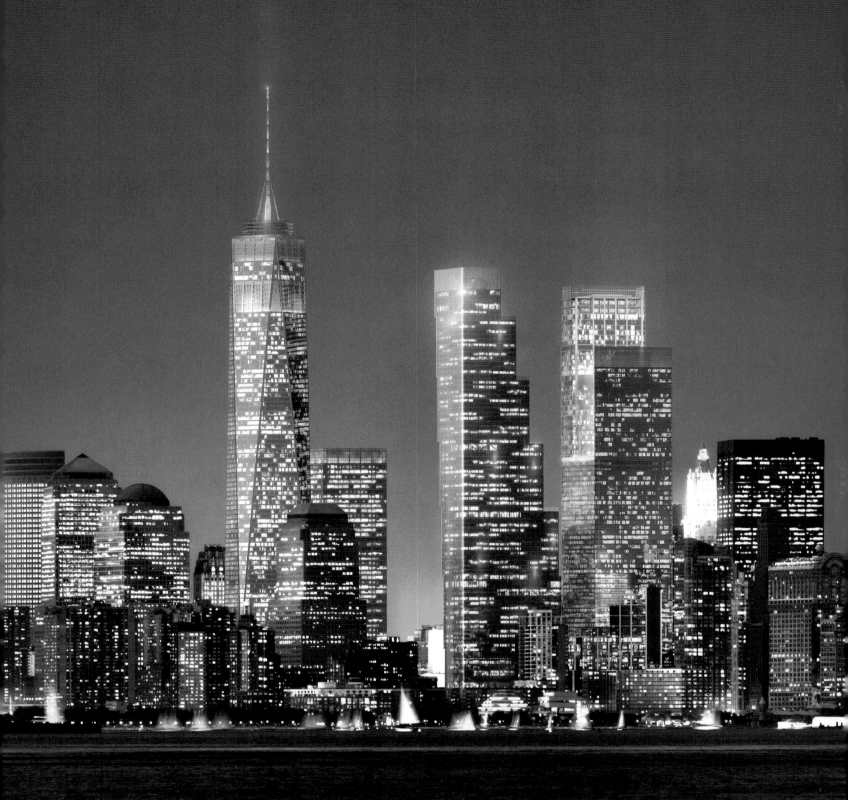

"One World Trade will stand the test of time.
Seen from either side of the
Hudson, it's extraordinary. Timeless."

PATRICK J. FOYE, Executive Director, The Port Authority of New York and New Jersey

Burj Khalifa
828 m / 2,717 ft
Dubai, 2010

Shanghai Tower
632 m / 2,073 ft
Shanghai, 2015

Makkah Clock
Royal Tower
601 m / 1,972 ft
Mecca, 2012

Ping An Finance Center
599 m / 1,965 ft
Shenzhen, 2016

Goldin Finance 117
597 m / 1,957 ft
Tianjin, 2016

Lotte World Tower
555 m / 1,819 ft
Seoul, 2016

One World Trade Center
541 m / 1,776 ft
New York City, 2014

1 2 3 4 5 6 7

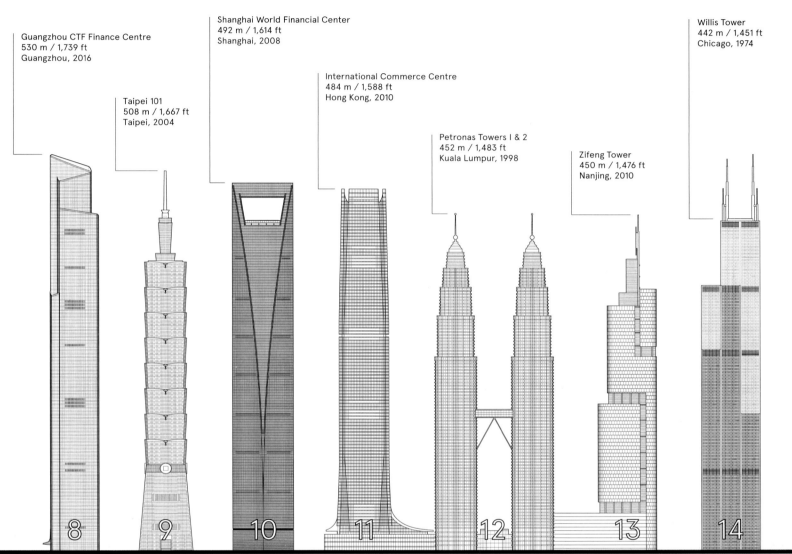

Guangzhou CTF Finance Centre
530 m / 1,739 ft
Guangzhou, 2016

Taipei 101
508 m / 1,667 ft
Taipei, 2004

Shanghai World Financial Center
492 m / 1,614 ft
Shanghai, 2008

International Commerce Centre
484 m / 1,588 ft
Hong Kong, 2010

Petronas Towers 1 & 2
452 m / 1,483 ft
Kuala Lumpur, 1998

Zifeng Tower
450 m / 1,476 ft
Nanjing, 2010

Willis Tower
442 m / 1,451 ft
Chicago, 1974

8 9 10 11 12 13 14

Measuring Skyscrapers

Collecting technical data on tall buildings is not as simple as it may seem. When it's not possible to view elevation drawings, one is forced to rely on correspondence with architects, contractors, and developers—or even on press releases. For a variety of reasons, floor counts can be incorrect. Ground floors might not be included (the convention in Europe is to designate the second floor as Level 1) and mezzanine levels are sometimes left out, as are mechanical or plant floors. In the West, the thirteenth floor of many hotels and residential towers is skipped because of the superstitious belief that the number 13 is unlucky. Thanks to a similar superstition in China, floors ending in 4 are often omitted. A "fifty-story" skyscraper in Hong Kong may actually have only forty-five floors, because floors 4, 14, 24, 34, and 44 have been skipped!

Determining exact heights can be tricky as well. Someone not experienced in reading blueprints might look only at the top of the drawing to get the exact height— not realizing that many elevation drawings are measured from mean sea level or city datum, rather than from the sidewalk level. In such cases, the elevation from sea level to the base of the building must be subtracted from the total. Press releases are notorious for rounding off building heights. A 689-foot building could very well be listed as 700 feet in a news article. One must also decide whether to include decorative and functional features atop buildings, such as spires, domes, and cupolas, in the official height. Per criteria established by the Council on Tall Buildings and Urban Habitat, antennae, flagpoles, signs, and façade maintenance equipment do not figure in the official height. The only sure way of determining a building's correct height and floor count is to submit the blueprints to an expert for review.

MARSHALL GEROMETTA Database Editor, Council on Tall Buildings and Urban Habitat

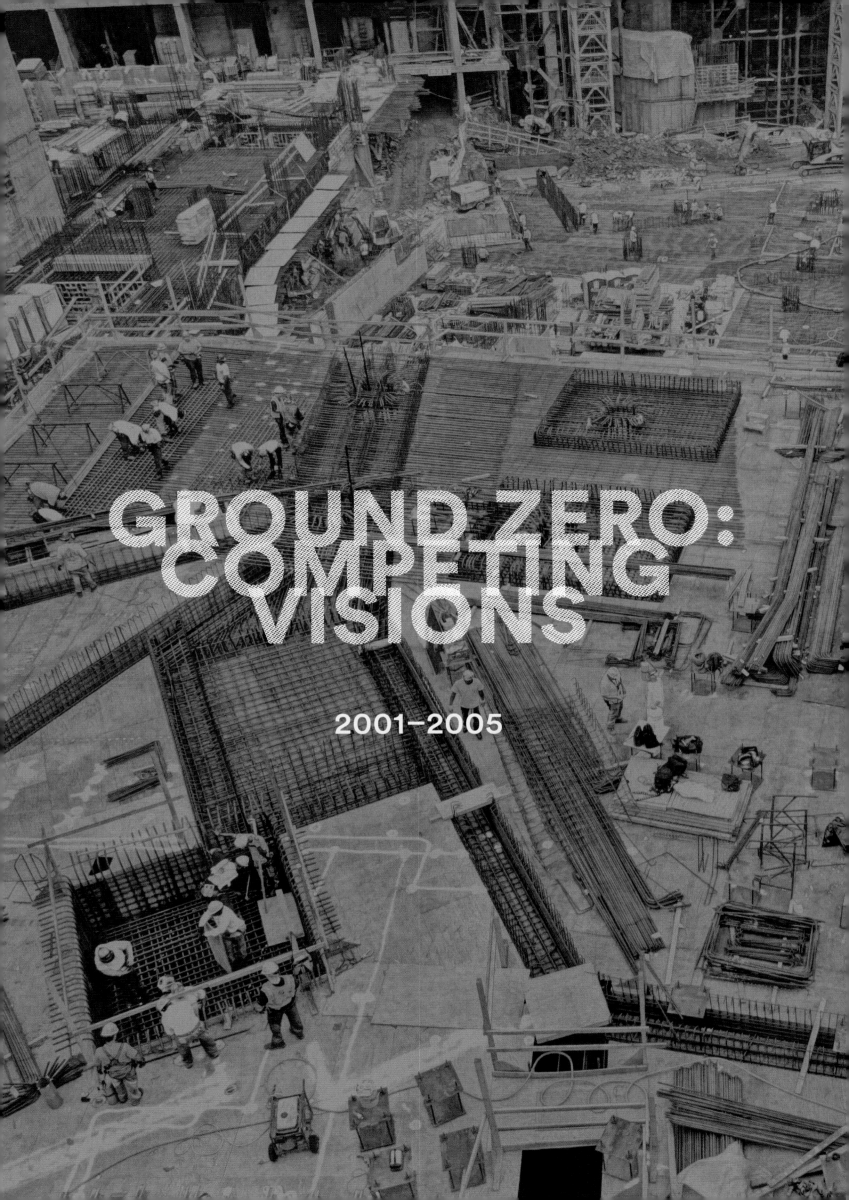

GROUND ZERO: COMPETING VISIONS

2001–2005

20

Around Ground Zero, a foldout map conceived by architect Laura Kurgan and produced by New York New Visions in December 2001, helps make sense of the radically altered Trade Center neighborhood. It indicates construction zones, sight lines, locations of temporary memorials, and suggested pathways around the site, and commemorates the losses suffered there. It is in the permanent collection of the 9/11 Memorial Museum. The map's central section and legend are reproduced here.

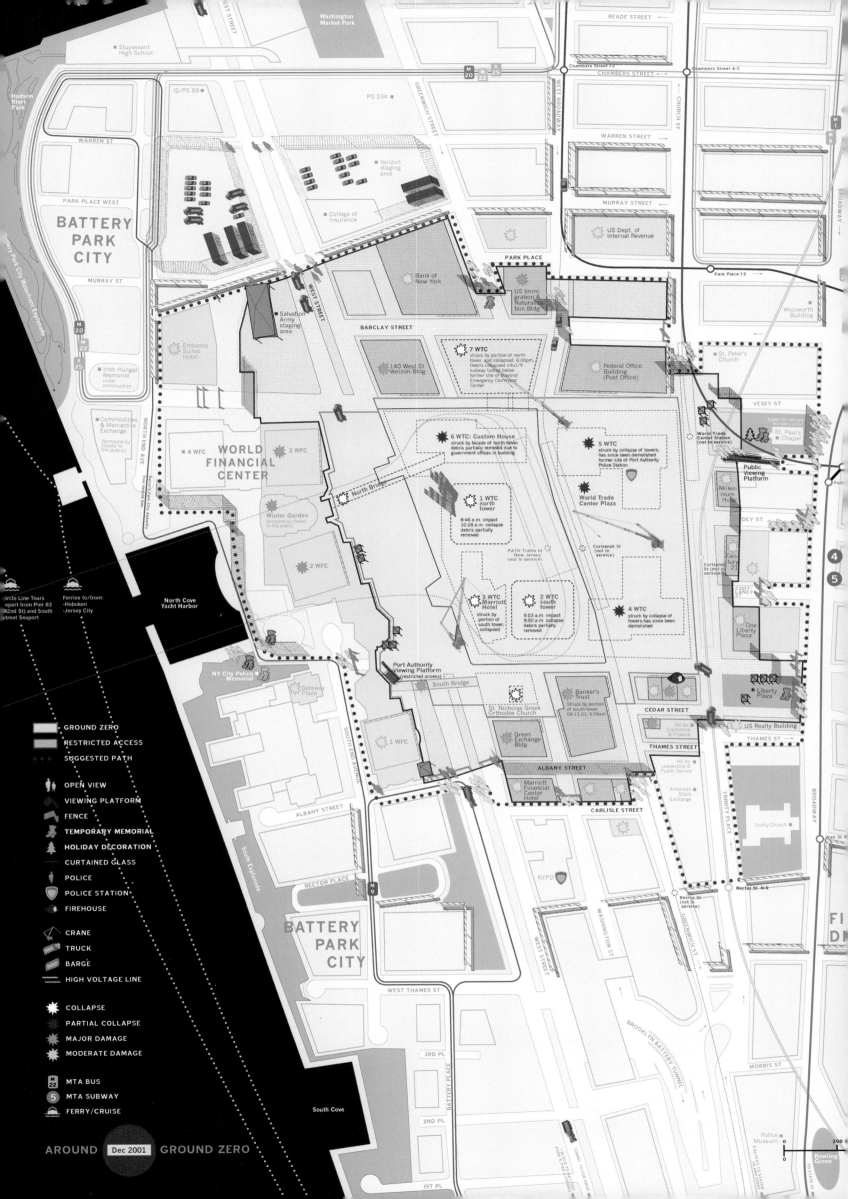

STUYVESANT HIGH SCHOOL

WASHINGTON MARKET PARK

READE STREET

WEST STREET

Stuyvesant High School

Hudson River Park

IS/PS 89

CHAMBERS STREET

Chambers Street 1·2 Chambers Street A·C

GREENWICH STREET

PS 234

WEST BROADWAY

CHURCH ST

WARREN STREET

WARREN ST

Verizon staging area

MURRAY STREET

College of Insurance

US Dept. of Internal Revenue

BATTERY PARK CITY

PARK PLACE WEST

MURRAY ST

Park Place 1·2

PARK PLACE

Bank of New York

US Immigration & Naturalization Bldg

Woolworth Building

Hudson River Park

Irish Hunger Memorial under construction

Salvation Army staging area

BARCLAY STREET

7 WTC
struck by portion of north tower, and collapsed, 6:00pm. Debris collapsed into1/9 subway tunnel below. former site of Mayoral Emergency Command Center

Federal Office Building (Post Office)

St. Peter's Church

VESEY ST

Embassy Suites Hotel

140 West St Verizon Bldg

World Trade Center Station (not in service)

St. Paul's Chapel

(open to rescue ...)

Commodities & Mercantile Exchange (temporarily closed to the public)

4 WFC

WORLD FINANCIAL CENTER

3 WFC

6 WTC: Custom House
struck by portion of north tower, debris partially removed due to government offices in building

5 WTC
struck by collapse of towers, has since been demolished. former site of Port Authority Police Station

Public Viewing Platform

Millennium Hotel

DEY ST

NORTH END AVE

North Bridge

World Trade Center Plaza

Winter Garden temporarily closed to the public

1 WTC north tower

8:46 a.m. impact 10:28 a.m. collapse debris partially removed

Cortlandt St (not in service)

Century 21

4
5

Circle Line Tours depart from Pier 83 (42nd St) and South Street Seaport

Ferries to/from: -Hoboken -Jersey City

North Cove Yacht Harbor

2 WFC

PATH Trains to New Jersey (not in service)

Cortlandt St (not in service)

CORT-LANDT

One Liberty Plaza

3 WTC Marriott Hotel
struck by portion of south tower, collapsed

2 WTC south tower

9:03 a.m. impact 9:50 a.m. collapse debris partially removed

4 WTC
struck by collapse of towers, has since been demolished

Liberty Plaza

NY City Police Memorial

Gateway Plaza

Port Authority Viewing Platform (restricted access)

South Bridge

St. Nicholas Greek Orthodox Church

Banker's Trust
Struck by portion of south tower, 09.11.01, 9:59am

CEDAR STREET

US Realty Building

THAMES STREET THAMES ST

1 WFC

Green Exchange Bldg

HS for Economics & Finance

BATTERY PARK CITY

SOUTH END AVENUE

ALBANY STREET

ALBANY STREET

Marriott Financial Center Hotel

American Stock Exchange

HS for Leadership & Public Service

Trinity Church

TRINITY PLACE

SOUTH ESPLANADE

CARLISLE STREET

Rector St (not in service)

Rector St N·R

BROADWAY

RECTOR PLACE

NYPD

Wall St

BATTERY PARK CITY

WEST THAMES ST

WASHINGTON ST

GREENWICH ST

WEST STREET

BROOKLYN BATTERY TUNNEL

MORRIS ST

3RD PL

2ND PL

South Cove

1ST PL

BATTERY PLACE

Police Museum

Bowling Green

Legend

GROUND ZERO
RESTRICTED ACCESS
SUGGESTED PATH

👥 OPEN VIEW
VIEWING PLATFORM
FENCE
TEMPORARY MEMORIAL
🎄 HOLIDAY DECORATION
CURTAINED GLASS
👤 POLICE
🛡 POLICE STATION
FIREHOUSE

CRANE
TRUCK
BARGE
HIGH VOLTAGE LINE

✸ COLLAPSE
✳ PARTIAL COLLAPSE
✦ MAJOR DAMAGE
✺ MODERATE DAMAGE

🚌 MTA BUS
⑤ MTA SUBWAY
⛴ FERRY/CRUISE

AROUND Dec 2001 GROUND ZERO

September 12, 2001

"We're going to rebuild," vows New York City mayor Rudy Giuliani.

"America's Emergency Line: 9/11," an op-ed piece by Bill Keller in the *New York Times* that appeared on September 12, is the first use of the term *9/11*. The stark, unadorned date quickly becomes shorthand for the devastating events of the day.

A great civic outcry emerges, asking whether or how to replace the towers. Some demand that the Twin Towers be rebuilt as they were, only taller. Others say nothing at all should touch this newly sacred ground. Architects, who now have the most visible profession in the world, call for something spectacular to be built.

September 13, 2001

Architect Rick Bell plants the first seeds of New York New Visions, a coalition of twenty-one design organizations that come together to rebuild Manhattan. The coalition's very name embodies its aspiration to reinvent the city, not just replicating what had been there, but rethinking all of lower Manhattan.

Port Authority staff gather to mourn their colleagues and plan how to move ahead with reconstruction. WTC Construction Director Steven Plate compares the logistics they face to "a marathon race in which the runners simultaneously have to perform open-heart surgery."

22

"We should call on our best talents, perhaps by an international competition, run to the highest standards, and enlisting the greatest expertise. And until the answer is found and built, the site should be a ruin, a place to gather, and mourn, to think about how great, or trivial, our values are, perhaps even to know each other, and our city, better."

Architecture critic ADA LOUISE HUXTABLE, *Wall Street Journal*, **September 17, 2001**

September 21, 2001
Larry Silverstein holds a press conference and says he will build four 50-story towers at the World Trade Center site.

September 28, 2001
Silverstein hires Skidmore, Owings & Merrill (SOM) and Cooper, Robertson to redesign the World Trade Center.

November 2, 2001
Governor Pataki and Mayor Giuliani create the Lower Manhattan Development Corporation (LMDC), an agency that will oversee the WTC's redevelopment.

Who's Who

As of September 12, 2001, majority stakeholders at the World Trade Center include its owner, the **Port Authority of New York and New Jersey,** led by Republican New York governor **George Pataki** and Democratic New Jersey governor **James McGreevey**; and developer **Larry Silverstein,** who holds the property's lease. The **City of New York** owns the streets and sidewalks as well as rights-of-way within them. **The Metropolitan Transportation Authority** owns and operates the two subway lines that pass through the Trade Center, and the **New York State Department of Transportation** owns and operates the state highway known as West Street on the site's western edge. **Westfield America** has the right to operate up to 600,000 square feet of retail space on the site, while Marriott International has the rights to the same amount of footage for a hotel. These groups worked together, along with New York City mayor **Michael Bloomberg** and Deputy Mayor **Daniel L. Doctoroff** and a host of others who were officially or emotionally invested in the site, including family members, first responders, downtown residents and businesses, insurance companies, and a fair swath of the eight million who call New York City home. All of them, collectively, gave birth to the new World Trade Center.

December 19, 2001
The Fire Department of New York (FDNY) extinguishes the fires at Ground Zero, which had burned for ninety-nine days. Nearly two million tons (1.8 million metric tons) of tangled steel and rubble had to be removed from the chaotic, smoking pile. Most heartrending were the 2,753 souls lost at the World Trade Center; the remains of 1,115 people, never found, commingled with the ashes.

"We've got to think about it from the point of view of a soaring, beautiful memorial. And then if we do that right, if we do that part right, then the economic development will just happen. And millions of people will come here."

RUDOLPH GIULIANI in his last public address as New York City mayor, **December 27, 2001**

23

December 30, 2001
The first architectural response at the WTC is a viewing platform designed by David Rockwell, Kevin Kennon, Ricardo Scofidio, and Elizabeth Diller. The 30' × 16' (9 x 4.9m) platform is made of wood planks on steel scaffolding and stands at Church and Fulton streets. Initially unadorned, to filter the viewing experience as little as possible, it is soon covered with tributes, which the architects anticipated. The platform is replaced by another on Church Street in 2002.

January 1, 2002
New York City mayor Michael R. Bloomberg visits Ground Zero on his first day in office. He serves three terms as mayor, from 2002 through 2013.

In **January 2002**, New York gallery owner Max Protetch mounts "A New World Trade Center: Design Proposals," an exhibition of drawings, models, and photographs that present a phantasmagoria of innovative architectural thinking. London-based Foreign Office Architects proposes a group of 110-story tubes. Bundled together, the towers provide structural support for one another. At various points, they connect via sky lobbies.

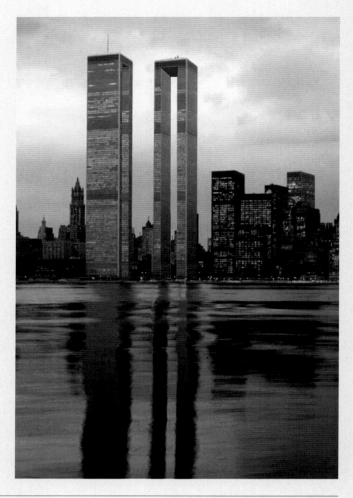

"A New World Arts Center," Carlos Brillembourg's proposal for the 2002 Max Protetch show, repeats the form of the Twin Towers that, now hollowed out, create a symbolic gateway. The mixed-use complex would include subsidized housing for artists and writers.

For the 2002 Max Protetch invitational, architects Hariri & Hariri conceived of a memorial composed of eleven monumental towers clad with informational displays and connected by free-form structures containing financial and cultural facilities. Fitted with misters, the towers would "weep" every year on September 11.

February 2002

Working pro bono, New York New Visions and a phalanx of others focus on finding solutions. Hundreds of people help draft *Principles for the Rebuilding of Lower Manhattan*, a document intended to "help build consensus among decision-makers and all who care about the future of our city." It puts forth seven principles, including capitalizing on lower Manhattan's culture, history, and geography; expanding and integrating mass transit; and defining a secure public realm with memorials and viewing areas. Immediate action had to be taken to address the needs of transportation, business owners, and residents, especially those living below Canal Street. Above all, *Principles* champions an inclusive planning process, so the future World Trade Center would meet the highest aesthetic and environmental standards. Much of what was proposed was eventually realized.

February 28, 2002

The Port Authority begins planning a transit hub that will link PATH, subway, and ferry lines.

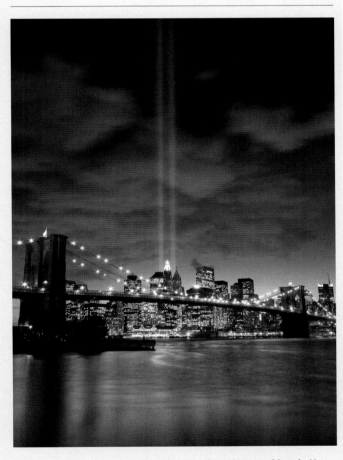

Tribute in Light is illuminated for the first time on **March 11, 2002**. Composed of twin beams formed by eighty-eight searchlights in two squares, sized and placed to reflect the configuration of the original towers, it is the first official, albeit temporary, memorial at Ground Zero. Installed in a parking lot in Battery Park City from 2002 until 2004, the work is moved south to the roof of a parking garage, also in Battery Park City, in 2005.

"Please, make it the seventh wonder of the modern world."

Plea from a man attending the LMDC's first public hearing on rebuilding the WTC on **May 2, 2002**

May 7, 2002

Silverstein Properties begins building 7WTC, the design of which largely determines the configuration of the WTC site. The Twin Towers were originally built atop an elevated superblock, obliterating five historic streets and twelve blocks of Radio Row. Earlier master plans had called for the reinstatement of Greenwich and Fulton streets, and the practical need to rebuild Seven made their restoration a reality.

May 22, 2002

LMDC selects Beyer Blinder Belle (BBB) as the WTC's master planners. The master plan has to accommodate ten million square feet (929,030.4 m²) of office space, 600,000 square feet (55,741.8 m²) of retail space, and a 600,000-square-foot (55,741.8 m²) hotel on a mere sixteen acres (6.5 ha). This was a condition of Silverstein's insurance policy, which required him to replace all of the lost square footage.

May 30, 2002

Workers remove the Last Column of the Twin Towers, marking the end of the cleanup operation. In 2010, the column was moved to the 9/11 Memorial Museum.

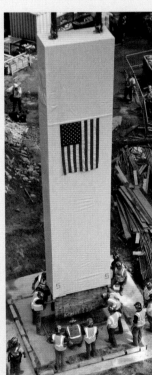

June 29, 2002

Vowing that nothing would be built where the Twin Towers once stood, Governor Pataki essentially determines the WTC's future configuration.

June 30, 2002

New York City transfers control of the WTC back to the Port Authority.

25

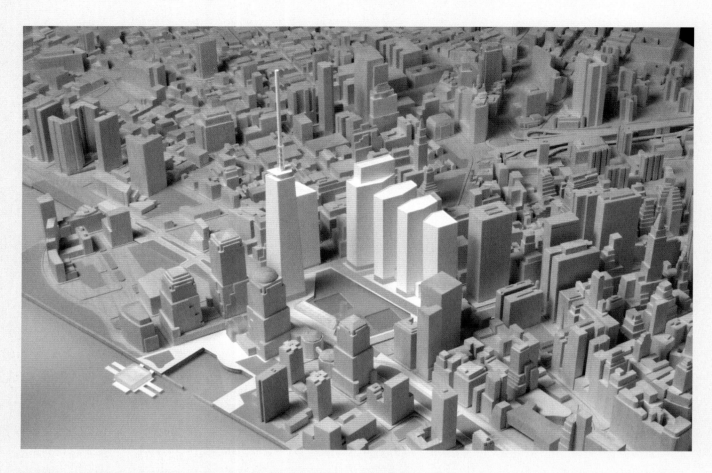

In the rotunda of venerable Federal Hall on **July 16, 2002**, Beyer Blinder Belle unveils six master plans for the World Trade Center. Rendered in muted shades of brown and gray, the plans get a tepid reception. Like a small seed that gives no indication of its future blooms, however, much of what BBB proposes will survive and influence what is eventually built. The plan places Tower One on the site's northwest corner, provides four towers of gradually increasing heights, restores Greenwich and Fulton streets, and creates a central memorial precinct.

Listening to the City

On a sweltering summer Saturday, nearly 5,000 New Yorkers convene at the Javits Center to discuss (and dismiss) the LMDC's proposals for rebuilding the Trade Center. "Listening to the City" is an open forum fashioned after an old-time commons meeting. Participants sit ten to a table, each given an electronic device so they can vote on the proposed BBB plans, which are projected on huge monitors. "It was a town meeting for the electronic age," recalled one participant, "and it was fun…. Instead of sitting passively as members of an audience, we talked with one another and discussed our votes." Critics, however, attacked the LMDC and other organizers for maintaining the charade of an "electronic democracy," when it was clear that the "choices" were tightly scripted and controlled, making a mockery of the hopeful, ostensibly democratic process that the Listening participants had anticipated. The public and the press deemed the master plans conventional and dull. "People were exposed to the whole planning process, which I think was good, but there was a backlash," architect Barbara Littenberg said of the event. The LMDC "essentially lost control of the process that they had laid out up to that point."

"I couldn't come in with a shovel and a pair of gloves—but this has allowed me to do something, however small, to express my love and support for NYC and the victims."

Participant, Listening to the City

August 19, 2002
To satisfy the public's hunger for imaginative rebuilding schemes, the LMDC regroups and issues a Request for Qualifications (RFQ), inviting proposals for what was called an Innovative Design Study. Hundreds respond.

"It looks like Albany." Participant's comment on the master plans shown at the Listening to the City forum

26

NOT a Design Competition

Even though the Innovative Design Study guidelines stated, on the first page and in bold type, "This is NOT a design competition and will not result in the selection of a final plan," the public and eventually the teams themselves begin to think of it that way. The LMDC's call for ideas becomes, in the minds of many, a competition. This shift abets an emerging climate of good guys and bad guys, winners and losers, in which everyone involved seemed possessed by the urge to beat everyone else. Nationalistic fervor also fuels the process— the nation was on the brink of invading Iraq, and a defiant optimism, even a large dose of patriotic testosterone, was running high. The perception that the LMDC was staging an all-or-nothing contest would slow the rebuilding process.

"Fantasies of new buildings became a form of recovery."

HERBERT MUSCHAMP, *New York Times Magazine,* **September 8, 2002**

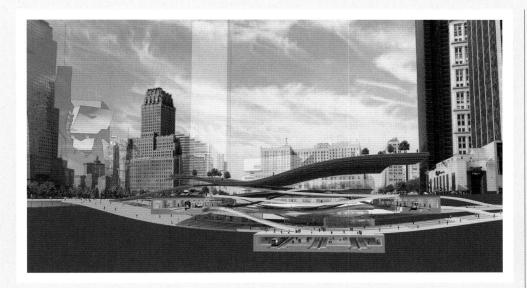

For the *Times'* invitational, Rafael Viñoly proposes a canopied multilevel transportation center that weaves together spaces above and below the ground, uniting these two ordinarily separate realms of the city.

Don't Rebuild. Reimagine.

Looking to shatter business-as-usual thinking, the *New York Times Magazine* invites architects to contribute ideas to its **September 8, 2002,** issue. Curated by then *Times* architecture critic Herbert Muschamp, the "Don't Rebuild. Reimagine" issue features glossy pages of proposals intended to expand the public's conception of what is possible downtown.

27

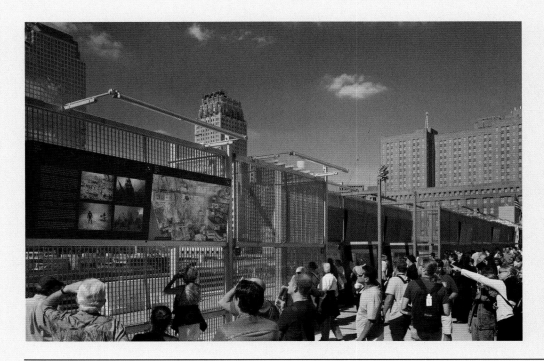

Even though there is nothing yet to see, Ground Zero is the most visited place in America, attracting tens of thousands of people every month. The Viewing Wall, a gridded fence with informational panels about the site and its history and a list of those who died in the 2001 attacks, opens on **September 10, 2002.** On Church Street, overlooking the site, the wall is a temporary monument that allows visitors to reflect and vicariously participate in the rebuilding. Designed by Diana Balmori and Pentagram for the Port Authority, it was the first narrative about 9/11 at Ground Zero.

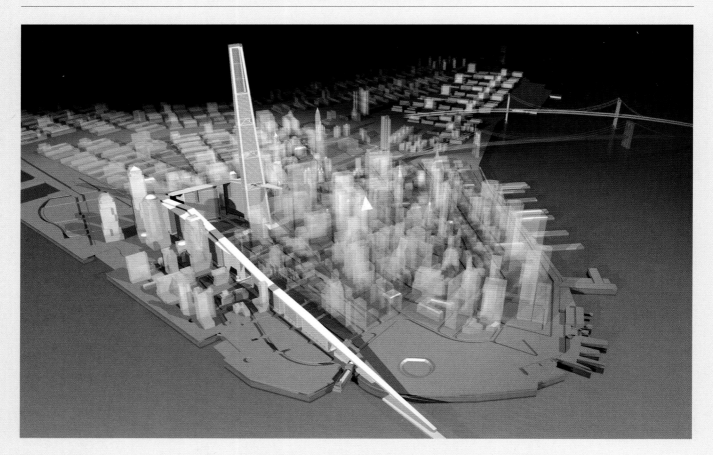

At a solemn first-anniversary ceremony, mourners observe four moments of silence—at 8:46 a.m., when American Airlines flight 11 struck the North Tower; 9:03, when United flight 175 hit the South Tower; 9:59, when the South Tower collapsed; and 10:28, when the North Tower fell. In 2011, two additional moments of silence—at 9:37, when American flight 77 crashed into the Pentagon, and 10:03, when United flight 93 crashed in Shanksville, Pennsylvania—are added. The observation becomes an annual tradition.

28

On **September 16, 2002,** *New York Magazine* publishes seven proposals by elite architects that seek to move New Yorkers to awe. William Pedersen of Kohn Pedersen Fox Associates proposes a 2,001-foot (609.9 m) tower overlooking reflecting pools set into the original towers' footprints. A memorial sky-promenade, rising above new residential and office buildings, stretches from the tower across the site and down to the Statue of Liberty's ferry landing.

September 17, 2002
The Winter Garden at the World Financial Center (now Brookfield Place) reopens after extensive repairs.

October 11, 2002
The LMDC selects the Innovative Design Study finalists from seven formidable architectural teams, giving them each $40,000 and eight short weeks to produce new designs.

December 18, 2002
The Innovative Design Study finalists present nine plans at the Winter Garden in a public spectacle of models, renderings, and video walk-throughs that is unprecedented in the field of architecture. The proposals, many visionary, meet with wildly enthusiastic applause. However, yet again, a key piece of the puzzle eludes the public's understanding: these new visions, like the first set that emerged from the Javits Center presentation, are proposed master plans only and might not ever be built.

December 26, 2002
SOM withdraws from the LMDC's design study in order to focus on its work for Silverstein.

"At a resonant 1,776 feet tall, the Freedom Tower—in my master plan, second in importance only to the 9/11 Memorial itself—will rise above its predecessors, reasserting the preeminence of freedom and beauty, restoring the spiritual peak to the city, and proclaiming America's resilience even in the face of profound danger, of our optimism even in the aftermath of tragedy. Life, victorious."

DANIEL LIBESKIND, speaking in New York, **December 18, 2002**

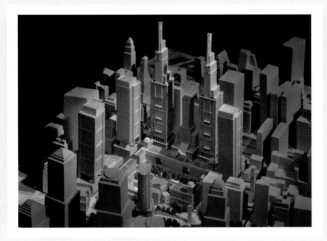

The Peterson/Littenberg Innovative Design Study proposal features streets, boulevards, squares, and towers organized around a central sunken garden. The garden contains an open amphitheater on the North Tower footprint. Underneath the theater, at bedrock, is a museum dedicated to the events of September 11.

29

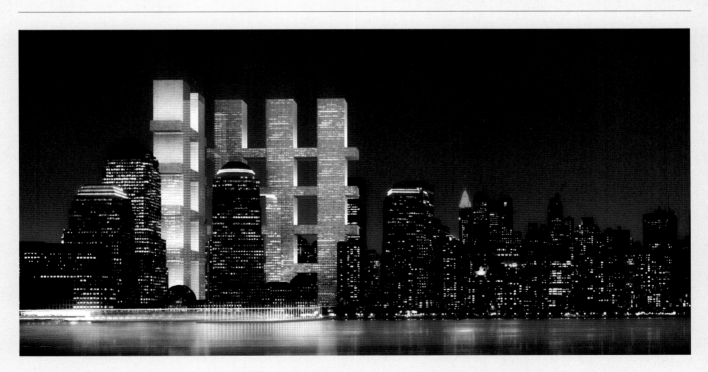

The team of Richard Meier, Peter Eisenman, Charles Gwathmey, and Steven Holl, along with their partners, propose two structures composed of five interconnected towers for the Innovative Design Study. The project's grid pattern is inspired by Manhattan's street grid and the profiles, now multiplied, of the original Twin Towers.

For the Innovative Design Study, Foster + Partners reimagines Minoru Yamasaki's Twin Towers as two dynamically integrated towers. The angular towers touch, or kiss, at two points. When viewed from different locations, the towers' profiles change and appear to dance together.

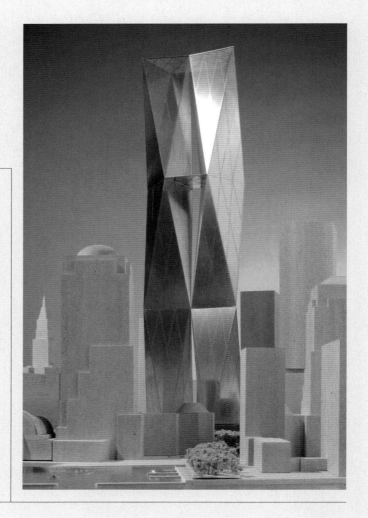

January 31, 2003

In a nine-page letter to LMDC Chairman John Whitehead, Larry Silverstein asserts his "right to select the architect responsible for preparing rebuilding plans." Because he had engaged SOM in August 2001 when he had taken over the World Trade Center lease and had since asked the firm to work on the site's master plan, he suggests that any firm the LMDC selects "be tasked with coordinating their efforts with SOM as well as, of course, with architects representing the Port Authority."

February 4, 2003

LMDC and the Port Authority select Studio Daniel Libeskind and Think, a team headed by Rafael Viñoly, Frederic Schwartz, Ken Smith, and Shigeru Ban, to further develop their master plan concepts.

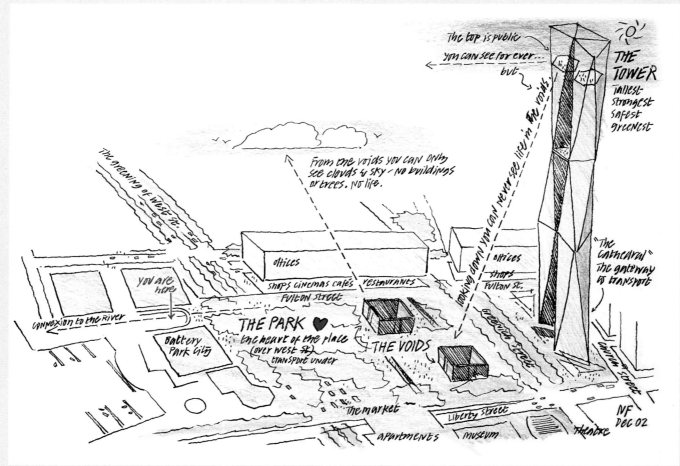

A Norman Foster sketch of the site focuses on points of view. The "kissing towers" overlook a park, at the heart of which are two voids that mark the original towers' footprints. A landscaped bridge crosses West Street, joining the site to Battery Park City and the Hudson River.

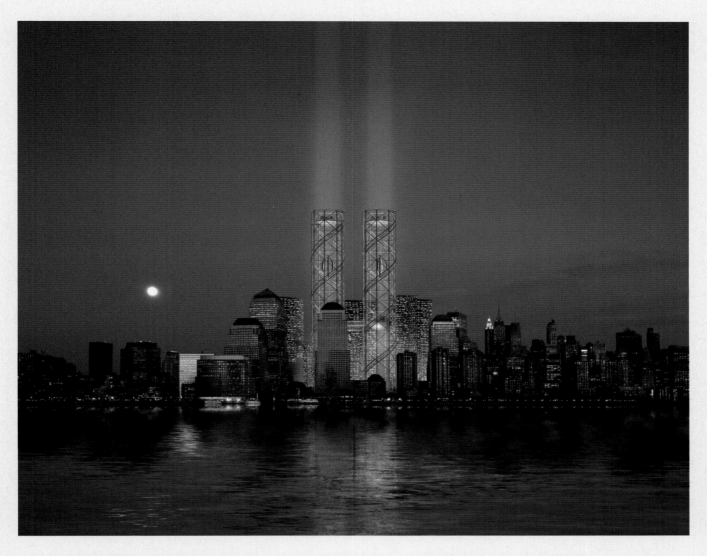

"World Cultural Center," Think's most impressive proposal, features two towers that recall the original Twin Towers, now restated in steel latticework, which would rise from two reflecting pools. The towers would house various cultural facilities designed by different architects. The plan also includes a transportation center, eight midrise office towers, and a hotel.

Think's second submission to the Innovative Design Study is the "Great Room," a thirteen-acre (5.3 ha) covered plaza with two latticed circular structures over the original towers' footprints.

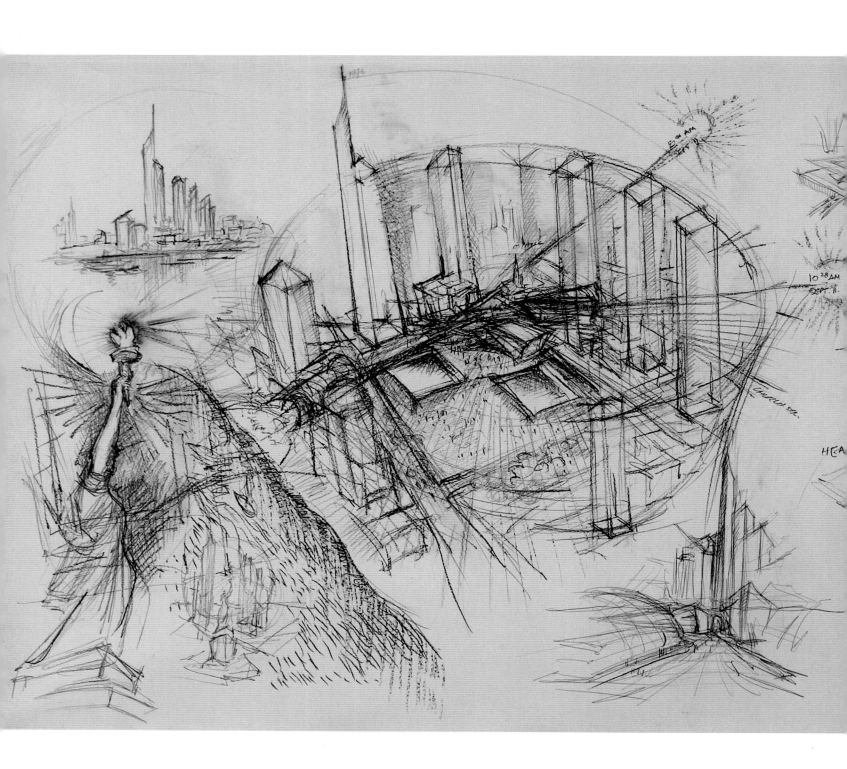

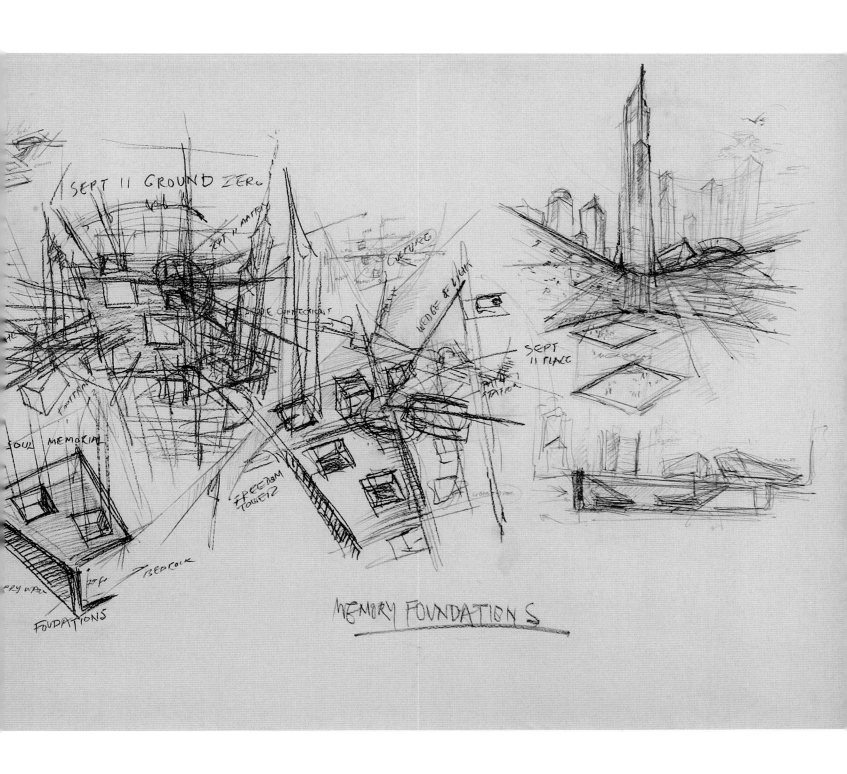

Daniel Libeskind's 2003 sketches reveal the thinking behind his "Memory Foundations" plan. On the left, the Statue of Liberty's upraised arm inspires his proposed design for Tower One. The sun's path determines the location of the Park of Heroes and the Wedge of Light. The right side emphasizes the importance of the slurry walls and the Twin Towers' footprints.

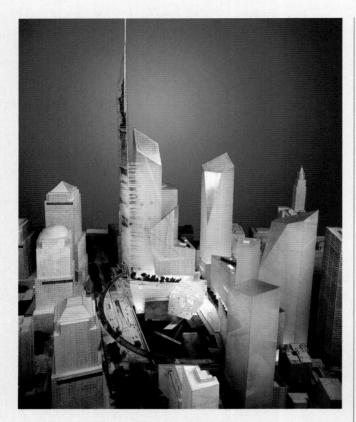

Libeskind's master plan transmutes the violence of 9/11 using the fractured, emotive architectural language for which he is known internationally, despite having built only a handful of projects. Its centerpiece is a 1,776-foot (541.3 m) skyscraper with an asymmetrical spire.

34

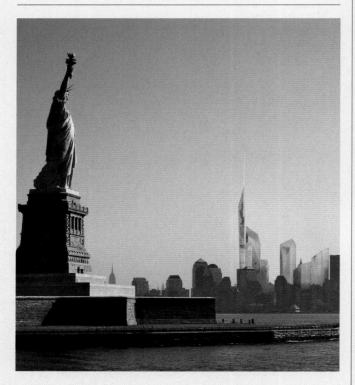

Libeskind's proposed tower echoes the nearby Statue of Liberty's upraised arm. Addressing the throngs gathered at the finalists' presentations, he said, "I arrived by ship to New York as a teenager, an immigrant, and like millions of others before me, my first sight was the Statue of Liberty and the amazing skyline of Manhattan. I have never forgotten that sight or what it stands for."

To commemorate those who died, Libeskind proposes two large public places, the Park of Heroes and the Wedge of Light. No shadow would fall on them on September 11 between 8:46 a.m., when the first tower was struck, and 10:28 a.m., when the second tower fell, he said, "in perpetual tribute to altruism and courage."

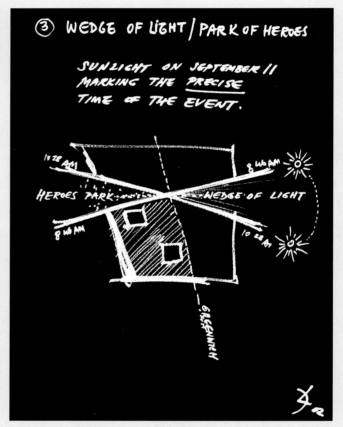

Libeskind vs. Think

The Libeskind and Think teams go into high gear, reengineering their final plans and campaigning for their visions. They hire PR firms, appear on *Oprah*, and garner backroom support. The cultural and academic community favors Think, as does the *Times'* Herbert Muschamp, who decries Libeskind's plan as "astonishingly tasteless" and, as the nation prepares to send troops to Iraq, "a war memorial to a looming conflict that has scarcely begun." *New York Post* reporter Steve Cuozzo, also anti-Libeskind, praises Think's proposal, saying the difference between the two plans was as vivid as that "between the promise of birth and the finality of interment."

February 27, 2003

LMDC selects Libeskind's "Memory Foundations" master plan. Although the plan will evolve almost beyond recognition in the years to come, the public is content for the moment, satisfied that they have helped birth something extraordinary.

April 1, 2003

The LMDC announces a design competition to commemorate the victims of the 2001 and 1993 WTC attacks. Proposals from sixty-three nations are submitted, 5,201 in all. Entry 790532, by Michael Arad, features two reflecting pools with water cascading down a square central opening. Ramps to the lower-level pools allow visitors to read the names of the dead and see the falling water. With respect to Libeskind's master plan, Arad said his scheme suggests "an alternative view of how the site can be integrated into the fabric of the city."

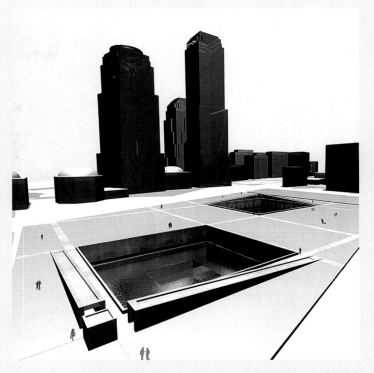

July 7, 2003

Larry Silverstein calls a press conference to announce that he has selected the designers for all five Trade Center towers, a move that is overly optimistic, given the decade of debates and delays to follow.

July 31, 2003

The Port Authority Board announces that Santiago Calatrava will design the new Transportation Hub, as part of the Downtown Design Partnership team, which includes the engineering firms of DMJM + Harris and STV.

September 11, 2003

The children of those who died on 9/11 read the roll call of their parents' names at Ground Zero.

35

"Precisely because architecture is so limited, it is the most spiritual. It's the reverse of what the romantic Germans thought—that the most ethereal art was music and therefore was closest to spirituality. On the contrary, what is heaviest, what is the most burdensome, what is written in stone, gives us a form of liberty."

DANIEL LIBESKIND, 2003

THE LOWER MANHATTAN DEVELOPMENT CORPORATION

New York governor George Pataki and New York City mayor Rudolph Giuliani created the Lower Manhattan Development Corporation (LMDC) in November 2001 to oversee the World Trade Center's redevelopment. The joint city-state agency, a subsidiary of the Empire State Development Corporation, was governed by sixteen board members appointed by Pataki and Giuliani. Pataki appointed John C. Whitehead, a veteran of D-Day; a former co-chairman of Goldman, Sachs; and deputy secretary of state under Ronald Reagan, to chair the board. Longtime Pataki associate Louis Tomson was president. Architect and planner Alexander Garvin headed planning, design, and development. With the Port Authority, the LMDC planned downtown's reconstruction and distributed some $21.5 billion in federal funds earmarked for its rebuilding and revitalization.

From the outset, the LMDC's ability to make decisions about this most intensely scrutinized project was hampered by a lack of clarity from public officials about whether remembrance or rebuilding was a priority, and by competing institutional claims between the state of New York, the city of New York, the Port Authority, and leaseholder Silverstein Properties.

In April 2002, the agency issued a Request for Proposals. They ultimately selected master plans devised by Beyer Blinder Belle, a practice known for its design of sensitive urban sites and restoration of Grand Central Terminal and Ellis Island. BBB did a sound job of analyzing the site and accommodating the as-yet-undesigned memorial and transit center. However, the public largely rejected these plans. Officials defended the plans as starting points for discussion, but their defense fell on deaf ears.

In hopes of generating more creative solutions, in August the LMDC issued an open Request for Qualifications (RFQ) that invited submissions for its Innovative Design Study. Proposals had to accommodate eleven million square feet (1,021,933.4 m²) of commercial space—and incorporate a distinctive skyline element, reintroduce certain city streets, include sustainable technology, anticipate security measures, and preserve the Twin Towers' footprints. Beyond that requirement-heavy program, the proposals had to "make lower Manhattan a destination for everybody in the world"; meet the demands for commercial space; stand as a symbol of both freedom and vengeance; provide healing and renewal; and be a fun place to shop and eat—in a context where it was already very difficult to do anything. In other words, they had to do the impossible.

More than four hundred submissions poured in. With a panel of advisers, the LMDC chose seven teams of elite architects and gave them two months to produce new master plans. Their presentations on December 18, 2002, featured a broad array of elements, from soaring towers to quiet memorial areas, as well as settings for office towers, the transit hub, and new streets. More than one hundred thousand people viewed them at the Winter Garden, and another eight million saw them online. The LMDC intended to pluck the best ideas from all the concepts and, somehow, combine them in one scheme. As the ideas emerged, however, it became clear that that wasn't going to happen. "The designs are polar opposites," Garvin said. "You can't really take half of Greg Lynn and put it with half of Richard Meier."

On February 4, 2003, the LMDC announced two finalists, Studio Daniel Libeskind and the Think team, led by Rafael Viñoly, Frederic Schwartz, Ken Smith, and Shigeru Ban. At the end of the month, the LMDC selected Libeskind's proposal,

"Memory Foundations." That's not to say that everyone preferred Libeskind's plan. In fact, when the LMDC convened on the Tuesday before the Libeskind plan was selected, they had decided in favor of Think. However, the next day the governor overruled them. "I may just be a hick from Peekskill," Pataki said of Think's plan, "but those towers look like death to me." The governor's influence on the World Trade Center rebuilding, never more apparent than on that day, handed Libeskind the most visible commission on earth.

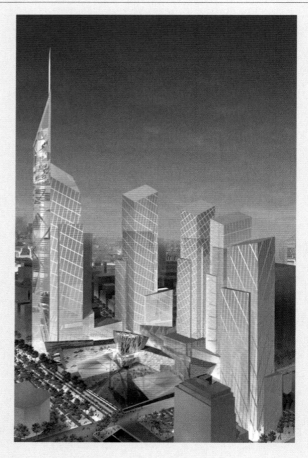

On **September 17, 2003**, the LMDC, working with the Port Authority and Studio Daniel Libeskind, releases a refined master plan that preserves essential elements of the original plan and reconciles infrastructure and transportation issues.

November 23, 2003

The temporary PATH station opens, reconnecting lower Manhattan and New Jersey. It is the first public WTC space to open after 9/11.

January 6, 2004

"Reflecting Absence," designed by architect Michael Arad and landscape architect Peter Walker, is selected for the 9/11 Memorial. Joined by architect Max Bond Jr., they present the final memorial design in December 2004.

The world's first glimpse of Calatrava's soaring Transportation Hub design is on **January 22, 2004.** As costs and security concerns grow, the design is modified.

April 8, 2004
LMDC appoints an advisory board to plan an underground interpretive museum at the Trade Center.

May 16, 2004
Power begins flowing through the ConEd substation at 7WTC for the first time since September 11, 2001.

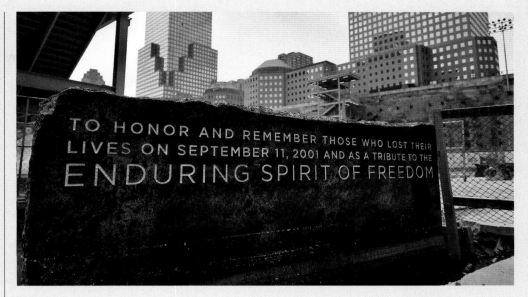

Governor Pataki presides over the Freedom Tower's groundbreaking on **July 4, 2004,** and dedicates its cornerstone, a twenty-ton piece of inscribed granite that is soon moved into storage on Long Island. Two months later, the Republic National Convention is held in New York City.

August 31, 2004
New York Police Department (NYPD) Deputy Commissioner for Counter Terrorism Michael A. Sheehan writes the Port Authority a letter about the Freedom Tower's "insufficient standoff distance" from West Street; the letter is apparently misrouted.

September 11, 2004
At Ground Zero, mothers and fathers recite the names of their daughters and sons, and grandparents name their grandchildren lost on September 11.

November 24, 2004
After three years of contentious negotiation, the City of New York, the LMDC, the Port Authority, and Silverstein Properties finally agree on the World Trade Center's design and site plan. Quietly signed on the day before Thanksgiving and called by insiders (somewhat in jest) the "Thanksgiving Accord," the agreement sets the terms for every aspect of the project, including the location of its buildings, streets, shops, and sidewalks. The executed agreement is a mere five pages long.

"There were varying points of view as to what would be rebuilt, and when, where, in what order, and what it would look like, but there was, I think, consensus from day one that rebuilding was what ought to happen. The democratic process unfolded."

PATRICK J. FOYE, Executive Director, Port Authority

37

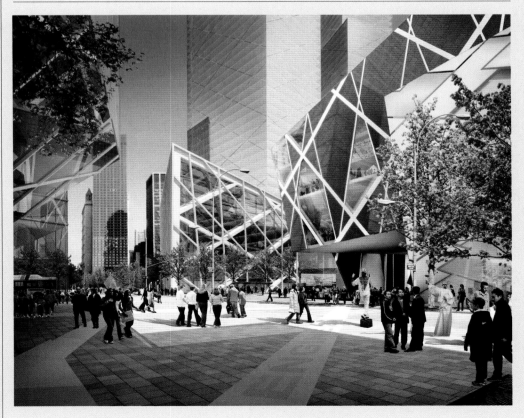

Libeskind's proposed Park of Heroes and Wedge of Light plaza.

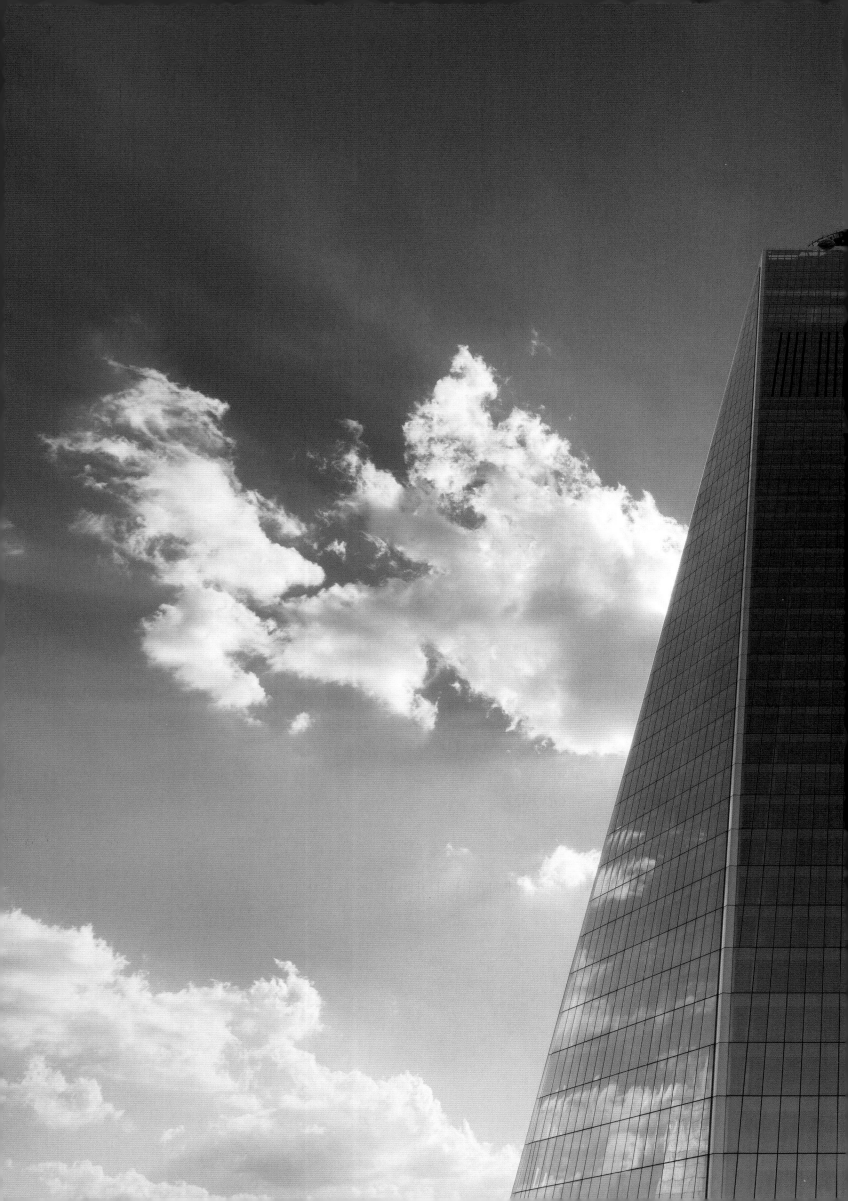

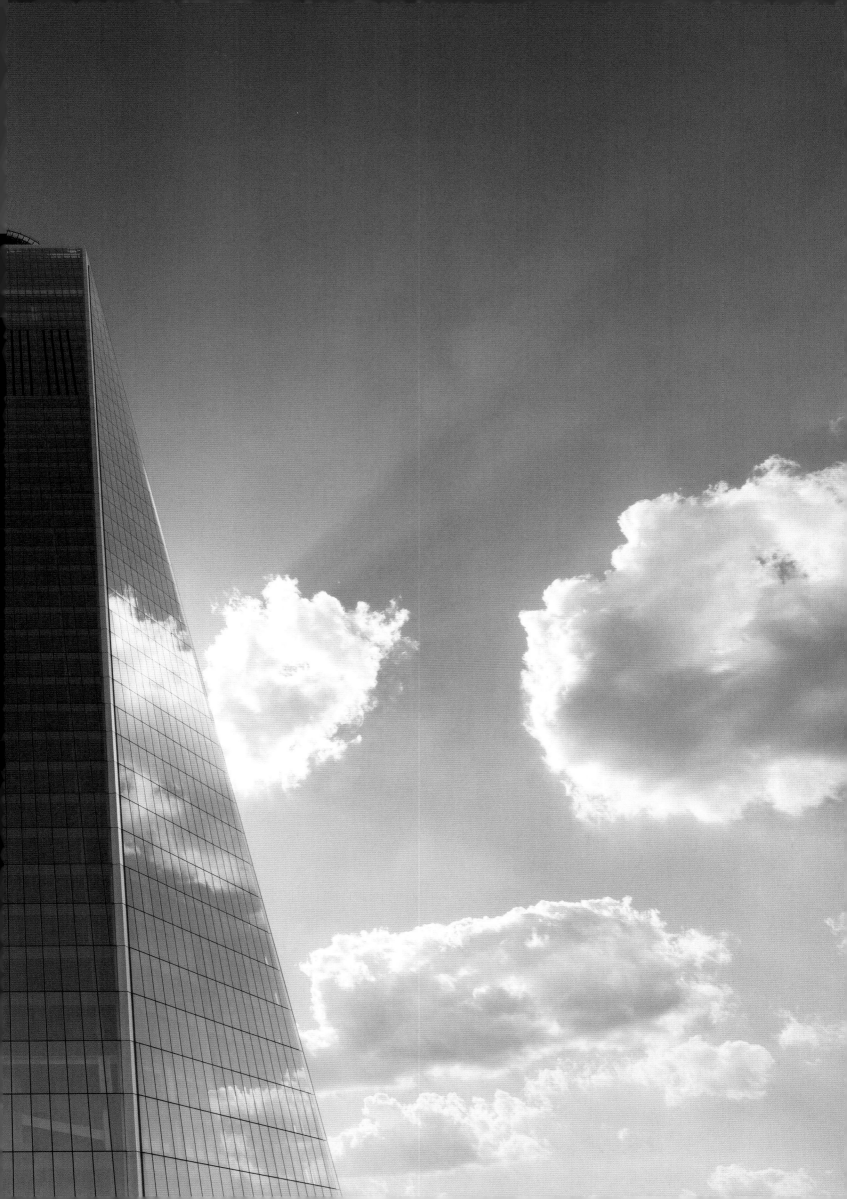

EVOLUTION OF THE TOWER'S DESIGN

2003–2005

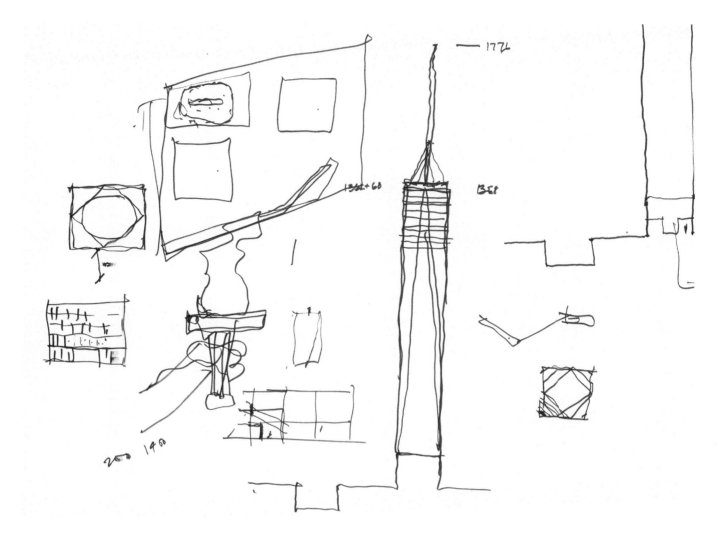

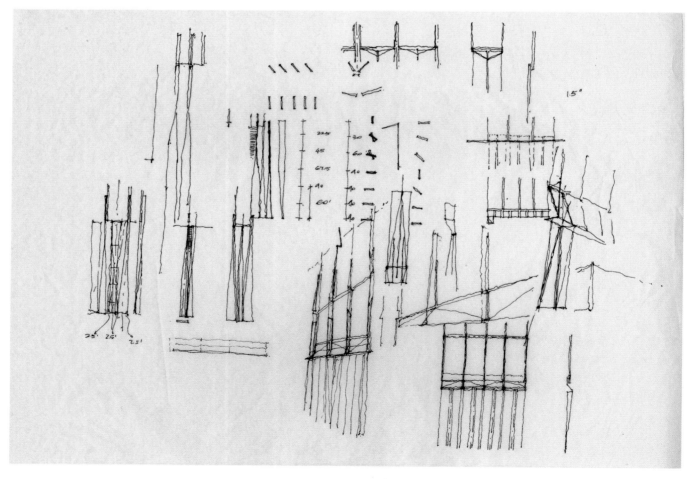

Exploratory sketches show the process by which SOM arrived at One's symbolic and physical form.

Interviewing Daniel Libeskind is like downing three cups of espresso. He's energetic, voluble, and supremely optimistic as he talks about the World Trade Center years after his master plan was selected in 2003. We first spoke then, when he was on top of the world. Years later, my understanding of his contributions to the World Trade Center broke wide open. Like many of his designs, his impact is impressionistic, the sum adding up to more than their many jagged parts. If you choose to linger in the morass that is the figuring out of who was responsible for what at the Trade Center, you will miss a profound truth—Libeskind's fingerprints are all over it—as well as a paradox: his name does not appear on any building.

His "Memory Foundations" master plan met with an enthusiastic reception. Anchored by the asymmetrical Freedom Tower and other skyscrapers that encircle a deep open pit, it laid claim to the entire site. Libeskind's plan also defined the Trade Center's outer spatial limits: Today, one can traverse the site's full dimensions in a day—from the 9/11 Memorial Museum's lower level at bedrock, seventy feet below ground, to the observation deck on top of One World Trade Center. His aesthetic sensibility emerges too in Snøhetta's Pavilion, the fractured wedge atop the 9/11 Memorial Museum. At the Transportation Hub, the skylight is positioned to catch sunlight at the precise angle he had proposed for the Wedge of Light park. A phalanx of architects has designed towers of graduating heights that swirl upward toward the northwest corner of the site, just as he proposed. His plan specified cultural amenities, including an interpretive museum. Perhaps his greatest coup was exposing the slurry wall, now a compelling symbol of American endurance.

Despite these powerful remnants of Libeskind's original vision, much of what he proposed was swiftly dissected. After the initial, euphoric planning stages, his influence receded as the Port Authority and Silverstein Properties reasserted control. The leases they had signed prior to September 11, which entitled Silverstein to 10 million square feet (929,030.4 m²) of office space, drove the program that ultimately reiterated Beyer Blinder Belle's earlier plans. Enormous pressure was exerted by the public and the media, which eagerly tracked every modification to the Freedom Tower's design.

The question of who would design the Freedom Tower was undecided. As a result, its design would undergo many iterations from 2003 to 2005, as these pages illustrate. Libeskind, sanctioned by the public as well as Pataki, felt entitled to design the tower. Silverstein insisted that Skidmore, Owings & Merrill (SOM), his architects, take the lead. Back in the summer of 2001, Silverstein had hired SOM, a firm that had been involved at the World Trade Center since David and Nelson Rockefeller conceived of it some sixty years ago, to renovate the Twin Towers. Well before the LMDC selected Libeskind's master plan, SOM was working on its own site plan for Silverstein in collaboration with Cooper, Robertson. Also within weeks of September 11, Silverstein commissioned SOM to design a replacement tower for Seven World Trade Center and was so enamored of the outcome that he asked the firm to design all the buildings at the Trade Center. Libeskind, on the other hand, had never built a skyscraper. Janno Lieber, who directs Silverstein Properties at the Trade Center, recalled Silverstein saying, "Dan, if I'm gonna have open heart surgery I want somebody who's done it before. And a building of 1,700 feet in height is the architectural equivalent of open heart surgery."

SOM saw themselves as seasoned guides who could help Silverstein, who did not have extensive experience with exclusive Class A office buildings, navigate the shoals of design and planning. In response to Silverstein's exclamation, "You're our new Yamasaki!"—referring to the architect of the Twin Towers—David M. Childs, SOM's lead architect, and T. J. Gottesdiener, the affable and meticulous managing partner who oversees SOM's finances and contracts, laid out the conditions of their involvement. "We spent quite a few months with Larry on a very close basis, a couple times a week, having conversations with him, talking about ideas, sketching things out, not only about Seven,

43

"if I'm gonna have open heart surgery"...

"You're experiencing a certain meaning as you walk through a city street or a museum or Ground Zero. That story is not told through words because architecture can't use words. It uses the means of architecture: shaping space, shaping light, carving the space in a certain way in which you would feel the intimacy, individually, of what that space is."

DANIEL LIBESKIND

but really about the larger site itself," Gottesdiener said. They discussed the site's most charged elements—"the issues of the families, the issues of open space, the issue of the connective tissue of the streets, the issues of Larry's financial investment.... There were a lot of different things at play."

Silverstein said Childs "is a gem of a human being, a superb architect." Childs described the developer's efforts at the Trade Center as a "mission he was entrusted to undertake, and he focused on every aspect to make certain it lived up to the challenge." Some said it was a Faustian bargain. Childs could give Silverstein "enough cachet to survive the byzantine political process and ruthless public scrutiny" at the site, while Silverstein had the power to hand Childs the nation's most visible and coveted commission, and the recognition that had eluded the architect. Their chemistry worked. Silverstein was determined to heal the hole in the city's heart with an extraordinary ensemble of buildings and, with guidance from SOM, he did so.

It was soon evident that Libeskind and Childs were designing two very different towers, both of which had some claim to being the "official" design. Their approaches were fundamentally at odds as well: Childs conceived of buildings in terms of their materiality, function, and contextual appropriateness, rather than in the metaphorical imagery that Libeskind preferred. While Libeskind worked on modifying his Vertical World Gardens scheme, SOM was developing a new design, a sophisticated tensile structure with wind turbines in the upper superstructure. To accommodate the turbines, they devised an internal cable system, which they discovered, as they got into the details, would be "unbelievably expensive." This scheme was developed to a high level of detail, requiring almost two years of serious effort, testing, and expense.

At the same time, the Port Authority continued to implement their own plans. Their mandate to secure the site and restore its transportation capabilities was unquestioned, and they forged ahead—rebuilding structural foundations, replacing below-ground utilities and infrastructure, and, in conjunction with reestablishing the PATH line, planning a vast new underground network of transportation corridors.

Their work proceeded entirely apart from the results of the Innovative Design Study, but it determined the placement of many of the planned features. Indeed, in July 2003, well before the Libeskind master plan was finalized, the authority announced that they had selected Santiago Calatrava to design the new transportation center; a few months later, in November, the temporary PATH station designed by the Port's chief architect, Robert I. Davidson, opened.

Pataki, frustrated that things were not moving ahead as quickly as he'd like, strong-armed an uneasy alliance between Childs and Libeskind, which the latter frequently described as an "arranged marriage." The governor told the LMDC to call a meeting and not to let Childs and Libeskind leave until an agreement was reached. On July 16, 2003, after an eight-hour negotiating session, the two agreed to design the Freedom Tower together. Childs, however, retained fifty-one percent voting capacity on the design, which, in all practical ways, relegated Libeskind to an advisory role. In September, a refined master site plan was presented to the public. At the end of October, Pataki surprised everyone by announcing that the architects would deliver a new design by December 15—giving the architects, already mired in aesthetic and structural contretemps, a mere six weeks to come up with it.

A new design for the Freedom Tower emerged in December 2003 with its original name, location, and symbolic height—though little else. Actually 1,500 feet tall (457.2 m), with an asymmetrical spire that reached to 1,776 feet (541.3 m), the glass-clad tower would be the tallest in the nation. Its seventy occupant floors would sit on a parallelogram-shaped base and wrap around a concrete core. The skyscraper would twist as it rose, culminating in an open, steel-lattice superstructure supported by two concrete cylinders. This lacy truss would minimize wind loads while maximizing the energy collected by the wind-harvesting turbines housed inside.

That design survived until 2005, when it underwent a seismic reconfiguration. The New York Police Department insisted that the tower's security standards, comparable to those of a federal courthouse, were insufficient. They demanded that the tower be moved deeper into the site, from twenty-five feet (7.7 m)

...strong-armed an uneasy alliance

Libeskind's original 2002 proposal included a 1,776-foot (541.3 m) tower with a spire. The scheme was called "Vertical World Gardens," because its upper reaches were to be filled with plants and trees, but it never progressed beyond the conceptual stage. However, the tower's symbolic height and location on the site's northwest corner were retained.

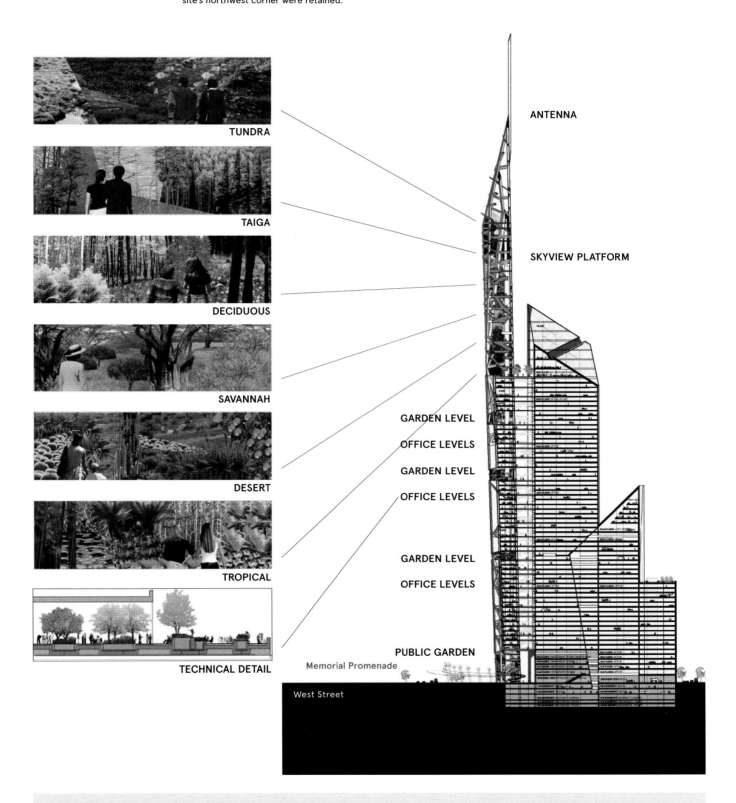

TUNDRA

TAIGA

DECIDUOUS

SAVANNAH

DESERT

TROPICAL

TECHNICAL DETAIL

ANTENNA

SKYVIEW PLATFORM

GARDEN LEVEL

OFFICE LEVELS

GARDEN LEVEL

OFFICE LEVELS

GARDEN LEVEL

OFFICE LEVELS

PUBLIC GARDEN

Memorial Promenade

West Street

45

Vertical World Gardens

"Memory Foundations" World Trade Center Design Study
Studio Daniel Libeskind, with Gary Hack (urban planner), Hargreaves Associates (landscape architect), Jeff Zupan (traffic engineer)

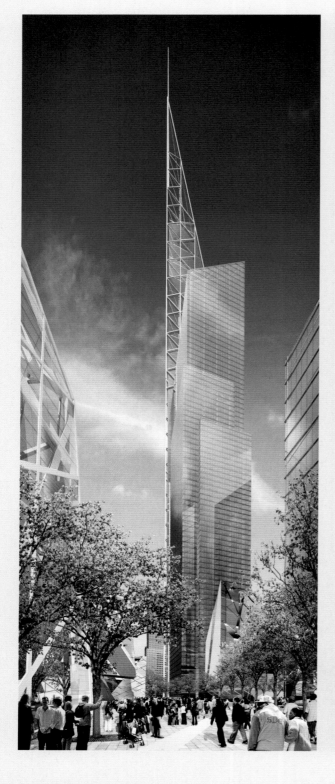

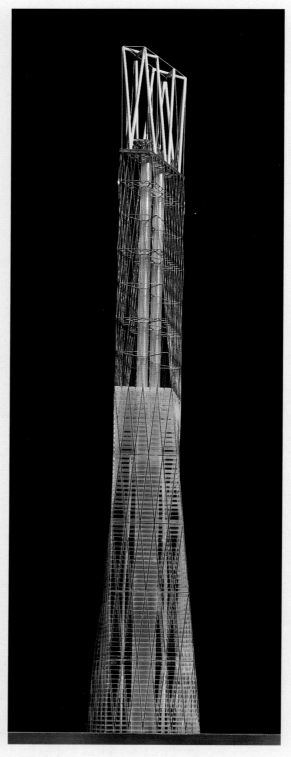

46

After Libeskind's master plan was approved in February 2003, he continued to modify his tower design. By fall 2003, the tower had been renamed the Freedom Tower and the spire was now fused to the top of a seventy-story office building.

SOM produced an entirely different Freedom Tower design in August 2003. The torqued, tapered tower featured wind turbines enclosed in an open-air superstructure topped by an antenna array.

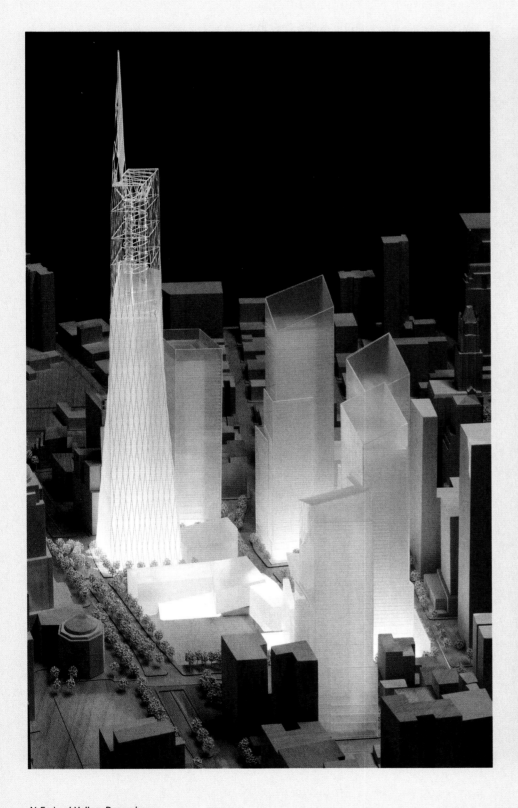

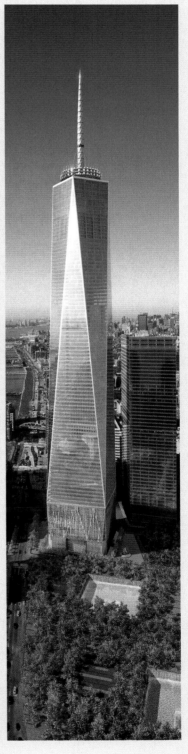

At Federal Hall on December 19, 2003, Childs and Libeskind unveiled a new hybrid design for the Freedom Tower. Libeskind's spire is reinstated, as are the tapered profile and open-air cable superstructure that Childs proposed.

Security concerns and financial considerations initiated a radical redesign of the tower. SOM released a new design with a central spire, reconfigured base, and enhanced safety features on June 29, 2005. The spire is enclosed in a radome, which would be eliminated in 2012.

to an average of ninety feet (27.5 m) from West Street, and that its base incorporate a blast-protection strategy. The NYPD also wanted to enforce 1,000-pound (453.6 kg) truck-bomb standards at all Trade Center towers, but Silverstein refused to turn the bases of his buildings, each one of which would include glass façades and shops at the street level, into bunkers. Instead, standoff zones with sidewalk barriers and sally ports to restrict traffic and building access were used. These security requirements changed the design of One World Trade Center and had an impact on the entire site, which, to the disbelief and anger of many at that time, was still a seventy-foot-deep (21.4 m) hole in the ground.

At the same time, it was becoming clear that the hybrid design presented in December would be costly to build. Who, exactly, was going to pay for the additional costs associated with its lofty spire and cable structure? Silverstein argued that he was obligated to rebuild the office tower only, and that the state should pay for its symbolic elements. Yet the state did not want to cover these additional expenses. Although

the NYPD's security concerns caused more delays, they came at an opportune time, conveniently breaking the stalemate over costs and initiating a redesign of the skyscraper, this time designed entirely by SOM.

Libeskind left his ivory tower long ago. Today, he waxes philosophic about his role downtown. "A lot of people talked about my frustrations. That's part of life. Who says that life should be easy? Who said that things should be handed to you on a platter? You should struggle," said the raised-in-the-Bronx scrapper. "New York is a tough place. You need to engage with everyone, work with everyone, and my task—and the master plan—was to make a consensus among parties that initially didn't agree on anything. Larry had his own ideas, SOM, the city, the governors, the Port Authority, everyone. My task in the master plan, my mission, was, how do you make consensus not through a mediocre compromise, but through ideas that are profound and are practical—and that can actually be built." And because he could not resist, he added, "By the way, the SOM building follows the plan very well. It does exactly what I asked for." ▲

48

Larry A. Silverstein (b. 1931) is the Chairman of Silverstein Properties, a real estate development and investment firm that has developed, owned, and managed 35 million square feet (3,251,606.4 m³) of office, residential, hotel, and retail space. The octogenarian possesses an unyielding drive, a defining characteristic that, like water on stone, erodes anything in its path. Proof of his unremitting determination is everywhere, from the completion of Seven World Trade Center in 2006, when virtually nothing else at the Trade Center was visible above ground, to his near-daily presence in the papers in connection with Two, Three, and Four World Trade Center, the three properties he is developing on the site, which represent a $7 billion investment. Seemingly tone deaf to politics, public opinion, and naysaying, he has pushed ahead, relentlessly, to rebuild the World Trade Center. In many ways, he is its unsung hero.

In July 2001, he closed on the largest real estate transaction in New York history, outmaneuvering many larger companies, when he signed a 99-year lease on the World Trade Center and the other buildings on the site for $3.25 billion, only to see them destroyed six weeks later. Earlier, he had acquired the rights to develop Seven World Trade Center, also destroyed on

September 11. In 2006, Silverstein relinquished the right to develop One and Five World Trade Center to the Port Authority in exchange for Liberty Bond financing for Two, Three, and Four World Trade Center. "Did we think it was fair? Not necessarily, but the important thing was to keep the momentum going," he said.

He is criticized and lauded, often in one breath, by those who have worked with him. An assessment by Chris Ward, former executive director of the Port Authority, is typical: "Silverstein is the one who said, repeatedly, 'Let's get this thing built.' And stuck with it. And stuck with it." He adds that Silverstein "deserves tremendous credit. That does not mean he is not an incredibly difficult, opinionated, driven negotiator of the highest order and will do what he needs to do. And I say that with a great degree of respect…. His perseverance and his continuing willingness to go into the fray and keep saying, 'This has to happen' was incredible."

Growing up in a seventh-floor walk-up in Brooklyn's Bedford-Stuyvesant neighborhood, he learned his trade from his father, Harry G. Silverstein, who leased building space in the rags, woolens, and remnants district of lower Manhattan, now SoHo. "It was the best teaching I could've had," Silverstein recalls. His father taught him the art of negotiating,

"how to bring people together, how to cajole, how to urge. I also learned that by being a broker, I would starve to death." Silverstein put together a syndicate of small investors and bought a building on East 23rd Street. "It was a sink-or-swim set of circumstances. And therefore we had to swim…. We went slowly but surely from modest renovations to gut renovations to total rehabs." It was just a matter of time before they "decided to dig the foundation, pour the slab, and build the building from scratch."

Silverstein prefers not to discuss his wide philanthropy. However, he contributes his time and resources to organizations that are dedicated to education and medical research, humanitarian causes, and the arts. A graduate of New York University, Silverstein served as vice chairman of the NYU Board of Trustees and continues to serve on the board of the NYU Langone Medical Center. He is the former chairman of the Board of UJA-Federation and a founding trustee of the Museum of Jewish Heritage in New York. He has served on the boards of the New York Philharmonic and National Jewish Health in Denver. A classical music enthusiast, passionate yachtsman, and devoted New Yorker, he is married to Klara Silverstein, a union of nearly six decades.

One World Trade Center's lead architect, **David M. Childs**, FAIA (b. 1941), is chairman emeritus and a consulting design partner at Skidmore, Owings & Merrill (SOM). Urbane, magnanimous, and patrician, Childs attended Deerfield Academy before studying architecture at Yale. He joined SOM's Washington, D.C., office in 1971 and, in 1984, relocated to SOM's New York office, where he became the firm's first chairman and senior design partner.

Like the elegantly detailed buildings that his firm is known for, Childs's edges are polished after years of dealings with an international clientele. Although some disparage his designs as being "polite," he has the political chops to see projects, especially complicated, messy ones like those at the Trade Center, to completion. He makes it evident, with a sincerity that goes beyond self-deprecation, that he cares

deeply about what people say about One World Trade Center, his skyscraper, the project he says they'll write about in his obituary.

Childs built his reputation on buildings and spaces that sensitively respond to their settings and programs, a refined sensibility that is evident in his projects around the world. They include the JFK International Arrivals Building, the renovation and preservation of Lever House, Time Warner Center, Seven World Trade Center, and 35 Hudson Yards, all in New York City. In Washington, D.C., Childs designed the Washington Mall and the Constitution Gardens master plan, the Four Seasons and Regent hotels, headquarters for National Geographic and U.S. News and World Report, and the Dulles Airport main terminal expansion. Internationally, Childs has completed such projects as the Toronto International Airport; the Ben Gurion International Airport

in Tel Aviv; and Tokyo Midtown, a mixed-use development in the Roppongi District, which reclaimed a site that had not been accessible in sixty years.

A vigorous advocate for the public good, he has chaired the National Capital Planning Commission and the Commission of Fine Arts in Washington, both presidential appointments. He has also served as chairman of the boards of the American Academy in Rome, the Municipal Art Society, and the National Building Museum, and has been an active member of the boards of the Museum of Modern Art, the Architectural League, and the National Housing Partnership Foundation. He has participated as a visiting critic or studio leader at leading schools of architecture, and has shared his knowledge at conferences and symposia internationally.

> "America didn't lose its freedom on 9/11.
> We were free before and we were free afterwards, and the
> attack did not destroy our freedom.... Draping the entire
> site forever in that moment denied its future—for where it
> could go, or should go, and would go over history."
>
> CHRISTOPHER O. WARD

49

Like few other architects, **Daniel Libeskind** is able to communicate architecture's spiritual, aesthetic, and moral responsibilities. Buildings, he believes, must do more than provide shelter. They are an expression of both body and soul, concrete proof of things invisible, and the means by which life's mysteries are understood.

Born in postwar Poland in 1946, Libeskind and his family settled in the Bronx. He became an American citizen in 1964. A virtuoso pianist as well as an accordionist in his youth, he switched to architecture, attending Cooper Union and eventually establishing a practice in Berlin in 1989.

Until his "Memory Foundations" master plan garnered international attention, he was best known for his theoretical explorations of architecture.

His first building, the zinc-clad Jewish Museum in Berlin, with its zigzag shape and evocative void, opened in 2001 to wide acclaim. It was followed by numerous museum commissions, including the Imperial War Museum North in Manchester, England; the Contemporary Jewish Museum in San Francisco; the Danish Jewish Museum in Copenhagen; and extensions to the Denver Art Museum, the Royal Ontario Museum in Toronto, and the Zhang Zhidong and Modern Industrial Museum in Wuhan, China.

After receiving the World Trade Center master plan commission in 2003, Libeskind moved his firm to Manhattan. Since then, Studio Libeskind, which he co-founded with his wife and business partner, Nina Libeskind, has designed a variety of commercial and residential structures worldwide, including Westside, a mixed-use project in Bern, Switzerland; the Crystals at City Center in Las Vegas; and Kö-Bogen, an office and retail complex in Düsseldorf. He has also realized residential towers in Busan, South Korea; Singapore; Warsaw; Toronto; Manila; and Sao Paulo.

What's in a Name?

In March 2009, the Port Authority announced that the Freedom Tower would now be known as One World Trade Center. In addition to sending a potentially incendiary message, the original name was causing confusion within the real estate industry. Leasing would proceed more successfully, real-estate agents believed, if the tower had an actual street address that could be used in marketing campaigns. One World Trade Center was a signature address, while Freedom Tower was a political message. That's not to say that "Freedom Tower" isn't still in currency. Certainly, the workers call it that, most probably because it conjures the heroic struggles inherent in their own labors. And, in late 2014, comedian Chris Rock hosted *Saturday Night Live*, opening with an edgy monologue that skewered the tower. He said, "They should change the name from the Freedom Tower to the Never-Going-in-There Tower. Because I'm never going in there.... I don't care if Scarlett Johansson is butt naked on the eighty-ninth floor in a plate of ribs." His bit provoked nervous chuckles and, within moments, rebukes on Twitter. One wonders how long it will take for the tower to lose its original moniker, and the associations it brings with it. There are others, such as those who were children in 2001, who have no firsthand memory of the original towers. As Erica Dumas, a spokesperson for the Port Authority, said of One, "*This* is my World Trade Center."

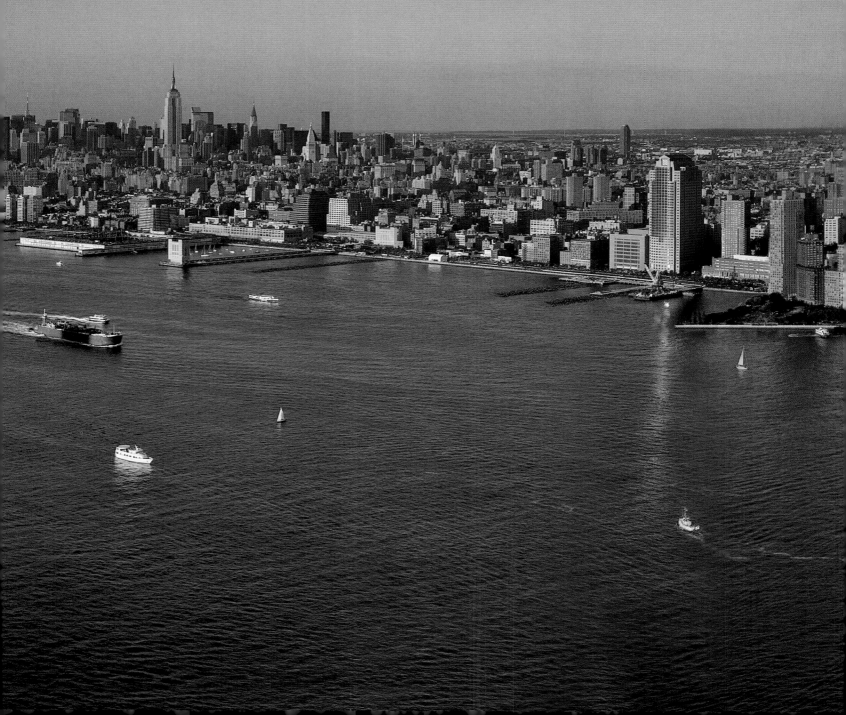

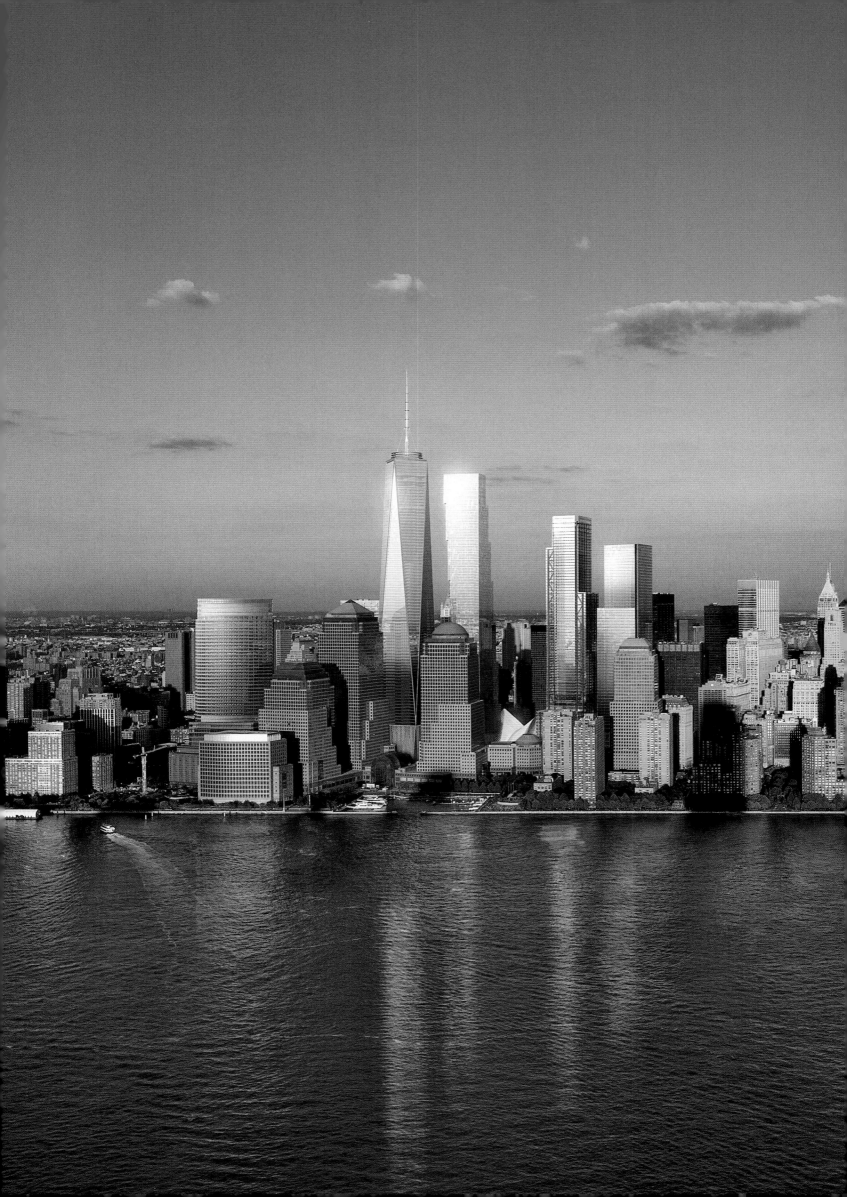

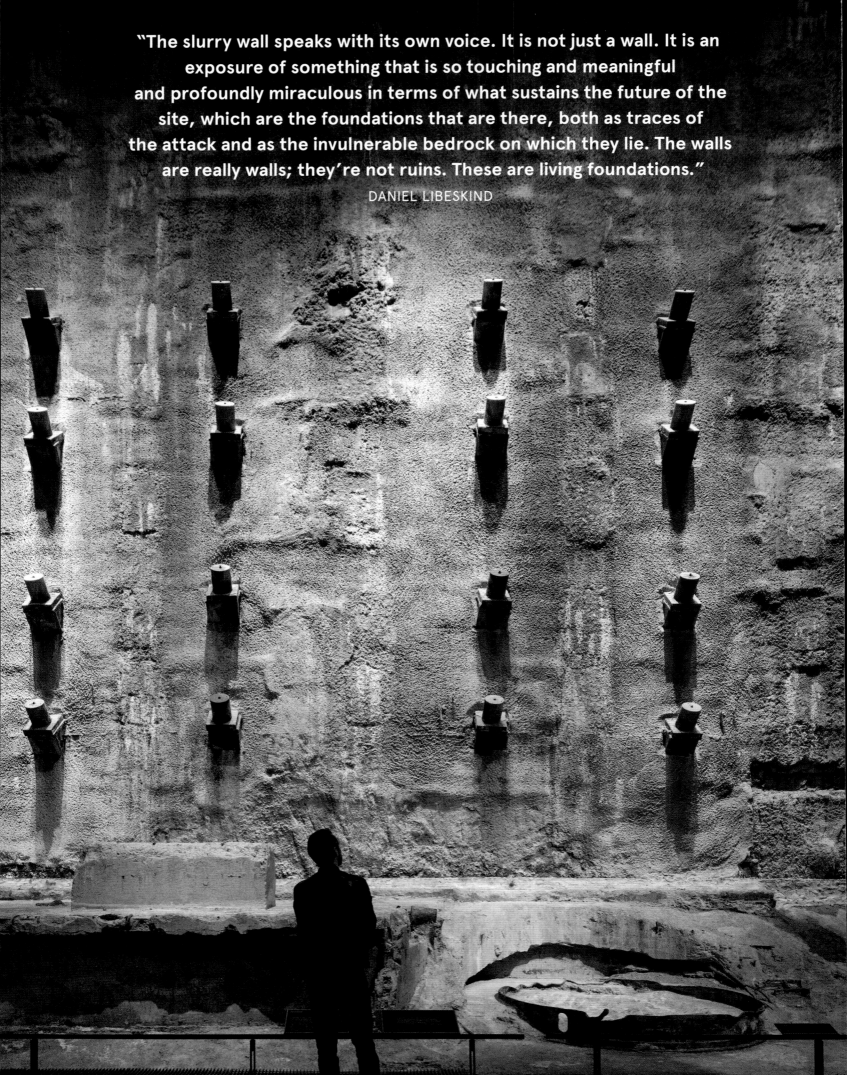

"The slurry wall speaks with its own voice. It is not just a wall. It is an exposure of something that is so touching and meaningful and profoundly miraculous in terms of what sustains the future of the site, which are the foundations that are there, both as traces of the attack and as the invulnerable bedrock on which they lie. The walls are really walls; they're not ruins. These are living foundations."

DANIEL LIBESKIND

The Slurry Walls

At one point in lower Manhattan's history, everything west of Greenwich Street was below water, part of the Hudson River. Over time, beginning in the late seventeenth century, the city expanded outward from its eastern and western shorelines, incrementally claiming new land by filling in its streams, ponds, wetlands, and other bodies of water with dirt, abandoned structures, and refuse. When the Twin Towers were excavated, their proximity to the Hudson River—in some instances just 160 feet (48.8 m) away—posed a problem that had to be solved before they could be built. To prevent river water from entering the towers' foundations, builders constructed "bathtubs," or watertight support structures lined with reinforced walls around the perimeter of the site. These reinforced walls, called slurry walls, supported the bathtub and resisted the river water's relentless, constant pressure. On September 11, these original slurry wall foundations—massive concrete walls roughly three feet (0.9 m) thick and 3,000 feet (914.4 m) long—stood and held back the river that threatened to inundate the site and much of lower Manhattan.

The sole structural survivors of the terrorist attacks, the slurry walls became infused with meaning, thanks to architect Daniel Libeskind, who proposed leaving portions of them exposed along the site's western edge. Recognizing their scarred power, his master plan glorified the unlovely slurry walls, which became a powerful metaphor of American resilience. Without his emphasis, the walls would have been covered up as they were originally, and the site would have lost one of its most enduring symbols.

George Tamaro, the éminence grise of slurry wall construction, is a partner at Mueser Rutledge and a specialist who holds several patents on the technology. He worked on both the original and new walls at the Trade Center. In the 1960s, the Port Authority sent him to Italy to learn slurry wall techniques from architect Pier Luigi Nervi, the maestro of concrete form, who introduced Tamaro to the foundation technology known in Italian as *il diaframma*. Constructing a concrete diaphragm (or slurry) wall involves

digging a deep, narrow ditch to bedrock and replacing the excavated dirt with a liquid mixture of water and clay called slurry, which prevents the ditch from collapsing. A cage of reinforced steel is lowered into the slurry and concrete is poured in, displacing the slurry.

At the original Trade Center, these walls were stabilized further with more than a thousand steel-cable tiebacks that were grouted and jack-yanked at a 45-degree angle deep into the bedrock until the Trade Center's seven basement and subbasement levels were erected. Once the walls were built, below-grade structural slabs were installed at various levels to provide permanent lateral support for the slurry walls and to support parking and other services. The resulting 500,000-square-foot (46,451.6 m²) concrete-lined area, 85 feet (25.9 m) deep, became known as "the bathtub."

Because of the slurry walls' precarious post-September 11 condition, an overall strategy for their long-term stability had to be developed immediately. The Port Authority commissioned a "mud map," a below-grade structural analysis that identified the forces the new stability system would have to resist: wind loads from the towers above, seismic loads, lateral soil loads, hydrostatic forces from the Hudson, and differential temperature stresses. Since Mother Nature is oblivious to boundaries between construction projects, the below-grade stability system had to work holistically across the entire site, accommodate staged construction plans, and be future-proof.

Tamaro worked with other foundational engineers from Mueser Rutledge and WSP, along with SOM, to ensure that the surviving walls were stabilized, waterproofed, and reinforced. There are in fact three such bathtubs—west, east, and south— that support the foundations of all structures on the site; contractors were responsible for the slurry walls that fell within the boundaries of their particular project. On the west side, the slurry walls were reinforced; on the east side, the bathtub was deepened. A new bathtub was constructed on the south side to accommodate the Vehicle Security Center and Liberty Park.

53

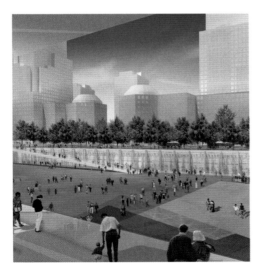

The retention of the slurry walls was integral to Libeskind's vision for the new World Trade Center.

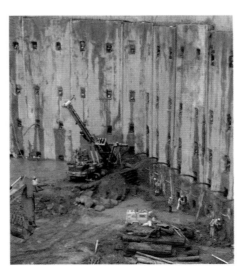

The slurry walls were fortified with an additional layer of concrete, about thirty inches (76.2 cm) thick. They are also supported by auxiliary walls that partition the site and resist additional lateral hydrostatic pressure from soil and water.

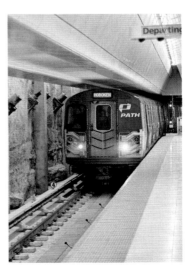

The public can see the preserved slurry wall inside the 9/11 Memorial Museum, where it serves as a metaphor for America's staying power. Unexpectedly, delightfully, a portion of the slurry wall also is visible on Platform A of the PATH station.

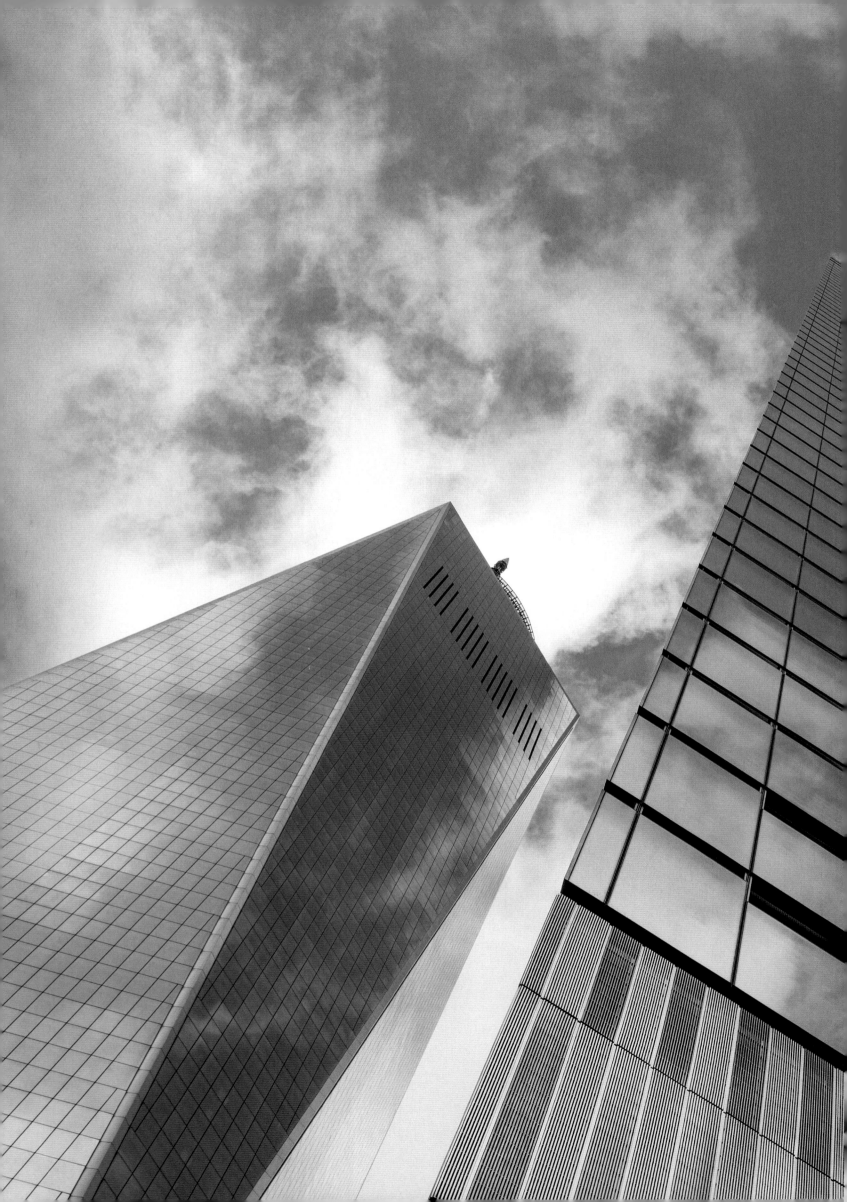

THE INFLUENCE OF SEVEN

SEVEN WORLD TRADE CENTER

To fully appreciate One World Trade Center, one must begin at Seven World Trade Center, simply called Seven, which is located just north of the site on Greenwich Street. Completed in 2006, Seven was the first tower to be rebuilt after September 11. Its construction was catalytic. It refocused prolonged discussions from what should be done at the World Trade Center to actually getting it rebuilt. The quality of Seven's design and materials, ingenious façade, safety measures, and civic generosity established a benchmark that set the tone for the rest of the World Trade Center.

58

Its innovations would be incorporated into every subsequent Trade Center tower—and towers built around the globe. Designed by SOM, engineered by WSP USA and Jaros Baum & Bolles, built by Tishman/AECOM, and developed by Silverstein Properties, Seven also saw the creation of a team of experts, all of whom would go on to work on One World Trade Center, bringing their skills and close working relationships to that project.

Routinely appraised as one of the finest new skyscrapers in Manhattan, Seven is a 42-story tower, sheathed in transparent glass, whose appearance changes over the course of the day according to the quantity and quality of available light. Its prismatic façade was created in collaboration with James Carpenter Design Associates, a firm known for pushing the aesthetic and environmental boundaries of building envelopes. "One of the great attributes of New York is the quality of light we have here, specifically, downtown," he said. "Because we're between two rivers, there's a lot of moisture in the air. Tiny spheres of water that are in the air make the light, endow it with

a physical presence." While the atmospheric conditions downtown are laden with potential, its narrow streets tend to be dark. To counter this, the curtain wall was designed to gather natural and ambient light from adjacent buildings and redirect it, illuminating the streets. The designers wanted to "express the qualities of light that are unique to this particular location," Carpenter said, "and give it back to the public."

Without the microscopic scrutiny that delayed construction of the adjacent sixteen acres, Seven was built quickly, despite complex structural issues. The building was an audition of sorts—for SOM, but to a far greater extent for Silverstein. Although he had built the original Seven World Trade Center, the eyes of the world were on him this time around. "The subtext of everything was that the state could come in and buy him out in a minute.... They were never going to pull that trigger, but he had to show that he was going to be a responsible developer, that he was building a good building," said architect Kenneth A. Lewis of SOM.

A parallelogram in plan, Seven's elegant profile was shaped by the restoration of Greenwich Street, a civic

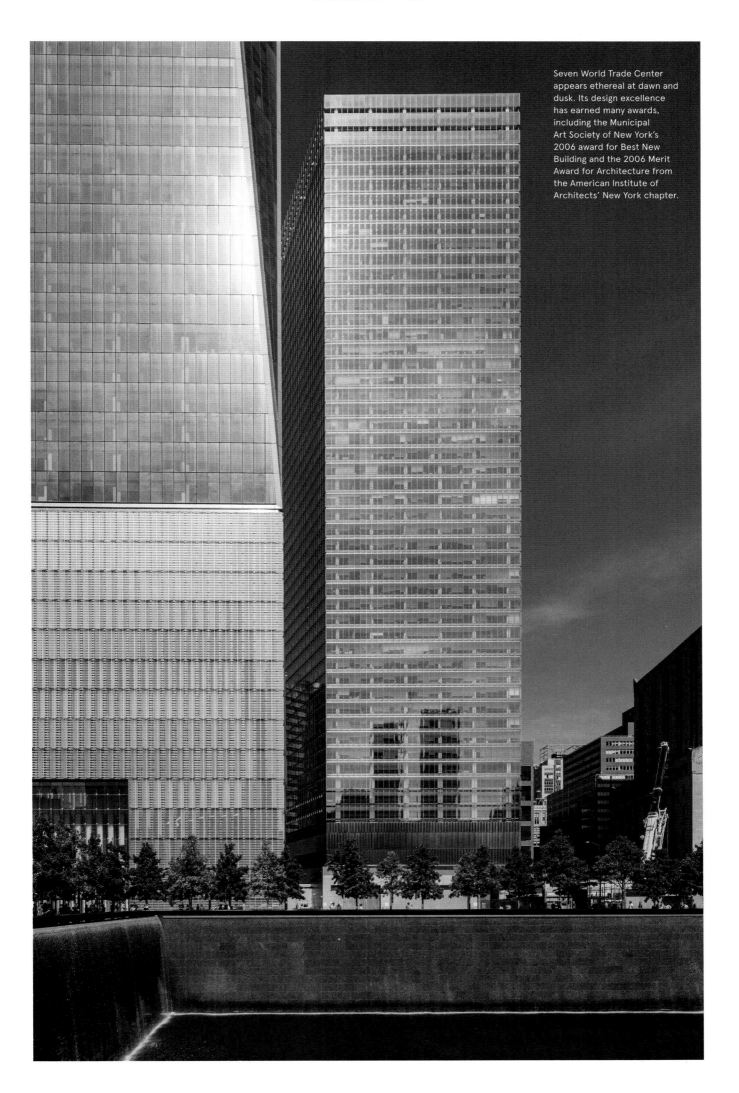

Seven World Trade Center appears ethereal at dawn and dusk. Its design excellence has earned many awards, including the Municipal Art Society of New York's 2006 award for Best New Building and the 2006 Merit Award for Architecture from the American Institute of Architects' New York chapter.

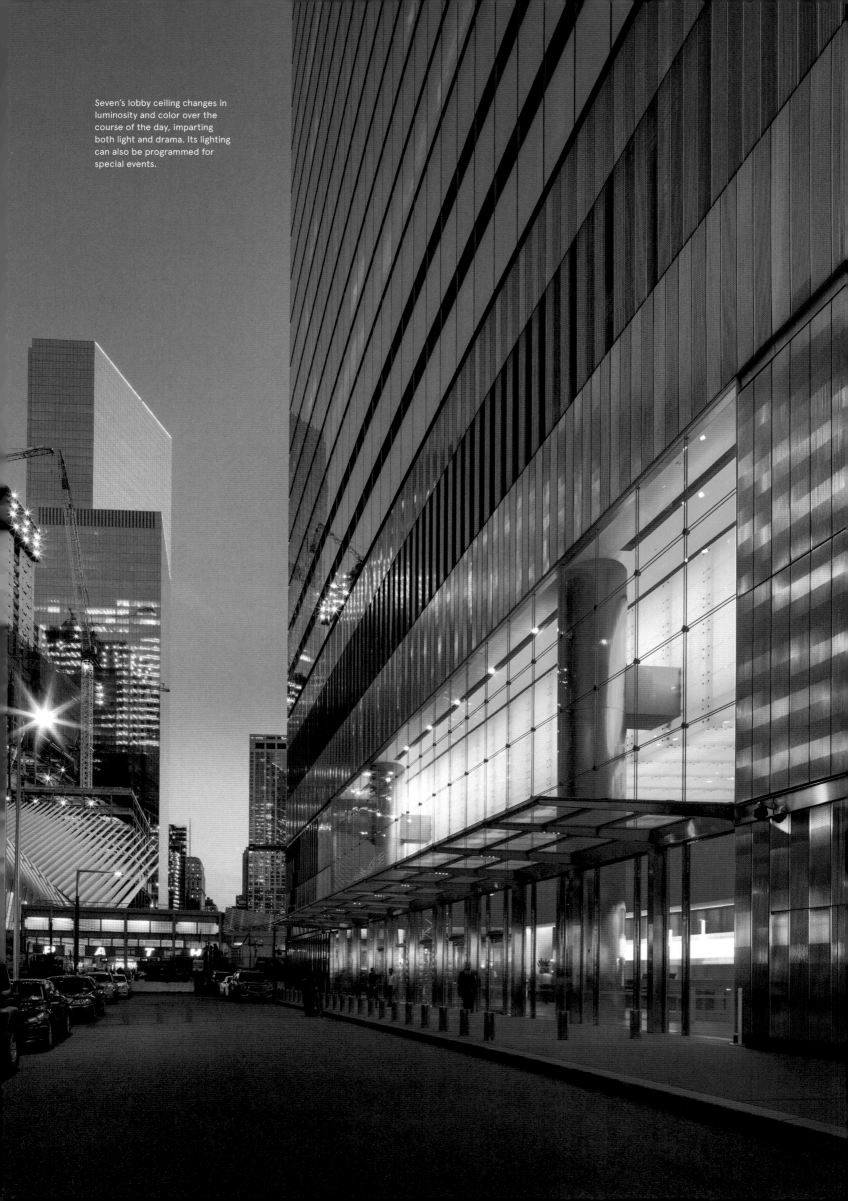

Seven's lobby ceiling changes in luminosity and color over the course of the day, imparting both light and drama. Its lighting can also be programmed for special events.

**"We had to do something to show the world
that was busy migrating out of lower Manhattan that we
were going to rebuild lower Manhattan....
I said, 'Let's get this rebuilt. Let's start the design.'
And that's exactly what I did."**

LARRY SILVERSTEIN

gesture that indicated that Silverstein wanted the new Trade Center to be as much about lively public spaces as it was about quality architecture. However, the new design required building a smaller tower and forfeiting leasable square footage. Geoff Wharton, who at the time led Silverstein Properties' efforts at the World Trade Center, convinced his boss, saying, "Larry, we've got thirteen other acres that we can put all that unused FAR [floor area ratio] onto. We don't have to use it on this site, let's do what's right for [Seven]," Childs recalled. Silverstein made Seven taller and narrower than its predecessor, and lost about 300,000 square feet (27,871 m²) in the process.

Seven's base made unique demands. It had to accommodate a new ConEd substation, after the one housed inside the original Seven World Trade Center was destroyed. The replacement substation contained massive transformers, each weighing about 250,000 pounds (113,398.1 kg) and measuring nearly eighty feet (24.4 m) tall. To reestablish a sidewalk entrance (the previous entrance had been elevated), Seven had to be built around these transformers, which are located on the north and south sides. Complicating matters further, the transformers had to be ventilated and above grade; they couldn't be lowered into the ground because the land is infill, reclaimed years ago from the

Hudson River. These requirements determined the design of Seven's eighty-two-foot-high (25 m) podium wall, which is sheathed in a double stainless-steel skin with a seven-inch (17.8 cm) internal cavity that permits uninterrupted airflow. The skin's stainless steel panels are variously angled to catch light, visually complementing the upper crystalline tower. Because the substation precluded putting shops and restaurants on the ground level, the podium scrim was fitted with LED fixtures that cast patterned blue and white light at night. To further animate the lower walls, motion sensors track movement on the sidewalk, displaying vertical bars of colored light as pedestrians walk by. When the new substation opened in May 2004, the beginnings of the new Seven, then about twenty feet (6.1 m) high, rose above it.

Security concerns also determined the design of the entrance. It appears remarkably open and light yet deploys a three-tiered security strategy. The entrance's cable-net glass wall brings in light but is blast-resistant. Inside the lobby, a protective illuminated ceiling changes in luminosity and color during the day (white) and at night (blue). A glass wall, sixty-five feet (19.8 m) wide and fourteen feet (4.3 m) high, behind the reception desk is actually a cleverly disguised blast shield that protects the elevator lobbies. It is also a work of art: *For 7 World*

61

Landscape architect Ken Smith designed the triangular park in front of Seven, formed by the intersection of Greenwich Street and West Broadway. Jetted fountains surround its centerpiece, Jeff Koons's whimsical *Balloon Flower (Red)*, a stainless steel sculpture on extended loan from the artist.

"let's do what's right"...

The entrance's cable-net glass wall was first developed by SOM, Carpenter, and Schlaich Bergermann for the Time Warner Center and later used at One World Trade Center. On the left is the blast-resistant wall that is an integral part of the Holzer/Carpenter installation.

These diagrams by James Carpenter Design Associates identify the components of Seven's unique "linear lap" curtain wall system. Sectional diagrams of the spandrel show how the sun's rays, indicated by the red lines, are redirected during summer and winter. A blue stainless steel reflector on the lower part of the spandrel bounces blue light up onto the curved reflector, enhancing the curtain wall's color and reflectivity.

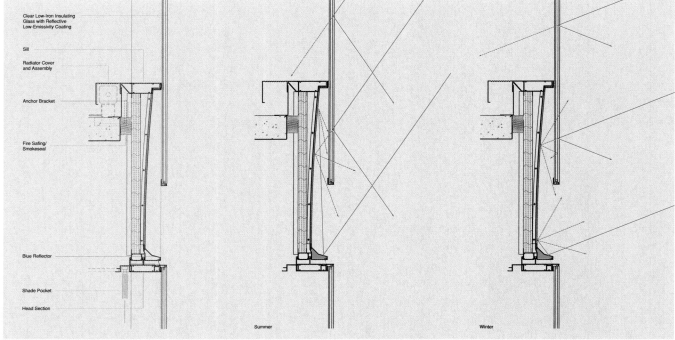

62

Trade is a 2006 installation by artist Jenny Holzer, made in collaboration with Carpenter, which features scrolling snippets of poetry and prose about New York. Carpenter designed the wall, which consists of two layers of glass, between which is suspended the LED system that generates the literary texts. More than a site-specific work, the piece marks the first time artists collaborated on the structural design of a building.

With input from others, Seven's architects and engineers developed safety and security solutions that formed the basis of future high-rise building codes. At the time it was designed, the New York City Building Code, not updated since 1986, was prescriptive. After September 11, the New York City Building Department rewrote the code, although changes governing security and safety would not be incorporated until 2008. SOM made life safety a prominent goal of the building design.

Throughout, Silverstein was actively involved, sitting "at the head of the table at every meeting, and follow[ing] everything, including all safety developments proposed for both Seven and One World Trade Center," Carl Galioto, formerly a technical partner at SOM, said.

Seven's safety measures largely established—and exceeded—the new code. Its stairwells, twenty percent wider than required, are pressurized and marked with glow-in-the-dark strips so tenants can exit easily and quickly during an evacuation. Leaky coaxial wiring for walkie-talkies allows uninterrupted emergency communications. Enhanced fireproofing material coats columns and floors. Critically, the central concrete core, two feet (0.6 m) thick and running the tower's full height, contains and protects stairways, elevators, communication systems, water storage, and power sources.

Seven boasts equally impressive environmental

...scrolling snippets of poetry

"We were collaborative for months and months.
That normally doesn't happen.... This was much more
intimate, much more moment-to-moment
and probably the best experience of the sort
that I've ever had."

PETER WALKER on working at Silverstein's offices, 2014

63

features. It was the first building in Manhattan to receive Gold LEED (Leadership in Energy and Environmental Design) certification from the U.S. Green Building Council. Its energy efficiencies include full-length glass windows that maximize daylight, high-performance HVAC and plumbing systems, and rooftop rainwater collection. Even the tenant leases are green: In 2011, Seven's leases became the first to incorporate groundbreaking language that allows owners and tenants to share the costs and benefits of sustainable improvements. The tower was fully leased by 2011.

Seven also served as the design headquarters for Two, Three, and Four World Trade Center. Silverstein created an atelier on the tenth floor, where upward of two hundred people worked daily in one large room. This arrangement, an unprecedented collaboration, was a classic Silverstein move—brilliant yet practical.

This photo commemorates the unveiling of the designs for three new Trade Center towers on September 7, 2006. Developer Silverstein (red tie) is pictured with his architects (left to right): Fumihiko Maki (4WTC), Norman Foster (2WTC), and Richard Rogers (3WTC). In 2015, Bjarke Ingels Group (BIG) was tapped to produce a new design for Two World Trade Center.

Having the towers' architects and engineers in the same room, along with those who would make sure the buildings met city and state planning requirements, made the work proceed more efficiently and helped avoid costly design changes. There was never a danger of design uniformity—the artistic egos involved guaranteed that —or of an aesthetic free-for-all that would undermine a visually cohesive site. Instead, there was a fusion of sensibilities that *Times* reporter David Dunlap aptly likened to the harmony of a "jazz quartet." ▲

brilliant yet practical...

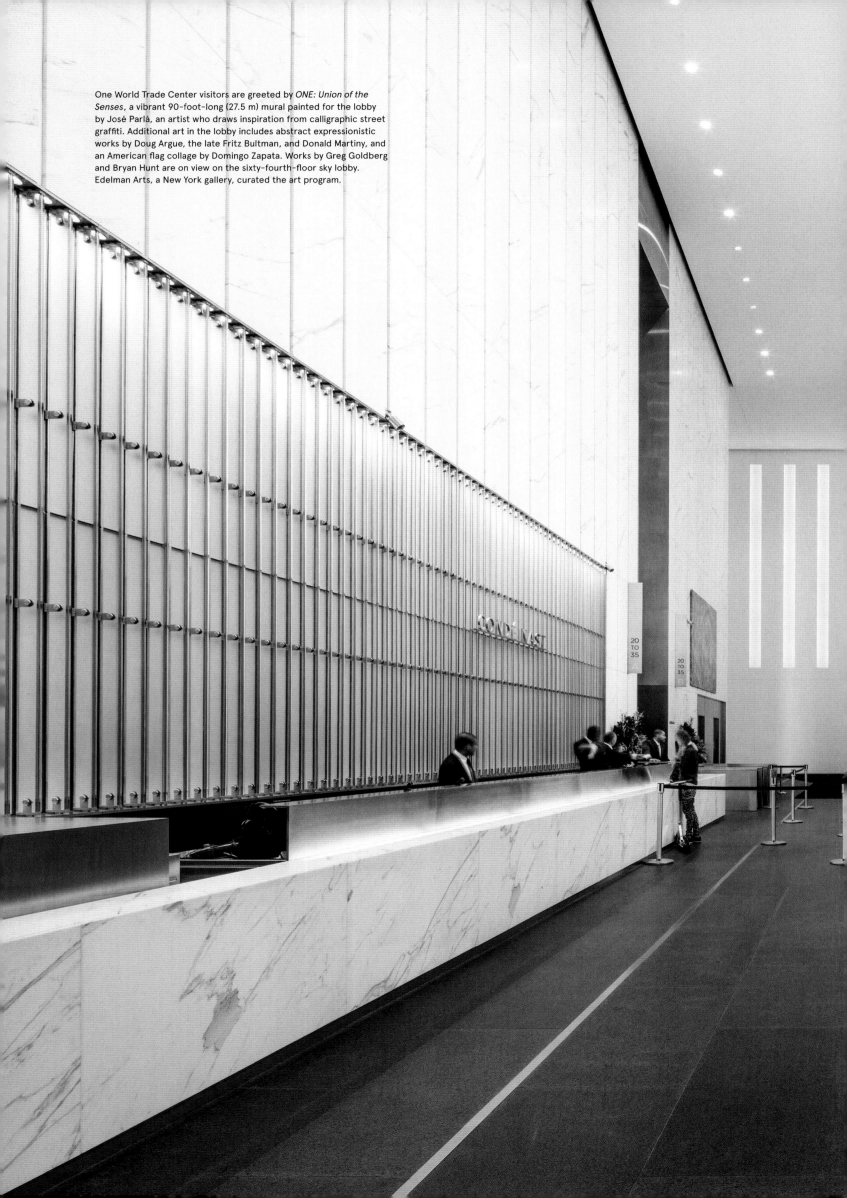

One World Trade Center visitors are greeted by *ONE: Union of the Senses*, a vibrant 90-foot-long (27.5 m) mural painted for the lobby by José Parlá, an artist who draws inspiration from calligraphic street graffiti. Additional art in the lobby includes abstract expressionistic works by Doug Argue, the late Fritz Bultman, and Donald Martiny, and an American flag collage by Domingo Zapata. Works by Greg Goldberg and Bryan Hunt are on view on the sixty-fourth-floor sky lobby. Edelman Arts, a New York gallery, curated the art program.

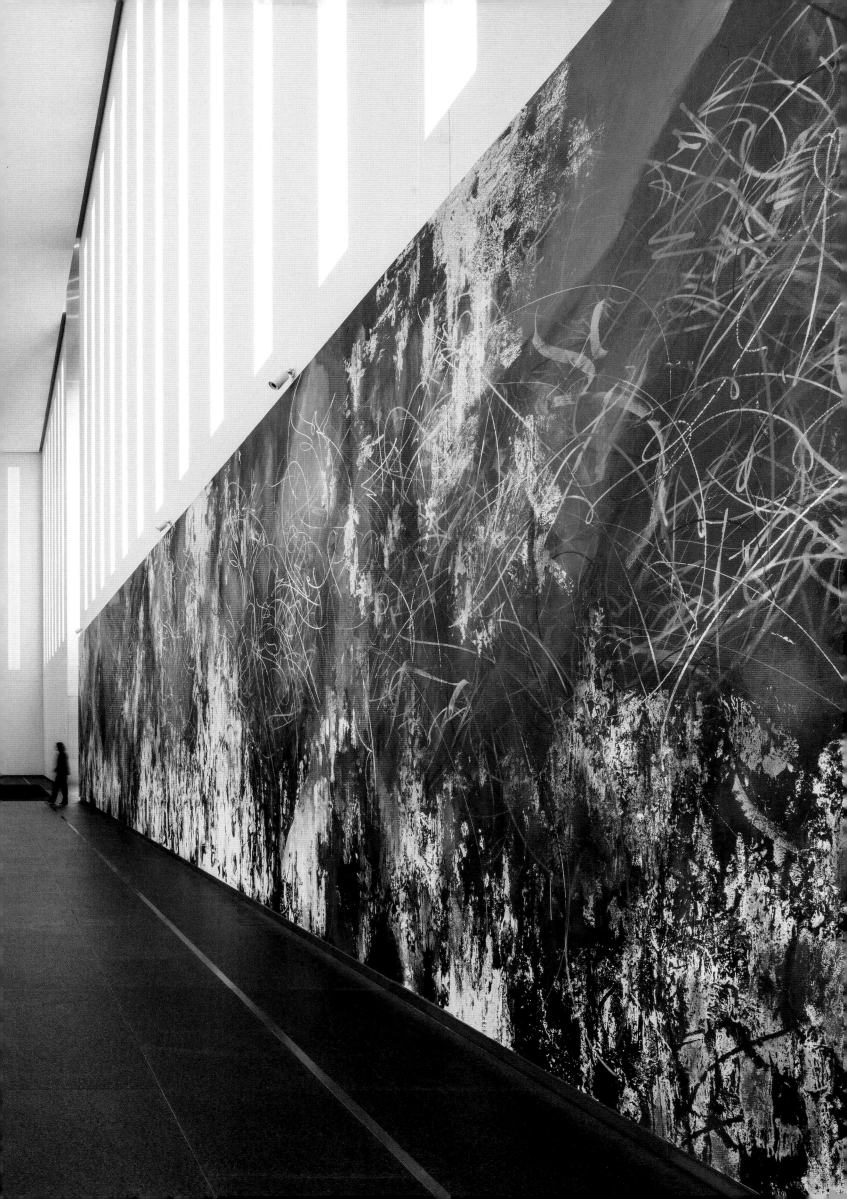

INTO THE BLUE

DESIGNING
ONE WORLD TRADE CENTER

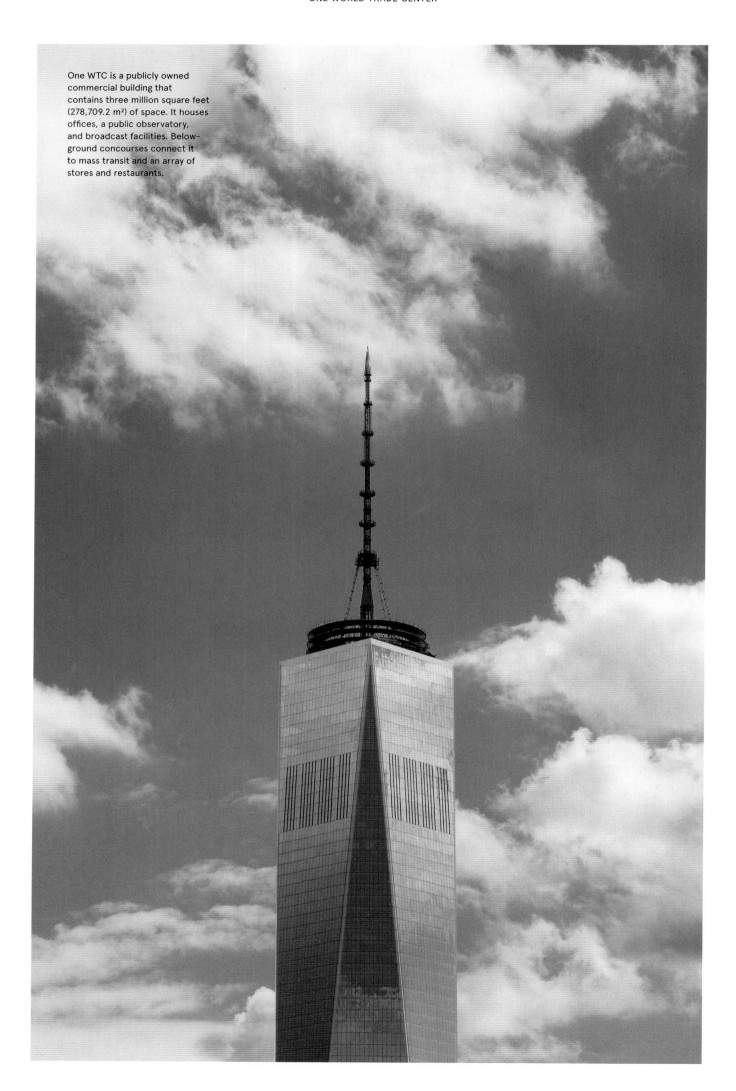

One WTC is a publicly owned commercial building that contains three million square feet (278,709.2 m²) of space. It houses offices, a public observatory, and broadcast facilities. Below-ground concourses connect it to mass transit and an array of stores and restaurants.

One World Trade Center is the color of the sky, assuming over the course of a day blue's every shade and nuance. Through this kaleidoscopic display of refracted light and color, the tower insists on the present unrepeatable moment and, for that reason, is forever new. A gentle giant, it meets its Janus task—to stand tall while avoiding any appearance of hubris—by inviting into its surface everything around it: wafting clouds; the architectures of the nineteenth and twentieth centuries, their ornament and angles caught in its planes; and the passersby who appear fleetingly in its story. Much like the city it loves, One's truest identity is found in its capacity to absorb, change, and endure. It may appear minimal and unadorned, but it is not.

Light, color, memory, emotion—architecture's most intangible, yet most profound materials—shaped One. SOM, its architects, also employed modernism's canonical palette of glass, steel, and concrete, here designed and engineered in tandem with other materials, often in ways that never have been attempted before. A mountain of a building, 104 stories tall and encompassing a total of 3.1 million square feet (287,999.4 m²), its immense size was determined by the need to replace the office space lost on September 11. An infinitely more challenging goal was to create a national symbol of all that was lost, and reclaimed, that day. SOM's inventive solutions and inspired collaborations yielded a building that is structurally audacious, incredibly strong, and welcoming.

For all of its prismatic changeability, the structure itself is austere, formed of fundamental geometries— square, octagon, square—that belie its structural complexity. Rising from a 200-foot-square (61 m) base, the tower gradually twists to form a perfect octagon at its midpoint, and, turning again, forms a new, now 145-foot (44.2 m) square. Its tapered, aerodynamic shape is a result of the eight triangular planes (four that point up and four that point down) that meet at the roof.

The 186-foot-high (56.7 m) base, or podium, contains a 50-foot-high (15.2 m) lobby and mechanical floors. Above that are seventy-one office floors that rise to an elevation of 1,131 feet (344.7 m) and offer long, column-free views. The floors range in size from 30,800 to 48,500 square feet (2,861.4 to 4,505.8 m²). To put these numbers in perspective, consider that a one-bedroom apartment in Manhattan is typically less than 1,000 square feet (92.9 m²), and often much smaller. Above the offices are additional mechanical floors and One World, a three-level public observatory. A three-story communications ring and an illuminated spire fitted with broadcast equipment on the very top bring the tower to its full, symbolic height of 1,776 feet (541.3 m), a reference to the year the Declaration of Independence was signed.

Lead architect David M. Childs of SOM wanted the design to express "serenity amongst all the cacophony of different things that are happening there." To accomplish this, he made the tower's profile experientially rich.

Its nuances become more apparent the more you look at it. At certain times of day, sunlight illuminates the stainless steel reveals that outline its triangular planes, another subtle reference to the original towers, which also had chamfered, or beveled, corners. "Their only moment of grace was when they caught light in some beautiful way," said Jeffrey Holmes, an associate partner at SOM and the project's senior designer.

One World Trade Center has a singular and symbiotic relationship with the 9/11 Memorial, to which it gestures in an act of respect and remembrance. Like the memorial, it derives its form and scale from what stood there before. From a distance, One World Trade Center indicates the memorial's location, but viewed from the plaza, its meaning expands. When one stands by the two square voids of the memorial pools, the eye naturally travels upward along the tower, which is the same height as the originals, causing the Twin Towers to visually resurrect in the mind's eye. Discussing the tower's dual obligations to symbolism and practicality, Childs said, "It's difficult to say one overweighs the other. Visually, emotionally, the symbolic aspects will hit you first, but then, as you get to know more about the building, you will see all those other efforts we were trying to excel in." The building is "very relevant, not only to its site—it could be nowhere else in New York—but to its purpose, which is totally unique. You couldn't put this building anywhere else in the world."

The tower restores the skyline. The original Twin Towers were an urban North Star: one quick glance up and they'd orient you. That too was gone when they fell, leaving in their wake an almost visceral desire to close the gaping hole in the skyline. Yet people had trouble remembering exactly where the Twin Towers had once stood. Childs recalled being on the phone with a friend from New York, who was in New Jersey at the time and scanning the horizon. He asked Childs, "Where is it?"

"Suddenly, it clicked in my mind that one of the building's most important nontechnical roles was to be the marker for the memorial. Its job was not to draw attention to itself, say 'look at me,' but to gesture to the memorial. It had to be the most beautiful, simple, powerful structure that makes that great marker downtown, fills the void, and completes the loss. It takes its power from its simplicity. When you look at the Washington Monument, its power is in the singularity of its form."

Childs, who had spent the outset of his long career in the nation's capital, knew well the stunningly abstract Washington Monument, a posthumous commemoration of the first president and the new democracy. His design recasts Washington's monument as a massive crystal, an illusion created by a curtain wall composed of thousands of glass windows. He describes its obelisk form as "a stick of butter cut with a hot knife."

It also alludes to architect Minoru Yamasaki's design for the original towers. Yamasaki, whose monolithic, inhospitable towers seemed to care nothing for New York, in fact configured them using Manhattan's fundamental DNA: His towers were just over 200 feet (61 m) square, the depth of a typical city block. New York's fabled street grid, and the continuity implicit

Floor plans shown here and on the endpapers illustrate the evolution of the tower's shape from a square to an octagon to a square. The first office space on the 20th floor is the largest, at 48,500 square feet (4,505.8 m²). Office space on the 90th floor is both the highest and, at just over 30,000 square feet (2,787.1 m²), the smallest.

70

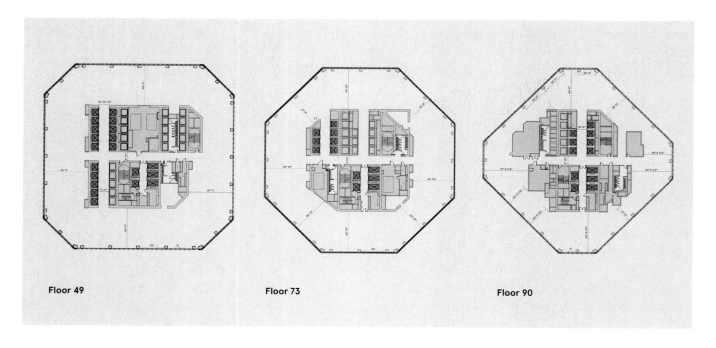

Floor 49 Floor 73 Floor 90

...Manhattan's fundamental DNA

The tower design is inspired by the Washington Monument and other obelisks. First used to mark land ownership, obelisks over time came to express a commemorative ideal. Robert Mills designed the Washington Monument (1884) as an obelisk, a tapered stone column capped with a pyramidal top, which the ancient Egyptians, the Roman emperors Hadrian and Trajan, and the English architect Christopher Wren, among others, once employed. Mills was fascinated as well by lighthouses and other navigational aids. Coupled with his preference for buildings that express permanence and social purpose, these two structural types naturally and inevitably blended in his mind.

in every sidewalk and corner, provides a constant that endures in the midst of ceaseless change. SOM's design similarly encompasses its urban context and also transforms cultural memory, yielding a structure that acknowledges the past and speaks to everything that got us to the place we are now.

Childs saw an opportunity in that 200-foot measurement. "We could take the exact footprint, but now extend it upward, so the building's profile would be identical to one of the lost towers," now done "in a way that was new, and inventive, and modern." Accordingly, One World Trade Center replicates the dimensions of the Twin Towers. From different vantage points, you can see the square top of the original towers. This reference is underscored at the cornice line, which is accentuated with a six-foot-tall (1.8 m) stainless steel parapet that marks the heights of the Twin Towers: 1,362 feet (415.1 m) and 1,368 feet (417 m; the originals were fraternal, not identical twins).

ENTRANCES AND PODIUM

A skyscraper makes two primary points of contact with the general public—where it meets the sky and where it meets the ground. These two views largely shape how a building is perceived. Some skyscrapers fulfill their skyline obligation in a dazzling way, but far fewer succeed at the sidewalk level, which, from a pedestrian's perspective, *is* the face of the tower. This is especially true in New York, where the tight street grid makes it impossible to back up and see the top of a skyscraper. One World Trade Center is an exception: situated in an open plaza, its structure can be viewed from top to bottom. Because One shares its location with one of the most solemn places in the city, its entrances and podium have to engage the public at street level and also harmonize with the activities around the memorial.

The tower has four front doors, each of them intentionally oversized to convey welcome and openness. The entrances on the south and north sides are monumental, nearly 70 feet (21.3 m) and 50 feet

(15.2 m) tall, respectively, to replicate the scale and sense of arrival associated with civic or ceremonial thresholds. Childs conceived these immense doorways, unprecedented in office tower design, to give the building "a front door that was appropriately scaled to its site."

As glorious as the entrances are, they initially presented a security problem. If made entirely of glass, they would offer little blast protection. SOM, in collaboration with others, worked out several ingenious solutions. The entries have highly transparent façades that are threaded with a cable-net grid. Much like a tennis racquet's strings, which spring back and push forward, the cable net is flexible, allowing the entrance walls to deflect and diminish the effect of an explosion. Just beyond them are secondary concrete walls that protect the lobby, which are clad in prismatic, dichroic glass that bathes the walls in shades of green, purple, and blue.

At night, the tower's podium is a startling azure blue, an illuminated square in the darkness that is as blue as a swimming pool on a sunny day. The entrances, luminous and white, are centered within these blue expanses. Together, the podium glass and entrances

71

as blue as a swimming pool...

A Roadmap Forward

By 2008, it was widely understood but unacknowledged that the World Trade Center project was off the rails. The main problem was a lack of prioritization and focus. Everything was important, everything was critical—the building, the memorial, the transit hub, the message. Everyone had the best intentions, yet the very scale of those hopes, coupled with the project's complexity and the sheer numbers who were involved, held the site in limbo. Some wanted the project stopped altogether, but, with billions of dollars already committed and the foundations already built, it was impossible to radically redefine the site. Albany too was in turmoil. Eliot Spitzer, whose brief tenure as governor was cut short by the revelation that he used an escort service, was replaced by David Paterson, who appointed Christopher O. Ward the executive director of the Port Authority in May 2008. He told Ward, "You need to establish new credibility downtown. You need to pull the budgets apart, pull the schedules apart, rip the Band-Aid off."

A complex contradiction of a man, Ward is larger than life. He is a survivor of the September 11 attacks and a graduate of Harvard Divinity School, fond of dropping both literary references and f-bombs in conversation. He is able to push stevedores and contractors into action. Along with others, he assessed "this wildly out-of-whack world" over many months. What they saw was "an inability to really answer the questions about how Silverstein's infrastructure would work with the museum's infrastructure, which would work with the retail part of each one of those components, which would deal with the Vehicle Security Center, which was the Port Authority's—up until then there hadn't been a centralized decision-making group representing all those stakeholders."

Ward established a steering committee that grappled with fundamental questions—What were they building? Who was building it? When would it be built? For how much?—that had to be resolved. Out of that committee came the realization that completing the memorial by the tenth anniversary of September 11 was, without question, the top priority. Some remarkable engineers from the Port Authority tackled the problem, devising a top-down construction strategy that decoupled the memorial's construction from the Transportation Hub's platform work below. This "deckover" approach—building the roof of the Transportation Hub's PATH mezzanine first, which would serve as the floor of the memorial plaza—would allow the memorial to be finished by that milestone date. "Not to be cynical, but nobody could argue with the memorial," Ward said. "That was the cutting of the Gordian knot."

In October 2008, five short months after Ward's appointment, he and his staff released a pivotal report, *A Roadmap Forward*, which put on the table all the political and legal disputes that had kept the rebuilding effort at a crossroads. It set forth schedules and budgets that reflected "the construction reality on the ground instead of politically or emotionally driven promises," with the intent of delivering "a level of certainty and control over this project that has been missing since its inception." The report urged the Port Authority to adopt a centralized decision-making process that would streamline construction logistics. It identified multiple reasons why One World Trade Center costs, originally budgeted at $2.9 billion when the Port took over the project from Silverstein in 2006, had increased to $3.1 billion (now $3.9 billion). They included revisions to the tower's schedule, staging, and scope, along with substantial increases in the costs of construction and materials, expenses that were exacerbated by the extended project schedule. A remarkably grounded and panacea-free document that gave the project a way forward, the report was prepared largely by Drew Warshaw, Ward's chief of staff, whom Ward praised as "a guiding force."

The report was met with relief, especially inside the Port Authority. Two months before Ward became executive director, Anthony Shorris, the former executive director, had given a speech downtown, saying that the World Trade Center would be completed by the tenth anniversary. When Ward came aboard, as he recalled it, "Everybody in Port Authority was just hunkered down in their bunkers, shell-shocked." Saying "Pencils down, stop the nonsense" recast the project in a more realistic light. Ward reeled off the names of others who supported the new approach—Bloomberg, Paterson, Silverstein. "And the museum felt engaged finally, because they knew the memorial, which was key to them, would be the priority. So I'd say it was a real relief."

echo, in reverse, the image of the dark memorial pools with their still darker central pools, a connection that is heightened because the podium's measurements—200 feet (61 m) wide by 186 feet (56.7 m) high—replicate the size of the memorial pools almost exactly. Diagonally across the site is the St. Nicholas National Shrine, which, also illuminated, restates in spiritual terms the secular emotion expressed by the tower's glowing podium.

During the day, the podium's structure becomes apparent. It is clad with vertical laminated glass fins, which are angled to produce dynamic patterns. Fitted with glass that reflects subtle hues of gray and lavender, the V-shaped fins—more than 4,000 of them, each one just over thirteen feet (4 m) tall—echo the vertical striations created by the cascading waterfalls in the nearby memorial. At the ground level, the fins are closed, opening up as they rise and then closing again to visually merge with the building's upper glass curtain wall.

Originally, the podium corners were to cant outward, an edgy solution that intimated a sense of shelter while simultaneously calling attention to the tower's massive size. However, SOM nixed this design "when it became apparent how difficult it would be aesthetically to resolve the clash between the vertical lines created by the fins and the sloping lines at each edge." That's why the tower's base meets the ground at a right angle. Interestingly, that original structure remains, though concealed inside the square base. Perhaps in the

future it will be uncovered or, even more minimally, its volume will be lit, making its presence known.

As a safety measure, the podium contains no office spaces, but it is hard for the casual observer to detect its many other security measures. Architect T. J. Gottesdiener said that the podium is "approachable, friendly, light; it sparkles and beckons." Many New York office buildings have retail shops on the street level, which naturally attract people, an advantage that this tower doesn't have. But, Gottesdiener said, "You still have the sense that you want to come up to this building. It completely disguises the notion that this is an impenetrable, secure building."

LOBBY

The lobby evokes the grandeur of a cathedral nave. Spare but luminous, it is clad in pristine white marble and its ceilings soar to fifty feet (15.2 m). On the upper walls, a series of narrow, extremely tall windows seem to present an abstraction of the city's skyline with its scores of skyscrapers. Le Corbusier's deep windows at Ronchamp and James Turrell's ethereal light sculptures also come to mind. More than anything, however, the long slotted windows read as the original Twin Towers, now multiplied, conjuring the buildings that are held in the memories and hearts of untold individuals. Entering the tower through the south entrance, look up through the elevator banks: you will see two windows, two towers enshrined, precisely framed by the walls.

Sunshine appears to be coming through the windows, but that illusion is ingenious artifice. Illusion is what Claude R. Engle III, whose firm designed the lighting for the interior and exterior of the tower, was after. As a child, Engle became intrigued with sleight of hand, learning magic tricks from a family friend who had studied with Harry Houdini. Later, right out of college, he began working in theatrical lighting, where architectural lighting has its roots. As he recalled, "We set the mood—was it day? was it night?—by the direction and color of the light." In 1968, he landed his first big commission, lighting the Twin Towers for Yamasaki, forming a friendship that would last until the architect's death in 1986. Since then, Engle has lit some of the world's most iconic structures, including the pyramid at

73

The lobby is clad in white Larissa marble extracted in Carrara, the storied quarry in northwest Tuscany, and chosen for its fine grain. The contrasting Mesabi Black granite on the floors was quarried in northern Minnesota.

"it sparkles and beckons"...

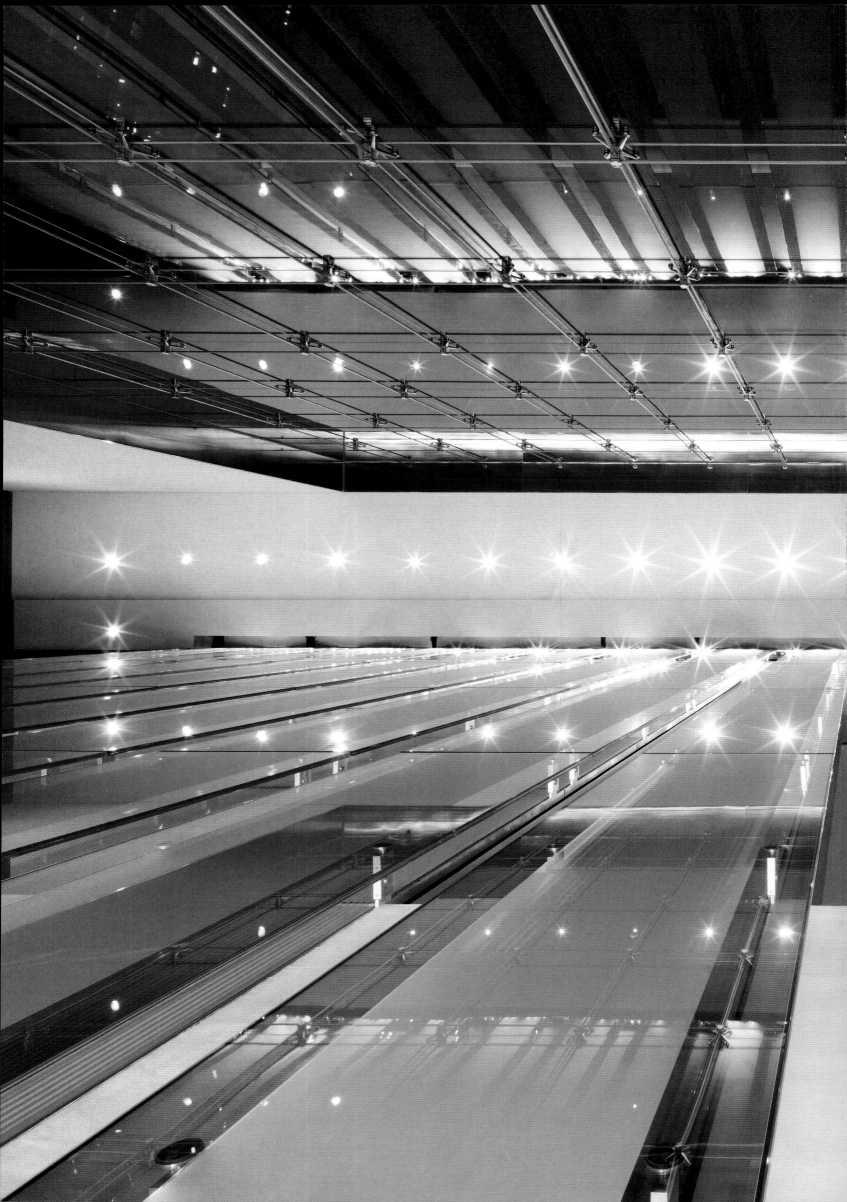

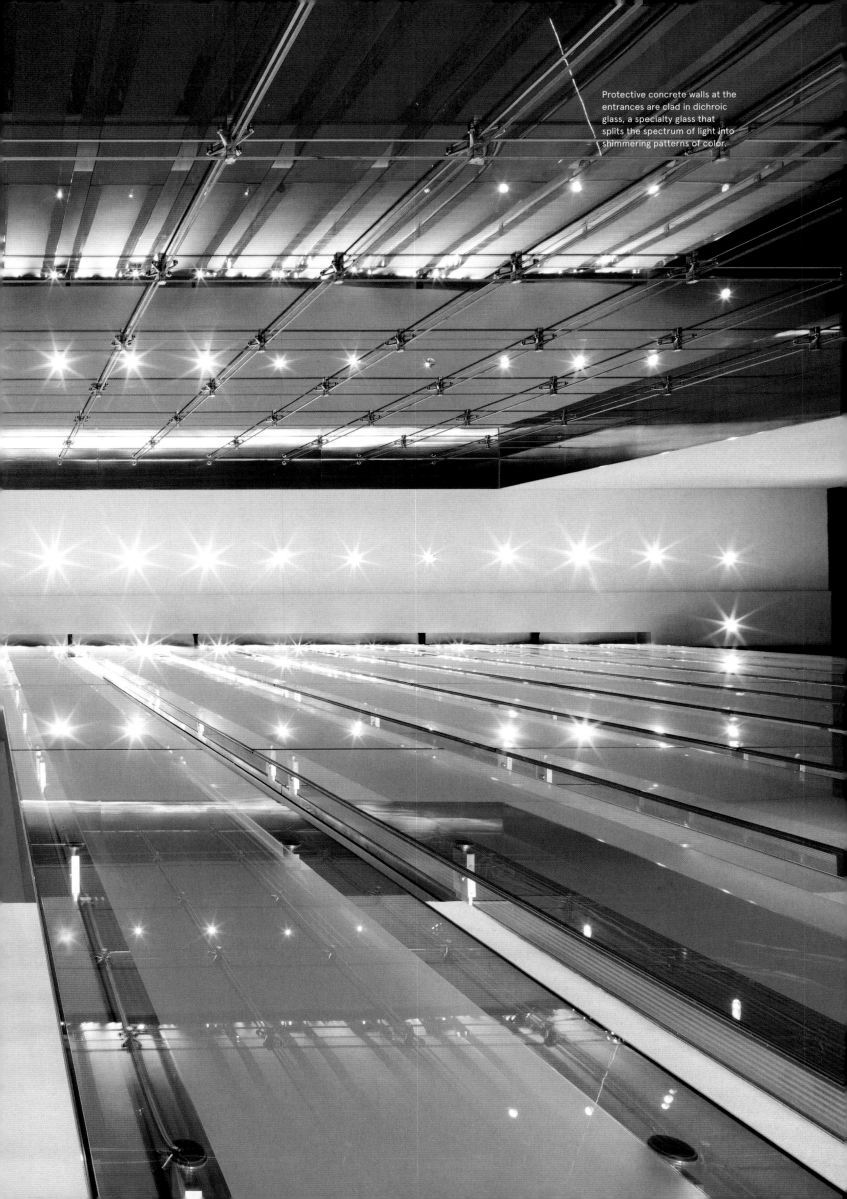

Protective concrete walls at the entrances are clad in dichroic glass, a specialty glass that splits the spectrum of light into shimmering patterns of color.

the Louvre Museum, Berlin's Reichstag, and London's Wembley Stadium Arch.

Engle envisioned the new tower long before ground was broken, using his years of experience to imagine the final structure. Before specifying fixtures, he worked backward from a fundamental question: What should the building *feel* like? "We were searching for what this building would mean on the horizon," he said. "What the lighting is going to do affects the building and what the building is going to do affects the lighting." The tower had to be recognizable from three places: at its base, from a short distance (such as 34th Street), and from afar. Each required a different lighting solution. At the base, the lighting had to have an open, welcoming feel. From a distance, the tower's many interior lighting conditions had to be legible as a single, integrated form. Configuring light is more an art than

In December 2012, the last two escalators for One World Observatory were hoisted by crane up to the 100th floor. The sight of an escalator floating in the sky captured people's imaginations—photos of the operation, taken by Scott Lahmers, a technical specialist at ThyssenKrupp Elevator, went viral.

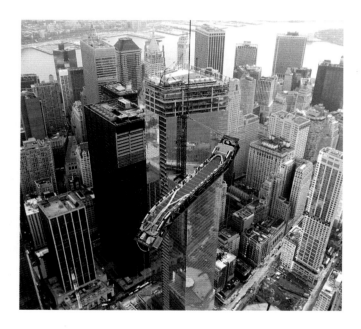

a science, "something that the computer just doesn't quite know how to do, so you've got to know how you see what you see and turn it into reality."

When Engle broke the news that the lobby isn't lit naturally, I was dumbstruck. The illusion is that real. "It's already working. It fools you, it does," he said, chuckling, like a magician pleased with his own trick. Given the thickness of the exterior concrete walls, it wasn't possible to cut windows into them, so the designers did the next best thing: they imitated sunlight using LED lighting, which supplements the daylight that enters from the east and west portals. In addition to greater energy efficiency and longer life, LEDs can be programmed to throw both warm and cool light. To

create the illusion of sunlight, cool light is used during the day; it crossfades to a weaker, warmer light at night. The lights are timed to mimic daylight; as the sun sets, the lights change slowly over a twenty-minute period so that the eye adjusts, rendering the change imperceptible.

ThyssenKrupp designed and installed the tower's seventy-one elevators and twelve escalators. Fifty-eight of them are passenger cars that use Destination Dispatch, a smart technology that brings occupants to the upper floors in the shortest possible time, using data encoded in the passengers' building passes. Grouping passengers in this way eliminates stop-and-go delays associated with traditional elevators, saving time and energy, and increasing security. Those working on the highest floors take an express cab to the sixty-fourth floor and switch elevators, a necessity created by the tower's slender upper profile. Visitors to One World ride dedicated elevators, the fastest in the Americas, reaching the observatory in less than a minute. The elevators are as quiet as they are fast. Aerodynamic aluminum shrouds deflect air and maintain speed, much as a spoiler on a car does. A special guide system minimizes vibrations, ensuring a smoother ride, while sound-suppressing materials limit noise. A global team of collaborators from Brazil, Germany, China, and the United States developed the state-of-the-art elevators, which were tested in a 25-story skyscraper in South Korea.

GLASS CURTAIN WALL

From a distance, or in photographs, the tower appears to be formed of uninterrupted planes of glass. The effect is the result of using large window panels on the upper floors and concealing the spandrels, or horizontal support elements, that are seen on older buildings. Containing just under one million square feet (92,903 m²) of glass, the curtain wall is composed of 13,000 insulated panels of crystal clear glass. It was engineered in tandem with the structure, which supports the weight of the curtain wall, and the three louvered mechanical levels.

To meet a range of safety and load requirements, the tower incorporates different types of glass. Laminated and tempered glass were combined in five thicknesses to resist various forces as the tower rises. The glass is heavier at the base for security reasons and at the top, where the tower bears the wind's full, unobstructed force. At each corner, trapezoid-shaped glass lights extend ten inches (25.4 cm) beyond the mullions and appear to float in front of the stainless steel corners, softening the tower's edges.

The public got a sense of just how slick and strong that glass surface was in November 2014, a week after the tower opened to its first tenants. Two window washers were stranded at the sixty-eighth floor when one of four cables holding up their scaffold failed,

...what should the building *feel* like?

When one looks up from the street, four of the tower's planes morph into pyramidal forms. The design references obelisks and pyramids, two ancient commemorative types. Its tapered silhouette also recalls spare Cycladic figurines, most of them funerary objects, made by prehistoric Aegean sculptors.

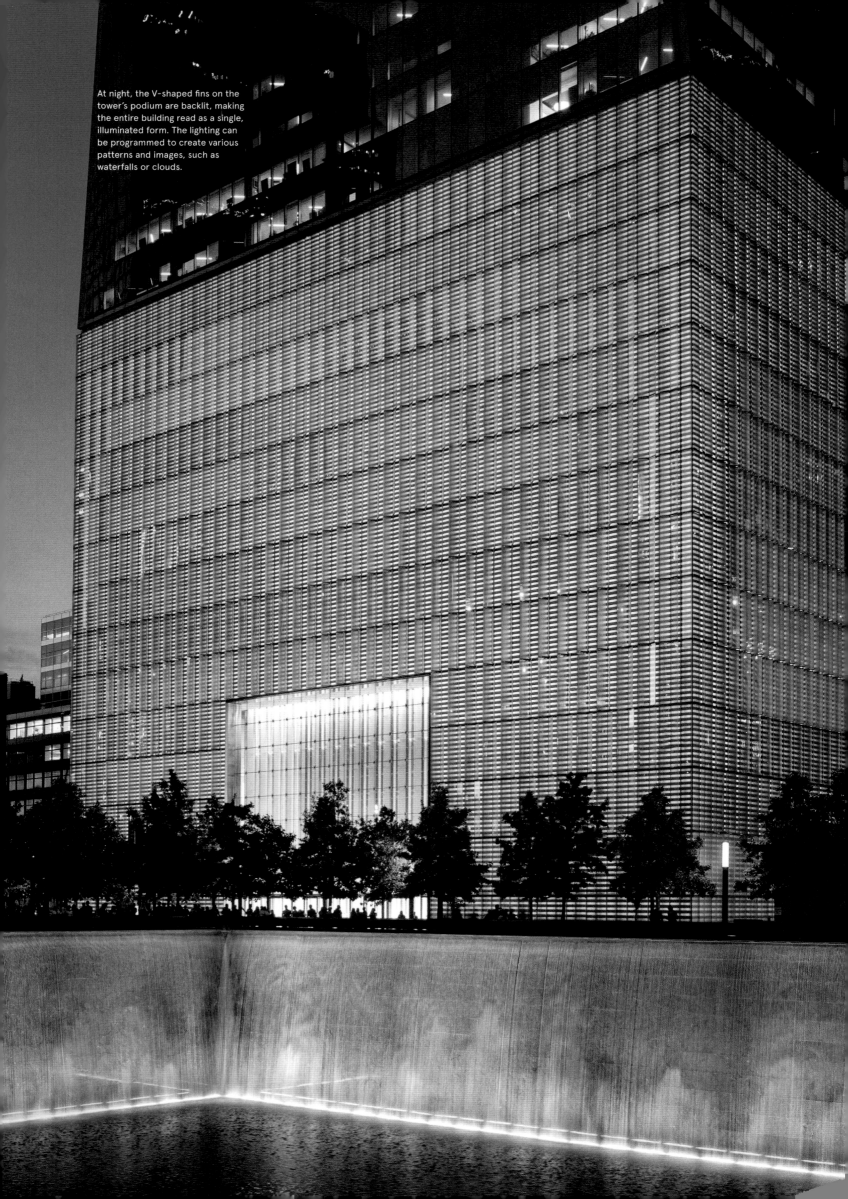

At night, the V-shaped fins on the tower's podium are backlit, making the entire building read as a single, illuminated form. The lighting can be programmed to create various patterns and images, such as waterfalls or clouds.

Durst Comes Aboard

As the Port Authority saw it, their best move would be partnering with a private developer, one with real "skin in the game," in the form of a minimum equity commitment of $100 million for a ten percent stake in One World Trade Center. After fielding bids from six developers, they awarded the Durst Organization a ninety-nine-year contract in 2010 to operate and lease the tower. Major changes to the building would follow—from sidewalk to spire—which modified certain design elements or eliminated them altogether.

The Durst Organization's portfolio includes some of the city's most iconic skyscrapers, including the technologically advanced 4 Times Square, where the publishing giant Condé Nast was once headquartered. At turns visionary and controversial, Durst is credited with cleaning up Times Square back when it was a seedy no-man's-land. Chairman Douglas Durst runs the empire with his cousin Jonathan (Jody) Durst, although many family members are involved. Floor-to-ceiling windows at their offices at the Bank of America Tower at One Bryant Park frame spectacular vistas of Manhattan south to the World Trade Center. Everything is sleek and modern, with the exception of the wall of vintage photographs of earlier Dursts, who over the past century built the real estate dynasty, now worth $4.4 billion, according to *Forbes*.

The firm's long game—precise timing coupled with an unerring instinct for the market's vicissitudes—is founded on an intense focus on practical economies. That sensibility might be genetic. Douglas's father conceived of the National Debt Clock, a giant public clock that has been keeping score of the country's debt, and each family's share of it, since 1989. First erected at Sixth Avenue and 42nd Street, the clock was moved two blocks north to 44th Street in 2004. But they're hardly penny-wise. They know when to spend and when to wait, and they believed that filling the World Trade Center with tenants was only a matter of time. "The view is what's going to solve that building," Douglas Durst said.

Their first move was to entice their 4 Times Square tenant Condé Nast to lease one third of One World Trade Center in May 2011, giving the tower a much-needed corporate anchor, one with enough star power to attract others. As one incentive, the Port Authority agreed to take on the last four or five years of the company's existing lease, held by Durst. Although Condé Nast received subsidies, to which all tower tenants were entitled, they "did not negotiate anything more that put city tax dollars or state money on the table," Chris Ward said. "Condé Nast could have come to the Port Authority and gone to the governor and to the mayor and said, 'We'll move downtown if you do this.'... But Condé Nast never played the corporate retention game, never played the 'you've got to pay for us to go downtown' game.... I give them incredible amounts of credit for that."

Condé Nast, then chaired by Samuel Irving "Si" Newhouse Jr., who has a keen interest in architecture, had had a pioneering influence on the Times Square area. They knew they would be moving their headquarters into one of the most significant new structures in the city. Recalling the negotiations, Ward said that Condé Nast had "kicked all the tires" before making a decision. Naturally, they were concerned about security. As he recalled it, a pivotal moment came when Donald Newhouse asked, "Will there be another terrorist attack?" Knowing the assembled group wouldn't want to hear platitudes, Ward addressed their concerns head on. "You've heard from David Childs that this is one of the best-built, safest buildings you'll ever see. I've spoken about the campus security plan. But none of that answers your question because that question can only be answered by people who live in a world of risk all the time, no matter where they are. That is every New Yorker's question. You can live with the risk or you can live without the risk. You can acknowledge it and go on living and deal with it or you can allow it to define you, and then they will have won. And then we got into a good argument about what that really meant." Ward added, "Condé Nast believed that going down there was as much a message about accepting risk and being in the new modern world as anything else."

Less predictably, Condé Nast's decision hinged on the availability of myriad transportation alternatives for their workforce, primarily millennials who lived outside of Manhattan. "We're hiring young, creative people and all of them need to live by a subway stop outside of Manhattan," they told Ward. "That's our workforce. They don't want to live in Jersey, they are never going to live in Westport, they're not going to live in Greenwich, and Brooklyn is somewhat full, or getting full, so we need to see everywhere they can get to." Once Condé Nast signed a lease on nearly 1.2 million square feet (111,483.6 m²) of space, One World Trade Center, and all of lower Manhattan, was primed for transformation.

Douglas Durst is the chairman of the Durst Organization, a century-old New York real estate dynasty, and the third generation of his family to lead the company. In addition to residential holdings, the company owns, manages, and operates a 13-million-square-foot (1,207,739.5 m²) office portfolio that includes eleven premier New York skyscrapers. The firm oversees the development, management, and leasing of One World Trade Center. Born in New York City in 1944 and a graduate of the University of California at Berkeley, Durst joined the firm in 1968, learning the family business from his father, Seymour, and uncles Roy and David. He is married to Susanne Durst, with whom he has three children. Two of them, Alexander and Helena, also work for the firm. Durst is a director of the Real Estate Board of New York, the New School, the Trust for Public Land, and Project for Public Spaces. A theater lover, he is a member of the board of directors of the Roundabout Theater and of Primary Stages. He is a trustee of the Old York Foundation, established by his father, which is committed to helping people understand Manhattan's history and buildings. Durst created McEnroe Organic Farm, one of the largest such farms in New York State, which promotes field-to-fork awareness. To let people know he's an environmentalist, Durst wears green socks every day.

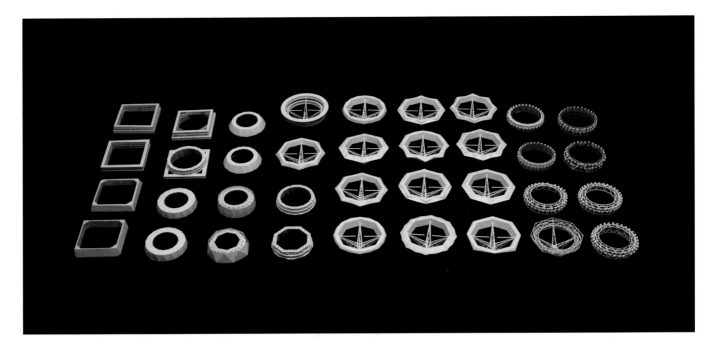

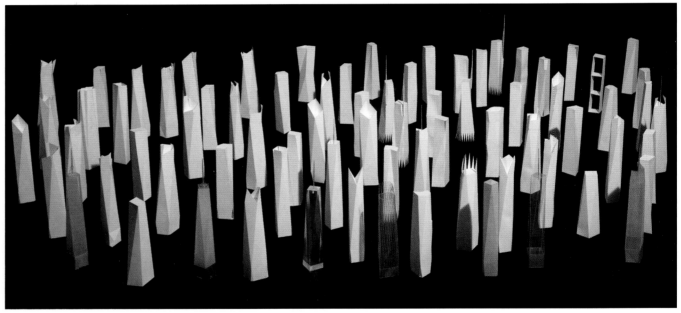

80

Dozens of investigatory models broke open SOM's thinking about One's design and moved it beyond the constraints of the open-air cable superstructure proposed in 2003. Remnants of earlier designs remain, but their geometries have been blended in new ways, yielding the final design of 2005.

Top: Potential treatments of the communications platform on One's roof. Center: Dozens of paper models illuminate the search for exactly the right form for the building. Bottom: Solutions for the tower's planes, spire, and spire cabling were explored using physical models made of polished acrylic, wood, aluminum, stainless steel, paper, and combinations of those materials.

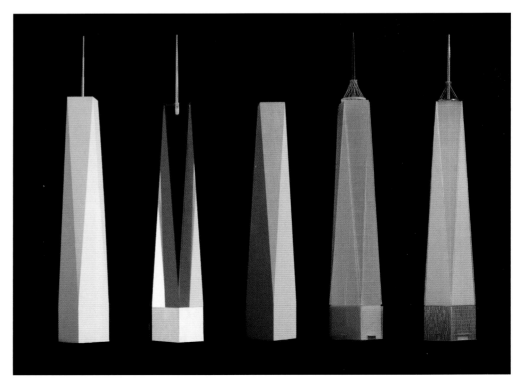

leaving them teetering on their washing rig for almost two hours. Using diamond cutters, FDNY firefighters sawed through the double-layered window and pulled the men to safety—a feat that made the city breathe a collective sigh of relief. Luckily, Benson Industries, which engineered, fabricated, and installed the curtain wall panels for One World Trade Center and Four World Trade Center, was prepared for such an eventuality, having designed the units with a four-sided structural silicone so that individual pieces of glass could be replaced.

Relief that the washers were safe was quickly followed by surprise that windows on skyscrapers are still washed by humans bearing sudsy squeegees. Although the rigs are controlled electronically, robots cannot "see" dirt like people can. And automated systems cannot properly clean the irregularly shaped buildings that have been made possible by advances in glazing technology and computer software. Tractel, a global manufacturer of scaffolds and window-washing platforms, designed the custom rigs. Those rigs engage with the curtain wall, riding on the tracks formed by the vertical mullions of the glass units. The Durst Organization estimates workers from the Local 32BJ union will be washing Tower One's windows 200 days a year.

SPIRE

The tower is crowned with a 408-foot (124.4 m) steel spire that is encircled by a three-level communications platform. When measured from the roof slab, which rises to 1,334′ 8″ (406.8 m), the spire is actually 441′4″ (134.5 m) tall. However, it rests within a 33′ 4″ (10.2 m) rooftop well that screens the cooling towers and other equipment. Michael Stein, a managing director at Schlaich Bergermann, likened the spire's telescoping geometries to those of a tree. It rises from a wide base, eighteen feet (5.4 m) in diameter, gradually tapers, and culminates in a steel and glass beacon. Along its length, the spire is punctuated with circular platforms that allow maintenance access. It is anchored to the roof with four sets of paired cables made of aramid, a plastic much lighter and stronger than steel, which allows radio waves to be transmitted without interruption.

In addition to the spire's symbolic importance, it has the practical function of housing broadcasting equipment that supports radio, television, and data communications. For New York, the nation's largest media market, this broadcast infrastructure is vital, replacing the facilities that were lost on September 11. Currently, most major broadcasters operate transmission facilities at the Empire State Building, which has a 200-foot (61 m) broadcast tower, and has been operating as a radio transmitter since 1930. One World Trade Center's spire, twice as tall, has enough space for every station in the market to install transmitters, according to Durst Broadcasting, which runs the facility.

Defining the building from a distance was critical. Creating a signature architectural flourish on the skyline required lights of extreme intensity to compensate for the altitude of the installation, more than 1,400 feet (426.7 m) up, and also had to factor in the climate, which is different above the clouds and influences how light is perceived. Barbizon Lighting, in tandem with SOM and others, developed a module consisting of 264 fifty-watt LED chips—each three feet (0.9 m) across—that throw intensely focused light down the length of the spire. (In contrast, a handheld LED flashlight uses a one-watt bulb.) The modules are contained inside the rotating beacon (which slows or stops in strong winds to prevent the motor from shearing or burning out in gale-force winds). Barbizon devised an efficient spinning assembly that allows the 264 LEDs to shoot light up and down into mirrors, concentrating the lights into a focused beam, which the human eye reads as a single column of light. This beam is not designed to be seen close up; it can best be perceived as a single column only from a distance.

ENVIRONMENTAL ADVANCES

One World Trade Center is a practical beauty, with an agenda beyond mere dazzle. It is an efficient office building, in terms of financial return, ease of operation, and occupant comfort. Inside, it is a place that simply feels good, endowed with abundant daylight and fresh air. Increasingly, worker performance and well-being,

The beacon, the last piece of the tower, was hoisted to the top of the spire in May 2013. Kammetal of Brooklyn fabricated the seven-ton (6.3 metric ton) stainless steel and glass beacon.

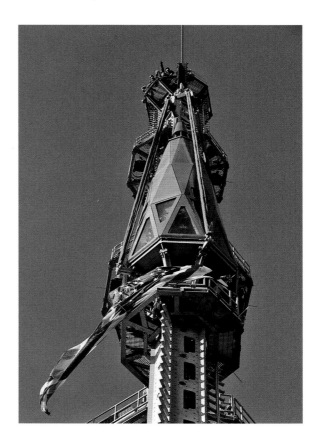

The radome's fate recalls that of the George Washington Bridge (1931), which was to have been clad in pink granite. The bridge's exposed latticework structure is now considered a treasure of modernist design.

rather than lower energy costs, are sustainability's best yardstick.

Location, location, location—always applicable to New York City real estate—is also the foundation of sustainable design. Wide access to mass transit is the backbone of eco-efficiency. Approximately ninety percent of those working at the World Trade Center commute via one of the subway, rail, and ferry lines that converge there. Additionally, One World Trade Center incorporates strategies for water and energy conservation, reclaiming one hundred percent of rainwater, operating on one hundred percent renewable energy, and using twenty percent less energy than required by code. Tenants control their own electrical meters, which encourages them to use less.

Floor-to-ceiling windows made of low-e glass maximize the use of natural light and minimize heat gain. Interiors achieve up to ninety percent daylighting, bright enough to read a newspaper without additional lighting; light dimmers kick in on sunny days to save energy. Low-e glass is standard for this building and most others. The e stands for emissivity, referring to the amount of solar radiation that penetrates the glass. Low-e coatings keep inside temperatures at reasonable levels and also offload the huge amounts of heat generated by the mechanical systems. The tower's windows are fixed and don't open, further improving thermal performance. On the mechanical floors, an open, louvered system is used.

Throughout the building, the air is filtered twice, using charcoal and MERV-6 filters. To ensure that the air is as pure as possible, it is brought in from the top of the tower, where the air is nearly free of particulates, then filtered, and then filtered again by air handlers on each floor. Air from up high is also cooler, which reduces air conditioning costs. Lower energy costs are also attributable to an unlikely source—the elevators. Even though some of the tower's elevator motors weigh as much as 50,000 pounds (22,679.7 kg), they are not the biggest energy hogs. More energy, about sixty percent, is

typically consumed by air conditioning and ventilation needed when the elevator cabs are in standby mode. At One, however, the elevators actually produce energy. They are equipped with regenerative drive technologies that harness energy from the braking system, generating enough power to feed the entire lighting system and also reduce the amount of air conditioning needed.

Above all, the architects wanted to create a place where people "are the happiest," Childs said. To understand what future occupants would want, SOM filled the building with hypothetical tenants of diverse professions. Based on those studies, they constructed an "exemplar space," a high-performance office space that would help tenants design their spaces to "maximize their energy efficiency" and show "how improved the lives of their employees are going to be," Kenneth A. Lewis of SOM said. A means of green advocacy, the exemplar space was supported by quantifiable energy savings, environmental benefits, and suggestions for low-emission paints, fabrics, and carpeting.

In the United States, a building's sustainability is typically measured using the U.S. Green Building Council's LEED rating system, which allots points for energy efficiencies. While not proof-positive of environmental responsibility, the rating does quantify certain sustainable features and shows that green office space is an increasingly critical aspect of corporate identity. The early points are easy. "Some of them, quite frankly, are getting so embedded in the building codes, you just do it anyway. You would not put anything but a low-volume flush toilet in a building today," said Dan Tishman, who managed construction. "As you get towards the higher end ratings, there are more difficult

The beacon, hoisted to the top of the spire. Together, the spire's base and mast weigh 1,800 tons (1,633 metric tons). Because of its weight, the spire was shipped in eighteen sections and moved by barge from Montreal to Pier 25 in lower Manhattan.

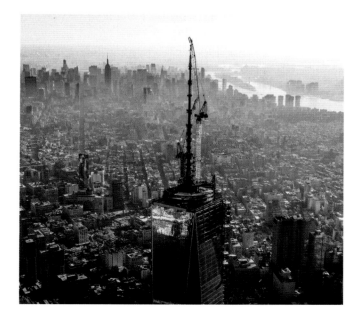

...location, location, location

Off with Their Heads

On August 5, 2010, the day the Port Authority said they would partner with the Durst Organization to develop One World Trade, they also announced "a value engineering effort" that would save approximately $26 million. The most visible of these hotly contended design revisions occurred at the very top and bottom of the tower—its spire and the podium on which the building sits. The story of these changes presents in microcosm the many forces that ultimately shaped the tower.

Durst's agreement with the Port Authority entitled them to a $15 million fee and, as an additional incentive, a percentage of any changes that they initiated that would "result in net economic benefit to the project," initially pegged at seventy-five percent of cost savings up to $12 million and fifty percent of savings in excess of $12 million. That equation later changed, with Durst receiving seventy-five percent of savings up to $24 million, with percentages stepping down to fifty percent, twenty-five percent, and fifteen percent as savings increased. In other words, Durst would recoup a portion of all design changes that saved the authority money, in addition to a percentage of the tenants' first-year rent. When asked if the design revisions were driven by these financial incentives, Durst's lawyer, Gary M. Rosenberg, said that they only made recommendations and the "Port decides whether they are free to do it or not." "We don't cut costs," Douglas Durst said. "We tell them how they can do it. Many times they prefer to spend a dollar rather than save seventy-five cents and give us twenty-five cents."

SOM intended to sheathe the spire in a fiberglass enclosure called a radome. They conceived of the radome as a work of art, to be made of interlocking triangles, which would complete the tower, providing the visual heft that would allow it to be seen from a greater distance. Sculptor Kenneth Snelson, known for his exquisitely balanced tensile sculptures, worked on its aesthetics. Schlaich Bergermann engineered both the spire and the radome. Eventually, they changed the radome's structure from an enclosure made from many parts to one of fewer, but much larger, forty-foot-long (12 m) segments, which would be more economical. "We would have designed the spire differently if we knew it was not going to be enclosed," Michael Stein, a managing director at Schlaich Bergermann, said. "We designed it to optimize function and minimize fabrication costs. It has [an] industrial look now, with all its trusses, diagonals, and platforms exposed, which were intended to be covered by a beautifully designed radome. You could say the building's masterpiece was that enclosure."

Here the story wants to split into three columns, labeled He said, She said, and What was built. SOM and Schlaich Bergermann have vast experience in erecting tall buildings, including the Willis Tower, the top of which features antennas encased in radomes. Radomes, in fact, are used on buildings throughout the world to protect maintenance workers and broadcasting equipment from the wind and weather. One World Trade Center's engineers found, however, that the radome would increase the spire's wind resistance. Durst was concerned that it would create access issues for maintenance workers, an important consideration as the mast would support future broadcasting equipment that would need periodic inspection. They also cited the radome's cost, estimated at $20 million, a significant sum in the context of their co-ownership deal.

The mast's role in maintaining the tower's height of 1,776 feet (541.3 m) was critical because of its symbolism and because the title of the nation's tallest tower was at stake. If the mast was deemed a functional antenna and not, like a spire, an integral part of the building, then the tower would be measured only to the roofline, at 1,368 feet (417 m), and lag behind the heights of the Willis and Trump towers in Chicago. But that would be decided later.

Pragmatism prevailed, to the architects' bitter disappointment, and the radome was removed.

Devising the glass cladding for the podium kicked up another storm. In 2006, David Childs presented a revised tower design to seven hundred engineers and architects gathered for the American Institute of Architects' New York Chapter's awards ceremony. He showed a model of a 186-foot-tall (56.7 m) concrete base sheathed in prismatic glass that, catching sunlight, would cast rainbows of color across the base. It would, he believed, delight the public.

Two years later, the Port Authority contracted DCM/Solera, a joint venture between DCM Erectors and Solera Construction, to manufacture and install the glass. DCM/Solera subcontracted Zetian Systems, a firm in Las Vegas, to procure the glass from Sanxin Glass, the Chinese manufacturer that won the contract in 2009. That decision inflamed the three North American glass manufacturers that had also bid on the work and collectively invested "high seven figures in developing products specific to this project."

Ultimately, although everyone acted in good faith, efforts to produce laminated prismatic glass, which had never been done on this scale before, proved futile. The Chinese glass was brittle. Under pressure, it did not crumble into small bits, as friable automotive safety glass does, but instead fractured into large, potentially dangerous shards. In 2010, Douglas Durst emailed SOM, saying, "You've got to stop and come up with a new design.... We had a deadline." The Port Authority scuttled the prismatic podium cladding.

Durst saw two issues with the podium cladding that had to be solved. "First of all, we set the criteria," architect Tony Tarazi said. "We told SOM two things, basically: We want this glass to be maintainable because we maintain things, and the second thing was we wanted it to be made modular. We gave them a design challenge. We said we want to use a curtain wall module to do that. Make it work. SOM rose to the occasion." After exploring various options and materials, SOM designed the glass and stainless steel fin structure that now covers the podium.

Other changes were made at the sidewalk level. A small triangular plaza on the tower's west side provides an above-ground entrance to One World Observatory and includes a block-long planter that doubles as seating. However, landscape architect Peter Walker, who designed the memorial plaza, originally conceived it as a stainless steel plaza that would have been embedded with lights, providing the tower with a "shimmering skirt.... Light would travel at night, down the base of the building, along the terraces, out into the plazas in this really beautiful, dynamic way," Jeffrey Holmes said. Walker, equally disheartened, said, "It was going to be something quite extraordinary.... They were ideas about the use of public space that aren't anyplace else in New York." However, Durst deemed the design impractical. Walker stepped away, replaced by Mathews Nielsen, the landscape design firm founded by Kim Mathews and Signe Nielsen, which designed the new plaza.

points to consider—do you put a green roof on, or do you put a cogeneration plant in, or do you produce your own power?" Every structure at the Trade Center, including the plaza itself, will apply for its own LEED certification.

Determined to go beyond LEED, however, SOM, Tishman, Silverstein, the Port Authority, the Bloomberg administration, and others developed additional environmental criteria for the entire World Trade Center. One World Trade Center was the first structure to conform to sustainability guidelines, published in 2005, that would yield "an exemplar for large-scale, mixed development in the Northeast and across the United States." In October 2005, New York City mandated that nonresidential public buildings costing $2 million or more be built to LEED standards, a law that took effect in 2007.

"Sustainability wasn't limited to building energy," said Lewis, who helped develop the environmental standards for the overall site. Renewable energy sources, non-ozone-depleting chemicals, and recycled materials that minimize waste and pollution were used. Designers, engineers, and contractors worked together to identify building methodologies that would minimize light and noise pollution and control air quality during construction. In a congested city, especially on a construction site, controlling air quality reduces respiratory disease, allergies, and asthma attacks. One World Trade Center was constructed using ultra-low-sulfur fuel, catalytic converters, and particulate filters, which since have become a New York City standard. Even after construction is completed, particulate—fine road and construction dust, diesel soot, and other visible and microscopic particles—floats around. To reduce these toxins, the tower's floors were flushed with fresh air once construction finished.

SAFETY MEASURES

Shock swept through design and engineering communities after 9/11. For professionals, the event forced a move from prescriptive building codes to performance-based design, construction, and emergency management. The public got into the act too, inundating One World Trade Center's architects with safety suggestions that ran the gamut from helipads (not practical for moving large numbers of people) to zip lines. "The most critical question we had to ask ourselves was, 'What problems are we solving for?'" said Carl Galioto, a former technical partner at SOM. "Our top priority was maintaining life safety during an extreme event."

Given the tower's location, it had to meet stringent safety demands. The designers first had to identify all threats, natural and human, plausible and otherwise, whether explosive, biological, or radiological, and assess their nature and scale in the context of the architectural program. To that end, the tower is prepared

for a dark spectrum of worst-case scenarios. Its design incorporates improved building evacuation, optimal firefighting access, more reliable communications systems, dense fireproofing, biological and chemical air filters, areas of refuge for tenants, backup power sources, numerous structural redundancies, and tenant training programs. These life-safety systems meet or exceed those required by current local and national building codes even today, ten years after the start of the design process. "Brute strength veiled in prismatic elegance" is how architect Lewis describes the tower.

The overall structure is protective. Its most vital artery is its reinforced concrete core, with walls that are as much as six feet thick (1.8 m), which contains and shields its life-safety systems, including stairs, elevators, sprinklers, ventilation shafts, and communication antennas, along with multiple back up systems. With the exception of the lobby, there are no occupied floors on the lower 186 feet (56.7 m) of the building, which removes occupants from harm's way in case of a street explosion. To avoid a progressive collapse of the structure, as happened at the Twin Towers, they implemented a system for protecting the perimeter columns. "Should one or more columns fail, for whatever reason, the building would stand," Gottesdiener said. The upper glass curtain wall is also blast-resistant. To test it, a full-scale mock-up, three stories tall, was built in a New Mexican desert. Galioto was in a bunker a quarter mile (0.4 km) away, watching the detonation. Even from that distance, he could feel the ground shake, he said, yet the glass remained intact.

It was critical that the design be based on real-life emergency criteria. SOM sought practical advice from the New York City police and fire departments to better understand their operations and firefighting techniques. It was "a process of listening and learning," Gottesdiener said. Fire chiefs from several battalions attended a planning meeting held early in the design process. "You're our client," Galioto told them. "We want to understand what you need to be effective." Stunned, they replied, "No one has ever asked us that before." They wanted the lobby, in the event of a fire, to be dedicated to firefighting operations, so all tenant staircases empty into the surrounding streets, not into the lobby, freeing the room for firefighters. One elevator has a shaft and doors designed to ensure safety in a fire. In an emergency, the shaft is pressurized and an emergency door opens into a pressurized, dedicated vestibule that connects to a stairwell reserved for firefighters. And because of the failure of communications systems on 9/11, the tower incorporates multiple wireless systems for emergency responders, as well as tenants, that are closely monitored and, if necessary, can be diverted to transmitters or amplifiers.

In the United States, there has never been a major fire in a commercial building with a functioning sprinkler system. To ensure the effectiveness of One's

84

...real-life emergency

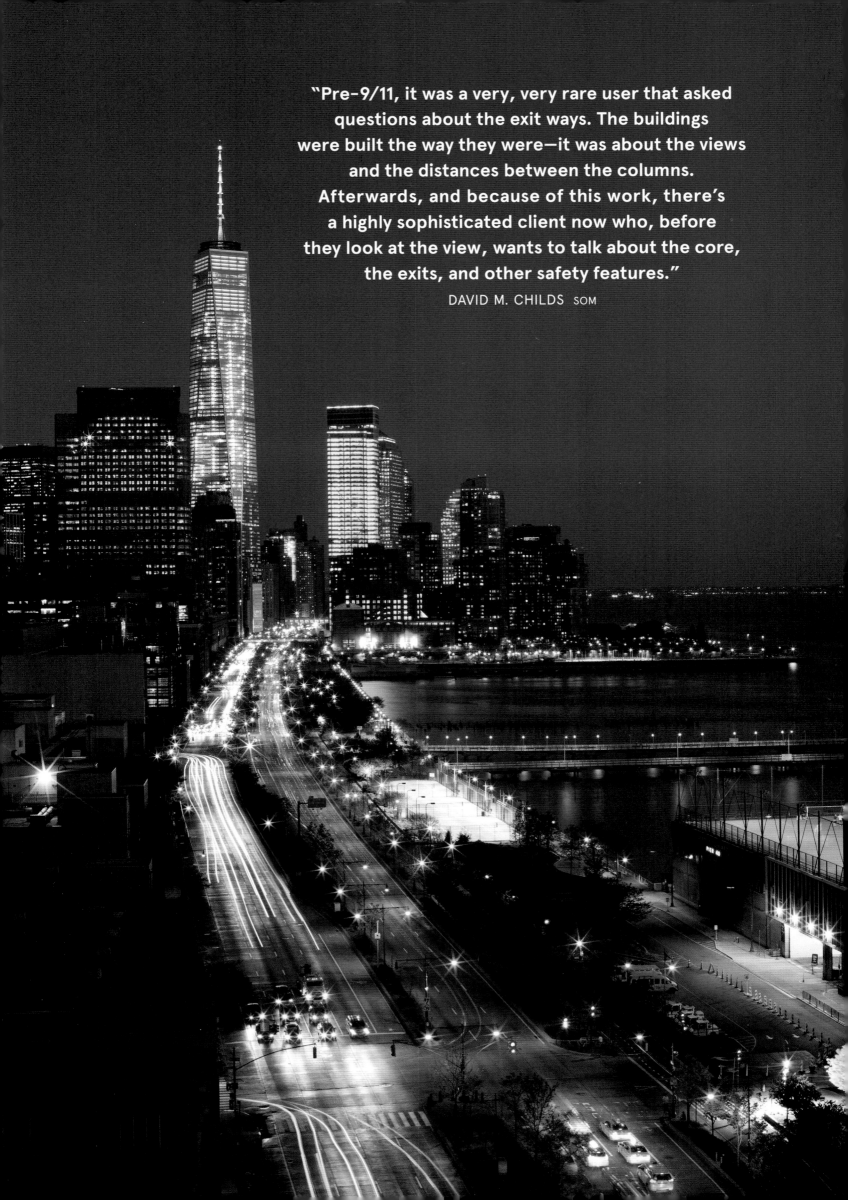

"Pre-9/11, it was a very, very rare user that asked
questions about the exit ways. The buildings
were built the way they were—it was about the views
and the distances between the columns.
Afterwards, and because of this work, there's
a highly sophisticated client now who, before
they look at the view, wants to talk about the core,
the exits, and other safety features."

DAVID M. CHILDS SOM

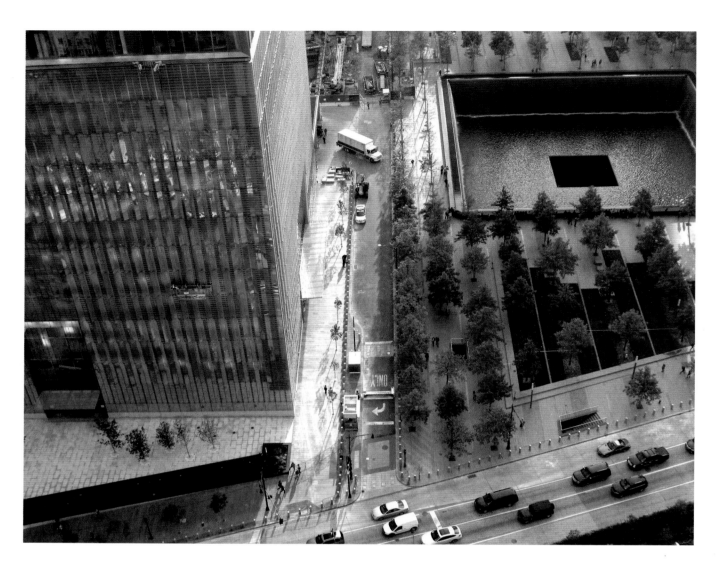

86

One World Trade Center and the 9/11 Memorial derive their physical dimensions and symbolic meaning from the original Twin Towers.

sprinkler system, they increased the number of sprinkler heads and the amount and reliability of the water supply. Standpipes, used on both sides of the building, are interconnected on alternating floors: if one breaks, the other one will still work. Each Trade Center building has its own system of capturing and storing rainwater, which is used for fire protection, irrigation, and cooling. Air intakes, which bring fresh air into the building, are on the roof, as far as possible from ground level, to limit the impact of a biochemical attack.

SOM also mined its extensive global portfolio, particularly embassy and courthouse designs, to fortify the new tower with features that never existed before in New York City. In Hong Kong, for instance, "there's a requirement for buildings over a certain height and a certain size for what they call refuge floors, a floor that does literally nothing but allow a fire-protective place for people in the building to congregate should there be a disaster. In England, they require that one of the elevators physically secured within the building be given over to firefighters and it have a protective, not quite waterproof, but serious water protection. Obviously, when the sprinklers go off, they

start flooding, and flooding gets into machinery and electricity. But they protect those and allow firefighters direct access," Gottesdiener said.

In the past, it was assumed that tenants on two, possibly three, floors would evacuate during a fire. Now, especially at this location, the design of the egress system assumes a full-building evacuation. SOM ran computer simulation models to study human movement. "We started to analyze how people moved on a floor and multiple floors, and how they all accumulated to get down the stairwell. We got a better understanding of how long it literally took to empty a building," Gottesdiener said.

Other solutions arose after mulling over photographs taken on 9/11, which showed firefighters climbing narrow staircases while occupants were rushing down. For many decades, the standard staircase width in New York City's commercial buildings has been forty-four inches (111.8 cm), enough space for two abreast. Over the years, however, people have gotten bigger. And studies show that we actually shift subtly from side to side when walking. Also, firefighters carry more gear. Consequently, the designers made the stairs twenty percent wider than required by code. Glow-in-the-dark strips on the risers, handrails, and exits are an extremely simple yet enormously helpful navigational aid. Air pressurization, not yet required by

...assumes a full-building evacuation

code, can keep smoke out of the stairwells, which are also lined with concrete rather than flammable drywall, and fitted with emergency lighting. If exit doors become blocked with debris, interstitial "mixing" floors allow occupants to find alternative routes out. Beyond the stairs, fifty-eight passenger elevators are capable of transporting twelve percent of the building's ten thousand occupants to safety in five minutes.

The reality is that almost everything that could be done to secure the tower has been done, but those involved acknowledge the limits of what's possible. "What we can deal with is what happens inside the building," Lewis said. "The control of the airspace and the areas around the building is a governmental responsibility." Multiple safety and health benefits have accrued from the innovations introduced at Seven and expanded at One that, now part of the building code, influence the design of every tower built in New York City and many of those abroad.

TALLEST IN THE NATION

In November 2013, the Height Committee of the Council on Tall Buildings and Urban Habitat (CTBUH) met in Chicago to debate whether One World Trade Center or the Willis (Sears) Tower was the nation's tallest building. One World Trade Center claims an official height of 1,776 feet (541.3 m), with 408 feet (124.4 m) of the total provided by the mast atop its roof. The Willis, which had held bragging rights as the country's tallest

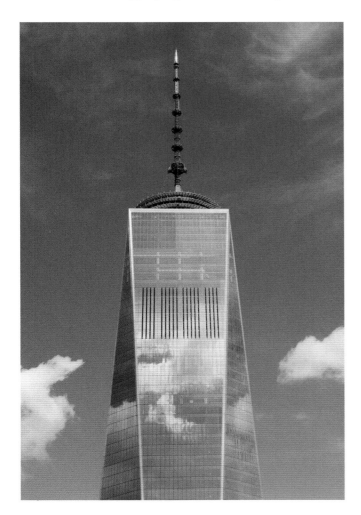

tower for forty years, was 1,451 feet (442.3 m) tall when measured to its highest habitable floor. What caused the committee to pause is One's spire. Was it merely an antenna? The Council, recognized internationally as arbiters of skyscrapers' height, has a rule about what counts toward the final measurement: spires, considered an integral part of a building, do. Antennas don't.

Childs made an emotional appeal that day, comparing One's spire to the torch held aloft by the Statue of Liberty, which inspired a change of heart in those present. After hours of closed-door deliberations, the CTBUH named One World Trade Center the nation's tallest tower. Residents of the Second City took the decision in stride. After all, it was a moot point, given that One's height soon will be surpassed by a raft of midtown upstarts and that the Burj Khalifa in Dubai, at 2,723 feet (830 m), looms over all American towers. And, since 1997, the title of world's tallest has resided overseas, when Petronas Towers in Kuala Lumpur wrested it from the Willis Tower. Moreover, there's not going to be another world's tallest in the United States anytime soon. The Federal Aviation Authority prohibits towers over 2,000 feet (610 m). Even if the FAA loosens its regulations, it will take time to catch up. Building the tallest skyscraper would take at least five years—the minimum amount of time it takes to design, engineer, and build a "megatall," as skyscrapers over 600 meters are known.

No, the 2013 debate was about something other than feet or meters. It was about the meaning of height and the ideals implied by 1,776 feet (541.3 m). Just as the Statue of Liberty will never lose her breathtaking scale because she stands alone in the harbor, literally incomparable, One World Trade Center occupies a realm beyond mere measurement. Undoubtedly, many more record-breaking skyscrapers are to come. However, this tower aspires to a higher order, where what is most important is intangible. Remembrance, resolve, faith in the future, and other ideals depend on what the individual claims not for himself or herself but on behalf of others. Dedicated to freedom, the tower will stand as tall as each individual believes it can. This is One World Trade Center's essential identity—beyond physical height, cost per square foot, and all the other practicalities we consider down here on earth—and why it measures up. ▲

87

bragging rights...

STRONG AND TRUE

ENGINEERING
ONE WORLD TRADE CENTER

One World Trade Center's heroic structure evokes the engineering marvels of an earlier era: the Empire State Building, the Hoover Dam, and the George Washington Bridge, all erected against improbable odds during the Great Depression and willed into being by a determined belief in the future. The tower recalls, too, the legendary story of the spire of the beloved Chrysler Building, which was constructed secretly inside the tower in 1930 in order to take 40 Wall Street by surprise and wrest from it the title of world's tallest building. It shares that magnificent hiddenness with One World Trade Center, whose groundbreaking structure is also concealed from view.

92

Realizing a structure on this colossal scale required nimble solutions to complex technical, political, and security considerations. The 104-story structure is a hybrid system consisting of a concrete core wrapped in a muscular steel perimeter frame that was designed to redistribute gravity loads in the event of an explosion or natural catastrophe. While the tower's multifaceted planes are aerodynamically efficient, they made unique structural demands that necessitated the inclusion of special nodal elements to diffuse the forces of nature.

Although One's timeless design transcends any one moment, its structural technologies bear witness to the tensions of the post-9/11 era. Greater security demands were made on it than on any other tower. Together, its engineers and designers conceived a new range of high-rise security and life-safety measures that were not available in any building standard at that time. Given the new normal in the United States—heightened security in all places at all times—many if not most of the arcane details of the tower's extensive safety features will not be disclosed to the public, the majority of whom only want confirmation that it is safe and secure. By every measure and logistical miracle, it is.

Ahmad Rahimian of WSP USA led the structural engineering efforts. His collaboration with SOM, the architects, and Tishman/AECOM, the contractors,

was immediate and intimate, as is standard with supertowers, where structural inefficiencies can mean millions in extra costs. Beyond the challenges that accompany the erection of any extremely tall building on a tight urban parcel, the tower's location and the site itself imposed additional constraints. Libeskind's master plan had placed it in the northwest corner, the most difficult and vulnerable place on the entire site. Below-grade conditions in that corner were complicated by existing infrastructure, which included the foundation walls in that area, which had sustained the most damage on September 11. Building there meant building over the four curving rail lines that serve the PATH system, which had to stay operational during construction, and next to the traffic-heavy West Side Highway, which increased security concerns. Additional constraints were imposed by the adjacent structures, with which One shares foundations and mechanical systems.

CONCRETE CORE
Because of One's height and slenderness, WSP devised a reinforced concrete-core structure. By virtue of its strength and stiffness, a concrete core supports gravitational loads—the force of gravity, the weight of the building itself, and that of the occupants—and resists wind and seismic forces. WSP had long been

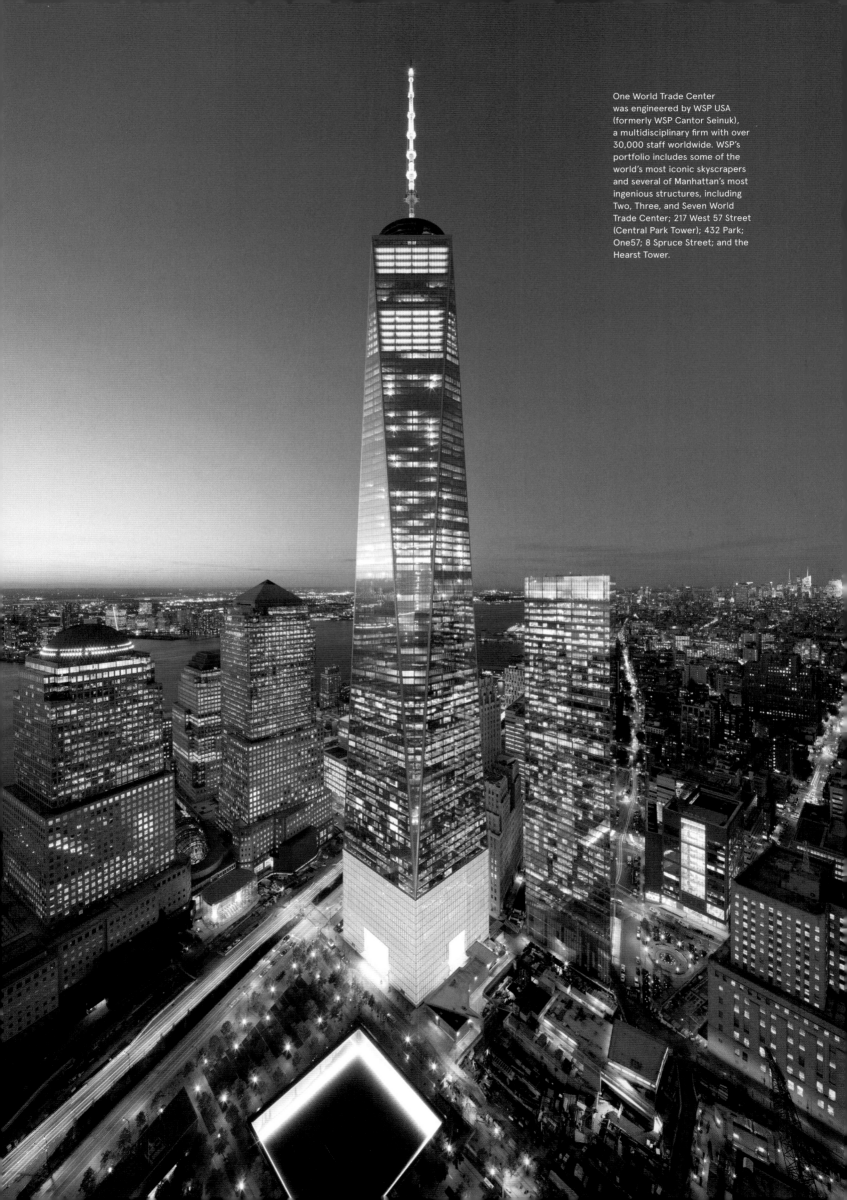

One World Trade Center was engineered by WSP USA (formerly WSP Cantor Seinuk), a multidisciplinary firm with over 30,000 staff worldwide. WSP's portfolio includes some of the world's most iconic skyscrapers and several of Manhattan's most ingenious structures, including Two, Three, and Seven World Trade Center; 217 West 57 Street (Central Park Tower); 432 Park; One57; 8 Spruce Street; and the Hearst Tower.

a proponent of concrete-core structures, which are highly efficient. In New York, however, because of union jurisdictional issues, peculiar to the city, which govern the ways that steel and concrete crews work with each other, concrete cores were less frequently used. That changed after 9/11, when so many were trapped inside the Twin Towers, which had exterior load-bearing walls made of steel, with no means of escape. A concrete core protects exit routes, so everyone on the team—engineers, architects, and developers—was determined to construct a core that would establish new industry standards.

Architect T. J. Gottesdiener said, "Dan Tishman and the Tishman team and Silverstein and his team were very good about getting all the unions to sit down, saying, Let's put this behind us. Let's build this core out of concrete. It's a great structural material for the core. It's a great protective material, both in terms of shielding what's inside the building and mitigating a shearing force. That was one of the biggest leaps forward in the technology of designing a building in New York City today."

WSP and SOM applied the lessons they learned on Seven World Trade Center to One World Trade Center's structure, having the resources to conduct an internal investigation of the probable causes for the Twin Towers' failure. They were not alone: Engineering and architectural communities worldwide engaged in intensive post-9/11 studies, which culminated in a series of recommendations issued by the National Institute of Standards and Technology (NIST) that made changes in high-rise building codes in eight categories, ranging from increased structural integrity to improved public education.

Much like a spine, the core runs through One's center, from bedrock to roof, and is socketed eighty-five feet (26 m) down into Manhattan schist. It is 110 feet (33.5 m) square at the base, larger than many office or residential buildings, and it houses stairs, elevators, communications equipment, and the conduits that serve the mechanical floors. Above ground, where safety concerns are greatest, the core walls are up to four and a half feet (1.4 m) thick; at higher levels, the walls slim down to two feet (0.6 m). The walls are reinforced with steel, concrete floor slabs, and an internal maze of partitioning walls, which provide additional strength, as do the walls between the core and the perimeter walls. On the upper mechanical levels, the core is connected with a series of multilevel orthogonal outrigger trusses, bracing systems that further resist seismic movement and wind pressure. Taken together, the steel perimeter and concrete core make the tower safer than either system alone would, thanks to the redundancy they provide.

Sequencing construction was another key aspect of the structural design, as it influenced the way various elements were connected, especially between the core and adjacent areas. It also affected the vertical members, which compress or shorten; the method used to determine that shortening; and the ways that construction could compensate for it. Ordinarily, in hybrid construction, the concrete core would be constructed independently and ahead of steel framing. The sequence at One World Trade Center was reversed, with the steel framing system erected first throughout each floor, inside and outside the core, before the concrete core was constructed. The core's inner steel framing is primarily an erection system that is embedded in the concrete core walls.

FOUNDATIONS

One World Trade Center's foundations pass through four subterranean levels and, at the lowest basement level, over live PATH rail lines. To build the foundation, temporary steel framing was built over the train tracks and eventually integrated into the final structure. Columns were planted in the "dynamic envelope," the voids between the PATH tracks, with every inch pressed into service. Outside the live lines, temporary safety zones were established to protect workers. Because of the constraints imposed by the track locations, workers had to excavate deeper into bedrock in certain places to achieve a higher bearing capacity of up to 114 tons (103.4 metric tons) per square foot (.09 m²). In these areas, rock anchors were embedded eighty feet (24.4 m) into bedrock to mitigate the effects of extreme winds.

Contractors also had to work around remnants from the original site, mostly existing slabs and some steel below the third subterranean level, which were not removed; new slabs span directly over them. Since removing the original infrastructure, along with power and antenna lines, would have been extremely difficult and expensive, the decision was made early on to work around them. The new structure does not incorporate any materials from the original towers.

One World Trade Center's foundation extends out beyond the tower's footprint, providing access to loading docks, parking, and other functional spaces. The below-grade structure incorporates long-span, flat-slab construction supported by reinforced concrete and composite columns. Although enhanced by the below-grade structure, the tower's stability does not rely on it; the tower is self-supporting. The tower sustains and transfers gravitational, wind, and seismic loads to its foundation without depending on the below-grade foundation walls for additional support. This measure was both prudent and pragmatic, allowing the structural design to proceed without being affected by the separate bathtub-design schedule (see "The Slurry Walls," page 53).

CONSTRUCTION LOGISTICS

Once the engineers had devised the foundation design, contractor Tishman/AECOM had to figure out

...down into Manhattan schist

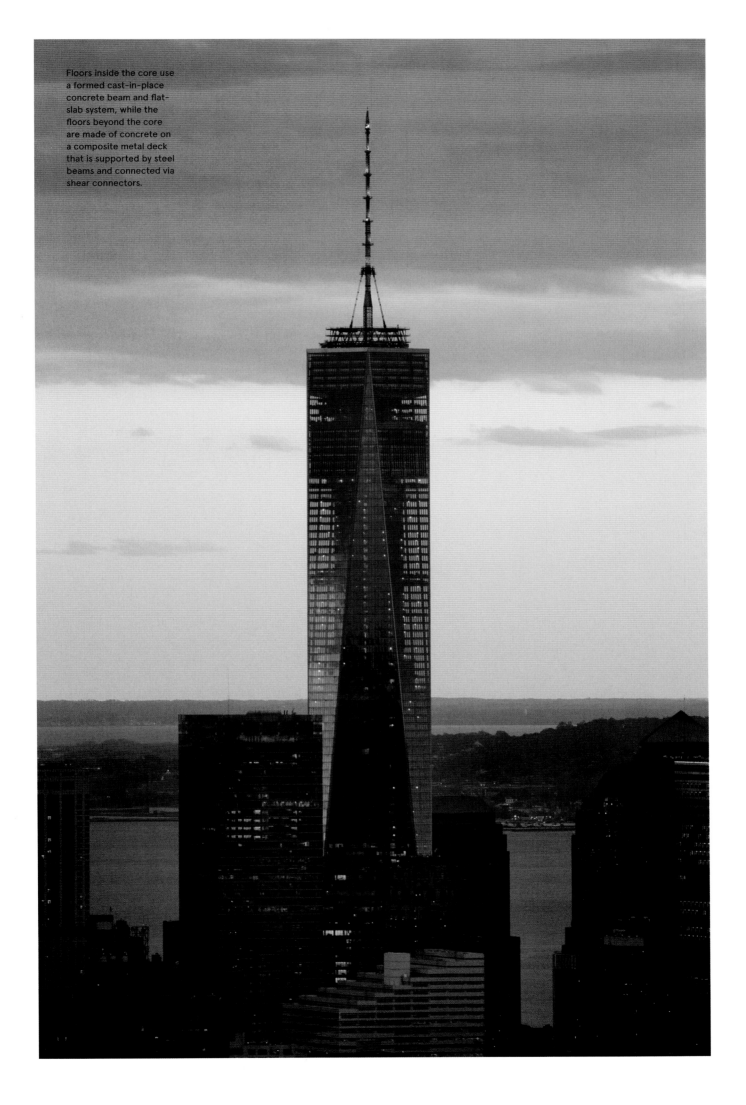

Floors inside the core use a formed cast-in-place concrete beam and flat-slab system, while the floors beyond the core are made of concrete on a composite metal deck that is supported by steel beams and connected via shear connectors.

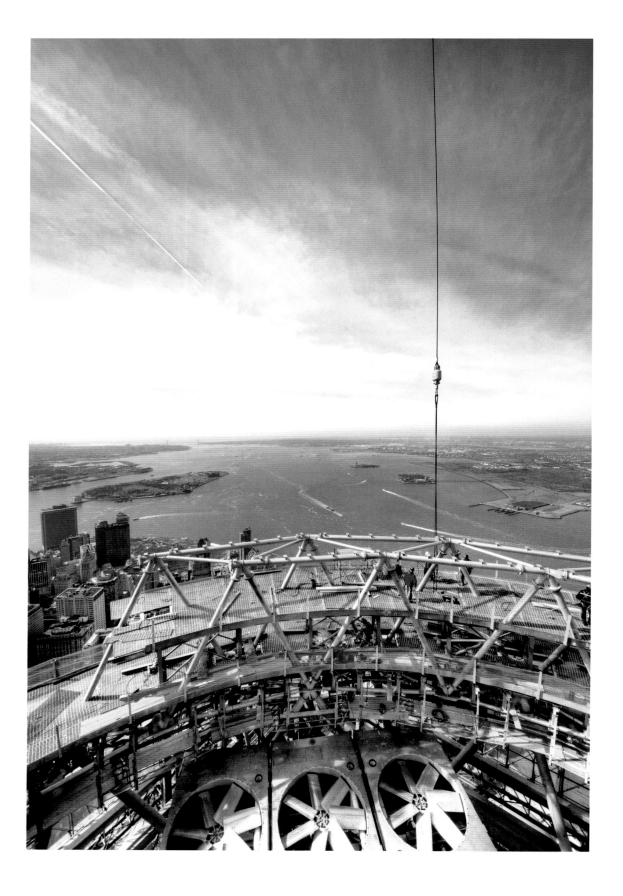

The three-level communications ring on the roof is 65 feet (19.8 m) tall and 125 feet (38.1 m) in diameter. It was designed in conjunction with Schlaich Bergermann and fabricated in Quebec by the ADF Group.

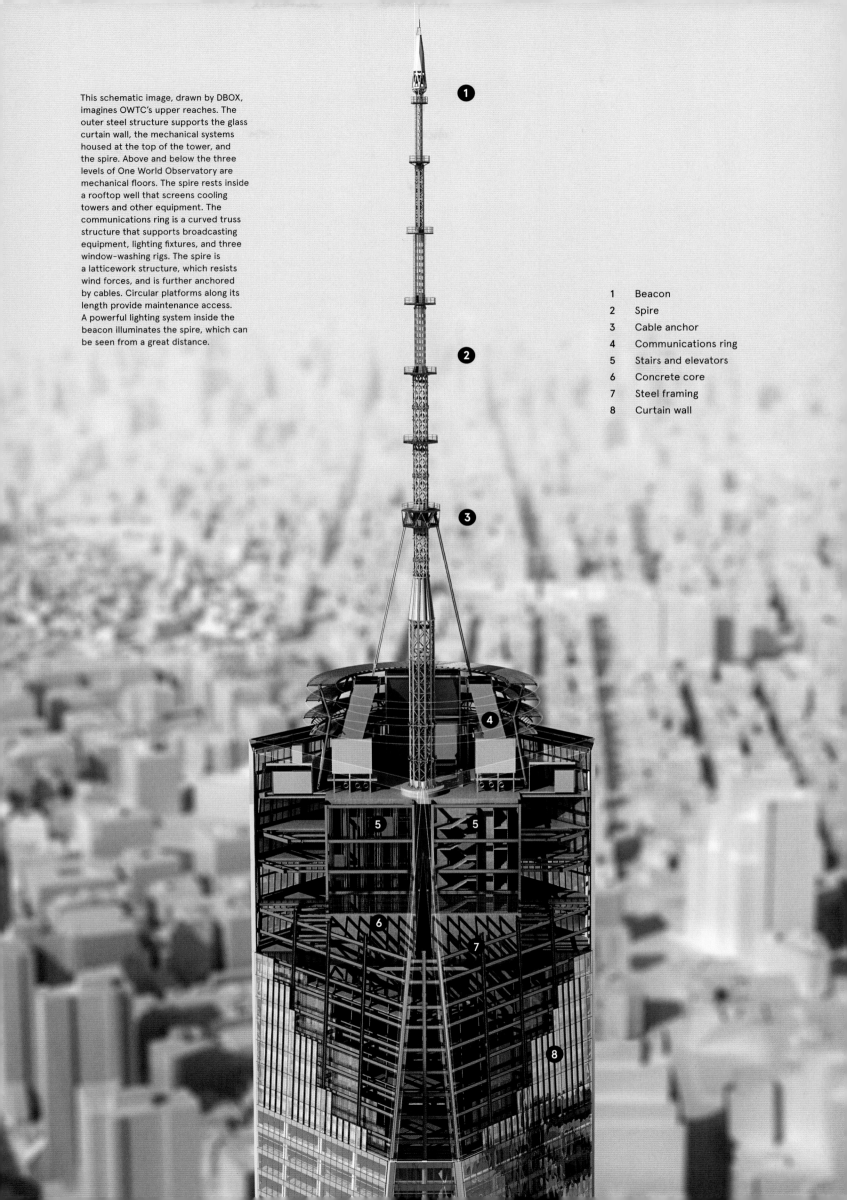

This schematic image, drawn by DBOX, imagines OWTC's upper reaches. The outer steel structure supports the glass curtain wall, the mechanical systems housed at the top of the tower, and the spire. Above and below the three levels of One World Observatory are mechanical floors. The spire rests inside a rooftop well that screens cooling towers and other equipment. The communications ring is a curved truss structure that supports broadcasting equipment, lighting fixtures, and three window-washing rigs. The spire is a latticework structure, which resists wind forces, and is further anchored by cables. Circular platforms along its length provide maintenance access. A powerful lighting system inside the beacon illuminates the spire, which can be seen from a great distance.

1 Beacon
2 Spire
3 Cable anchor
4 Communications ring
5 Stairs and elevators
6 Concrete core
7 Steel framing
8 Curtain wall

Early Solutions

Long before engineers began planning One's structural design, a vast number in their field had worked at Ground Zero. In the immediate wake of September 11, engineers provided the technical expertise and critical assessments that allowed massive, entwined structural members to be removed in ways that would protect rescue and recovery workers and avoid triggering destructive slides or falls. They included experts from WSP USA, which designed One, Two, Three, and Seven World Trade Center, and Mueser Rutledge Consulting Engineers (MRCE), the geotechnical and foundation experts that designed the below-grade foundations on which One World Trade Center stands.

A second below-grade engineering challenge was rebuilding the PATH train tunnels. However, the first task after 9/11 was stanching the flow of water that was flooding them. "We immediately began laying sandbags at the western end of the Exchange Place station to prevent water from advancing further into the system," said Michael DePallo, PATH's former director. "We then instituted a pumping operation to extract water flowing from the tunnels into Exchange Place. It took forty days to pump all the water out." The flooding was caused initially by the millions of gallons of water pumped from the Hudson River to extinguish the fires at Ground Zero. The tunnels, located at the bottom of the World Trade Center basement, functioned as a natural drain but were clogged by building dust, powder, and debris. The slurry walls had not yet been stabilized, so sixteen-foot-thick (4.9 m) concrete plugs were inserted into the tunnels at Exchange Place to make sure that if they did collapse, the rest of the PATH system wouldn't be inundated with water. The flooding damaged most of the equipment inside the tunnels, requiring that it be completely rebuilt. By the time the recovery effort was finished, in May 2002, the Port Authority already had begun reconstructing the two PATH train tunnels along with a temporary station to serve New Jersey commuters. At the same time, the Metropolitan Transit Authority had begun the reconstruction of a tunnel to accommodate IRT subway lines 1 and 9.

ways to build it, spending months on logistics before construction began in 2006. Dan Tishman, chairman of Tishman/AECOM, said that the solution "in a remarkable way was not that complicated. When in doubt, go low-tech. That happens in lots of places, in lots of other projects. Thankfully, this was not the first building we've done that was going to be built around other infrastructure or facilities that needed to be operational." In Manhattan and other urban centers, it's a safe bet that something—subway tunnels, utility pipes, or sewer lines—will be encountered below ground.

Architect Nicole Dosso, a technical director at SOM, represented the architects on the day-to-day execution of the project and managed the below-grade portion of the tower, which, at a half-million square feet (46,451.5 m²), is enormous. Dosso is a rarity in her field: young, only thirty-eight when SOM named her to a senior leadership position in 2013, and female in a profession that is still visibly male. After working on Seven World Trade Center, she started on One World Trade Center in 2006, resolving field issues and managing upward of thirty architects working on the site. To oversee literally hundreds of construction documents, she worked three-dimensionally, using Revit software to coordinate the placement of structural steel nodes at the tower's base and transitions; it was the first large-scale use of this now industry-standard CAD program. Coordinating everyone's efforts was her biggest and most time-consuming challenge. "There were multiple parties, multiple owners and contractors, and everybody had a stake," she said. "We were not dealing with a single owner, a single set of architects, and a single set of engineers—there could be fifteen architects to coordinate one opening in a wall.... Reaching ground level was one of the highlights because it took us so long to get to that point."

THE FORCES OF NATURE

Loads, or forces, that are exerted on a structure are diffused throughout the structure. Axial shortening, or compression, becomes more critical in hybrid structures. The design and construction have to accommodate the differing natures and behaviors of the materials being used, such as steel and concrete, which expand and shrink over time at different rates. Axial shortening studies were performed to anticipate the deformation of the concrete core wall and perimeter steel framing during and after construction. The floors were leveled and positioned at theoretical elevations. Then, as compensation for shortening, the contractor adjusted the elevation of both the perimeter steel columns and the concrete core walls. For the structural steel, for instance, this was achieved both by making the columns longer than the theoretical elevation and shimming them during construction.

Structures are in constant motion, due to winds, shifting foundations, thermal effects from the sun, or

..."when in doubt, go low-tech"

"Every structure interacts with the wind. Imagine a blade of grass,
a long reed. Even though it may have an extremely small sail
area, it tends to be very compliant in the wind and can deflect a lot."

JON GALSWORTHY Wind Engineer, Rowan Williams Davies & Irwin (RWDI)

crane loads. Often imperceptible, all movement has
to be monitored and accommodated, since a small
miscalculation can compromise the structure's
many interconnected parts. To make sure One rose
straight and true, DCM Erectors relied on a structural
monitoring and positioning technology developed by
Leica Geosystems and first used at the Burj Khalifa.
Using a network of ground controls in conjunction with
GPS antennas that were attached to structural steel, the
system tracked the vertical position of the tower's beams
and walls to within a few centimeters. This system
was used in tandem with inclinometers, devices
installed on the core walls that measure tilt variations
to the structure's main axis.

AERODYNAMICS

Wind is a skyscraper's nemesis. At the top of a very
tall building, even on a calm day, winds can gust to
speeds greater than 50 mph (80 kph). Taming its force
is key to designing the most efficient structure, one
that will stand years into the future. To design the most
aerodynamic structure possible, Tower One's architects
and engineers had to consider wind action outside

and inside the tower. As the tower tapers and turns, it
deflects wind forces, redirecting the wind rather than
blocking it. Lessening wind resistance translates to
greater efficiency, economy, and safety. Architect Lewis
said, "Inefficiency in the design of a building of this scale
has incredible repercussions.... The building will actually
want to pull out of the ground."

Wind testing, conducted during various stages of
the design process and completed before construction,
assessed how the tower, along with its spire, glass
curtain wall, and mechanical systems, would respond
to wind under normal conditions and during natural
disasters such as hurricanes. They also measured how the
tower met human comfort criteria, predicting people's
experience on different floors and at the sidewalk level.

To make sure One would perform well in every conceivable
kind of weather, RWDI built a customized wind tunnel,
approximately eight feet (2.4 m) tall, eight feet wide, and
100 feet (30.5 m) long, that re-created in miniature the
structures and wind conditions at the site. Blocks inside the
tunnel create turbulence the same way a building does.

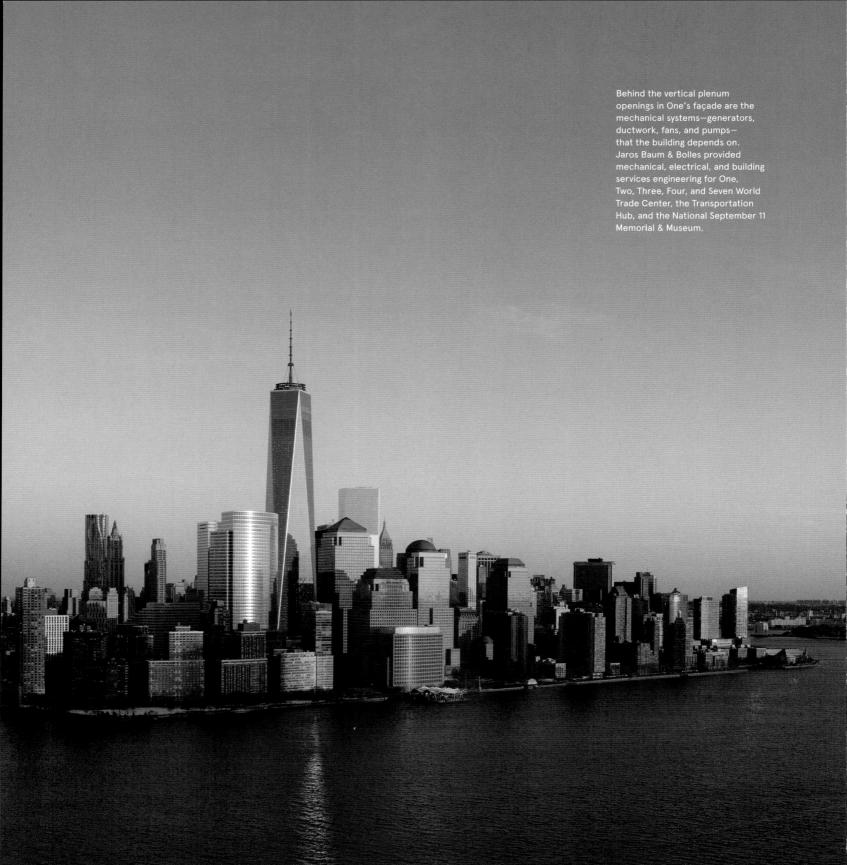

Behind the vertical plenum openings in One's façade are the mechanical systems—generators, ductwork, fans, and pumps—that the building depends on. Jaros Baum & Bolles provided mechanical, electrical, and building services engineering for One, Two, Three, Four, and Seven World Trade Center, the Transportation Hub, and the National September 11 Memorial & Museum.

RWDI, expert wind engineers, tested and analyzed wind action on towers One, Two, and Three, and also provided peer reviews of Tower Four and the Transportation Hub. To gain a comprehensive understanding of wind forces at the site, RWDI built a wind tunnel that simulated its turbulence and also re-created the forces operating within the atmospheric boundary layer, the layer of atmosphere that is closest to the ground and anywhere from 500 to 2,000 feet (152.4 to 609.6 m) in height. Wind picks up speed as height increases. Wind testing requires some theoretical guesswork, but the science is well founded. "It's the only reliable method to determine what the wind actions will be on the building. You can't design with the aid of a simple building code, because the code doesn't fully address all the issues you have on a building of this scale," Jon Galsworthy, RWDI's wind engineering director, said. At the moment, there is only one general wind design standard in the United States, which municipalities adapt to their needs.

Although the 13,000 glass panels that cover the tower appear to be identical, the glass varies in thickness and type according to its location. For the glass curtain wall, a different model was used to test wind pressure, some of which is relieved by the tower's twisting profile. RWDI measured peak wind-induced pressures, concentrating their "instrumentation in areas where we expect the loads to be the highest. Typically, that's close to the corners, the set-backs, close to any discontinuities in the geometry," Galsworthy said. Additional testing simulated driving rain with a plane propeller and water, drenching the glass panels in order to evaluate their performance in tornado-like conditions. Ryan Kernan, project manager for Benson Industries, which engineered the curtain wall, enumerated the tests that were performed—wind, rain, thermal, structural, seismic, fire—basically "anything Mother Nature can throw at it."

All buildings sway when exposed to wind. They are designed to move side-to-side relative to their height. Typically, a building is designed to sway as much as 1/500 of its height under a very strong wind event, which might happen only twice in a century. On a breezy day, the top of Tower One might move in the range of two to three inches (5.1 to 7.6 cm) in any direction, motion too small to be detected by most people. What shapes motion perception is the building's movement in concert with the body's own movement, particularly the head, where the organs governing equilibrium reside. Engineers quantify occupant comfort in terms of a milli-g, or one thousandth of gravitational

acceleration. RWDI's engineers measure the same forces fighter pilots experience, albeit in exponentially smaller quantities. When the building is moving, especially when it is changing its motion, it vibrates or accelerates. "People inside the building feel that acceleration as a small force that is pushing them back and forth. We can quantify those forces as a fraction of g. They start to feel motion when that acceleration is in the range of two to five milli-g. A more sensitive person would feel motion at two milli-g and nearly all would feel it at five," Galsworthy said. Nausea usually doesn't set in until acceleration reaches between ten and fifteen milli-g.

The "surroundings effect" also factors into aerodynamic design, especially in cities and particularly at the World Trade Center, which is one of very few clusters of supertall buildings in the world. The effect refers to the pressure that arises as wind flows around and above neighboring structures. When I asked Rahimian how the surroundings effect was calculated for towers Two, Three, and Four, which were barely a gleam in Larry Silverstein's eye when structural planning commenced, he said any major building would "become an obstruction to the wind flow. That obstruction sometimes can be helpful, but it's very difficult to figure out with hand calculations. Depending what the angle is, what the shape is, what the position is, you may shield the building from some of those pressures, but it could also create a slingshot effect, picking up speed while it goes around the building." Since they didn't know when or if the other towers would be built, they commissioned RWDI to test for multiple scenarios that considered One World Trade Center with and without the adjacent buildings and the maximum impact on the structure.

Large volumes of air also move inside a building due to temperature fluctuations: cooler air outside the building drives the warmer air inside upward through the building. While this movement, the "stack effect," occurs naturally in structures of all sizes, it is magnified in skyscrapers. Stack effect is most commonly experienced as a rush of air into a building's lobby, typically in winter, when a door is opened or, alternatively, as whistling elevator shafts and doors. While these might be minor nuisances, stack effect causes more significant problems related to energy, safety, and building operations. It can result in uncontrolled airflow into a building, called infiltration, which pushes out warm air and drives up energy costs. It is also capable of producing large pressure differences across doors, leading to slamming or difficulty opening them, a concern especially during an emergency.

101

all buildings sway...

Finally, in some buildings, stack effect sometimes stalls elevators: elevator doors have safety mechanisms that are triggered by air pressure differences in the shafts, causing the elevators to stop until the doors are reset.

Another aspect of RWDI's work involved managing the building's exhaust—from mechanical, kitchen, and diesel generators—and that of its neighbors. Although venting systems remove and discharge air contaminants away from buildings, they can find their way back into the fresh air intakes, thanks to wind currents. RWDI also examined the emergency smoke exhausts at the bottom of the tower, including venting for a train-fire scenario in the PATH tunnel.

Just as water flows around an obstacle, so does wind. "Water and wind follow the same dynamic laws," Rahimian said. "Obviously, water is fluid and air is a gas, both having their own nuances, but they follow the same laws. When your car breaks down in the middle of the road, what happens? All of the cars go around it, just as the flow of the wind goes around a building. That's aerodynamic. Aeroelasticity, however, refers to a structure's innate flexibility. Engineers consider the flexibility of each element individually and in tandem with other elements, and they study how both interact with many different types of loading."

102

You carry all the ingredients
To turn existence into joy,
Mix them, mix
Them!

HAFIZ (c. 1320–1389)
To Build a Swing, trans. Daniel Ladinsky

CONCRETE

In conjunction with the Port Authority Materials Division and its concrete producers, WSP specified for the superstructure a custom-designed concrete that was durable and extremely strong, ranging from 10,000 to 14,000 pounds per square inch (psi) (68.9 to 96.6 MPa) of compressive strength, the latter the strongest concrete ever used in New York City. For comparison's sake, concrete of 3,500 to 4,000 psi (24.1 to 27.6 MPa) is used on many buildings up to ten stories in height. As heights rise, demand increases because of additional loads; a 40-story tower might use 6,000-psi (41.4 MPa) concrete, while very tall towers require even greater strength. When WSP engineered the Trump Tower in 1980, for instance, they used 8,500-psi (58.7 MPa) concrete, the first time that strength was used in

Manhattan; in 1998, they successfully used 12,000 psi (82.8 MPa) on Trump World Tower, which, until One World Trade Center was designed, was the highest compressive strength ever used in the city.

The strength of the concrete does more than support the structure; it increases safety while using less material. While it would have been possible to achieve the tower's safety requirements using concrete that wasn't as strong, doing so would have required a different design and reinforcements. The 14,000-psi concrete permitted a minimal design that created more leasable floor space. After all, Rahimian said, if we built only with the materials that were available two thousand years ago, we would still be building pyramids. The higher the strength of the concrete, the less concrete is needed. Generous with metaphors, he also mentioned the Empire State Building. Although it was designed by brilliant engineers, "with the same material, today we could make another three buildings out of it."

To illustrate just how strong this concrete is, Rahimian told me that if my big toe was made of 14,000-psi concrete, a five-ton elephant could stand on it without a problem. When I ask why only five tons, Rahimian said, "Those are the biggest elephants I could find." His quip calls to mind the hidden elephant in Saint-Exupéry's *Little Prince*, which isn't surprising, given Rahimian's childhood penchant for spending time in the cool darkness of the library that his father, a poet and a novelist, had built in their home in Tehran. "My father had a huge library, just thousands of books, so what did I do in the summers? Yes, I could play football with my friends, but a lot of afternoons it was too hot, so I was in the library, picking up books. Many of my father's books weren't for me, not for a ten-year-old kid, but there were a lot of fantastic titles. I started reading them. I read John Steinbeck, Hemingway, Dostoevsky, many others." He also read books by the great Persian poets Rumi, Hafiz, and Khayyám, with their experiential considerations of the self in relation to the physical world. If architects can be compared to novelists, who tell a sweeping story, then engineers surely are poets, finding beauty in economy.

For an engineer, economy is the sum definition of beauty, which arises from finding the most minimal solution to a given condition, using as few materials as possible to create an optimal structure. Rahimian said, "Anybody could do engineering, if you remove the safety and economic criteria. Pour enough cement in a site, that could do it. It only becomes an engineering problem when you bring safety in light of economy." One World Trade Center's beauty is expressed in the economical way it meets all the challenges that were thrown at it. Its engineers had to prioritize and address each of many considerations coherently in order to arrive at a solution that works as a whole. Utter reliability has an invisible beauty about it. ▲

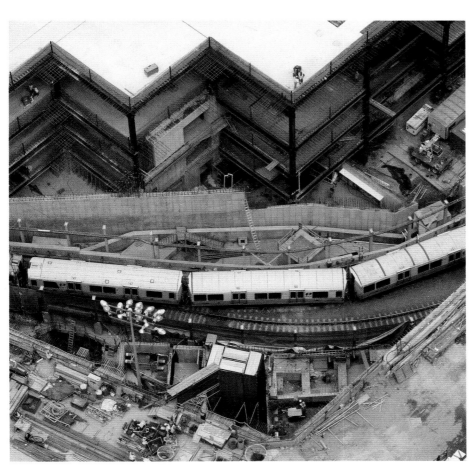

An aerial view shows a PATH train running through the construction site. Because the PATH trains had to remain operational during construction, building strategies were a key component of the design of the below-grade structure. Work often had to be performed late at night and on weekends.

Ahmad Rahimian, a director of building structures at WSP USA, led the structural engineering efforts. Rahimian is soft-spoken and urbane, and his approachability belies the string of letters— Ph.D., P.E., S.E., F.ASCE—that follows his name. An internationally recognized expert in tall buildings, Rahimian has implemented innovative designs for supertowers and sport facilities. He has played a key role in the structural engineering of numerous landmark skyscrapers in Manhattan and around the globe, including Torre Mayor, the tallest building in Mexico City; Trump World Tower in Manhattan, at one time the world's tallest residential tower; and the London Shard, the tallest building in Europe. He has been honored with many awards for his pioneering structures and holds multiple U.S. patents for seismic-protective design.

103

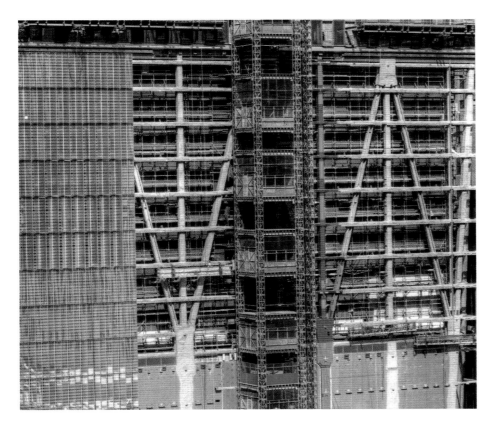

A construction view of the podium, partially clad in glass, reveals the belt truss system that provides the tower's structural support. A temporary service elevator runs up the center.

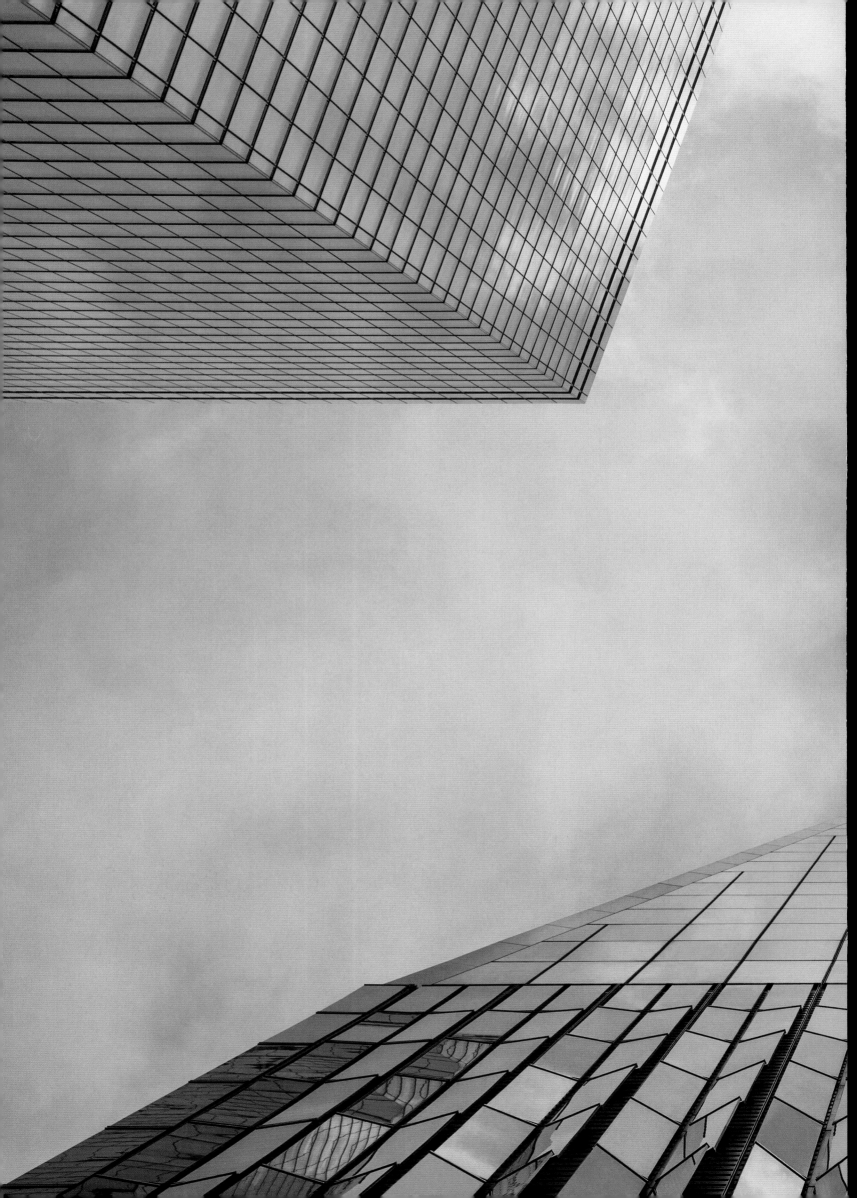

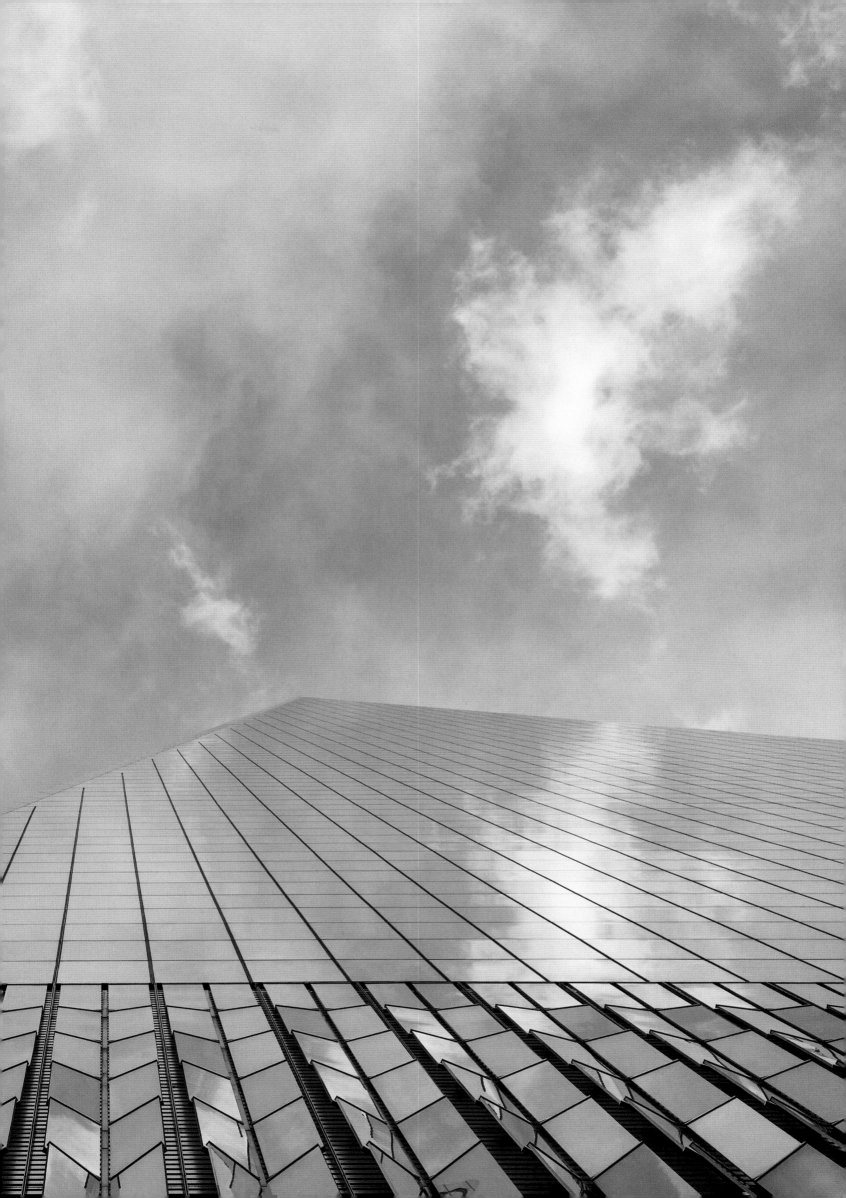

HIGH STEEL

BUILDING
ONE WORLD TRADE CENTER

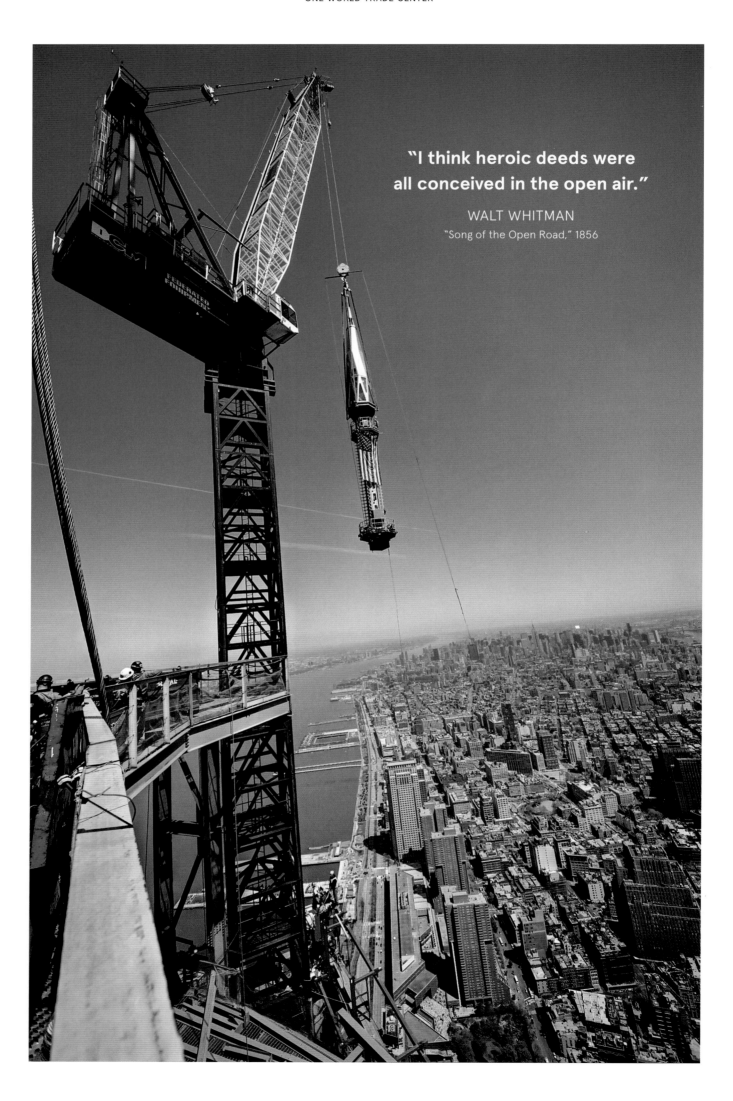

"I think heroic deeds were all conceived in the open air."

WALT WHITMAN
"Song of the Open Road," 1856

Constructing the World Trade Center depended first on the configuration of the below- and above-ground transportation network. That network determined where the stores and restaurants along the transit corridors would go. Next, the mechanical systems and foundations shared by the site's nine structures had to be integrated, both vertically and horizontally. Eight acres (3.2 ha) are devoted to the 9/11 Memorial, the plaza of which serves as a massive green roof, a fully constructed ecosystem, above multiple subterranean structures, including mass transit passageways and tracks, the 9/11 Memorial Museum, and the central chiller plant.

Ordinarily, a building has its own owner and sits on its own plot. Next door is another building, another owner. That situation didn't exist at the Trade Center, where multiple buildings that were owned or controlled by multiple parties were stacked on top of each other. Moreover, each structure had its own schedule and managers, each of whom was answerable to multiple masters. "Everyone had to dance together or it wouldn't work. Reaching that level of collaboration took time," said Craig Dykers of Snøhetta, designers of the museum's entrance pavilion. "It was like threading the needle through a concrete block."

The ensuing scrum was an atypical but unavoidable means of construction, given the site's interconnected nature. Every conversation about this unusual way of sharing space and resources started with "Huh?" Steven Plate, who directed World Trade Center construction for the Port Authority, said, but "we slowly and methodically broke it down into the finest elements and attacked that problem." Plate's office allocated a percentage of shared infrastructure costs to each structure, basing it primarily on square footage but also on other parameters, such as the structure's load, weight, or the amount of water or air conditioning it needed.

Building owners are billed separately for maintenance and direct energy use.

Michael Kraft, who coordinated construction for the Port Authority, unfurled a complicated diagram in a rainbow of colors to show me the specific responsibilities of each entity on the site. "We use this as a tool, not just to represent where stakeholders reside in the site, but also as a working document to resolve conflicts," he said. Project areas yet to be reconciled in color were readily apparent. Pointing out one multicolored block, he said, "That's where we need to bring the architects and engineers together and work that conflict out." In every instance, during meetings held weekly since 2005, owners saw the entire site, not just their small piece of it, enabling this remarkable collaboration to unfold.

BUILDING STRATEGIES

My father, who has a knack for coining apt new turns of phrase, speaks of events marked with the "asterisk of sorrow" to describe circumstances whose outcome has been influenced by grief. The rebuilding of the Trade Center was so asterisked, prompting an unprecedented outpouring of ingenuity and hard work. A state-of-

The Central Chiller Plant is a key element of shared infrastructure. It cools the 9/11 Memorial Museum and other low-rise public buildings, as well as the Transportation Hub, No. 1 subway platforms, and retail stores. The office towers have independent cooling systems. Energy efficiencies include using water from the Hudson River, about 30,000 gallons (113,562.4 L) per minute, to cool the chillers. The water is filtered before being discharged back into the river, and its impact on marine life is monitored in accordance with New York State Department of Environmental Conservation requirements.

110

The construction site is a noisy place. There are many voices here, all of them speaking at once: the hushed voices of the dead, the barked orders from the project's many timekeepers, the laborers' mutterings and jokes, boom boxes blaring hip-hop. They mix with the sounds of jackhammers, welders' arcs, concrete spreaders, and lumbering trucks. It's a jumbled cacophony of political perspectives and contradictions, a Rachmaninoff concerto, intense and sublime, all of it gathered into the ever-present existential roar of the memorial's waterfalls.

Inside too is a glorious collage—exhaust pipes, heating ducts, aluminum tiebacks, glass panels, and steel pulleys that hang down like beads, glinting silver and platinum in the light. There are piles of strange loveliness: slabs of sheetrock, wooden spools of red and blue wire, plastic buckets, cinder blocks. Some pieces are spray-painted "Save." Dense hieroglyphics— the signatures, thoughts, and drawings of those lucky enough to be inside with a few minutes and a Sharpie— cover the walls. One reads, "Te Amo Tres Metros Sobre el Cielo," meaning, "I love you three meters above heaven." Scissor lifts are poised to rise. Orange netting hangs like celebratory bunting from the ceilings. Over everything is a fine pale dust that makes what is material seem immaterial, transporting the visitor to another realm that exists not entirely on earth. I will save this.

the-art enterprise, it required the skills and brawn of thousands, many of them union members. Their numbers include riggers, painters, drywall tapers, plumbers, waterproofers, electricians, and others. All told, forty-nine unions were represented; these estimable brotherhoods are listed at the end of this book. A discussion of the union workers who handled the tower's primary building materials—steel, concrete, and glass—is shorthand for the extreme talent and determination that so many trades invested in the tower. A timeline of historic construction photographs, shot by the Port Authority over the past decade, documents the heroic business of building a skyscraper.

Steven Plate is an engineer from a union family. Hands-on, and as dedicated as he is demanding, he created a climate of cooperation at the congested site, negotiating daily who-has-access-first issues among the myriad building teams there. Plate was joined in his efforts by Dan Tishman, chairman and executive of Tishman/AECOM, who would visit the original site with his father, the pioneering contractor who managed the Twin Towers' construction. Tishman/ AECOM managed construction for the Port Authority on a number of the Trade Center's major structures and portions of the underground infrastructure. A Tishman/ Turner joint venture built the Transportation Hub, along with the Downtown Design Partnership. Liberty Security Partners developed the Vehicle Security Center.

Raising the tower was not a linear process. Everything—design, engineering, and construction— was developed concurrently and collaboratively. Because of the economics of large-scale construction, the foundations and underground portion of One World Trade were under way long before the design of the building was complete, shaving at least three years off the schedule. "We had a footprint, we had a layout of the building, we had the beginning of a structural system. We knew where the columns were going to come down. It was unusually informed," Tishman said. "It's like a big game of chess. No one move is a move unto itself. Everything you do has a domino effect on many, many other things."

Before construction of the superstructure began in 2006, months were spent crafting scheduling strategies that ultimately allowed the construction of two floors every two weeks. One such tactic involved building a structure made of thirty-six shipping containers that was hoisted to the tower's upper levels. Dubbed "the hotel," it contained a Subway sandwich shop, so workers could avoid making a slow trip to street level for lunch, as well as lockers and restrooms. But it provided much

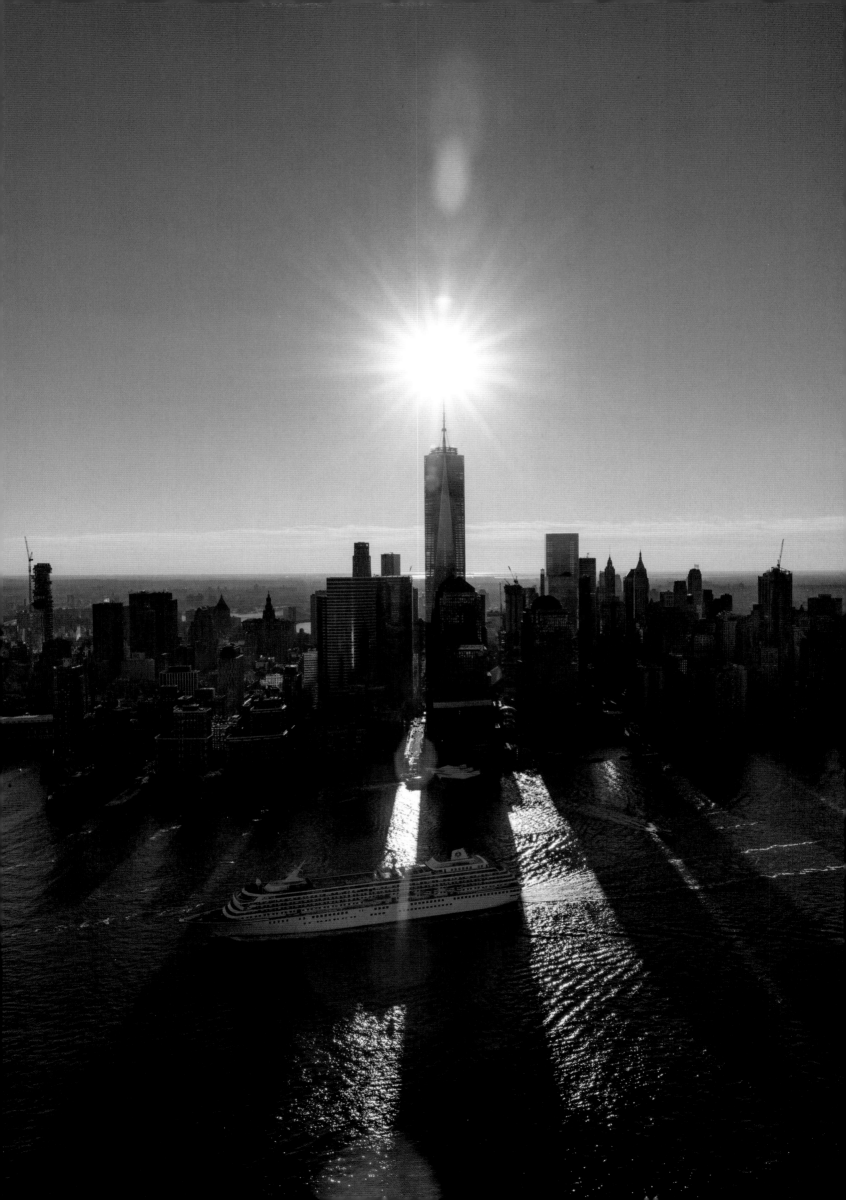

"I knew I would never do anything, nor would I want to do anything, of this magnitude again."

DAN TISHMAN Tishman/AECOM

more than $5 foot-longs. The hotel stabilized the tower's steel frame and reduced the amount of steel that had to be erected before the concrete core, ten floors behind steel erection, caught up. Placed inside the core void, the hotel acted as a roof, protecting workers below from the ironworkers above and from rain, allowing concrete work to continue regardless of the weather. The hotel was dismantled in 2012, when it reached the ninetieth floor, the level at which the tower was too slender to support its size.

In a construction first for New York City, Tishman/ AECOM devised a two-story lightweight steel traveling system, called a "cocoon," that eliminated the need for ironworkers to balance on beams and prevented tools and materials from blowing away in the wind. The cocoon, which contained work platforms, wrapped the tower's upper limits in steel-framed, fire-resistant netting that draped down twenty floors. As the steel was erected, cranes raised the cocoon. Another ingenious move was building an internal seventy-story shaft up to the 100th floor so hoists could be used inside the tower to avoid shutting down an exterior hoist when winds exceeded 30 mph (48 kmh), as required by law. To allow core and curtain wall operations to proceed simultaneously, Tishman cantilevered a slider crane off the tower's sloping northwest corner; this crane was used exclusively for concrete rebar and lumber. The slider traveled up just beyond the curtain wall.

Construction was staged in four tightly orchestrated sequences: steel framing, metal deck and concrete outside the core, concrete core shear wall, and concrete floor construction inside the core. The ironworkers who erected the steel preceded the other trades by eight to twelve floors. They were followed by the concrete workers. Fireproofing, curtain wall installation, carpentry, tiling, and a host of other services came later.

STEEL

All told, the superstructure consumed approximately 45,000 tons (40,802.4 metric tons) of structural steel. Ironworkers, the raising gangs who erect structural steel, loom larger than life. They are the royalty of the trades, the first to define the tower's far borders, hundreds of feet above ground.

Four of the lead ironworkers—Field Supervisor Kevin Murphy, Foreman Kevin Scally, Connector Tom Hickey, and Connector Mike O'Reilly—have been working on the site since September 11, first helping with the rescue and recovery efforts and then, in 2006, once the tower's substructure was completed, raising the skyline one beam of steel at a time. They're big, tough guys doing arduous work, and as tenderhearted a group as you'll ever meet. Each has touched every piece of steel in the tower. It's hard to wrap your imagination around that fact, seemingly such a small thing, a touch, yet it says a lot about the building, which has been assembled by hand, and about them.

All of them belong to Local 40, the metropolitan region's structural ironworkers union. They work for DCM Erectors, the firm contracted to erect the steel for the tower and its spire, the Transportation Hub, and Four World Trade Center. MRP, a company owned by the Davis Group, which also owns DCM, fabricated the steel.

Typically, a raising gang needs six workers to maneuver a piece of steel—the foreman; a hooker-on, who hooks the steel to the crane cable; a tagline man, who makes further adjustments; a signal man, who uses hand gestures or a phone to guide the crane, and two connectors, who place and bolt the beam into place. Before work on One began, however, the gangs had to assemble and "jump" the massive cranes used to lift the steel. Four cranes were used to erect the podium; after the twentieth floor, builders used two tower cranes. Before erecting the steel, they must "shake it out." Shaking out is the process of sorting the steel, piece by piece, using hooks attached to the crane ball. The beams are then moved and placed upright at the location where they will be erected, an efficiency that saves time and makes erection easier. The beam weights vary from a few hundred pounds to forty tons (36.3 metric tons) each, while the podium columns weighed fifty tons (45.4 metric tons).

Two gangs, called North and South, raised the tower. A rivalry arose between them. "When there are two cranes, you want to race each other. Makes it more thrilling. It's always a race," the ironworkers say. Foreman Scally cautions, "A safe race." Indeed, safety is the top priority—a worker can be thrown off the job

...cranes raised the cocoon

for wearing ear buds, considered a distraction. On pace to complete one floor per week, the ironworkers were followed by a host of others, who plumbed, welded, and secured the beams.

On this job, Hickey and O'Reilly were the connectors. They have worked as a team for a long time. "We don't have to communicate as much," O'Reilly said. "He gives me a look and I know what the look means." "Like husband and wife," Hickey shoots back. Everyone guffaws. A strong sense of the gang's family ties permeates the conversation. It's in the blood, they say. O'Reilly's father, who worked on the Twin Towers and the original 7 WTC, didn't want his son to become an ironworker. Beyond the work's obvious rigor, his father had fallen in 1985 while working on Seven and was paralyzed from the waist down. September 11, as O'Reilly recalled it, called him to the profession. He signed a beam, "This one's for you, Pop." Murphy is a third-generation ironworker, one of many in his family. He caught the bug from his father, a "rough and tough ironworker known as Cigar Murphy," who taught apprentices, many of whom now work with his son. Hickey's father also worked on the original towers. He is a fourth-generation ironworker on his father's side

and third-generation on his mother's. "I do as my father did, as his father did," he said. "I want to keep the name going. It's pride in the family."

Similarly, in the tradition of their fathers and grandfathers, about thirty Kahnawake and Aquasasne from the Mohawk nation of Quebec walked the high steel at One World Trade Center. Renowned ironworkers, the Mohawks helped build the Twin Towers, the Empire State Building, 30 Rockefeller Center, and other major buildings and bridges in Manhattan.

When I asked the group what particular skills it takes to raise steel, I anticipated some modest mumbles about strength, balance, and courage. There was a long pause, as though they had never been asked this question before — though they are the very best in the world at what they do. Finally, one joked, "Well, you can't be afraid of heights." It's a constant adrenaline rush. Are they afraid of falling? "You have to constantly be aware of where you're at, but when you're working, you're in the zone," O'Reilly said. "It's second nature. You're not thinking, 'If I miss this step, I'll fall.' You have to think about your partner. Everything I do affects him."

A typical day starts at 6:30 a.m. "We're here seven days a week, sometimes twelve hours a day." On site, conditions are hard, apart from the omnipresent winds and fifty pounds (22.7 kg) of bolts and wrenches they carry. "Weather-wise, we're out in the cold, we're out in the heat. It's brutal sometimes. You just man up and do the work." When it snowed, which it often

Tom Hickey and Mike O'Reilly, two of the lead ironworkers, have been working on the site since September 11, 2001.

113

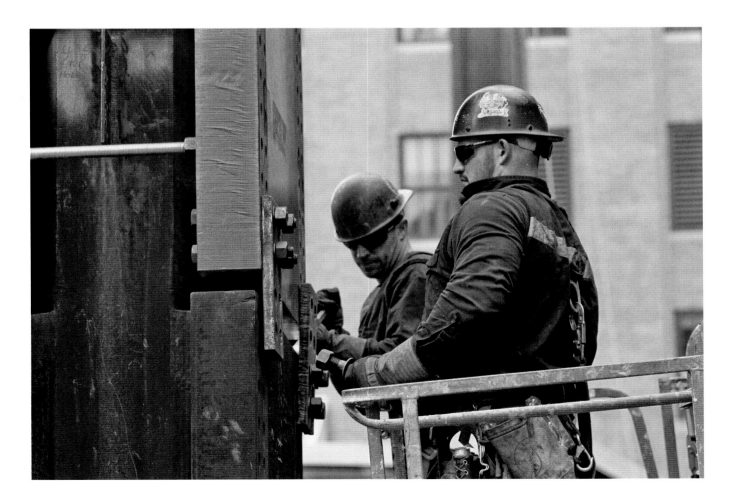

did, dumpsters were hauled up into the tower and the ironworkers had to shovel off each beam and lift the snow into the dumpster. Then they chopped off the ice. If the beams were still icy, they used "'rosebuds' that shoot fire"—blowtorches—to melt the remaining snow and ice. On summer days, the steel sometimes got so hot that it couldn't be touched. The work takes an extreme physical toll. "You're lucky, when you retire, if you can walk," Hickey said.

The erection of the spire segments, eighteen of them, was a milestone. Two raising gangs, a team of twelve ironworkers, erected the spire, along with the crane operators and those who prepped it. On a cold morning in January 2013, they hoisted the first segment, the heaviest segment, weighing more than sixty-seven tons (60.8 metric tons), into place. The rest of the segments followed in sixteen more trips. The last two segments were joined on the ground and lifted together. Scally and signalman John Collins assisted the four connectors—O'Reilly, Jim Brady, Tim Conboy, and Ryan Gibbs—who bolted the last piece, the beacon, into place on May 10, 2013. "It was an amazing day. There was a lot of relief when the spire was completed,

These materials were moved by barge to the metropolitan area and then trucked to the Red Hook section of Brooklyn, where they were blended according to a customized recipe, stringently tested, and monitored. Steve Jackson of Eastern Concrete, which manufactured concrete for One and Three World Trade Center, as well as the Transportation Hub, said, "There were actually four cement products in each one of the mixes, as well as chemicals supplied by BASF. These mixtures were first of a kind, special mix designs just for this project." Given the massive amounts of concrete needed—the tower consumed 208,000 cubic yards (159,027.4 m³)—materials were constantly replenished. "We received material anywhere from three to four in the morning until five to six at night, every day, just to keep restocked," Jackson said.

Once mixed, the concrete was poured into the drums of Eastern's fleet of trucks, and delivered to lower Manhattan in ten minutes. Pending traffic, of course. The plant's close proximity was crucial for concrete of this strength, which cures quickly: if a batch could not be produced, delivered, and discharged from the truck in ninety minutes, it was no longer fit to use. Timing

"If we had a really boom-boom, perfect, summer, low-wind day, forty units would be a good day. We had one or two where we hit fifty, but that was a perfect storm of every condition working out."

ROBYN RYAN Project Coordinator, Glass Curtain Wall, Benson Industries

and a lot of pride, which the entire city shared." Asked if they'll ever work on another building like this one, they shook their heads. "This one was special." Despite the constant danger, excruciating work, and long hours, they said, almost in unison, "Twenty years from now, we will be able to look back and think of all the fun we had. We were blessed to do this work."

CONCRETE
The specialized concrete mix used at One World Trade Center was made from local materials, including cement and stone from upstate New York. Making the concrete required nearly 200,000 tons (181,437 metric tons) of sand. It was quarried in Long Island, which, once the glaciers retreated twenty thousand years ago, was endowed with distinctive sand that has a combination of coarse and fine grains that is well suited for making concrete. Sand from the Port Washington peninsula, known as "Cow Bay sand," was used to build New York City's sidewalks and some of its most memorable skyscrapers, including the Empire State Building, Rockefeller Center, and the original World Trade Center.

became even more urgent as the tower rose, since it took longer to pump the concrete to the upper levels. The small window of opportunity closed even more tightly during extremely hot or cold weather, since concrete also has temperature constraints. In the heat of summer, pours were planned for the cooler times of day. "At times we had to use ice to cool down the concrete to stay within the temperature specs. In the winter, we use heated water. When it's 50 to 60 degrees, that's the best time because it's easier to maintain the temperatures," Jackson said. And weather was not the only consideration. "As it sets and strengthens, concrete gains heat and produces heat. Even when you pour it in the wall, there are certain temperatures that must be maintained. The cooler you pour it, the more you hold down the temperature because it produces heat. Quite a bit of heat. When you're pouring concrete in the summer and [air temperature is] 80 to 90 degrees, [the temperature of the concrete will] easily reach 150 to 160 degrees." Radio Frequency Identification Devices (RFID) were embedded in the concrete to measure its internal temperature and to report on the maturity

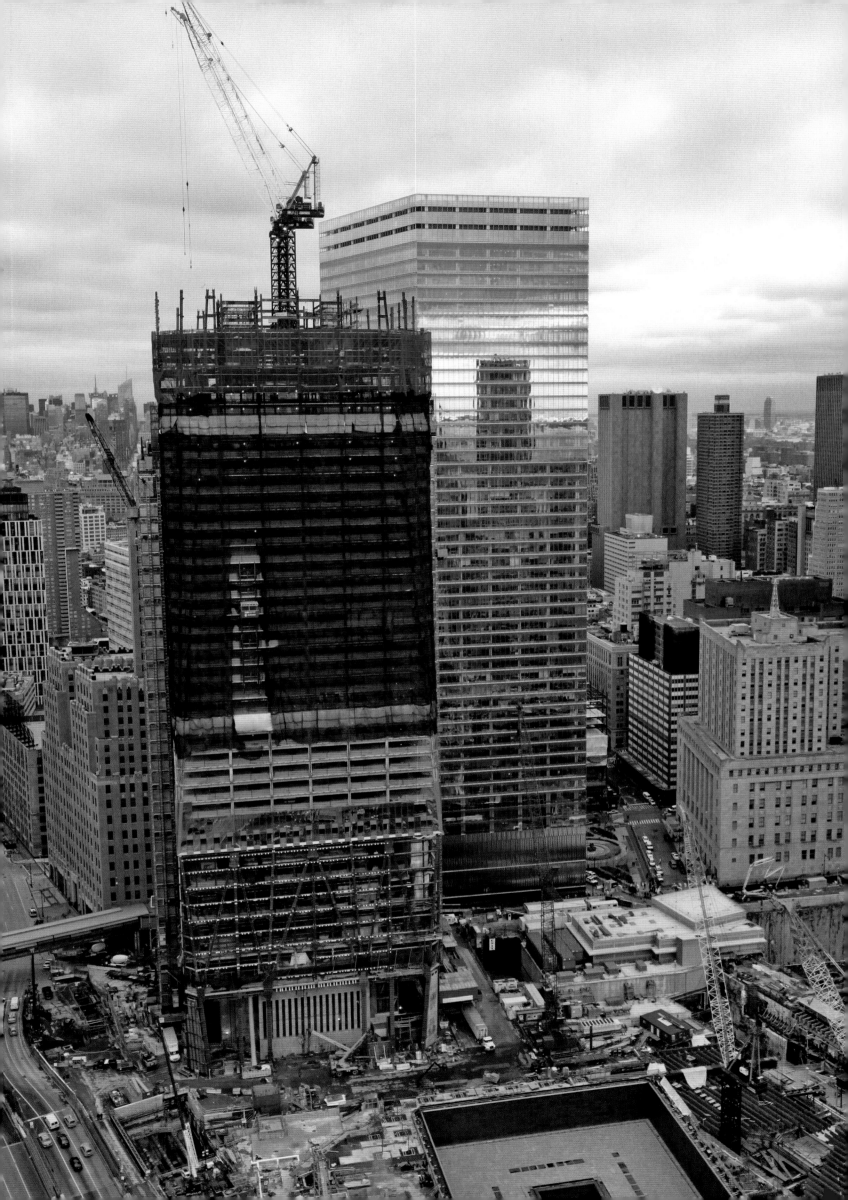

of the newly poured concrete, which facilitated early formwork removal and shortened construction time. What happens if the concrete inside the trucks doesn't make it to the site on time? "You have to chop it out," said Jackson.

The concrete was delivered in a continuous loop: load, discharge, return to the plant, reload, and go back to the site. "Most times we'd start at five or six in the morning, but sometimes it was as early as two, and there were nights where there were issues on the site, equipment problems, things like that. Once you start one of those pours you have to go until you're done, so you'd either start real early or work real late, whatever was required.... We did pours anywhere from 200 yards to 800 to 1,000 yards. Ten yards to a truck, eighty loads a day. Not eighty different trucks. We run twenty-five to thirty trucks and rotate them back and forth all day," Jackson said. Once on the site, Eastern could place concrete only after the steel and formwork in a given area had been inspected and certified. After the concrete was discharged, an army of workers poured it into forms or pulled it across the floor's steel decking.

GLASS

Developing and installing the glass curtain wall presented a complex geometric puzzle. Every one of the 13,000 panels was numbered and tagged according to where it was to be placed, a system that also corresponded to the production, fabrication, and scheduling of the entire curtain wall. But before any of that could happen, Benson Industries, which engineered, fabricated, and installed the glass panels for One World

Workers casting the superstructure's shear walls. After it is mixed, concrete must be placed within ninety minutes or it cannot be used.

One's façade is composed of 13,000 glass panels that are framed in aluminum and steel. Each unit is over thirteen feet (4 m) tall and weighs about 2,000 pounds (907.2 kg); some weigh as much as 6,000 pounds (2,721.6 kg). Only a handful of the panels were broken during installation because the glass is so strong that only a very specific kind of blow will fracture it.

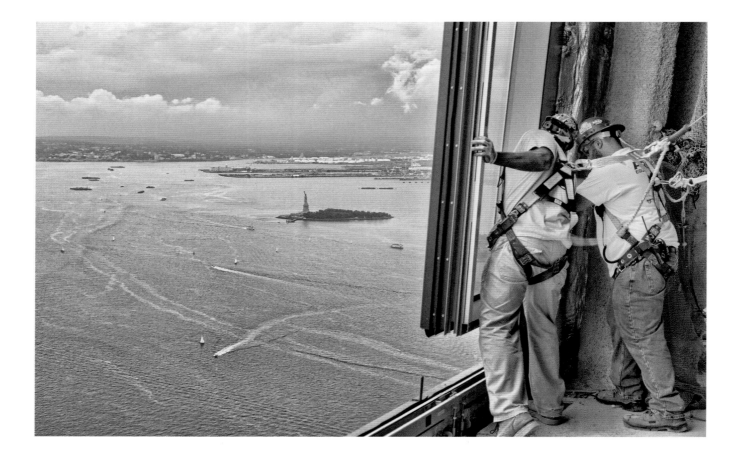

...eighty loads a day

Trade Center and Four World Trade Center, had to spend two years working out the logistics of crating, moving, and lifting the window units.

The glass itself was manufactured by Viracon, an architectural glass supplier in Minnesota, and then shipped to Benson in Portland, Oregon, where the individual units were assembled. The panels were crated—four curtain wall units per each of 3,200 crates—a load size dictated by their size and weight and also by restrictions on what can be brought on a flatbed truck into New York City. Once crated, they were moved by rail across the country to New Jersey, trucked to the site, loaded one crate at a time into a hoist elevator, and moved into position for installation. A typical floor had 160 units, which were installed by Local 580, the ornamental ironworkers union. "You're dealing with a 2,000-pound panel, so you're not just sending one guy over to take it out by hand. You're going to send five guys over there to lay the panel down onto a wheeled car, which then you wheel into position to be able to be picked by our floor crane to hoist it into the designated position," Ryan Kernan, Benson's Project Manager, said. They also had to consider the number of trades working on a given floor and the unpredictability of the weather.

Manufactured using a recipe that was specified by the architects and glass designers, the high-performance glass adheres to tight standards, ensuring that the panels match. Visual mock-ups of the units were made to be sure that "everybody's happy with the way the glass looks and performs," according to Kernan. "It's minutia and micro and macro every day," Robyn Ryan, Benson's Project Coordinator, said. "If something is off by a quarter of an inch, or one of the bolts doesn't have the finish specified in the approved drawings, we have to get that changed."

More demands were made by the tower's sloped walls. A tower crane was required to lift some of the initial curtain wall corner units, which had been assembled into large frames, to accommodate the intricate joinery of the converging stainless steel panels and the trapezoidal glass units adjacent to them. At higher levels, a floor crane with a boom arm was used to install the units at exactly the right angle. Ensuring the window units were plumb required expert surveying, assisted by computers, GPS, and satellites to configure the mean plumb of the building, which fluctuates according to the weather, the rate of thermal expansion, and other factors that come into play when erecting a supertall. ▲

Following spread: One WTC's incremental growth was captured in time-lapse photographs taken by EarthCam, a company that provides streaming and still documentation of large-scale projects around the globe. Since 2001, their cameras have tracked the recovery and construction of the WTC, an archive now in the collection of the National September 11 Memorial & Museum. Views are also available at EarthCam.com.

Steven Plate has served as the Port Authority's deputy chief of capital planning and director of World Trade Center construction since 2006. He is responsible for the site's operations, construction, financing, and environmental standards, including management of a $15–20 billion five-year capital program. A civil engineer, Plate has worked for the Port Authority since 1985. Before he was tapped to direct construction at the Trade Center, he managed the project as deputy director, starting in 2004. Earlier, he oversaw the construction and delivery of the Port Authority's $2-billion AirTrain JFK, the elevated railway that has revolutionized commuting for millions of New Yorkers. His unstinting efforts have earned him numerous accolades, including being named an Honorary Fellow of the United Kingdom's Institution of Civil Engineers and an *Engineering News-Record* 2011 Newsmaker. A native of the Bronx, Steve settled in Glen Ridge, New Jersey, with his family, where he served as mayor from 1999 to 2003.

117

Daniel R. Tishman is vice chairman at AECOM Technology Corporation and chairman and chief executive of Tishman Construction Corporation, one of the country's largest construction companies. Founded in 1898 by Julius Tishman, the family firm built its reputation on innovative, cost-effective construction methods and has enlarged its scope to include solutions that are environmentally responsible. His father, John L. Tishman, pioneered the nascent field of construction management in the 1960s, serving as a conduit between owners and general contractors on a series of complex landmark projects that include the original World Trade Center, Madison Square Garden, John Hancock Center in Chicago, and Disney World's Epcot Center.

In addition to constructing most of the World Trade Center,

Dan Tishman co-chaired the 9/11 Memorial Museum Building Committee and serves on the board of the National September 11 Memorial & Museum. An ardent environmentalist and a major force in sustainable building, Tishman is the chair of the Natural Resources Defense Council. He also works with the Trust for Public Land to protect land, particularly in Maine and Colorado. In 2006, he was appointed by Mayor Michael Bloomberg to New York City's Sustainability Advisory Board, which provided expertise and input for the creation of PlaNYC 2030, the blueprint for greening the metropolis. His firm managed the construction of 4 Times Square, the first green skyscraper in New York City; Seven World Trade Center, the first office tower in New York City to be certified under the Leadership in Energy and Environmental Design (LEED) rating system; and the Bank of America Tower at One Bryant Park, the first skyscraper in the world to be certified LEED Platinum.

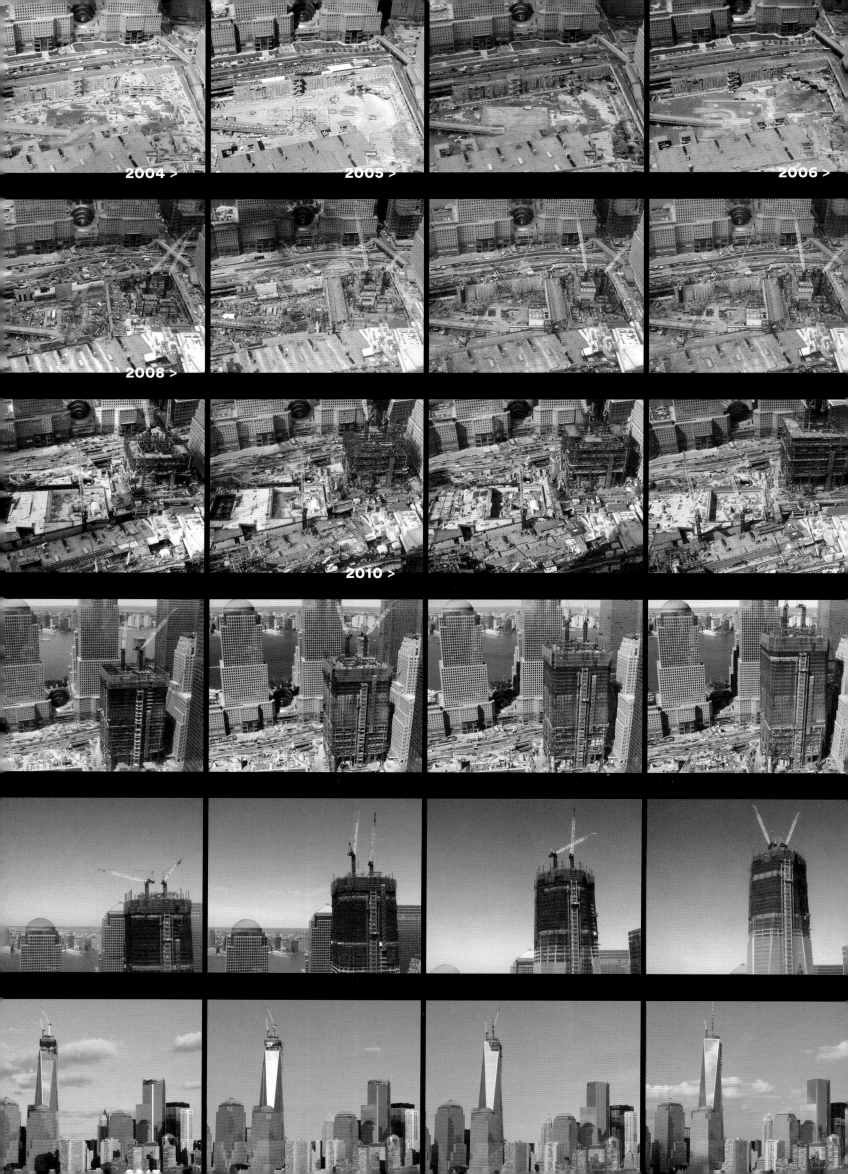

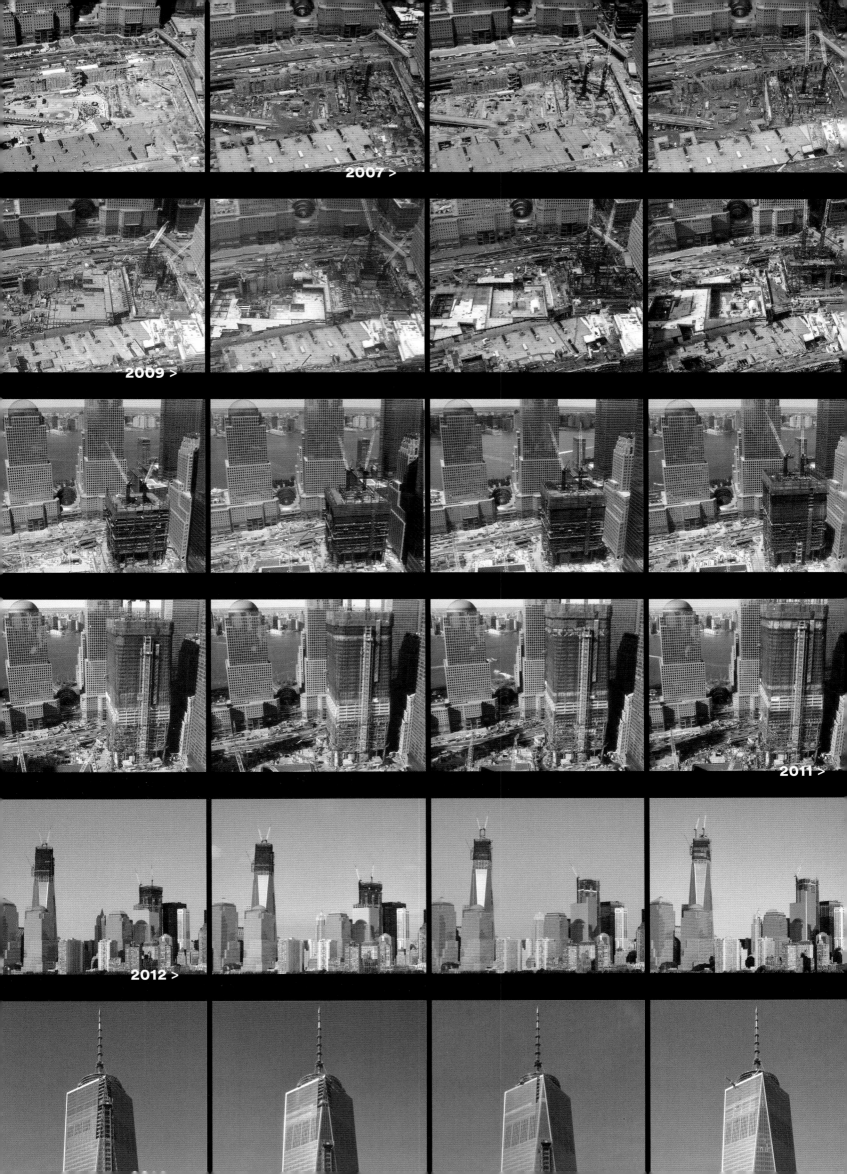

2007 >

2009 >

2011 >

2012 >

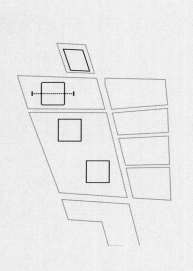

CONSTRUCTION TIMELINE

ONE WORLD TRADE CENTER

2006

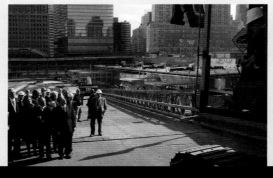

Apr. 27, 2006

Construction of the Freedom Tower (OWTC) officially begins with a groundbreaking ceremony attended by Governor George Pataki, NYC mayor Michael Bloomberg, the Port Authority, Larry Silverstein, and other officials.

May 23, 2006

Silverstein Properties opens 7WTC, the first building to be rebuilt in lower Manhattan after September 11. Total construction time: 48 months.

"Big money, prime real estate, bottomless grief, artistic ego and dreams of legacy transformed Ground Zero into a mosh pit of stakeholders banging heads over billions in federal aid, tax breaks and insurance proceeds."
DEBORAH SONTAG *New York Times,* Sept. 11, 2006

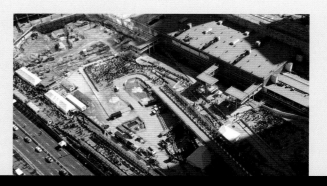

Sept. 7, 2006

Offering the most comprehensive vision to date of what the WTC will look like, Silverstein unveils architectural designs for 2, 3, and 4WTC.

Sept. 11, 2006

Mourners process down the Ground Zero ramp, as the fifth anniversary is marked with solemn remembrances across the nation.

Nov. 16, 2006

The Port Authority takes over the leases for OWTC and 5WTC from Silverstein.

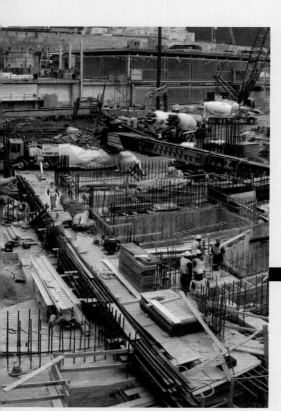

**5,858
CUBIC YARDS**
of concrete

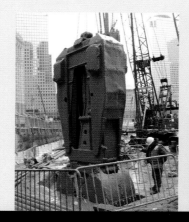

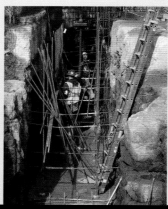

Feb. 2, 2007

To date, 5,858 cubic yards (4,478.8 m³) of concrete have been poured at OWTC.

Feb. 20, 2007

A massive clam shell excavator digs out the slurry walls.

Mar. 14, 2007

Shear-wall rebar and trenching work under way in the area south of the 9/11 Memorial.

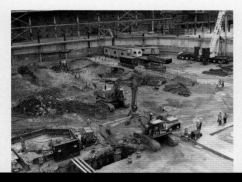

June 21, 2006

Work on OWTC's footings and foundations is under way.

June 28, 2006

Lead architect David Childs of SOM presents significant design changes to the Freedom Tower.

July 6, 2006

To streamline costs and efforts, the Port Authority assumes responsibility for the National September 11 Memorial & Museum construction.

July 26, 2006

Arcelor's mill in Luxembourg rolls out the Freedom Tower's first steel—more than 800 tons (725.8 metric tons). Banker Steel in Virginia finishes it into I beams; the first one is seen here.

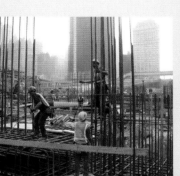

2007

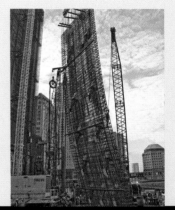

Nov. 29, 2006

Tishman continues with line drilling, excavation, concrete, and rebar installation at OWTC.

Dec. 19, 2006

OWTC's first steel—two massive columns, more than 30 feet (9.1 m) long and weighing 49,579 pounds (22,488.7 kg) and 53,342 pounds (24,195.5 kg)—is raised.

Jan. 24, 2007

The first of 64 steel cages, which will reinforce the slurry wall that wraps around the site, is erected.

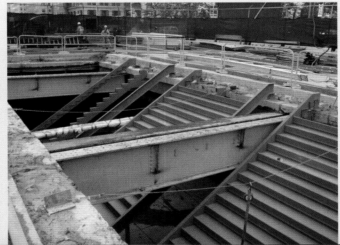

$276.48 MILLION contract

Apr. 26, 2007

Foundations and footings for the 9/11 Memorial and 9/11 Memorial Museum are more than 50 percent complete.

May 22, 2007

Stair treads are installed at the temporary PATH station.

May 23, 2007

After protracted legal battles, $4.55 billion in insurance money is paid to Silverstein and the Port Authority to cover the loss of the Twin Towers. The largest single insurance settlement to date, it will cover only a fraction of the rebuilding costs.

July 26, 2007

DCM Erectors is awarded a $276 million contract to fabricate, deliver, and erect the structural steel for OWTC.

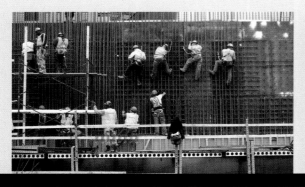

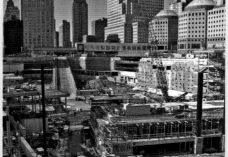

Aug. 22, 2007

Forming and rebar are completed along the East-West Connector, the pedestrian walkway under West Street.

Sept. 11, 2007

For the first time in six years, September 11 falls on a Tuesday. A remembrance service is held at nearby Zuccotti Park since the WTC site is full of cranes.

Sept. 12, 2007

A site overview shows the slurry wall on the right; temporary staging on the left; and, in the center, the ramp used to bring materials down into the pit.

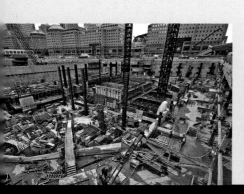

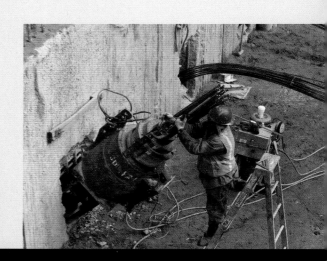

Jan. 2, 2008

Concrete placement at OWTC's north core shear walls is complete; south core concrete shear walls are insulated and still curing. To date, Collavino has placed a total of 5,386 cubic yards (4,117.9 m³) of concrete.

Jan. 17, 2008

Inspectors check the integrity of the original river-water piping in the west slurry wall.

Jan. 17, 2008

Slurry wall anchors utilize high-strength steel tendons that are grouted into a drilled hole and tensioned against the wall.

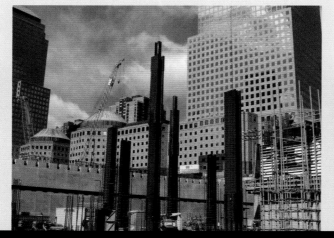

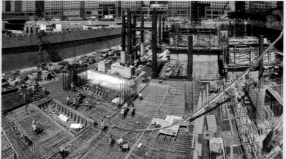

Apr. 20, 2008

Pope Benedict XVI visits the WTC site and blesses it.

May 17, 2008

OWTC's steel columns rise above grade for the first time, marking the transition from substructure to superstructure.

May 19, 2008

Christopher O. Ward, the Port Authority's new director, sets out to untangle the WTC's rebuilding, which, he says, has become "monumentally unmanageable."

June 12, 2008

Concrete subcontractor Collavino pours in excess of 500 cubic yards (382.3 m³) of concrete for OWTC's B3-level slab.

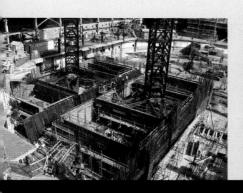

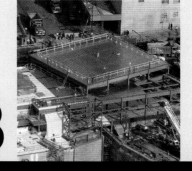

2008

Oct. 12, 2007

Final concrete formwork for OWTC's core foundations is under way.

Dec. 4, 2007

Workers complete the first section of the East-West Connector liner wall.

Jan. 2, 2008

Roofers work on the roof decking for the PATH entrance.

3-STORY-HIGH

mock-up

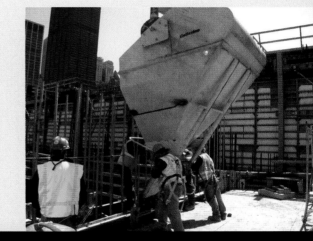

Feb. 17, 2008

The Port Authority completes excavation of 3 and 4WTC and turns the sites over to Silverstein Properties.

Mar. 28, 2008

A three-story-high mock-up of OWTC's curtain wall is tested outside Los Angeles to ensure the glass will withstand extreme conditions.

Mar. 31, 2008

The temporary PATH station officially opens.

Apr. 15, 2008

Workers pour concrete, casting the second lift at OWTC's north core.

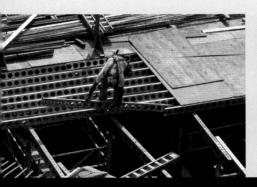

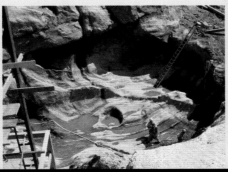

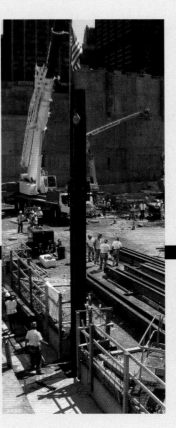

7,700-POUND
steel column

Aug. 27, 2008

Temporary formwork is placed prior to pouring a concrete deck at OWTC.

Aug. 27, 2008

Excavation of 4WTC reveals a glacial pothole formed 20,000 years ago. Although beautiful, the geological feature must be blasted away so the tower can be footed securely in bedrock.

Sept. 2, 2008

The memorial's first steel column, weighing 7,700 pounds (3,492.7 kg), is erected in the footprint of the original North Tower.

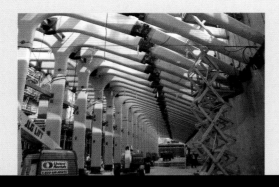

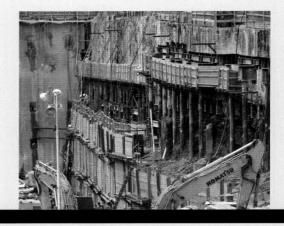

Sept. 3, 2008

All 47 steel arches and diagonal support beams for the East-West Connector have been installed.

Sept. 9, 2008

Snøhetta unveils its design for the Pavilion entrance to the 9/11 Museum.

Sept. 10, 2008

Mini piles along a demising wall support the No. 1 subway line.

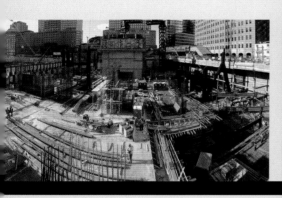

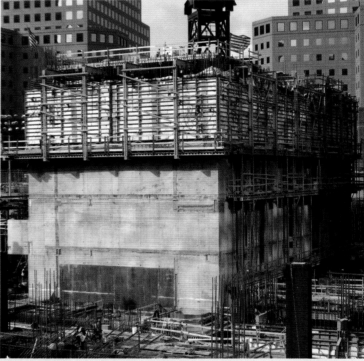

Nov. 10, 2008

A panoramic view shows the progress on OWTC's foundation excavation, reinforcing, and substructure concrete.

Nov. 20, 2008

OWTC's south core now rises approximately 29 feet (8.9 m) above street level.

460-FOOT
ramp is removed

2009

Jan. 14, 2009

After seven years of logistical and ceremonial duty, the 460-foot-long (140.2 m) ramp down to the bedrock level is removed.

Feb. 6, 2009

Four massive pipe elbows that pierce the slurry wall will bring water from the Hudson River to the Central Chiller Plant.

Mar. 27, 2009

The Port Authority officially changes the name of the Freedom Tower to One World Trade Center.

Beijing Vantone, a Chinese real estate company, signs on as OWTC's first commercial tenant.

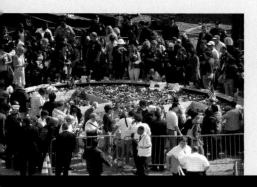

> "Uncertainty is expensive—both in terms of hard dollars given the explosion of construction and commodity prices, and in terms of schedule with the risk associated with a design process that never ends."
>
> THE PORT AUTHORITY OF NEW YORK & NEW JERSEY
> *A Roadmap Forward*, Oct. 2, 2008

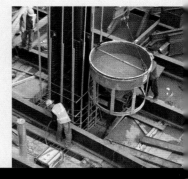

Sept. 11, 2008

Mourners throw flowers into a small pool at Ground Zero to honor September 11 victims.

Oct. 2, 2008

The Port Authority presents strategies that will simplify the Transportation Hub and allow the memorial to open by 9/11's tenth anniversary.

Oct. 6, 2008

Concrete finishers place 30 cubic yards (23 m³) of concrete to cast a single column for OWTC's substructure.

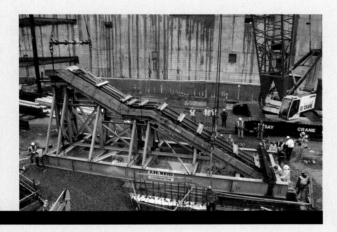

Dec. 11, 2008

The Vesey Street staircase that hundreds used to flee on 9/11 is placed permanently inside the 9/11 Memorial Museum.

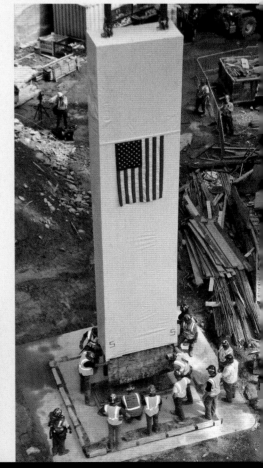

> "For the first five or ten years, there was this desperate search for the new Robert Moses, and people were caught up in that. I'm essentially saying there's no Robert Moses here. It's ordinary people doing extraordinary things."
>
> STEVEN PLATE Director of WTC Construction

May 11, 2009

The Port Authority cancels construction of 5WTC to reduce the amount of office space available at the Trade Center.

Aug. 14, 2009

DCM ironworkers begin to assemble a new Manitowoc 16000 crawler crane, capable of lifting over 400 tons (362.9 metric tons), to erect the lower tiers of OWTC's superstructure.

Aug. 26, 2009

Ironworkers install the Last Column in its permanent location at the 9/11 Memorial Museum.

"Why is it taking so long?" asks a *New York Times* editorial, mirroring the sentiments of many who gather at Ground Zero to remember the dead.
Sept. 11, 2009

Sept. 9, 2009

A view of a PATH train running through the site. The PATH trains and No. 1 subway ran continuously during construction.

Sept. 14, 2009

A worker prepares the floor decking for a major concrete pour at OWTC.

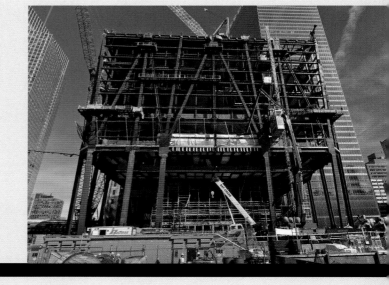

2010

Dec. 7, 2009

Rock drill testing evaluates conditions under Greenwich Street. Work here and under the No. 1 subway tunnel proceeds six days per week, two 10-hour shifts per day.

Jan. 15, 2010

Steel bracing for the Greenwich Street corridor is substantially complete.

Mar. 2, 2010

Ironworkers must install framing, metal decking, studs, pour stops, and flashing before the concrete contractor can construct a floor slab.

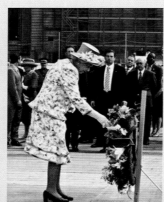

237-YEAR-OLD remains of a wooden sloop discovered

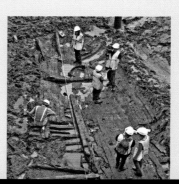

June 23, 2010

The weir that will divide the memorial fountain into cascading streams is installed in the North Pool.

July 6, 2010

During her first visit to the U.S. since 1976, Queen Elizabeth II places a wreath on the site in tribute to the 9/11 dead.

July 7, 2010

Winning a bidding war for a stake in OWTC, the Durst Organization takes over the tower's leasing and management.

July 13, 2010

Excavators at the southern edge of the Trade Center discover the remains of a 45-foot (13.7 m) wooden sloop built in 1773. Eventually, it will be installed at the New York State Museum in Albany.

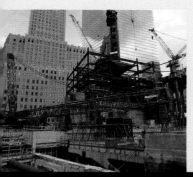

10 DAYS
to assemble a
390-FOOT
crane

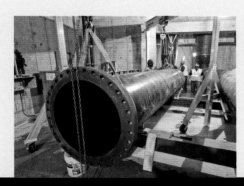

24
jumbo
steel
columns

Sept. 24, 2009

To erect OWTC's massive perimeter columns, DCM Erectors begins to assemble a Manitowoc 18000 crawler crane, a job that takes 10 days. With a capacity of 660 tons (598.7 metric tons) and a height of 390 feet (118.9 m), the mighty Manitowoc is the largest crane on the site.

Oct. 5, 2009

To construct OWTC's core, a large concrete pump and a red knuckle boom were used.

Nov. 6, 2009

Twenty-four jumbo steel columns now surround the perimeter of OWTC, a major milestone.

30,000 GALLONS
of water
per minute

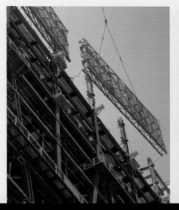

Mar. 9, 2010

Large-diameter piping is delivered for the Central Chiller Plant, which will use up to 30,000 gallons (113,562.4 L) of water per minute.

Mar. 25, 2010

The Port Authority, Silverstein Properties, and the State and City of New York agree on a development plan for the east side of the WTC site.

Apr. 5, 2010

In a construction first, steel erectors begin wrapping OWTC with a "cocoon," a protective system that prevents workers and their tools from falling to the ground.

June 18, 2010

Five massive condensers and evaporators for the Central Chiller Plant arrive for installation.

"I care a lot about darkness because if I didn't, I wouldn't be a very good lighting designer."
PAUL MARANTZ
WTC Lighting Designer,
Fisher Marantz Stone

16
white
oaks

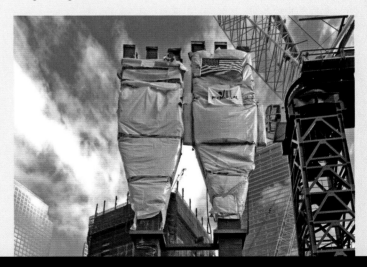

Aug. 26, 2010

The Port Authority approves plans to construct 2, 3, and 4WTC.

Sept. 3, 2010

Sixteen swamp white oaks are planted, the first of the 400 trees that will grace the memorial plaza.

Sept. 10, 2010

Two "tridents"—70-foot (21.3 m) columns from the original North Tower—move to their permanent home in the Pavilion at the 9/11 Memorial Museum.

Sept. 11, 2010

At Ground Zero, mourners hold up photos of their loved ones—and signs protesting the plans to build a Muslim community center nearby.

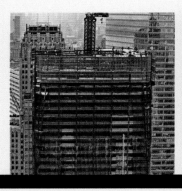
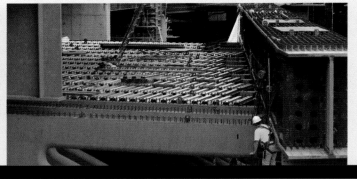
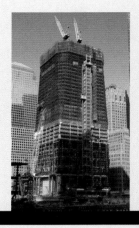

Sept. 28, 2010

Steel erection is complete to OWTC's 40th floor.

Oct. 28, 2010

Inspection of the decking above the ceiling ribs within the Transportation Hub's West Concourse. The decking forms the base of Fulton Street.

Nov. 22, 2010

Steel has risen to OWTC's 48th floor.

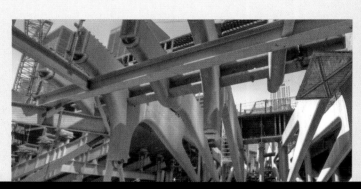
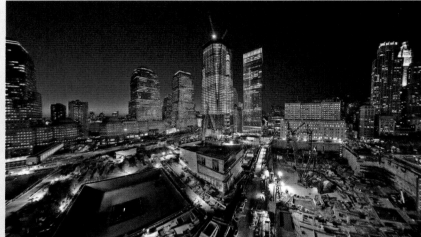

Mar. 5, 2011

The steel roof trusses, each one unique, that will form the PATH Hall's roof are installed.

May 4, 2011

Steel has risen to OWTC's 64th floor.

May 18, 2011

Condé Nast signs on as OWTC's anchor tenant, making downtown a cool place to do business.

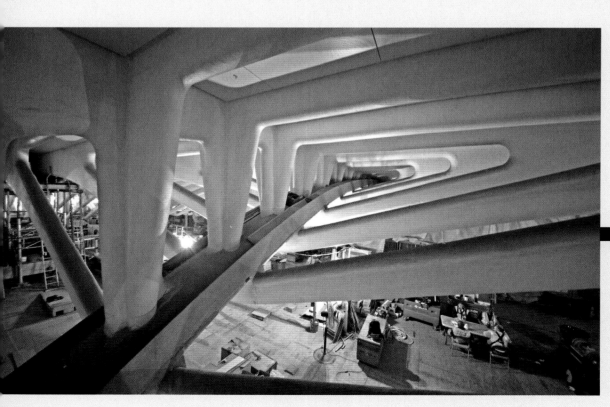

Aug. 5, 2011

A mammoth Vierendeel truss—140 feet (42.7 m) long and weighing more than 270 tons (245 metric tons)—forms the Transportation Hub's spine.

2011

Dec. 17, 2010

Steel has risen to OWTC's 52nd floor.

Feb. 24, 2011

The Port Authority approves a major contract to fabricate and erect the steel for the Transportation Hub's above-grade structure, known as the Oculus.

Mar. 3, 2011

Benson installs OWTC's curtain wall to the 27th floor. Custom glass panels accommodate the tower's chamfered edges.

"There's knowledge… but a lot of it is people skills, being able to work with people and get a job done, no matter what."
RYAN KERNAN
Project Manager, Glass Curtain Wall,
Benson Industries

July 29, 2011

Workers power-wash the precast pavers inside the memorial's North Pool.

"The workers knew that September 11 was really for the families, and they respected that. But on their own accord they got together and decided to have a moment. I think it was either 12:00 or 11:00, somewhere in the morning, to have all the cranes—we have upwards of 30 cranes at the site—to stop working for a moment of silence. Take off the hard hats, they all had their flags, and all the cranes—have you ever heard a crane blow its horn? It's like a diesel train—blew their horns at the same time, and they took the booms of the cranes, and they all dropped them and faced the pools in reverence."

STEVEN PLATE Director of WTC Construction, before the 9/11 Memorial dedication, Sept. 9, 2011

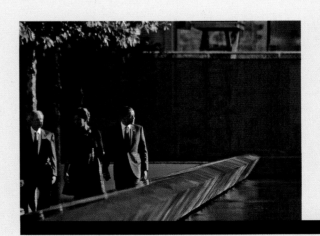

Sept. 11, 2011

Presidents Barack Obama and George W. Bush, First Lady Michelle Obama, and other officials gather with family members to dedicate the 9/11 Memorial.

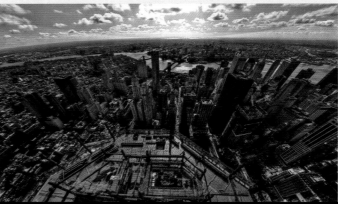

Sept. 12, 2011

The world's largest American flag flies from OWTC, as the 9/11 Memorial opens to the public.

Sept. 19, 2011

Panoramic views from the top of OWTC, now more than 1,000 feet (304.8 m) tall.

Oct. 14, 2011

The Port Authority and the Greek Orthodox Archdiocese of America reach an agreement, greenlighting St. Nicholas's construction.

Oct. 20, 2011

Patrick J. Foye is unanimously approved as the Port Authority's new executive director.

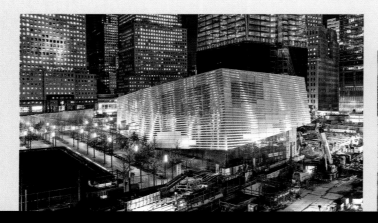

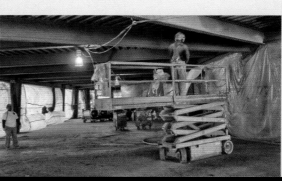

Mar. 1, 2012

The Pavilion glitters in the midst of the construction site.

The WTC Performing Arts Center hires Maggie Boepple as its senior adviser.

Apr. 6, 2012

Fireproofing is in progress on OWTC's 77th floor.

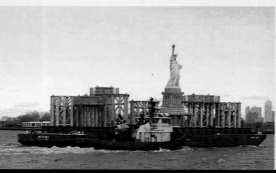

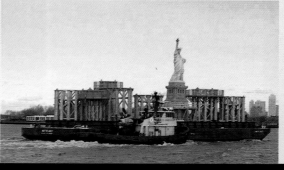

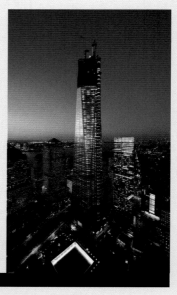

Sept. 26, 2012

Workers celebrate the signing of the final piece of steel, which will complete OWTC steel erection.

Oct. 29, 2012

Hurricane Sandy batters the East Coast, flooding the WTC site.

Nov. 16, 2012

OWTC's spire segments arrive in New York Harbor after a journey of 1,500 nautical miles (2,278 km) from Valleyfield, Quebec, to Port Newark.

Dec. 11, 2012

OWTC is lit for the holidays, but work continues. Beginning at midnight, workers pour 820 cubic yards (627 m³) of concrete and complete OWTC's final roof slab 15 hours later.

$1 BILLION
in WTC contracts

450,000 SQUARE FEET
of shopping and dining space

2012

Jan. 12, 2012

The Port Authority announces the awarding of $1 billion in WTC contracts to businesses owned by women and minorities.

Feb. 2, 2012

Steel is lifted to the top of OWTC, as steel erection reaches the 92nd floor.

Feb. 9, 2012

The Port Authority Board approves a joint venture with the Westfield Group to develop, lease, and operate 450,000 square feet (41,806.4 m²) of shopping and dining space at the WTC site.

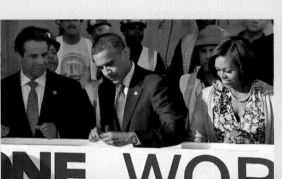

Apr. 30, 2012

Beams marked "1271" are placed, surpassing the Empire State Building's height and making OWTC the tallest structure in New York.

May 19, 2012

The American Institute of Architects confers special gold medals upon fifteen architects, including David Childs, Steven M. Davis, Santiago Calatrava, and Michael Arad, honoring them as "Architects of Healing" for their work in rebuilding the World Trade Center.

June 14, 2012

President Barack Obama and First Lady Michelle Obama join governors Andrew Cuomo and Chris Christie in signing one of the last beams placed atop OWTC.

June 25, 2012

4WTC's final steel beam, signed by hundreds of construction workers, is raised.

67-TON
spire segment

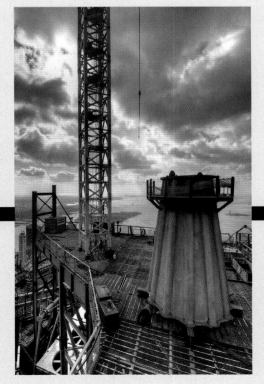

$1 MILLION
in seed money

2013

Jan. 15, 2013

Ironworkers and crane operators lift and install the spire segments, the heaviest of which weighs more than 67 tons (60.8 metric tons).

Jan. 31, 2013

LMDC authorizes $1 million in seed money for the WTC Performing Arts Center.

Feb. 14, 2013

Workers begin installing high-performance glass panels on the podium wall.

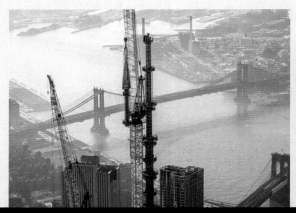

Mar. 20, 2013

The Port Authority Board selects Legends Hospitality to develop and operate One World Observatory on floors 100–102.

May 10, 2013

When ironworkers place the final piece of OWTC's 408-foot (124.4 m) spire, it reaches its iconic height of 1,776 feet (541.3 m), now the tallest building in the Western Hemisphere and third tallest in the world.

Sept. 6, 2013

The last of the tower and derrick cranes are removed from the roof of OWTC.

Sept. 11, 2013

A ceremony is held at the 9/11 Memorial. The Port Authority remembers its employees lost on September 11, 2001, and February 26, 1993, at a service at St. Peter's Church.

2014

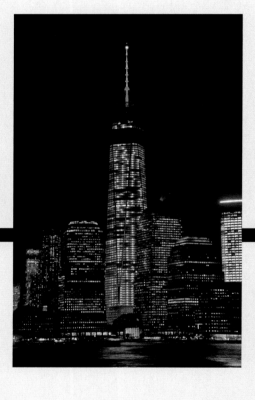

Jan. 29, 2014

For its first official lighting, OWTC's spire shone alternately orange and green during Super Bowl XLVIII, in honor of the team colors of the Denver Broncos and Seattle Seahawks. The spire ultimately shone green to celebrate the Seahawks' win.

Feb. 15, 2014

The first PATH station platform opens to the public.

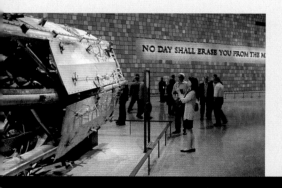

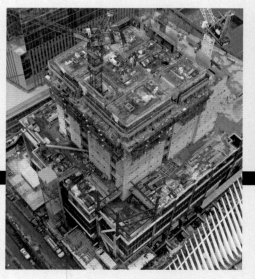

May 21, 2014

The 9/11 Memorial Museum opens to the public.

May 28, 2014

To date, the Port Authority has awarded minority, women-owned, and small-business enterprises approximately $1.2 billion in WTC contracts.

June 25, 2014

The Port Authority Board votes unanimously to advance the construction of 3WTC.

June 26, 2014

Silverstein resumes construction on 3WTC.

July 28, 2014

U.S. Court of Appeals for the Second Circuit affirms the 9/11 Memorial Museum's right to display the Ground Zero Cross, a steel crossbeam that was salvaged from the site.

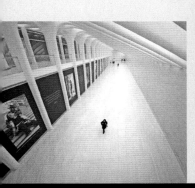

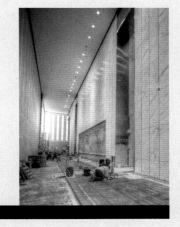

Oct. 24, 2013

The West Concourse, which links the PATH station and Brookfield Place, is the first part of the Transportation Hub to open.

Nov. 8, 2013

Spire and beacon lighting is tested.

Nov. 12, 2013

The Council on Tall Buildings and Urban Habitat rules that OWTC is taller than Chicago's Willis (Sears) Tower, making it the tallest building in the U.S.

Nov. 13, 2013

Mayor Bloomberg, Larry Silverstein, and others cut a ribbon to mark the official opening of 4WTC, the first tower completed on the WTC site.

Dec. 4, 2013

The Port Authority sells its remaining interest in the WTC retail project to the Westfield Group.

Dec. 6, 2013

Masons install Mesabi Black granite floors in OWTC's lobby.

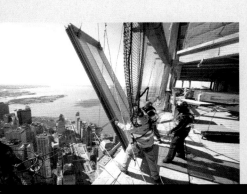

> **"The end is like the finish line of the longest marathon."**
> RYAN KERNAN
> Project Manager, Glass Curtain Wall,
> Benson Industries

 Feb. 21, 2014

Workers move one of OWTC's 13,000 glass window panels into place.

 Mar. 26, 2014

Signatures and art cover OWTC's temporary walls. Worker John Finn draws a woman dancing with a skeleton, inspired by the Day of the Dead, a holiday that honors the dead by showing them enjoying life.

May 15, 2014

The 9/11 Memorial Museum is dedicated and remains open 24 hours a day through May 20 for 9/11 families, rescue and recovery workers, active-duty first responders, survivors, lower Manhattan residents, and business owners.

May 15, 2014

Fences around the 9/11 Memorial are removed, allowing public access to the site for the first time since 2001.

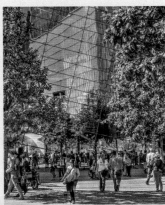

1 MILLION VISITORS
in the first four months

 Sept. 11, 2014

The memorial now opened, this is the first anniversary that visitors can walk freely onto the site.

 Sept. 16, 2014

In the four months since its opening, one million people visit the 9/11 Memorial Museum.

Oct. 17, 2014

OWTC sidewalks (Vesey, West, and Fulton streets) open to the public.

Oct. 18, 2014

Archbishop Demetrios blesses the St. Nicholas National Shrine's cornerstone in the presence of hundreds of members of the Greek Orthodox Archdiocese of America.

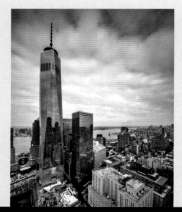

"The New York City skyline is whole again."
PATRICK FOYE
Executive Director of the
Port Authority, on the opening
of OWTC, Nov. 3, 2014

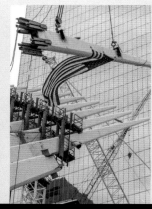

Nov. 3, 2014
OWTC opens its doors to anchor
tenant Condé Nast, publisher of
Vanity Fair and *The New Yorker*.

Nov. 4, 2014
"People love to complain about the WTC,
but I never hear any articulation about
what they actually wanted instead that isn't
wildly delusional. It's a quasi-private office
development, which throws out the window
any sort of obligation for its developers to
lose money for the sake of pet projects of
architectural novelty.... Rant over."
Colonel Pancake, *Dezeen* post

Nov. 12, 2014
A cable motor on a window-
washing rig fails, stranding two
workers in their scaffolding
outside the 68th floor. The
FDNY pulls them to safety in
an hour and a half.

Nov. 25, 2014
Workers install the last of the
Transportation Hub's 114 steel
rafters.

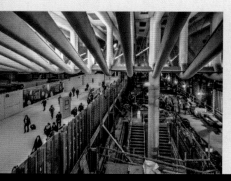

Jan. 23, 2015
Passengers arrive on PATH
Platform A while work continues
on Platform B.

Jan. 30, 2015
The No. 1 line ticket-vending
machines power up.

Mar. 4, 2015
A midwinter aerial of
construction progress.

Mar. 4, 2015
The Port Authority
returns to the World
Trade Center, moving
their offices to 4WTC.

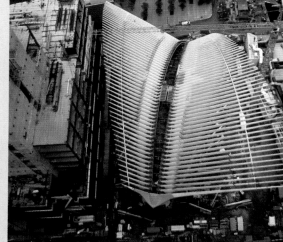

5 DECADES
since the intersection
at Greenwich and
Fulton was last open

May 29, 2015
One World Observatory opens,
allowing visitors to "see forever."

June 3, 2015
The first glass panels are
fitted into the narrow central
skylight of the Oculus.

June 4, 2015
Two media giants, News Corp. and
21st Century Fox, sign a letter of
intent with Silverstein to lease nearly
half of 2WTC. Bjarke Ingels Group
(BIG) will replace Foster + Partners
as the tower's architect.

June 25, 2015
The intersection at
Greenwich and Fulton
streets is open to
pedestrians for the first
time in fifty years.

> "The new WTC is so ridiculously popular, it's scary to think how overrun it will be when it's finished."
> STEVE CUOZZO
> *New York Post,* Dec. 21, 2014

2015

Dec. 9, 2014

The Duke and Duchess of Cambridge visit the 9/11 Memorial & Museum.

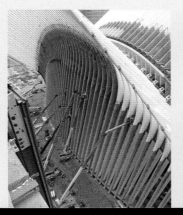

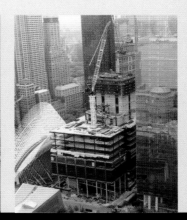

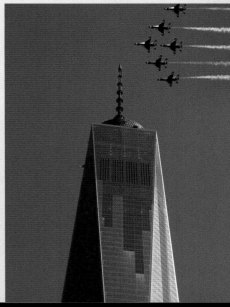

Mar. 4, 2015

The first curtain wall glass is installed in the Transportation Hub Oculus.

May 7, 2015

PATH Platform B opens to the public.

May 12, 2015

Workers place concrete up to the 18th floor of 3WTC.

May 22, 2015

Air Force Thunderbirds fly over OWTC, where the waterproofing, signage, and painting are substantially complete.

> "Here, amid pain and grief, we also have a palpable sense of heroic goodness which people are capable of, those hidden reserves of strength from which we can draw."
> POPE FRANCIS
> World Trade Center, Sept. 25, 2015

Aug. 4, 2015

Port Authority police officer Brian McGraw delivers Asenat Abdrabo, a healthy baby girl, at 2:36 a.m. on PATH platform B, the first baby born at the World Trade Center. Joy!

Sept. 11, 2015

The names of the 9/11 dead are read. Many speakers add details about the lives of surviving children.

Sept. 25, 2015

Pope Francis prays at the Memorial South Pool and blesses the families of the 9/11 dead. Later, inside the 9/11 Memorial Museum, he prays for peace, alongside Buddhist, Christian, Hindu, Jewish, Muslim, and Sikh religious leaders.

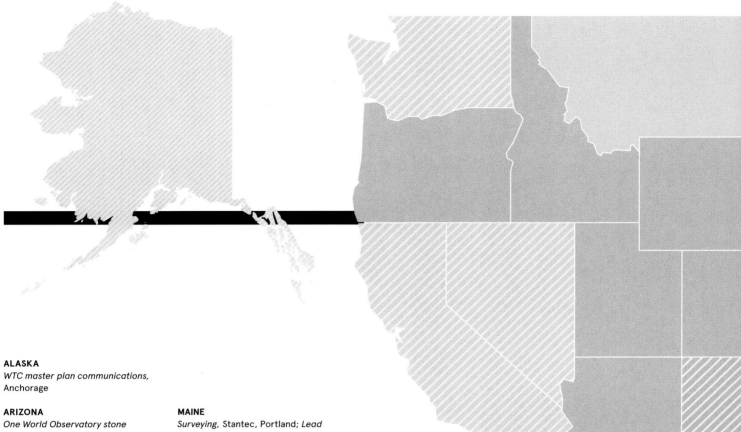

ALASKA
WTC master plan communications,
Anchorage

ARIZONA
One World Observatory stone displays, Dixon Studios, Tucson

ARKANSAS
Steel, Nucor Yamato, Blytheville

CALIFORNIA
Façade performance testing,
Construction Consulting Laboratory West, Ontario; *One World Experience design*, Hettema Group, Pasadena

COLORADO
Specialty Lighting, Barbizon, Denver

CONNECTICUT
Fuel cells, United Technologies Corp., Hartford; *Fuel storage tanks,* Berco, Watertown; *Actuators,* Belimo, Danbury

FLORIDA
Steel inspection, Mactec, Jacksonville; *One World iPad app,* Haneke Design, Tampa

GEORGIA
Elevator hoist cable wire ropes, Brugg, Rome

IDAHO
Plaza irrigation controls and sensors, Baseline Inc., Meridian

ILLINOIS
Steel, Bureau Veritas, Downers Grove; *Sheetrock and gypsum panels,* USG, Chicago

INDIANA
Heat exchangers, Peru

IOWA
Concrete formwork, EFCO, Des Moines

KANSAS
Beacon LED panelboards, LynTec, Lenexa

KENTUCKY
FSD, Lexington

MAINE
Surveying, Stantec, Portland; *Lead archaeologist for unearthed 18th-century ship,* University of Maine, Orono

MARYLAND
Switchgear, Powercon, Severn; *Lighting,* Claude S. Engle, Chevy Chase; *Articulating cranes,* Fascan, Baltimore

MASSACHUSETTS
Temporary composting toilets, Clivus Multrum, Lawrence

MICHIGAN
Glass, Guardian Glass, Auburn Hills; *Spire stainless steel,* Ken-Mac Metals, Detroit

MINNESOTA
Air handlers, McQuay International, Plymouth; *Curtain wall glass,* Viracon, Owatonna

MISSOURI
Spire cables, WireCo, Kansas City

NEBRASKA
Beacon LED lights, Ballantyne Strong, Omaha

NEVADA
Podium glass procurement, Zetian Systems, Las Vegas

NEW HAMPSHIRE
Spire ice testing, Mt. Washington

NEW JERSEY
Numerous suppliers and consultants

NEW MEXICO
Curtain wall testing, Socorro

NEW YORK
Numerous suppliers and consultants

NORTH CAROLINA
Automatic transfer switches, Welcome

NORTH DAKOTA
Architect, Jeffrey Holmes, Senior Designer, SOM, Grand Forks

OHIO
Concrete admixtures, BASF, Beachwood; *Spire steel,* Timken Co., Canton

OKLAHOMA
Butterfly valves, Oklahoma City

OREGON
Curtain wall glass, Benson Industries, Portland

PENNSYLVANIA
Sheetrock, USG, Aliquippa; *Steel,* L&M Fabrication & Machine, Lehigh, and ArcelorMittal, Coatesville; *Rebar,* Dayton Superior, Allentown

RHODE ISLAND
Thermal expansion tank, Amtrol, West Warwick

SOUTH CAROLINA
Steel, Owen Steel, Columbia

TENNESSEE
Elevators, ThyssenKrupp, East Memphis

TEXAS
Fly-ash, Mineral Resources Technologies Inc., The Woodlands; *Turnstiles,* Kouba Systems, Bastrop

UTAH
Stainless steel, Pohl Inc., West Valley City

VERMONT
Electronic leak detection system, IR Analyzers, Williston

VIRGINIA
Steel, Banker Steel, Lynchburg

WASHINGTON
Curtain wall scaffolding and hoisting, Spider, a division of SafeWorks, Seattle

WEST VIRGINIA
Cement mix, Euclid Chemical, Alloy; *Wire and cable,* Service Wire Co., Culloden

WISCONSIN
Generators, Darien

WYOMING
Insulation, Green River

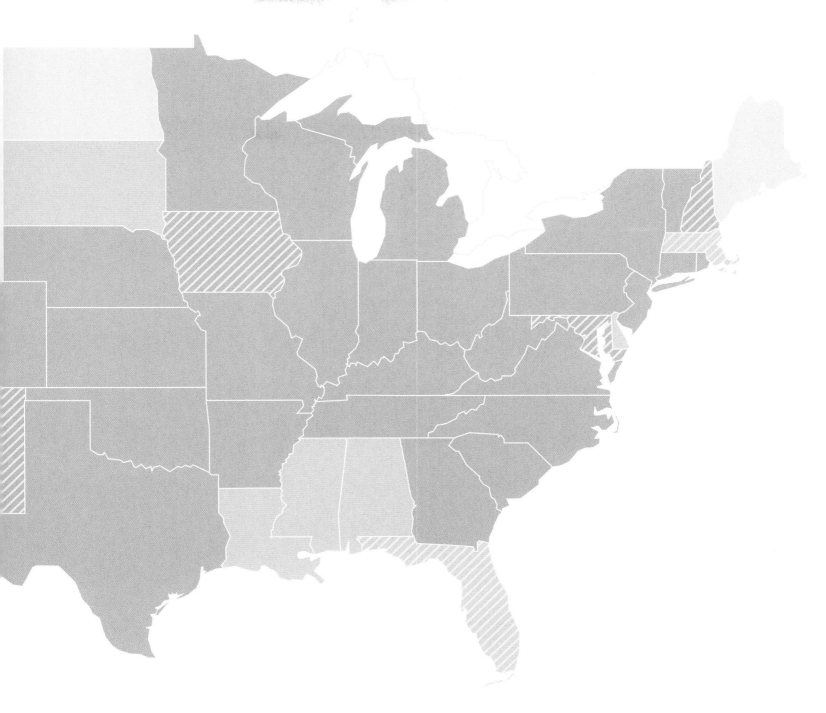

ADDITIONAL COUNTRIES

AUSTRIA
Oculus glass, Eckelt Glas, Steyr

BRAZIL
Elevator roller guides,
ThyssenKrupp Brazil, Rio de Janeiro

CANADA
Spire Fabrication, ADF Group,
Terrebonne, Quebec; *Concrete
Superstructure,* Collavino
Construction, Windsor, Ontario

CHINA
Elevator development,
ThyssenKrupp China, Beijing

FINLAND
AC drives, Vacon, Vaasa

FRANCE
Spire tubes, Vallourec, Boulogne-
Billancourt

GERMANY
Structural engineering consultant,
Schlaich Bergermann, Stuttgart;
Elevators and escalators,
ThyssenKrupp, Essen; *Podium
glass,* Interpane, Lauenförde

ITALY
Lobby marble, Savema, Pietrasanta

LUXEMBOURG
Steel, ArcelorMittal,
Luxembourg City

NETHERLANDS
Construction hoists, Raxtar,
Eindhoven

SOUTH KOREA
Elevator motors and drives testing,
ThyssenKrupp, Seoul

SWITZERLAND
Elevator cables, Prysmian Cables
and Systems, Manno

UNITED KINGDOM
*Public safety communications
system,* Axell Wireless, Chesham;
Engineering consulting,
SOM, London

FROM MANY, ONE

Nearly every state in the United States
contributed skills, technology, or materials to
One World Trade Center. Other countries also
provided key structural components. If your
state contributed but is not listed, contact us—
we'd like to include you.

 PERSONNEL 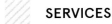 MATERIALS //// SERVICES

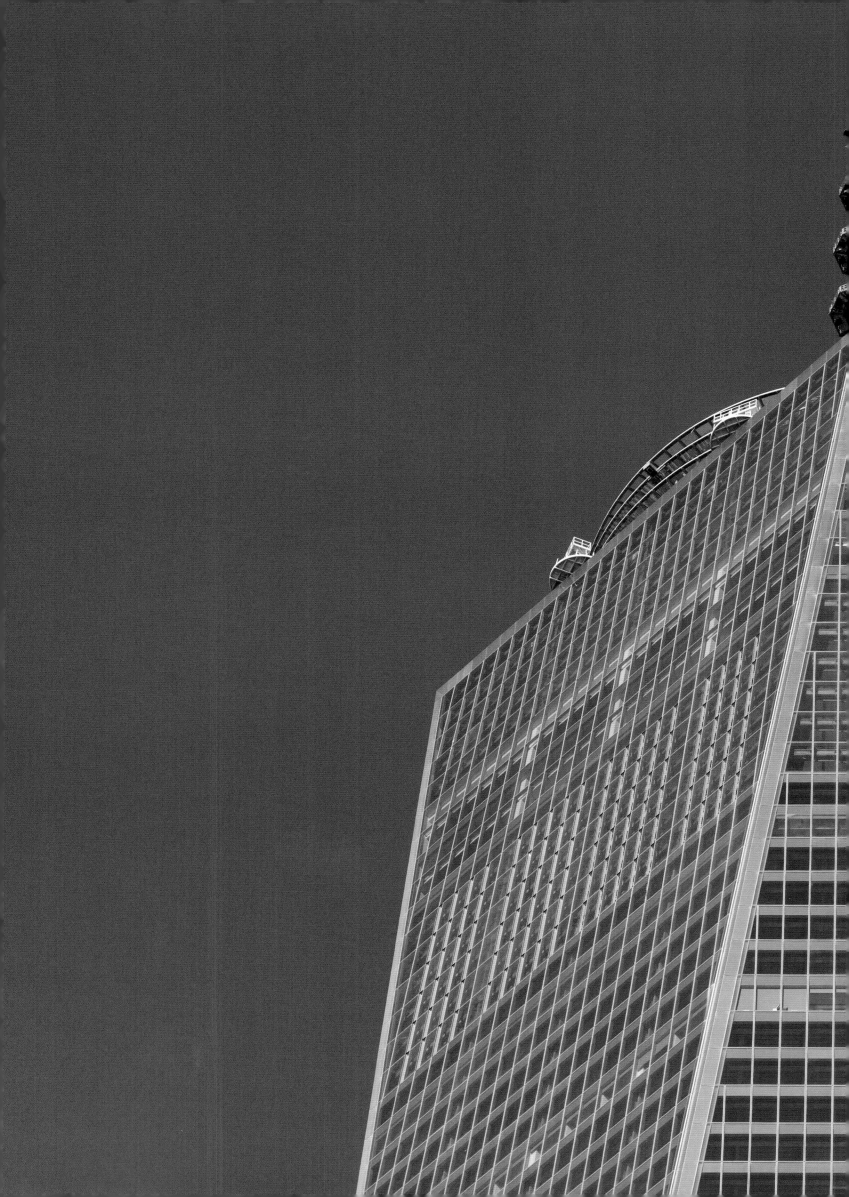

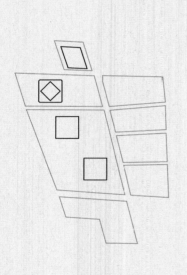

SEE
FOREVER

ONE WORLD OBSERVATORY

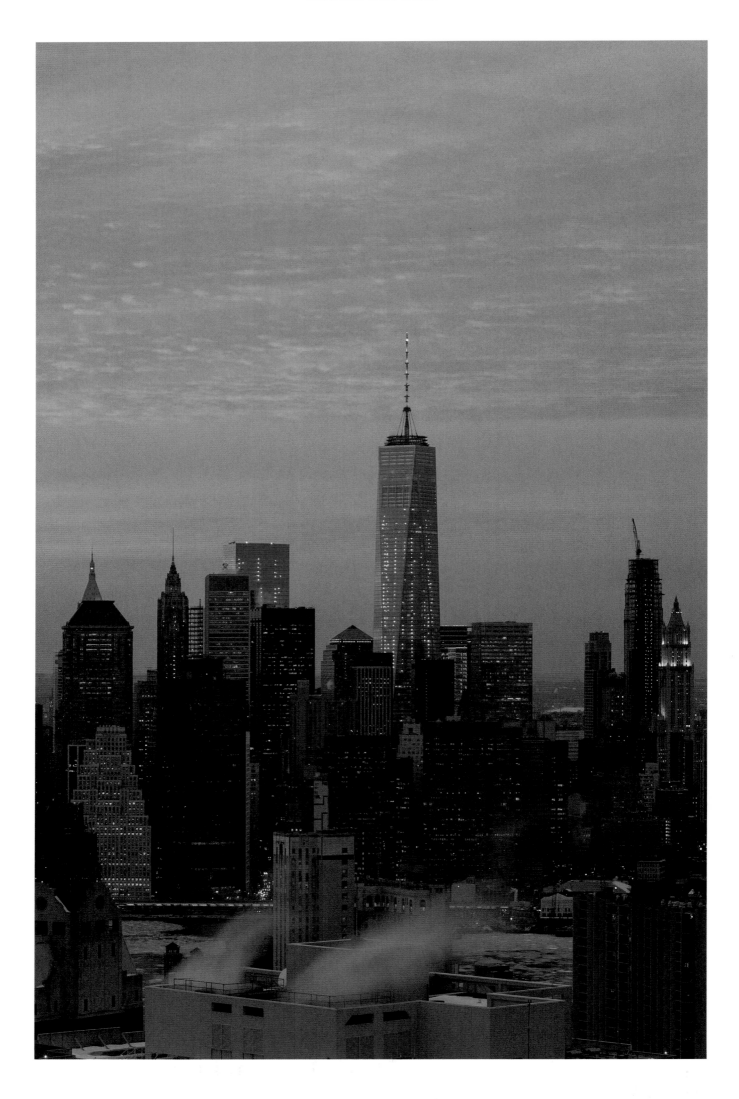

"See Forever," commands the tagline of One World Observatory—a jewel perched atop One World Trade Center that offers unrivaled vistas of Manhattan and beyond. On a clear day, you nearly can see forever: south to Coney Island and north to the suburbs of Westchester, past Roosevelt Island and beyond to Queens, and west to the Palisades that hug the curve of the Hudson. You can also time travel back to the days when the Lenape fished the riverbanks right up until the moment time-stamped on your ticket.

From the 102nd floor, 1,268 feet (386.5 m) up——the highest public vantage point in New York——panoramic skyline views tell the grand story of the metropolis. Capturing the imagination, the observatory vistas reveal a teeming center of culture and commerce, a physical terrain shaped by ancient geological forces, and an arena of human endeavor that stretches from prehistory to the present. With its unparalleled perspective on the region, One World makes clear that this supertall skyscraper could exist only in New York, and that the city itself is an integral part of One World Trade Center's identity.

Blurring the line between media and architecture, One World immerses guests in New York's ever-changing story, from the bedrock up. What sets it apart from other world-class observatories is a series of interactive experiences that begin even before visitors board high-speed elevators to the top. Traveling along a corridor's length of vibrant cinematic narratives, guests hear first-person stories told by the men and women who built One World Trade Center. These accounts give a human face to the tower's larger-than-

life statistics and create the sense that one is hearing about its design and construction from a trusted friend.

Sky Pods, five state-of-the-art ThyssenKrupp elevators, among the fastest in the world, take visitors up to the observatory in forty-seven seconds. Crisp floor-to-ceiling digital displays on the cab walls reveal Manhattan's geological and structural history, whisking visitors through time-lapse views of the past five hundred years. Lenape wigwams give way to the gabled houses built by Dutch settlers; St. Paul's Chapel is quickly surrounded by Wall Street buildings, followed by a resplendent proliferation of bridges and skyscrapers. It's the only time that September 11 is referenced: the façade of the South Tower of the original World Trade Center appears momentarily and then disappears. Some will recall sadly that this sight was the last seen by many. The last fifteen seconds are a tour de force: the steel structure of One World Trade Center appears to grow around the cab, taking its final form just before the doors open.

On the 102nd floor, the See Forever Theater captures the city's rhythms and moods in a cinematic collage of bird's-eye imagery, time-lapse shots, and abstract

only in New York...

"A view is power, a form of majestic surveillance. To gaze is to own."

JUSTIN DAVIDSON 2015

patterns. The collage builds in tempo and then dissolves, and the screen rises to reveal the real star of the show: a spectacular northward view of Manhattan.

Panoramas of all five boroughs, New Jersey, the East River, the Hudson River, and New York Harbor unfold from One World's double-height space on the 100th floor. Designed to emphasize the views, the observatory lets the city itself take center stage. Vistas north, south, east, and west reveal the region's architectural fabric—from skyscrapers to apartment houses, the Brooklyn and George Washington bridges, the national treasures of the Statue of Liberty and Ellis Island. Looking north, the city's structural patchwork ripples up, down, and up again, as skyscrapers in downtown and midtown indicate where the Manhattan schist that made the city's tall towers possible is most readily available. It's a breathtaking visual primer of American structural technology of the past three centuries.

Bright-eyed, friendly guides roam the floors, ready to answer questions. More hospitality is available on the 101st floor, where three restaurants offer casual and fine dining options. At the One Mix bar and grill, there's a dish for each borough: Pastrami Reuben bites (Manhattan), Astoria shish kebab (Queens), potato knish (Brooklyn), empanadas (the Bronx), and meatball sliders (Staten Island). Labels from bottles of One White and One Red, the observatory's own line of wine, will no doubt make their way into family scrapbooks. A free side of killer views comes with every plate.

One World was developed and is operated by Legends, a sports and entertainment company that is owned by the New York Yankees, the Dallas Cowboys, and an investment fund headed by David Checketts, Legends' former chairman and chief executive.

Meeting the public's expectations is always a challenge, especially in Manhattan, where people expect "much, much more." The firm has invested a good deal of effort into quantifying what makes an experience unforgettable. For example, sports events allow people to escape the ordinary, letting them

Before ascending, visitors hear the story of One World Trade Center's design and construction, told by those who built it.

...a free side of killer views

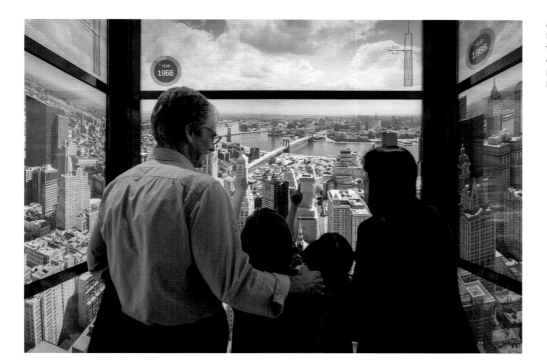

An animated timeline of lower
Manhattan's history unfolds inside
the elevators. The show was
designed and produced by the
Hettema Group and Blur Studio,
both based in California.

Without a doubt, love blooms
in high places. At observatories
around the globe, one sees lovers
clinging to each other, inspired
by tenderness (or perhaps
acrophobia). At One World, the
spot for both is the Sky Portal,
a circular disk, fourteen feet
(4.3 m) in diameter, set into the
floor on the 100 level. Thanks
to real-time high-definition
cameras focused on the street
below, guests can virtually hover
a quarter mile (0.4 km) above
the sidewalks.

147

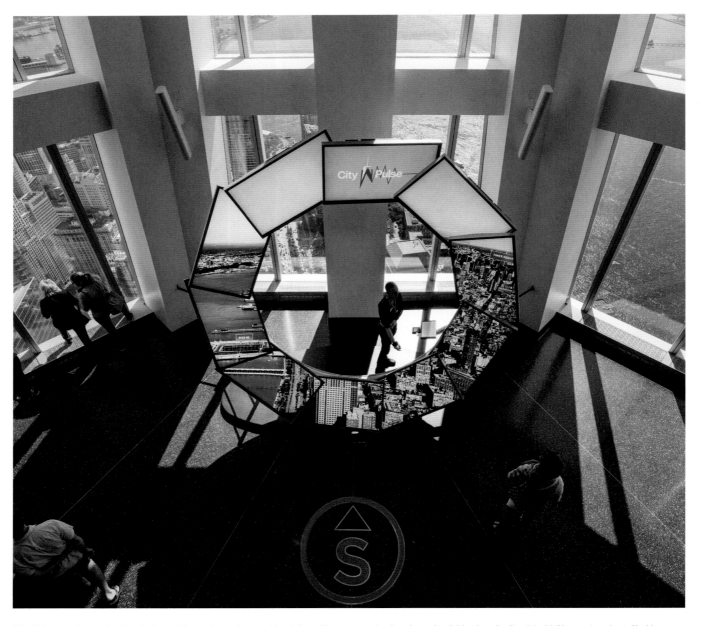

City Pulse, two large circular displays of dynamic media, provides information on area landmarks and neighborhoods. One World Observatory is staffed by knowledgeable "ambassadors," who know the best places to hear jazz or what's playing on Broadway.

148

vicariously participate in thrilling highs and lows. At many Legends sports arenas, notably Yankee Stadium, those moments of human drama are combined with historical monuments and plaques that conjure both the past and the present. Similarly, One World blends history with an intense experience of the present moment, augmented by enhanced digital effects.

Those effects were developed by Legends and the award-winning Hettema Group, a California design studio that won the 2013 competition to design One World. Phil Hettema, owner of the Hettema Group, cut his teeth at Disneyland and Universal Studios and went on to develop projects around the globe, including the Statue of Liberty Centennial, the 1984 Olympics in Los Angeles, and the "Beyond All Boundaries" experience at the National World War II Museum in New Orleans. Their designs are highly

interactive, since visitors who participate are far more likely to enjoy and remember what they've experienced. That interactive spirit guided the design of One World, which, beyond its dazzling bells and whistles, explores the essence of human nature through storytelling.

At most observatories, once you've seen the view, it's all downhill from there. That feeling has been dubbed "Grand Canyon Syndrome," because after looking over the rim of the canyon for five minutes, people ask, "Now what?" In response, One World's designers saved a final surprise: special effects inside the descending Sky Pods create the illusion that the elevator cab, having broken through the tower's walls, is orbiting around the building. With this last bit of magic, the elevator re-enters the building and guests, now with new stories to tell, go on their way. ▲

...now with new stories to tell

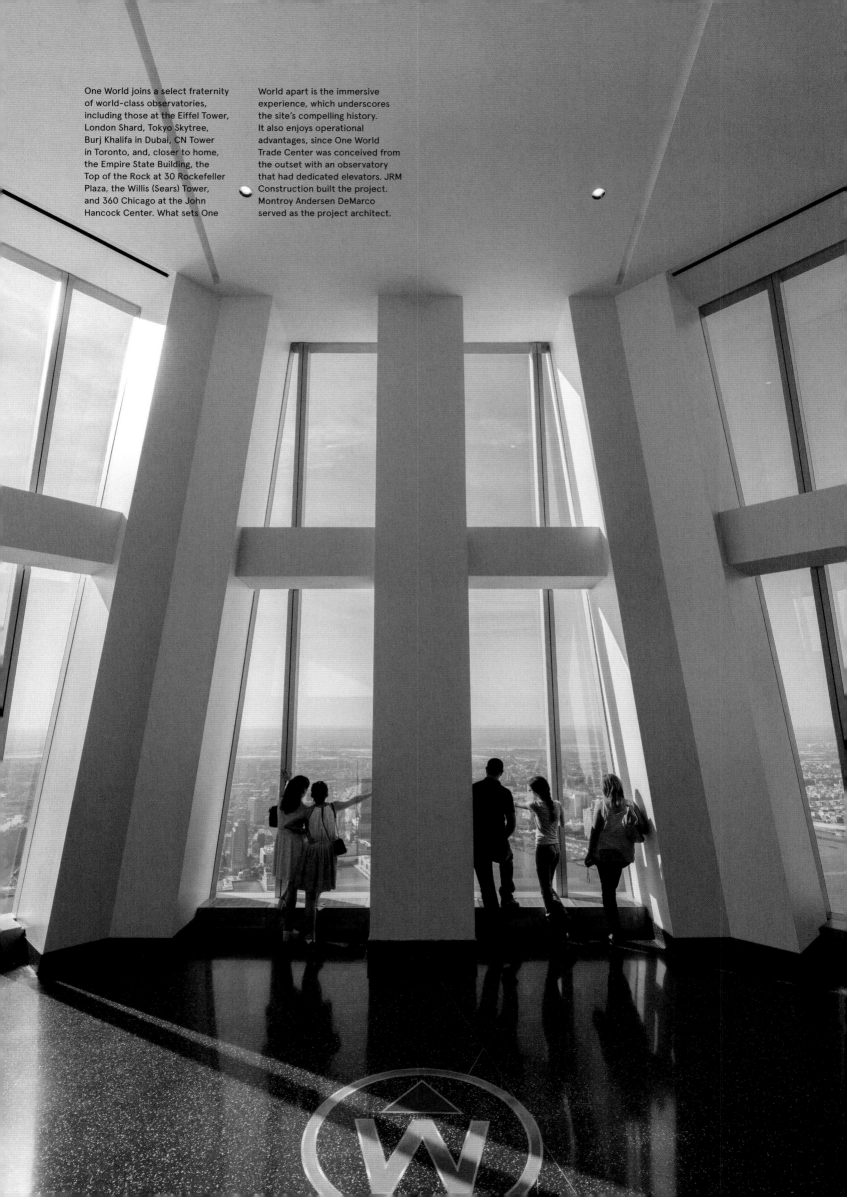

One World joins a select fraternity of world-class observatories, including those at the Eiffel Tower, London Shard, Tokyo Skytree, Burj Khalifa in Dubai, CN Tower in Toronto, and, closer to home, the Empire State Building, the Top of the Rock at 30 Rockefeller Plaza, the Willis (Sears) Tower, and 360 Chicago at the John Hancock Center. What sets One World apart is the immersive experience, which underscores the site's compelling history. It also enjoys operational advantages, since One World Trade Center was conceived from the outset with an observatory that had dedicated elevators. JRM Construction built the project. Montroy Andersen DeMarco served as the project architect.

You may be able to see forever, but can you identify the region's key landmarks? On the following pages, we provide some help, with aerial views in all four directions and descriptions that will help you pinpoint these architectural and engineering marvels as they appear from the sky.

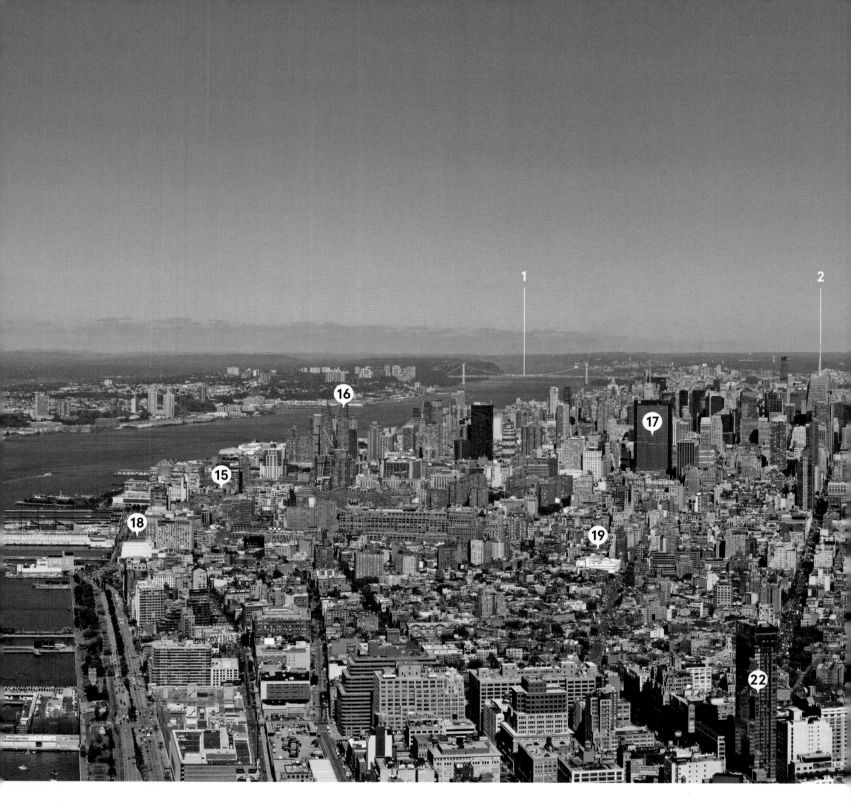

1. GEORGE WASHINGTON BRIDGE *(Othmar Ammann, 1931)* The GWB was the first major bridge designed to accommodate cars. At its opening, President Franklin D. Roosevelt declared the 3,500-foot-long (1,067 m) suspension bridge "almost superhuman in its perfection." Steel latticework towers on both sides of the Hudson bookend the elegant span, which was the world's longest until San Francisco's Golden Gate Bridge opened in 1937.

2. BANK OF AMERICA TOWER/ONE BRYANT PARK *(COOKFOX, 2010)* This slender glass skyscraper has an advanced eco-friendly design. Inspired by the Crystal Palace at New York's 1853 World's Fair, the tower slopes inward to allow sunlight to reach the street, reuses rainwater, and provides fresh filtered air to employees. Developed by the Durst Organization, which also developed OWTC, the tower was the first office building in North America to achieve LEED Platinum certification.

3. ROCKEFELLER CENTER *(Reinhard and Hofmeister; Corbett, Harrison & MacMurray; Hood and Fouilhoux, 1933–1940)* Commissioned by John D. Rockefeller Jr., this limestone skyscraper complex was built during the Great Depression. The architects created a "city within a city," designing fourteen buildings of varying heights clustered around a central 70-story tower (originally called the RCA Building) on a T-shaped plaza between Fifth and Sixth avenues. Its public spaces include rooftop gardens, a skating rink, and an open plaza, where the annual lighting of a giant Christmas tree is a beloved city tradition.

4. EMPIRE STATE BUILDING *(Shreve, Lamb & Harmon, 1930)* A legend among New York's many renowned towers, the ESB was the world's tallest structure when it opened, a title it kept for forty years. The icon is clad in limestone, rising in setbacks to its full height of 1,454 feet (443.2 m). Its pinnacle, brilliantly lit for special events, has been captured in myriad photos and, memorably, in the original *King Kong* movie (1933).

5. 432 PARK *(Rafael Viñoly Architects, 2015)* This razor-thin tower is so tall (1,396 feet; 426 m) that an aviation consultant had to determine whether it would interfere with aircraft. The first of many planned ultra-luxury residential towers in midtown, it rises in a series of perfectly square modules and features oversized 10 × 10-foot (3 × 3 m) windows that highlight its primary asset—spectacular views.

6. METLIFE [PAN AM] BUILDING *(Emery Roth & Sons, Walter Gropius, Pietro Belluschi, 1963)* MetLife's 59-story headquarters is a looming edifice of precast concrete, glass, and steel. When it was completed, it blocked views down Park Avenue, causing an uproar. Bauhaus legend Gropius failed to uphold the social responsibility he espoused, one critic noted, by creating an octagonal behemoth that dwarfs neighboring Grand Central Terminal.

7. CITIGROUP [CITICORP] CENTER *(Stubbins and Associates, with Emery Roth & Sons, 1977)* With its jaunty slanted roof, this 59-story tower makes a unique skyline statement. Its columns, also noteworthy, elevate the tower ten stories above the street to accommodate St. Peter's Church, which owned one third of the site and permitted construction only if it received a new church building in return. That elevation also made room for public amenities, including shops, a plaza, and subway access.

8. CHRYSLER BUILDING *(William Van Alen, 1930)* Built during the Roaring Twenties, this tower epitomizes the decade's focus on fun, excess, and the sense that New York City was the only place to be. Commissioned by automobile baron Walter P. Chrysler, the tower's Art Deco design, with its incomparable spire, playfully incorporates gargoyles fashioned after Chrysler hood ornaments and setbacks emblazoned with winged radiator caps. Completed at the outset of the Great Depression, its 77 floors celebrate the automobile and bygone joie de vivre.

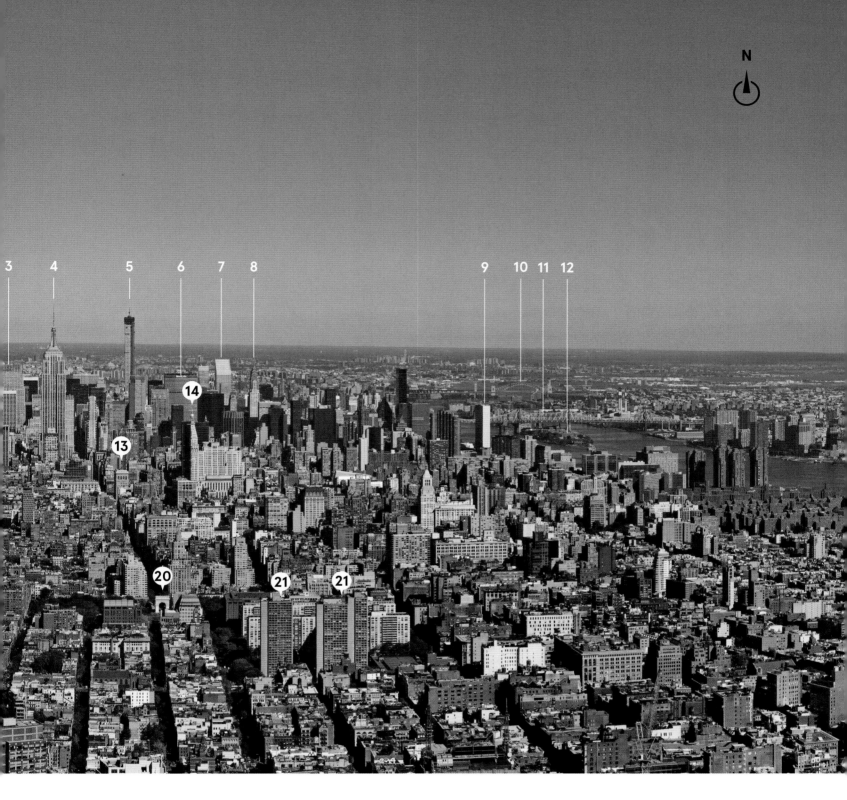

9. UNITED NATIONS SECRETARIAT *(11 architects, including Le Corbusier, Oscar Niemeyer, Wallace Harrison, 1952)* The United Nations wanted a building as novel as the organization itself, which was achieved with this modernistic design. A thin slab sheathed in glass, the 39-story tower rises dramatically above the East River. A recent renovation restored its pristine beauty and made it more energy efficient.

10. HELL GATE BRIDGE *(Gustav Lindenthal, 1917)* The dilemma in the early 20th century was how to extend the Pennsylvania Railroad into New England. The answer came from Lindenthal, a self-taught Moravian immigrant, who designed the bridge that connects Queens to Ward's Island, and two smaller bridges that brought the railroad into the Bronx. Today the least known of the city's eight major bridges, it was the longest steel arch in the world when it was completed, cementing Lindenthal's reputation for brilliant engineering.

11. THE ED KOCH/59TH STREET/QUEENSBORO BRIDGE *(Gustav Lindenthal and Henry Hornbostel, 1909)* The bridge that connects Manhattan and Queens is more workhorse than thoroughbred in design. Its cantilevered steel frame spans 3,724 feet (1,135.1 m) across the East River, secured by mammoth masonry piers. A farm wagon returning to Queens

was one of the first vehicles to cross the bridge.

12. ROOSEVELT ISLAND Formerly called Blackwell's Island, this was first used as farmland by Dutch settlers. Later, it became the site of a penitentiary, a smallpox hospital, and the Welfare Hospital for Chronic Diseases (Goldwater Hospital). It is home to Louis Kahn's Four Freedoms Park (2012), a tribute to President Franklin D. Roosevelt, for whom the island was renamed in 1971. A new Cornell University graduate school for science and technology will open here in 2017.

13. FLATIRON [FULLER] BUILDING *(Daniel Burnham, 1902)* The Flatiron is New York City's oldest surviving skyscraper. Its distinctive profile and nickname stem from the triangular shape of its lot at the convergence of Fifth Avenue and Broadway. Only 22 stories high, the tower's unusual shape has earned a permanent niche in the city's psyche.

14. METROPOLITAN LIFE TOWER *(Napoleon LeBrun & Sons, 1909)* By appealing to a burgeoning immigrant population, the Metropolitan Life Insurance Company became the largest life insurer by the early 1900s. It marked that achievement with a 50-story tower that was the world's tallest from 1909 to 1913. Topped by a pyramidal spire, cupola, and beacon, it replicates the Campanile in Venice's Piazza San Marco.

OTHER LANDMARKS

15. Hudson Yards (under construction)
16. Silver Towers (2009)
17. One Penn Plaza (1972)
18. Whitney Museum of American Art (2015)
19. Lenox Hill HealthPlex (1964, formerly St. Vincent's Hospital)
20. Washington Square Arch (1892)
21. Silver Towers/University Village (1966)
22. Trump SoHo Hotel Condominium (2010)

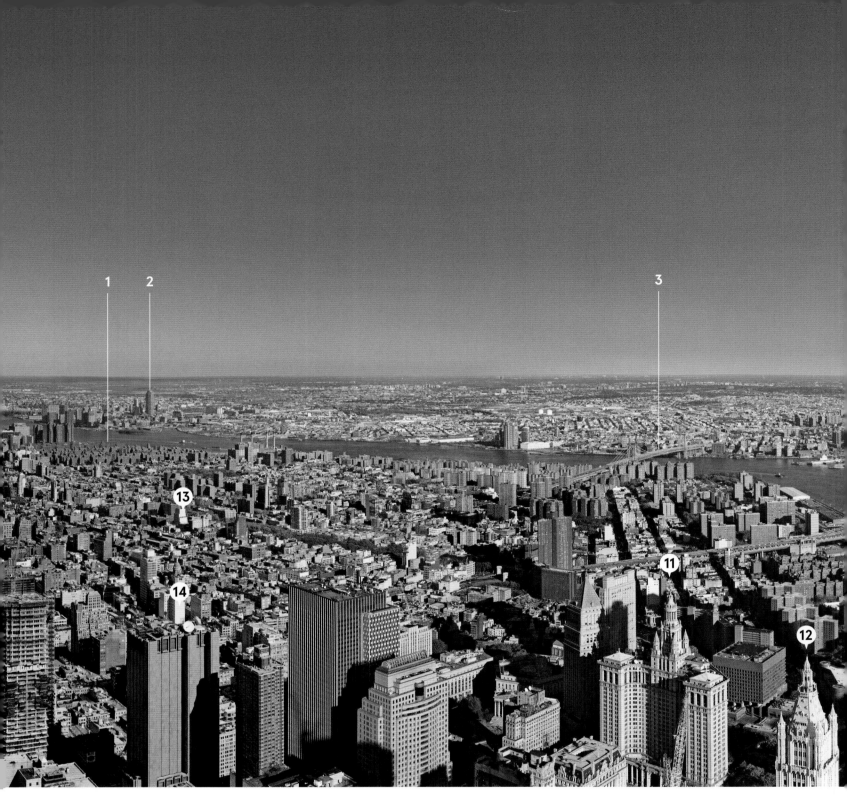

1. STUYVESANT TOWN–PETER COOPER VILLAGE
(1942–1947) Covering 80 acres (32.4 ha) between 14th
and 23rd streets, this massive planned community of
110 brick towers was developed by the Metropolitan
Life Insurance Company. The development highlights
the complex urban renewal issues of the 20th century,
especially under urban-planning powerhouse Robert
Moses. The enclave is beloved by its residents, many of
whose families have lived there for several generations,
enjoying its leafy gardens and rents below market rates.

2. ONE COURT SQUARE [CITIGROUP BUILDING]
(Skidmore, Owings & Merrill LLP, 1990) This 50-story
steel tower is sheathed in green-tinted glass, with a
distinctive ziggurat top. It is located in Long Island City,
Queens, where, until recently, it was the only
skyscraper in a neighborhood of much smaller
buildings, making it highly visible from several vantage
points. The tallest building in New York City outside of
Manhattan, its 1.3 million square feet (120,774 m²) of
office space expanded commercial development in the
city's outer boroughs.

3. WILLIAMSBURG BRIDGE *(Henry Hornbostel, 1903)*
Connecting Manhattan's Lower East Side to Brooklyn's
Williamsburg neighborhood, the bridge was the world's
longest suspension bridge for twenty-one years. More
sturdy than elegant, it was built to carry four trolley

lines, four carriage lanes, two elevated rail lines, and
two pedestrian walkways. The main 1,600-foot (487.7
m) span hangs from a cable system supported by two
335-foot (102.1 m) steel towers. Trussed towers
support the side spans, an extra fortification that
made the bridge unusual for its time.

4. 8 SPRUCE STREET *(Frank Gehry, 2010)* This
shimmering 76-floor residential tower was Gehry's first
skyscraper design, and the tallest residential tower in
the Western Hemisphere when it was built. It rises
in a series of setbacks that pay homage to the designs
of its older neighbors. The exterior is made of 10,500
steel panels of different shapes, creating a sense of
undulating movement on the façade that resembles
rippling streams of water. The skyscraper sits on
a six-story, brick-clad base that houses a public
grammar school and a hospital.

5. MANHATTAN BRIDGE *(Leon Moisseiff, 1909)* This
two-decker bridge connects downtown Brooklyn with
lower Manhattan and was built to alleviate traffic on
the Brooklyn Bridge. A steel suspension structure with
a total span of 6,855 feet (2,089.4 m), the bridge
carries cars, trucks, and pedestrians, as well as four
subway lines, the weight of which has caused the
bridge's upper levels to shift at times. A $920 million
reconstruction project completed in 2007 was

designed to fix that and other problems.

6. JANE'S CAROUSEL *(Philadelphia Toboggan
Company, 1922, 2011)* Built for a theme park in
Youngstown, Ohio, the carousel was purchased by
David and Jane Walentas in 1984. Jane, an artist, spent
twenty-plus years lovingly restoring the forty-eight
wooden horses and two chariots that now grace her
eponymous confection in Brooklyn Bridge Park.
Architect Jean Nouvel designed the transparent
pavilion that houses the carousel, which reopened in
2011 to the delight of many.

7. BROOKLYN BRIDGE *(John A. Roebling, Washington
A. Roebling, 1883)* Fourteen arduous years of
construction that were marked by determination and
ingenuity culminated with the opening of a bridge that
is now world-famous. Spanning the East River and
1,595 feet (486.2 m) long, it was the world's longest
suspension bridge for twenty years. Envisioned by
John A. Roebling, who died before the bridge was
built, it was realized by his son, Washington Augustus
Roebling, with his wife, Emily Warren Roebling.

8. BROOKLYN HEIGHTS PROMENADE *(Andrews & Clark,
1950–1951)* One of the most romantic places in New
York City, this waterfront path resulted from
a decision to build a parkway connecting Brooklyn and
Queens. New York building czar Robert Moses wanted

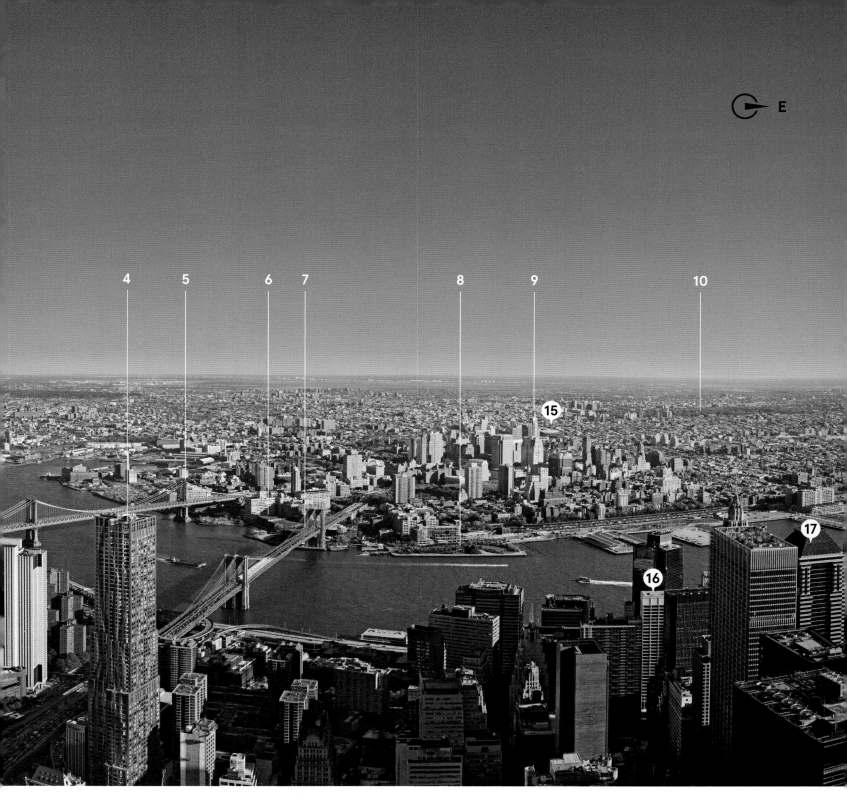

the new highway to cut through tony Brooklyn Heights, but residents fought for a better solution. They prevailed, and a two-deck parkway was constructed in the late 1940s, with the promenade, a walkway measuring one third of a mile (0.5 km), on top. The promenade's spectacular views draw millions of visitors each year.

9. WILLIAMSBURGH SAVINGS BANK [1 Hanson Place] *(Halsey, McCormack & Helmer, 1929)* Brooklyn's tallest building soars 512 feet (156 m) skyward in a series of setbacks. It is topped by a monumental four-faced clock, 27 feet (8.2 m) in diameter and the largest in the world at the time. Its vast, baronial interiors, designed to make every depositor feel like a millionaire, feature twenty-two kinds of marble, a mosaic ceiling, and sculpted symbols of commerce, thrift, and industry. In 2008, it was converted into apartments.

10. PROSPECT PARK *(Frederick Law Olmsted, Calvert B. Vaux, 1865–1873)* Olmsted and Vaux, who earlier had designed Central Park, considered this 585-acre (236.7 ha) park in the heart of Brooklyn their true masterpiece. Artifice at its best, the meadows, hills, and lakes they constructed here were purpose-built, allowing urbanites to enjoy long walks amid the trees, birdsong, and fresh air.

11. MUNICIPAL BUILDING *(McKim, Mead & White, 1914)* Designed by the architectural firm that was once the most prominent in the nation, this building reflects the Gilded Age's majestic, Eurocentric vision. When it was built, the 30-story limestone tower was a new kind of skyscraper, combining great height and classical features in a unified design. It was also the first building in New York to incorporate a subway station. A screen of Corinthian columns flanks its central triumphal arch. At the top, Adolph Weinman's statue *Civic Fame* is a female figure holding a five-point crown representing the five boroughs.

12. WOOLWORTH BUILDING *(Cass Gilbert, 1913)* Nicknamed the "Cathedral of Commerce," the skyscraper spirals upward in a Gothic fantasy of arches, spires, flying buttresses, and gargoyles. Retail magnate Frank W. Woolworth commissioned the 792-foot (241.4 m) tower, which was the world's tallest building from 1913 to 1929. A constant advertisement for his stores, the eponymous tower reflects his prominent place in American retail history. Faced in terracotta with a copper cupola, it remains a singular presence in Manhattan's skyline.

OTHER LANDMARKS

13. The New Museum (2007)
14. AT&T Long Lines Building (1974)
15. Barclays Center (2012)
16. Wall Street Plaza (1973)
17. 60 Wall Street (1989)

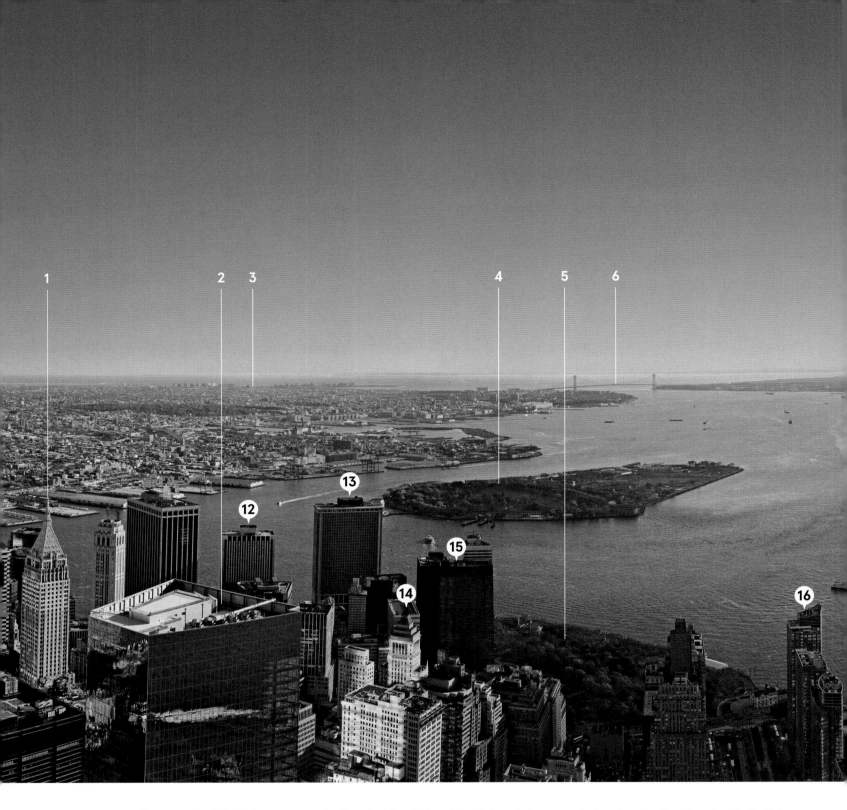

1. 40 WALL STREET [TRUMP BUILDING] *(H. Craig Severance, Yasuo Matsui, 1930)* This 70-story skyscraper was built with remarkable speed, in less than a year. However, it is best known for failing to win an informal race in 1930 to become the world's tallest building, losing to the Chrysler Building, which had ingeniously kept its spire hidden during construction. Decades later, more notoriety followed when the United States froze the assets of former Philippine president Ferdinand E. Marcos, who had quietly purchased it. Now developer Donald Trump owns the tower and, as usual, has named it for himself.

2. FOUR WORLD TRADE CENTER *(Maki and Associates, 2013)* This flawlessly executed skyscraper has the uncanny ability to "disappear" into its surroundings. Maki's Tokyo-based firm designed the 980-foot-tall (298.7 m), energy efficient tower using new and traditional Japanese building principles. Its reflective façade provides a reverential mirror image of the adjacent 9/11 Memorial. A triangular terrace juts out at the 57th floor and offers spectacular views of the entire WTC site.

3. CONEY ISLAND Between 1880 and World War II, Coney Island was the largest amusement complex in the United States, drawing millions of people annually. At its peak, it was home to three major amusement parks: Dreamland, Luna Park, and Steeplechase Park. The 250-foot-tall (76.2 m) Parachute Jump, a now-defunct amusement ride, was originally designed to train paratroopers. Called the Eiffel Tower of Brooklyn, the Parachute Jump was built for the 1939 New York World's Fair, moved to Steeplechase Park in 1941, closed in 1965, and named a national historic landmark in 1989.

4. GOVERNORS ISLAND For more than 200 years, the U.S. Army and Coast Guard used the island, which is only 800 yards (731.5 m) from lower Manhattan, as a military base. Landfill from the Lexington Avenue subway excavation in 1901 added 103 acres (41.7 ha) to the island, which now measures 172 acres (69.6 ha). Its use changed with the creation of the Governors Island National Monument in 2001 and the sale one year later of 150 acres (60.7 ha) to the people of New York. Today, it features a 30-acre (12.1 ha) park, with more green space to come, and its reputation for superb arts and cultural events continues to grow.

5. THE BATTERY The park has a history that dates back to Dutch settlers, who founded a settlement there in 1625. In the 1800s, it grew with significant additions of landfill. Today, it is a popular destination for visitors and residents alike. It features numerous monuments and gifts to the city, among them a grove of eleven cedar trees from the city of Jerusalem. Castle Clinton, a circular fort that was used in the 1800s as a performance space, is a premier attraction.

6. VERRAZANO-NARROWS BRIDGE *(Othmar Ammann, 1964)* Designed by the Swiss-born engineer who designed six of New York's major bridges, this bridge connects Staten Island and Brooklyn with a 4,260-foot (1,298.5 m) center span that made it the longest suspension bridge in the world when it opened. Its immensity is evidenced not only by its length, but also by the bridge's two 693-foot (211.2 m) towers, which are slightly angled away from each other because of the earth's curve and the distance between them.

7. NEW YORK HARBOR The region's fortunes were made on New York's naturally deep, protected harbor. Connected to the Hudson River and the Atlantic Ocean, the harbor is rich in maritime and cultural history and home to 22 national parks. The Lenape populated the sprawling estuarine complex before Giovanni da Verrazzano arrived in 1524, followed by the Dutch in 1609. By the late 1830s, nearly two thirds of all goods arriving in the United States and three quarters of all immigrants entered through the harbor. By 1900, New York was the world's busiest port; today, it is the nation's third-largest port after Los Angeles and Long Beach, California.

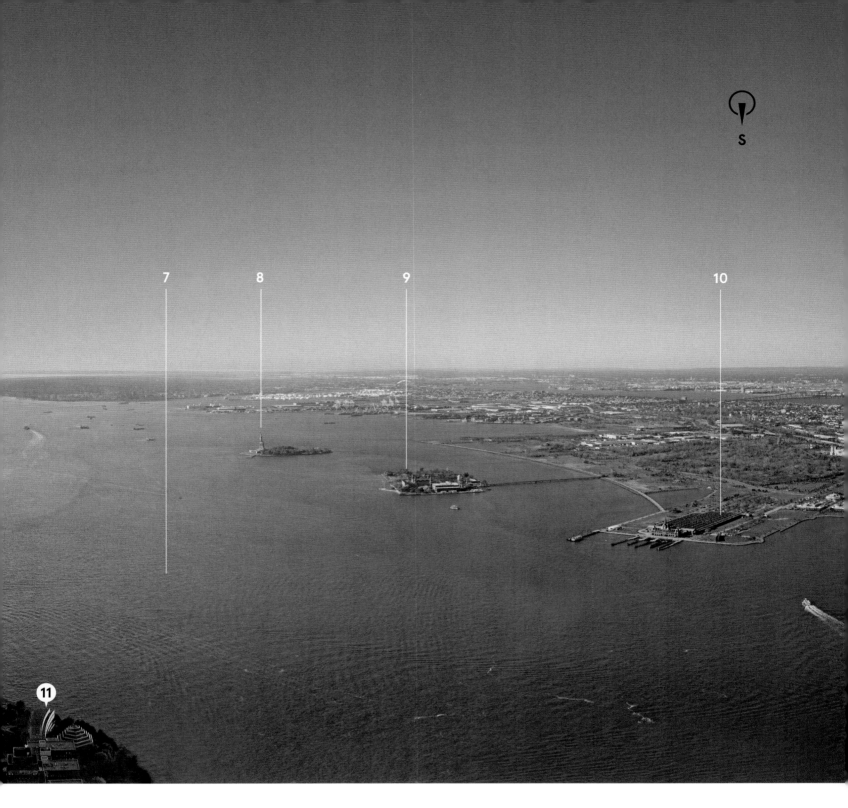

8. STATUE OF LIBERTY *(Frédéric-Auguste Bartholdi, designer; Gustave Eiffel, engineer, 1886)* This colossal goddess at the tip of Manhattan symbolizes the freedom and opportunity cherished by the country's founders and revered by the French, who gave the statue to the United States. Made of copper sheets that were hammered by hand over gigantic molds, the statue measures just over 305 feet (93 m) from pedestal to torch, making it the tallest structure in Manhattan when it was unveiled in 1886. Suffragists at the time were not all fans of Lady Liberty, whom they found too ironic for a country in which women still couldn't vote. Nearly as famous is Emma Lazarus's poem, inscribed on a plaque inside the statue's pedestal, which gives Liberty voice: "Give me your tired, your poor, your huddled masses yearning to breathe free."

9. ELLIS ISLAND *(1900)* Just 27.5 acres (11.1 ha) in size, Ellis Island is immortalized in memory as the place where millions of immigrants entered the United States during the 20th century. The federal government built a wooden immigration station there in 1892, but it burned down in 1897. A new center opened in 1900; through it more than 12 million immigrants passed before it closed in 1954. Today, Ellis Island is part of the Statue of Liberty National Monument, where visitors can trace their ancestry and experience the sweeping saga of immigration in America.

10. CENTRAL RAILROAD OF NEW JERSEY TERMINAL *(William H. Peddle, Peabody & Stearns, 1889)* Located in Liberty State Park in Jersey City, this rail terminal played a key role in the nation's history. After being processed at nearby Ellis Island, immigrants took a ferry to the terminal, where they boarded trains for their new homes. Built in the Richardson Romanesque style, it was used until 1967. At its peak, the terminal counted 128 ferry runs and 300 train departures daily. Now it is open only for special events, but passenger ferries still leave daily for Ellis Island and the Statue of Liberty.

11. MUSEUM OF JEWISH HERITAGE *(Kevin Roche John Dinkeloo & Associates, 1997)* The museum at Battery Park tells the story of the Jewish people before, during, and after the Holocaust. Its design also reflects Jewish history: the six-sided structure symbolizes both the Star of David and the six million Jews who died under the Nazi regime. A 70,000-square-foot (6,503.2 m$^2$) wing was added in 2003, with a theater, classroom space, galleries, and a Family History Center where visitors can hear testimony from Holocaust survivors.

OTHER LANDMARKS

12. Two New York Plaza (1969)
13. One New York Plaza (1969)
14. Standard Oil Building/26 Broadway (1924)
15. One Battery Park Plaza (1971)
16. Skyscraper Museum (2004)
 at the Ritz-Carlton (2001)

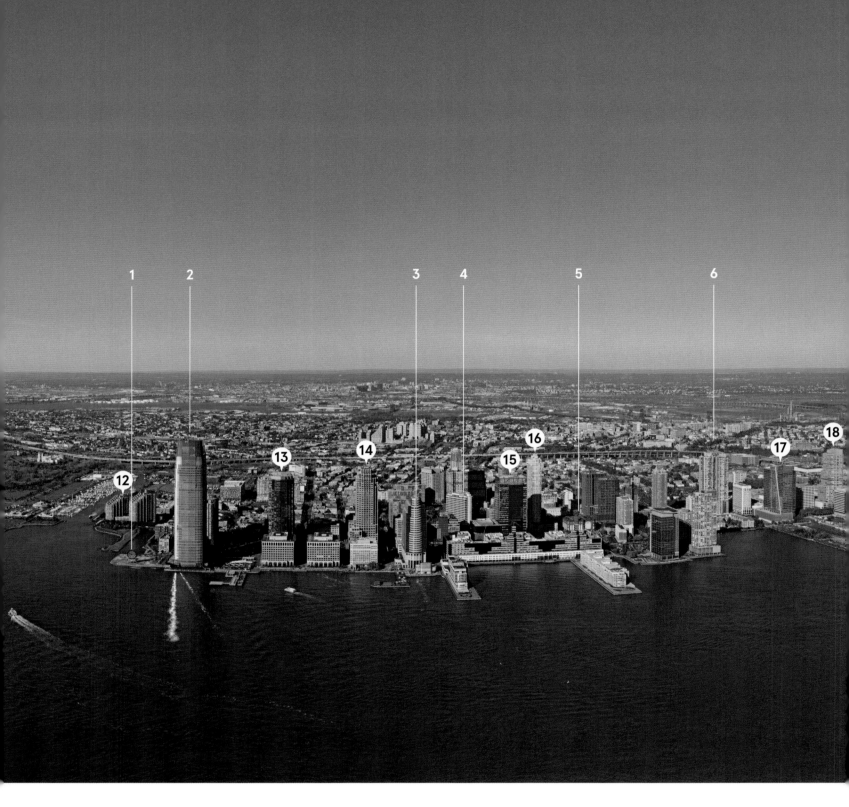

1. COLGATE CLOCK TOWER *(Warren Davey, 1908, 1924)* When it was built, the Colgate Clock was considered a marvel of engineering—and advertising. Engineer Davey designed the first clock, made in 1908, and the larger, nearly identical one that replaced it in 1924. Designed to be readable from across the Hudson River, the clock's massive octagonal dial, 50 feet (15.2 m) in diameter, was inspired by the shape of Colgate's Octagon Soap. More than 1,600 electric bulbs were used to outline its gigantic hands, its numbers, and a sign that read "Colgate Soaps-Perfumes." In 1995, the clock was rescued and relocated after the rest of the Colgate-Palmolive complex was razed.

2. 30 HUDSON STREET/GOLDMAN SACHS TOWER *(Cesar Pelli & Associates, 2003)* This 40-story office tower in Jersey City is New Jersey's tallest building. Built on a former industrial site, the $1.3 billion skyscraper features 1.6 million square feet (148,644.9 m²) of space. It is a glistening example of the style of architect Cesar Pelli, who creates surfaces that shimmer to soften a tower's impact on its surroundings. The architects achieved this effect spectacularly in this tower design, a landmark of Jersey City's developing waterfront.

3. EXCHANGE PLACE CENTER *(Beyer Blinder Belle, 1990)* This office tower is a colorful addition to

Exchange Place, the principal commercial district in downtown Jersey City that is sometimes referred to as "Wall Street West" because of the number of financial companies located there. The 515-foot (157 m) tower was the tallest building in New Jersey when it was completed.

4. JERSEY CITY, NEW JERSEY Perhaps no other city has benefitted from the success of the new World Trade Center as much as this one. Its waterfront, once fished by the Lenape, also appealed to the Dutch West India Company, which controlled much of it in the early 16th century and established the first ferry from Jersey City to Manhattan in 1660. Although the city declined in the 1970s, its extraordinary views and mass-transit options, coupled with exorbitant rents in Manhattan, has burnished its fortunes once again. Construction of new residential and office towers is proceeding apace.

5. HUDSON & MANHATTAN RAILROAD POWERHOUSE *(Robins & Oakman, 1908)* A monument of the industrial age, the powerhouse electrified the Hudson Tunnel, a "subaqueous" subway that physically connected New Jersey and New York, for the first time, on February 25, 1908. Then known as the Hudson tubes, now the PATH tunnels, they still run to the World Trade Center. The elegant red brick structure closed in 1929

and fell into disrepair, and its 200-foot-tall (61 m) smokestacks were removed. In 2001, it was named to the National Register of Historic Places.

6. THE UNDERGROUND RAILROAD *(19th cent.)* During the antebellum era, an estimated 70,000 fleeing slaves came through Jersey City, the last "station" on the Underground Railroad route. Once they arrived, abolitionists drove them, hidden in wagons, to ferries or coal barges that would take them across the Hudson River, called the "River Jordan," to New York, New England, or Canada. Earlier, in the 1640s, slavery was introduced in this same area at the Dutch settlement of New Netherlands at Harsimus.

7. HOLLAND TUNNEL *(Clifford M. Holland, Milton Freeman, Ole Singstad, 1927)* This 1.6-mile (2.6 km) underwater engineering marvel, which connects lower Manhattan and New Jersey, was built by the Port Authority to accommodate America's growing love affair with the automobile. Ridding the tunnel of the carbon monoxide fumes that came with that passion was the main engineering challenge. The solution, innovative for its time and still used today, was to construct four ventilation towers, two in the Hudson River and one on either riverbank, that house a total of eighty-four fans. The tunnel's two tubes were the first underwater mechanically ventilated tunnels.

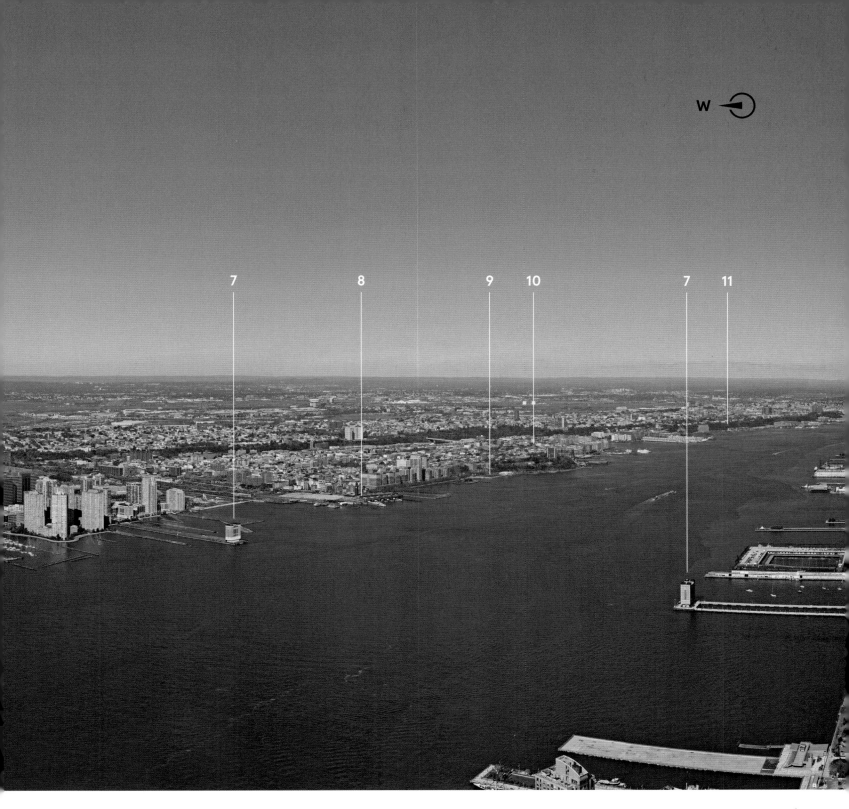

W

7 8 9 10 7 11

8. ERIE-LACKAWANNA TERMINAL AT HOBOKEN
(Kenneth Murchison, 1907) More than 50,000 people
per day take ferries from the Hoboken Terminal across
the Hudson River to lower Manhattan. A national
historical landmark, the Beaux-Arts terminal features
marble terrazzo floors, fine woodwork, and a massive
stained-glass skylight by Tiffany. At one time, it
included a hospital and a barber shop. The entire
structure was built over water, with an ingenious
steel and concrete foundation that compensates
for settlement. Its original 203-foot (61.9 m) clock
tower was replaced with a replica in 2007. The real
push to restore the terminal came after September 11,
when the PATH tubes were shut down and ferry
service was critical. The restoration was completed in
2012.
9. FRANK SINATRA PARK It is said that Hoboken's most
famous native son would stand in this park (renamed in
his honor in 1998) with its perfect views of the
Manhattan skyline, dreaming of making it big in the
"city that never sleeps." Sinatra's rendition of "New
York New York," practically a city anthem, has been
played at the end of every New York Yankees home
game since July 1980. Crooners vie to best emulate Old
Blue Eyes at the park's annual "Sinatra Idol" contest.
10. HOBOKEN, NEW JERSEY Charles Dickens wrote

about it, John Jacob Astor summered here, and
General John "Black Jack" Pershing's promise to
soldiers that they'd be in "Heaven, Hell, or Hoboken"
by Christmas of 1917 became a rallying cry for the
swift end to World War I. Even Henry Hudson, sailing
down his eponymous river, in 1609, noted the strategic
waterfront location that eventually would put
Hoboken on the map as a rail and water transit center.
The city claims many firsts, including the first officially
recorded game of baseball, on June 19, 1846, at
Elysian Fields (the New York Nine defeated the
Knickerbockers, 23 to 1). In addition to Frank Sinatra,
natives include sculptor Alexander Calder,
photographers Dorothea Lange and Alfred Stieglitz,
and Colonel John Stevens, inventor of the first
steam-driven ferry.
11. HAMILTON-BURR DUELING GROUNDS. Here, on a
wooded ledge just above the Hudson River, the most
famous duel in American history took place. On July 11,
1804, political rivals General Alexander Hamilton and
Vice President Aaron Burr met at the Weehawken
Dueling Grounds, already long established as the place
to settle scores. Burr shot and Hamilton fell, and he
died the next day in Manhattan. Hamilton's son Philip
had also met his death here in an 1801 duel, an omen
his father apparently chose to ignore.

OTHER LANDMARKS

12. Portside Towers (1992)
13. 70 Greene Apartments (2010)
14. 101 Hudson Street (1992)
15. Harborside Plaza 5 (2002)
16. Trump Plaza Residences (2008)
17. 480 Washington Boulevard (2004)
18. Newport Tower (1990)

REMEMBRANCE

THE NATIONAL SEPTEMBER 11
MEMORIAL & MUSEUM

Located on eight of the World Trade Center's sixteen acres (6.5 ha), the National September 11 Memorial & Museum commemorates the losses of September 11, 2001, and February 26, 1993. It consists of three structures—the 9/11 Memorial, the 9/11 Memorial Museum, and an entrance Pavilion—that are physically and symbolically intertwined. Composed of diverse elements, they acknowledge that individual ways of grieving are as unique as fingerprints. Some people want a peaceful setting that encourages contemplation, others seek a work of art that transmutes grief to beauty, and still others need to see an event's ravaged remains to understand what was endured. The National September 11 Memorial & Museum is the heart of the World Trade Center.

164

THE 9/11 MEMORIAL

On the morning of September 11, 2011, the 9/11 Memorial was dedicated in a solemn ceremony. Mourners gathered on the plaza amid newly planted oak saplings. Bells tolled and bagpipes keened above the roar of the memorial's waterfalls. A giant American flag, the largest ever made, rippled across the façade of One World Trade Center under skies as poignantly blue as those ten years earlier. Presidents Barack Obama and George W. Bush, along with other dignitaries, spoke, though no words could strike the chord that the recitation of the names of those lost did. That sad, now familiar litany was broken by six moments of silence—at 8:46, 9:03, 9:37, 9:59, 10:03, and 10:28—marking the attacks in New York; Washington, D.C.; and Pennsylvania.

The 9/11 Memorial features two immense pools on an eight-acre (3.2 ha) granite plaza. The pools, each nearly an acre in size and thirty feet (9.1 m) deep, are set within the footprints of the original towers. These twin voids, clad in dark gray granite, are the memorial's centerpiece. They contain thundering waterfalls, some of the largest fountains ever made, which cascade into a still lower central pool. Bronze parapets around the pools commemorate the 2,983 victims of the 1993 and 2001 attacks. Their names are cut into the parapet panels, inviting visitors to run their fingers over them, one of the most ancient forms of homage. At night, light shines up through the names, making each one glow. Open and welcoming, the memorial fosters the democratic values of public assembly, values that played a pivotal role in the collective public response to the September 11 attacks.

When the Lower Manhattan Development Corporation announced a competition to design the memorial in 2003, architect Michael Arad was thirty-four, with an international background. A former soldier in the Israeli army and the son of an Israeli diplomat, he was an American-Israeli citizen, had lived in Mexico and London, and attended Dartmouth and Georgia Tech. He had few commissions under his belt. What he did have was a clear vision of what he thought should be built, and enough naïveté to believe that it would be.

Arad's design, titled "Reflecting Absence," was selected as one of eight finalists from thousands. His essential concept was that the most fitting response to the loss of so many souls and the skyline itself would be absence rather than presence, a void rather than

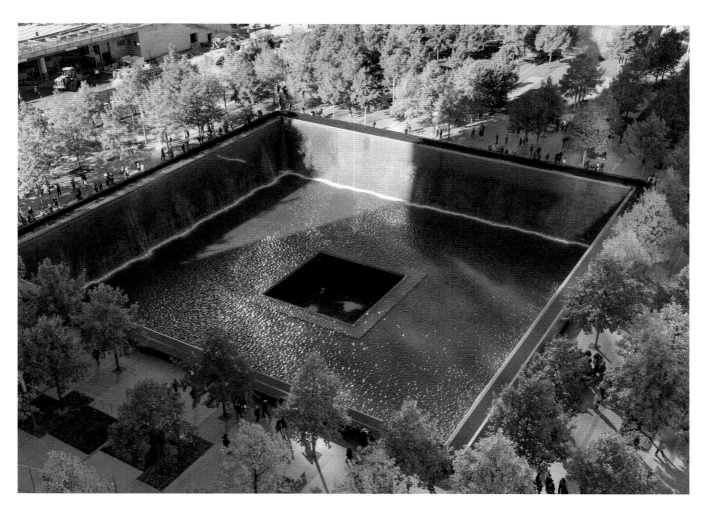

The memorial provides the victims' families with a place to mourn their dead, that most human of desires. Ground Zero is all many of them have—there are no identified remains of about forty percent of the victims. While the memorial pools mark the location of the Twin Towers, they do not commemorate the actual resting ground of many of the dead, whose remains were found all over the site and beyond it.

a solid structure. During the last stage of the competition, he joined forces with landscape architect Peter Walker, a luminary in his field, with more than four decades of international experience. Together, the pair designed the memorial, using a minimal palette and relatively few elements, aspiring to a broad symbolism that could be understood by all. By reducing the plaza's elements to a handful that do "five or six things" each, they achieved a nuanced, layered effect. "It's almost entirely spatial. It's nonobjective," Walker said. That minimalist approach, combined with the site's starkly flat plane, gives the memorial precinct the quality of a stage set, with the drama provided by seasonal color and an ever-changing cast of visitors. In time, the plaza would come alive with every sort of person, engaged in every sort of activity, just as Arad and Walker hoped it would.

Making a great work of art or architecture requires that you "think longer before you build," Walker said. "One of the wonderful things about this project is I've been able to think about it for years." The two produced the winning scheme, announced in 2004. A shotgun wedding, intended to soften Arad's austere proposal with Walker's landscaping, their relationship was

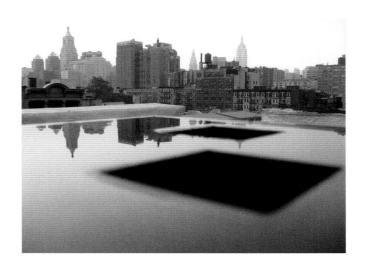

Spontaneous memorials often contain the seeds of permanent memorials. In October 2002, Michael Arad made a temporary installation on his East Village apartment rooftop to express the emptiness as well as the sense of community he felt during the autumn of 2001. The work consisted of two black voids hovering in a ghostly pool of water. Those rooftop seeds of grief and hope, transmuted in Arad's memorial design of 2004, became the double inverted fountains of the 9/11 Memorial. Although much would change in the coming decade, he conceived the fundamental idea of the memorial soon after the tragedy.

symbolism that could be understood by all...

volatile. However, their contract with the LMDC, which Walker describes as a "harness," stipulated that they would remain partners until the project was completed.

Glistening, musical, ceaseless—the waterfalls are the memorial's masterstroke, absorbing all other sounds into their song. They bring water, with its proven beneficence, inland from the Hudson River, continuing the work begun more than thirty years ago when a mile-long riverfront esplanade opened nearby at Battery Park City. Each memorial pool holds over 500,000 gallons (1,892,705.9 L) of water, which is pumped, filtered, and recirculated every twenty-two minutes, using sixteen pumps and water from the city water main.

Water has a nearly unlimited capacity for metaphor. It encompasses rather than divides, possesses form but embodies formlessness, and elicits an instinctive response, connecting visitors with larger realities. Recalling the ocean's horizon, the memorial pool's broad parapets gleam platinum in the sunlight like the shoreline, inscribed with names that, now indelible, are inured to life's changing tides. Like the central pools, with their unknowable depths, the surrounding parapets similarly engage the psyche. About waist-high, they create a barrier between the living and the dead, between the present and the future, giving rise to the fragile illusion that there is a distance between the infinite and us.

Fisher Marantz Stone, the lighting wizards that realized *Tribute in Light*, the beloved, twin-beamed memorial that has been illuminated downtown annually since 2002, orchestrated the lighting of the memorial pools and plaza. Designer Paul Marantz said they knew "from the first minute" that they were going to outline in light the waterfalls where they met the floor of the pool. The challenge was figuring out how to use low-voltage power, required by the city's building code, and submerge the lights underwater. In a solution that was as technical as it was aesthetic, the designers used LED lights, a gamble given the technology's newness at the time, and regulated their temperature by sheathing them in watertight pipes. It was critical that the underwater luminaires be placed precisely so that the water would refract their light, which would then travel up inside the waterfall and make each drop sparkle and dance.

A grove of more than four hundred swamp white oaks distinguishes the memorial precinct from the

Granite pavers and cobbles are set in a linear pattern, as are the low granite benches. Interspersed are rectangles of grass and ground coverings of evergreen English ivies and turf grass that soften the plaza's angularity. The design is sustainable, in terms of performance and maintenance.

surrounding streets, forming a reverential, protected sanctuary. The tree placement is subtle, Arad said, in an "abacus-like grid" that is at once formal and informal. From some angles, they coalesce into a forest. From others, it is apparent that the trees are placed in grid pattern. Working in collaboration with arborist Paul Cowie, Walker selected the species for its autumnal color, strength, and disease resistance. The oaks are expected to grow to about eighty feet (24.4 m), with leafy canopies that provide shade during the summer, colorful autumnal displays, and patterned tracery in the winter. To ensure their survival, they were planted in an enormous volume of soil—40,000 tons (36,287.4 metric tons)—that is concealed in troughs beneath the plaza. "Every drop of water or snowmelt on the plaza is captured," Walker said. The water is then channeled into large subterranean holding tanks to be reused.

Displaying the names of the victims, now forever linked by inclination and happenstance, presented an emotional conundrum and a typographical puzzle. Arad's initial design placed the victims' names at the foot of the waterfalls, thirty feet (9.1 m) below grade and reached via four long ramps. The powerful Coalition of 9/11 Families hated the idea of displaying the names underground, a configuration that also complicated

166

"We want the names above the ground. We want a safe and secure memorial that's built under the legal jurisdiction of the New York City building and fire codes. We don't want this convoluted multimillion- and billion-dollar, really meshuggeneh idea, OK?"

SALLY REGENHARD family member, 2006

...encompasses rather than divides

the positioning of utilities and train tracks. Also, Davis Brody Bond had centered the pools over the Twin Towers' actual footprints, a concept that is accepted as obvious today but that was not part of Arad's original vision. Arad suspected that moving the pools had more to do with Davis Brody Bond's bid to design a museum on the site (which they won), which would change the underground areas, aligning the pools with the sheared-off box columns and exposed slurry wall that are seen inside the museum. It wasn't until 2006, when New York City mayor Michael Bloomberg became chairman of the National September 11 Memorial & Museum, which took over the project from the LMDC, that the issue of where to display the names would be resolved. Few suspected that their placement would become the memorial's most profound element.

In 2006, Pataki and Bloomberg charged developer Frank J. Sciame with finding ways to reduce the memorial's mounting costs and alleviate security concerns. He recommended eliminating the ramps and

The names on the memorial are organized by "meaningful adjacencies" that reflect where victims died, their work affiliations, and their personal relationships. Poring over long rolls of annotated printouts, such as this one, Arad, his team, and museum staff worked intensely for a year to resolve the name placement. Some groupings are self-contained, such as those who worked at Cantor Fitzgerald, which, with 658 names, is the largest such block; within that block, significant relationships are also acknowledged. Other names are together because the victims were relatives or best friends or strangers who found themselves together at the end.

The World Trade Center Memorial Competition

The Lower Manhattan Development Corporation (LDMC) announced a memorial competition in April 2003. Their guidelines adhered to Libeskind's master plan, which set aside 4.25 acres (1.7 ha) for a memorial that would encompass the footprints of the north and south towers down to bedrock and expose the western slurry wall. Additional parameters were developed by two committees that included family members, residents, survivors, first responders, art and architecture professionals, and community leaders, and additionally shaped by thousands of comments generated at public meetings in all five boroughs, Long Island, Connecticut, and New Jersey, and those sent to the LMDC from around the world. The largest such competition ever held, it attracted 5,201 submissions from forty-nine states and sixty-three nations.

A thirteen-member jury winnowed these entries down to eight finalists. "Reflecting Absence," the winning proposal designed by architect Michael Arad and landscape architect Peter Walker, was announced on January 6, 2004. In April 2004, the LMDC solicited proposals for an associate architect, selecting Max Bond of the firm of Davis Brody Bond, which had worked on a World Trade Center renovation at the time of the 1993 bombing and had long ties to the Port Authority. An online exhibition of all submissions opened in February 2004.

167

the Twin Towers' actual footprints...

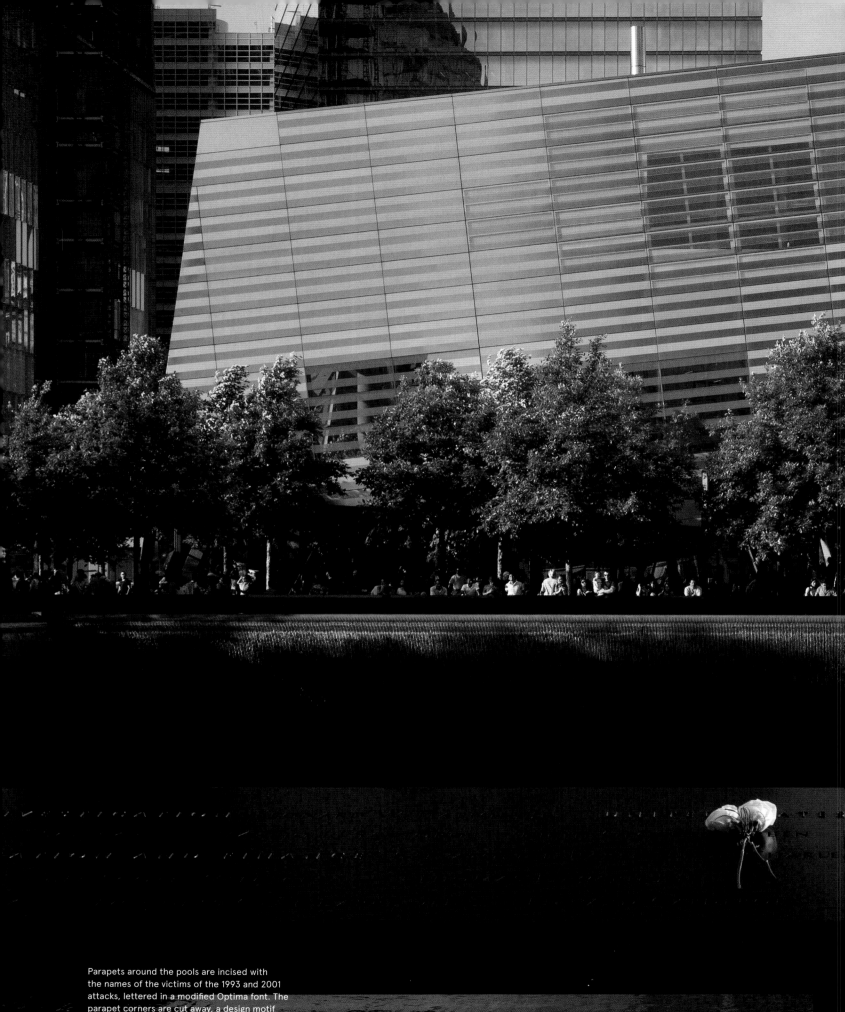

Parapets around the pools are incised with
the names of the victims of the 1993 and 2001
attacks, lettered in a modified Optima font. The
parapet corners are cut away, a design motif
repeated in the chamfered, or beveled, edges of
One World Trade Center. Although the parapets
appear simple, they are complex structures, with
concealed, precisely engineered mechanisms that
control their temperature, lighting, and thermal
expansion. Heating and cooling systems keep
snow off the bronze panels during the winter and
cool them during the summer.

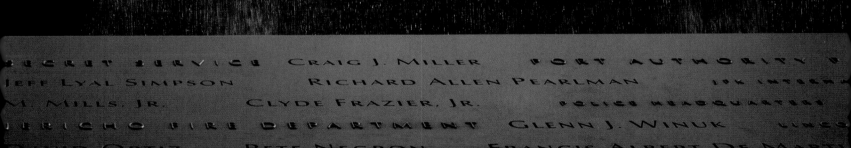

SECRET SERVICE CRAIG J. MILLER PORT AUTHORITY
JEFF LYAL SIMPSON RICHARD ALLEN PEARLMAN JPM INTERNA
M. MILLS, JR. CLYDE FRAZIER, JR. POLICE HEADQUARTER
JERICHO FIRE DEPARTMENT GLENN J. WINUK LINES
DAVID ORTIZ PETE NEGRON FRANCIS ALBERT DE MARTI

The Survivor Tree is the first tree to bloom each spring. A charred Callery pear tree that was rescued from Ground Zero, it was nursed back to health and returned to the site in 2010.

below-ground memorial galleries, key elements of Arad's design, and raising the names of the dead to plaza level. Arad was devastated. "I really felt for him. Here's a guy who's at the top of the world, and they've taken half of it away," Walker said. "He learned something. We all learn that way. I was probably a pretty tough kid when I started, too."

Once the decision was made to locate the names above ground, the issue of placing individual names remained. Arad had proposed in 2004 that they be arranged randomly around the pools, which would reflect the haphazard brutality of the attacks, but the families of the victims and first responders expressed their dissatisfaction with that approach in hundreds of letters. Ordering the names chronologically did not make sense, and alphabetizing them would have had the heartless anonymity of a phone book. Compounded by grief, the controversy over the names roiled on.

Bloomberg called Arad into his office to find a solution. What emerged was the idea to arrange the names in nine broad groups that would reflect the victims' geographic locations on September 11. At that point, Arad began to explore placing the names next to each other in meaningful ways within the nine groups. In June 2009, the 9/11 Memorial staff asked the victims' families for their input on their loved ones' affiliations and name placement on the memorial; all requests, more than a thousand, were honored. "It was a very emotionally charged and difficult period of time for the people involved in it. We were able to meet every adjacency request and enrich the meaning of the memorial profoundly. It doesn't visually change anything, but it emotionally changes it," Arad said. "It's a way to take a personal story of loss and convey it and transmit it in a very direct way that, in my mind, fights the abstraction of close to 3,000 dead."

When I asked Arad what the long process of bringing the memorial into being taught him, he paused. Finally, he said, "The fact that I'm taking some time to respond to that question is probably one of the ways that the project has changed me." It was a wry yet poignant observation from someone who was thrown into an arena of professionals who had far more experience than he did and who made sure he knew it. Yet, much like his advocate Maya Lin, whose strong opinions three decades ago decided the form of the Vietnam Veterans Memorial, he believed he had a moral obligation to see the memorial through as he envisioned it. And then he devoted a quarter of his lifetime to its realization. "I was very young, very idealistic. I don't think I could have done this any other way, without a dose of naïveté and belief that we will get this right. Seeing it from the other side, it seems like such a narrow path that we traversed as a group, and we easily could have slipped off the side of this path into something altogether different. Having a clear idea guiding the design was key." Throughout, he held on to two critical ideas: "Making absence visible and making it a public and civic space.... That public realm allowed us to come together and respond stoically and in measured fashion, but at the same time with compassion and feeling. That was always important to me and had to be part of how we thought about the site."

THE PAVILION

Approaching the memorial plaza, one sees a small wedge of a building glistening above the treetops. From some vantage points, it appears to spring from the ground; from others, it bows before the 9/11 Memorial. Designed to lead the eye and pique curiosity, the crystalline wedge, known as the Pavilion, attracted visitors even before its 2014 opening, thanks to its

Dan Euser Waterarchitecture engineered the ingenious fountains. In his backyard, just north of Toronto, Euser built a full-scale mockup of a forty-foot (12.2 m) section of one of the pools in order to study the water's performance, and then developed an elegant rounded weir along the lower part of the parapet. The weir's serrated metal edges channel the water into cascading streams.

...the issue of placing individual names

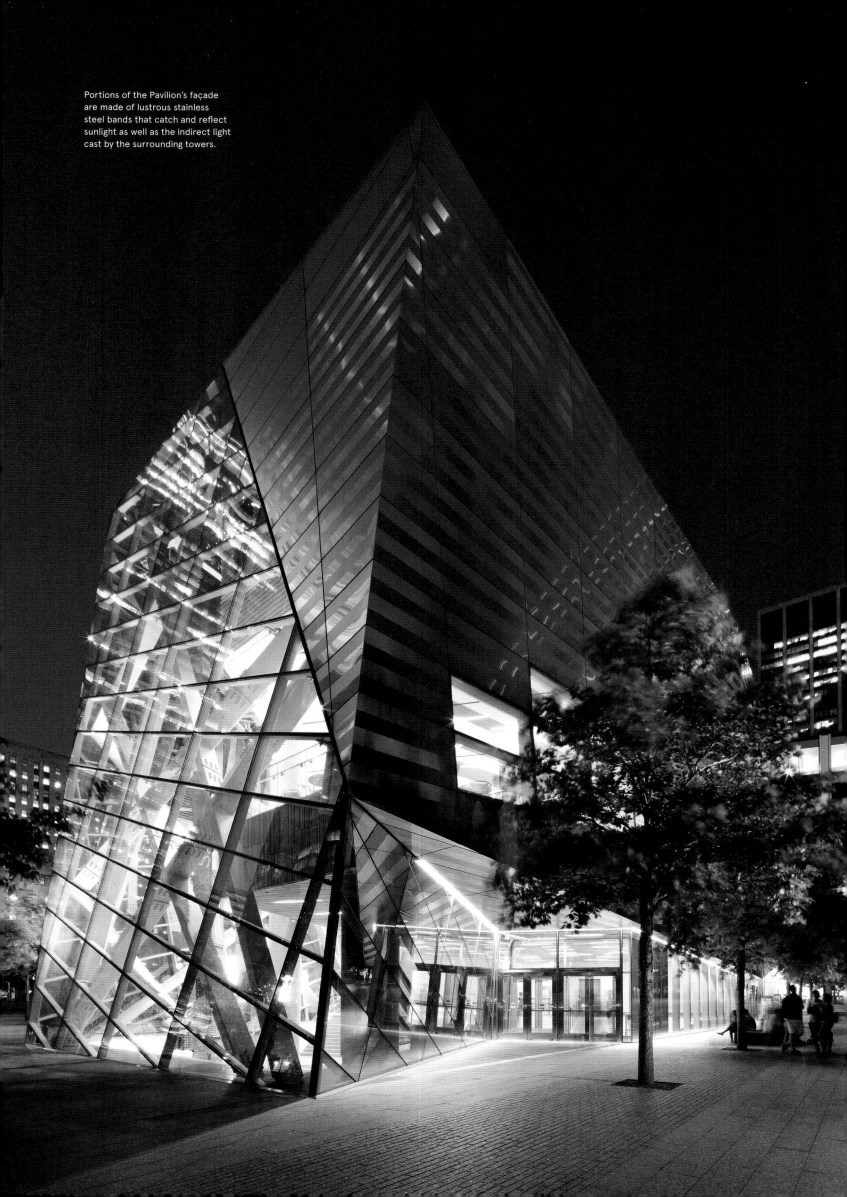

Portions of the Pavilion's façade are made of lustrous stainless steel bands that catch and reflect sunlight as well as the indirect light cast by the surrounding towers.

unique shape and reflective façade. The three-level structure serves as the entrance to the subterranean 9/11 Memorial Museum and also as a navigational guide, funneling visitors toward the space between the two memorial pools. The sole building on the plaza, it was designed by Snøhetta, an architectural firm founded by Kjetil Trædal Thorsen and Craig Dykers, the project's executive architect.

"We recognized one thing about New York City— it's a luxury to be horizontal," Dykers said. Snøhetta gave the Pavilion an intriguing, horizontal profile that would distinguish it from the square memorial pools and nearby towers. Much like a high-tech spider's web, it is woven from steel and glass. Portions of the exterior are striped with bands of lustrous stainless steel, an effect created by microscopic surface scratches in the steel that catch sunlight as well as indirect light from other buildings. According to the architect, the building "actually grows light." It recalls the fractured, deconstructed vision that Libeskind had put forward in his original master plan, which had included the Wedge of Light park that would mark the sun's movement at specific times of day. The comparison to Libeskind doesn't bother Dykers in the least; in fact, he's grateful "that we were able to maintain some stability across the generations of people that have worked on the site."

The Pavilion plays with the notions of inside and outside by providing views into and out from the interior atrium space. It also functions as a light well, bringing sunlight down into the museum lobby, an effective means of preparing visitors to begin the physical and mental transition from the sunshine of the streets to the dimmer lower levels. To further emphasize the structure's transitional role, the architects created a broad staircase, which, along with an escalator, brings visitors down a gentle incline into the Davis Brody Bond–designed museum. The stairs are made of different materials—wood on the upper level and cast concrete below—another way of defining what is above ground, what is at ground level, and what is below.

Two seventy-foot (21.3 m) columns, rusted to a warm patina, stand just inside the Pavilion. Called "tridents," they are two of the eighty-four columns that once were planted in bedrock and that supported the North Tower, rising five stories above the plaza before branching into three prongs, which gave them their name. These jagged façade columns remained standing when all else had fallen. The first of many giant artifacts extracted from Ground Zero that museum visitors encounter, the tridents are powerfully symbolic, recalling both the original towers and the recovery efforts. At the same time, they herald the rebirth of the site. As one

172

A drawing of the eastern façade of the original North Tower shows the two tridents (circled with a dotted line) that are now installed in the Pavilion.

Thirteen massive tridents were recovered from Ground Zero and stored at Kennedy International Airport in Queens until two of them were installed in 2010. They were so large that the Pavilion building had to be built around them.

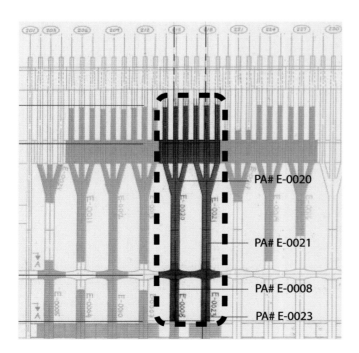

PA# E-0020

PA# E-0021

PA# E-0008

PA# E-0023

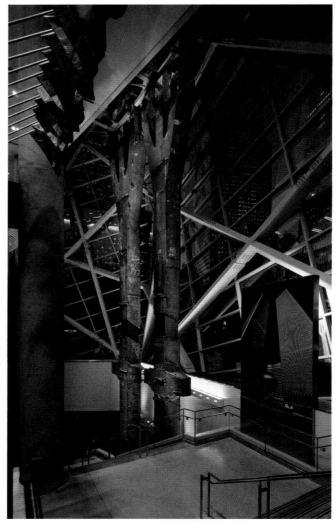

...remained standing when all else had fallen

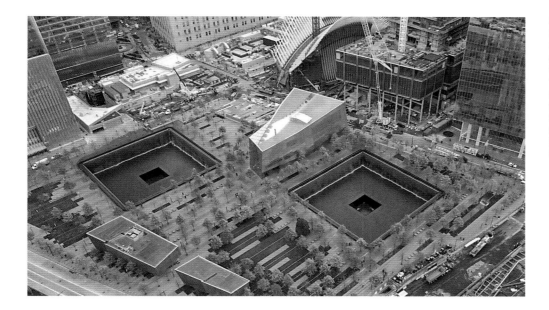

An aerial view shows the Pavilion's unique structure, which helps visitors locate the memorial. Architect Craig Dykers believes that if the Pavilion weren't there, "people would gravitate toward one spot in the middle or toward the edges of the pools." The building also contains a public auditorium, a café, and a second-floor room reserved for the families of 9/11 victims.

descends into the museum, the tridents rise up next to the glass wall on the Pavilion's northern side, framing a view of One World Trade Center, which, so framed, seems to spring from those tridentine roots and appears even larger than it is.

Preserving the tridents was suggested by Philippe de Montebello, director of the Metropolitan Museum of Art, in a *New York Times* op-ed piece shortly after September 11. He described them as the "searing fragment of ruin already so frequently photographed and televised that it has become nearly as familiar to us as the buildings that once stood there." His proposal, all but forgotten, was resurrected six years later when the National September 11 Memorial & Museum announced that two of the battle-scarred steel girders would be installed at the museum's entrance.

At first, many didn't grasp the tridents' immense size. They looked "manageable on the front page of the *New York Times*," said Mark Wagner, the architect who

The Pavilion's playful, mirrored form compels people to look inside. Dykers recalled seeing "two or three young people laugh for a moment, bringing a sense of joy to a site that is so tragic.... For a moment you remember that you're alive."

selected many of the artifacts that were salvaged from the rubble, "but anywhere from 80 feet to 175 feet tall [24.4 to 53.3 m], they were a monster to move." Taking out something that large had two constraints, Wagner said: "the weight (because over a certain tonnage the axles of flatbeds wouldn't be able to carry it) and also the length. We had to get off the island of Manhattan with a long piece on the truck. Between weight and length, that limited us to about forty tons (36.3 metric tons) of steel and about forty feet (12.2 m) in length. That determined the size of the sections that were cut, removed, and ultimately, reassembled." Halfway up each trident, you will see the sleeve where each beam was pieced back together, with the bolts deliberately exposed to make the reassembly evident.

The Pavilion is cantilevered across numerous subterranean structures. "We couldn't control what happened underneath us, so we found two places where we could actually build a foundation and then we bridged the building across it with no columns going down.... It doesn't have to be supported in between," Dykers said. That allowed below-grade construction to proceed without interference. It also functions as a symbolic bridge, linking the memorial and the surrounding skyscrapers. "There are these two worlds, the past and the future, and our building is the present," Dykers observed. It reflects presence— of people, movement, trees, other buildings, and the present moment—rather than the absence expressed by the memorial.

Conceptually, the idea of bridging the past and the present is captured inside when you are descending into the museum via the stairs or escalator. At one point, your eye is flush with the ground, Dykers said, and you can "see the plaza level at eye level." He said that the firm designs many projects with elements that may or may not be consciously noticed by the public. "Nobody may ever say anything about that, but they will feel it. Your body remembers things that your mind doesn't."

173

the "searing fragment of ruin"...

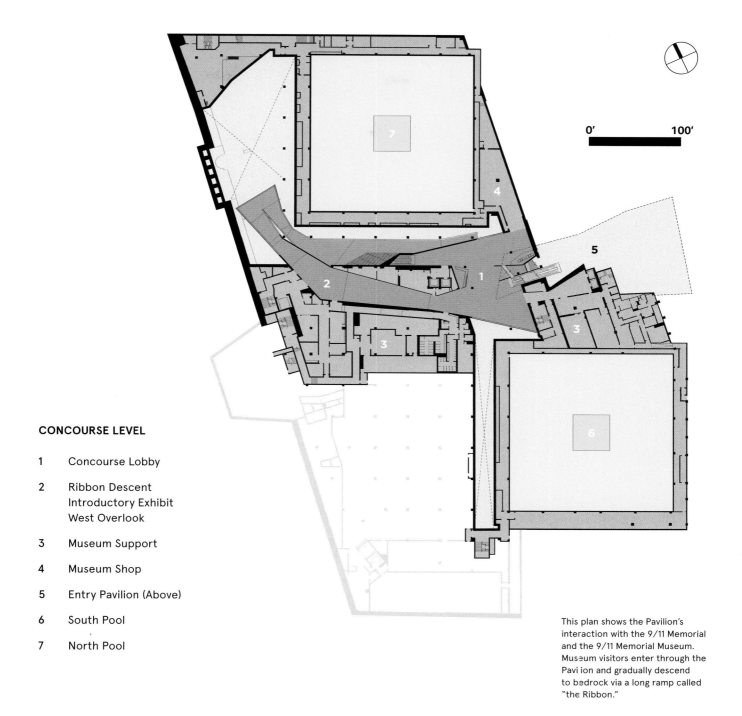

CONCOURSE LEVEL

1 Concourse Lobby

2 Ribbon Descent
Introductory Exhibit
West Overlook

3 Museum Support

4 Museum Shop

5 Entry Pavilion (Above)

6 South Pool

7 North Pool

This plan shows the Pavilion's interaction with the 9/11 Memorial and the 9/11 Memorial Museum. Museum visitors enter through the Pavilion and gradually descend to bedrock via a long ramp called "the Ribbon."

Opposite: This is a detail of *Trying to Remember the Color of the Sky on That September Morning* (2014), Spencer Finch's installation inside the 9/11 Museum. The work consists of 2,983 unique watercolors that represent the victims of the 1993 and 2001 attacks.

Left: Once Ground Zero was cleared, the remains of the steel box columns that defined the perimeters of the original Twin Towers became visible and were covered with protective plywood sheets. Preserved, they can now be seen inside the museum.

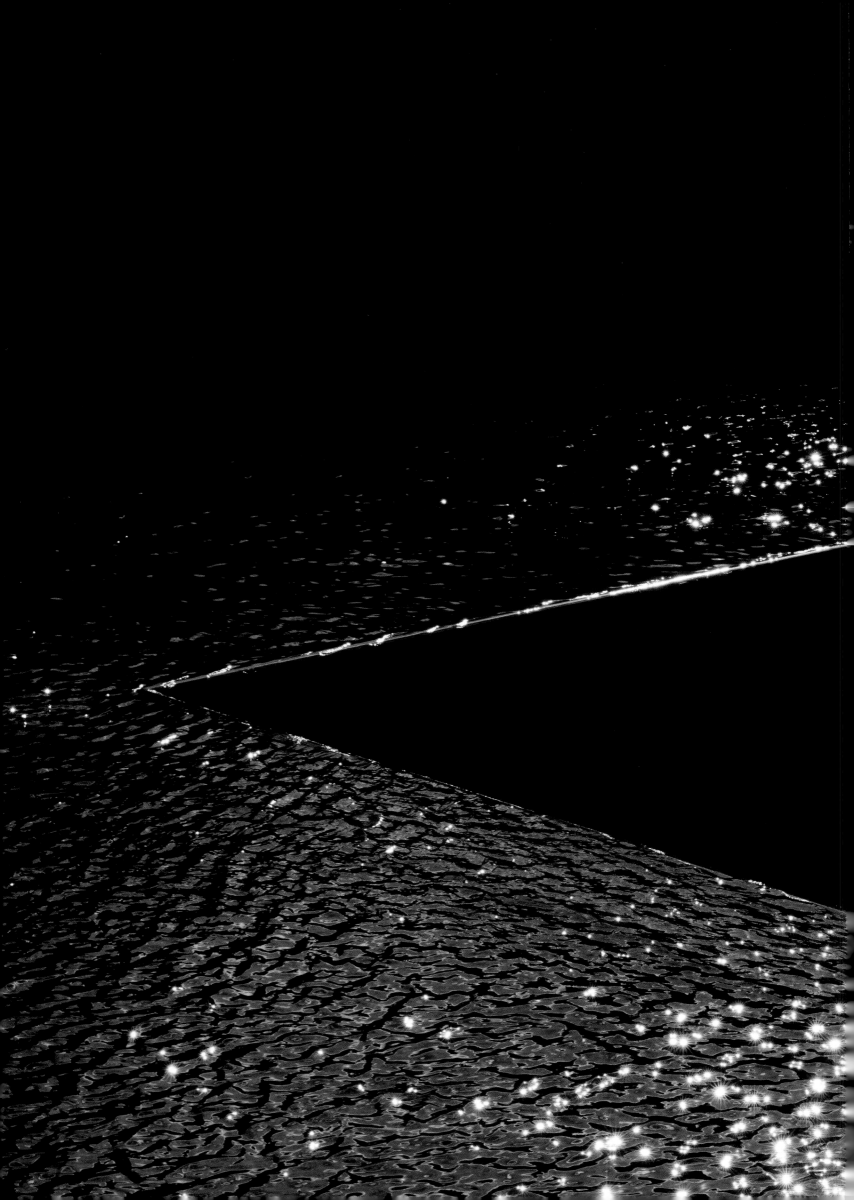

Craig Dykers, the Pavilion's lead designer, is a cofounder of Snøhetta, an architectural practice that opened in Norway in 1989 and maintains offices in Oslo and Manhattan. Their acclaimed design for a new library in Alexandria, Egypt, was followed by a wide spectrum of projects, including the Norwegian National Opera in Oslo; the redevelopment of Times Square in New York City; the San Francisco Museum of Modern Art expansion; the Museo de Ciencias Ambientales in Guadalajara, Mexico; the Lascaux IV Caves Museum in France; and the Väven Cultural Centre in Umeå, Sweden.

The firm was tapped in 2004 to design a World Trade Center cultural center that was to house two tenants, the Drawing Center and the International Freedom Center, but both institutions opted out by 2005 in the face of ideological and political hurdles. There were fears that a human rights museum might project anti-American sentiments, while an art museum might show the "wrong" kind of art. "I think something needs to be a little bit rough and not perfect to make the place authentic, and that's why I fought hard to keep our building there," Dykers said. He eventually convinced Governor Pataki of the need for a venue that was flexible enough to support a variety of activities. Pataki earmarked $80 million for the project, which assured Snøhetta's continuing involvement and eventually yielded the Pavilion design.

Dykers is an American who has lived in Europe for most of his life. The son of a United States veteran of three wars, he brought a broad perspective that was both American and non-American. He understood that people who spent as much time in the military as his father did had a different perspective on war than those who haven't. "They're very, very realistic. They are not interested in going to war," he said. "Usually, when tragic things happen, the people that most quickly want to go to war are those who know nothing about it.... What happens in conflict is never clearly good or bad, and a real soldier knows that." At meetings to discuss the rebuilding of the World Trade Center, he often felt his was "a voice from another place."

His understanding of space and psychology was shaped by his older brother, once a brilliant structural engineer who suffered a brain aneurysm in his thirties and lost his short-term memory. "Most of us live with the luxury of memory, which is also baggage that we carry around with us. When we move through a place or when we go anywhere, even here now, you'll remember sort of where you came in and you'll instinctively go back to where you were when you leave," Dykers said. Lacking this ability, his brother is always looking for psychological tools to navigate space, a "living experiment of who we are with all the stuff taken away." Dykers's fraternal observations make him keenly aware of how people move in public spaces and their need for landmarks that will orient them, an understanding that his Pavilion design makes plain.

Watch how people respond to the Pavilion. You'll see that they will put their noses right up to the glass to look in. Peering inside, they'll see the tridents; those inside see faces pressed to the glass looking back at them. It's in this moment, Dykers said, that one realizes that "you're part of a society. That's very different than looking into the emptiness of the pools and the infinity of the skyscrapers." The Pavilion delivers a shared, human experience, one that prepares visitors for their journey down into the museum while encouraging them to exult in the simple joys of being alive.

THE 9/11 MEMORIAL MUSEUM

As one descends into the 9/11 Memorial Museum, there is a moment of revelation that is easily missed. It occurs along the great ramp that leads down to the exhibits, at the place where you almost can touch the shimmering aluminum underside of one of the memorial pools. There, you sense the museum's enormous scale and experience a wave of memories. "It's where you realize that you can look down and see that the pools are authentically aligned with the footprints," Steven M. Davis of Davis Brody Bond, the museum's architect, said. These two footprints, the square foundations of the original towers, are marked above ground by the deeply recessed memorial pools and below by the museum. While the exhibits recount the events of 1993 and 2001 through monumental artifacts, personal objects, and multimedia displays, it is the space itself——a memorial within and beneath a memorial——that speaks most eloquently.

Because the site, rather than the museum or its collection, was the icon, Davis Brody Bond had to invert design formulas that shape more traditional museums. Few interpretive museums are located at the places that they commemorate, much less inside them. The museum's location and symbiotic relationship with the memorial endows it with palpable authenticity, as does its design, which references the dimensions of the original towers and incorporates structural remnants from Ground Zero. "Nothing is varnished in terms of the scale. The scale of the event, the scale of the Trade Center, the scale of the emotional impact, the scale of all of it is preserved. It is presented at the size that it was, and people instinctively know that," Davis said.

Early on, Davis realized that "in a hundred years, there wasn't going to be anyone left alive who experienced September 11. There had to be a narrative built into the architecture so that the story would tell itself." Accordingly, his firm conceived of a narrative framework that would stand on its own, relying on four principles——memory, authenticity, scale, and emotion—— to guide their design. In large part, that framework arose from the requirement to preserve the structural artifacts that remained——specifically, the box columns that once formed the perimeters of the Twin Towers, the slurry wall, and the Vesey Street staircase——and were protected under Section 106 of the National Historic Preservation Act. Section 106 is "probably the reason that the museum survived in any form," Davis said.

Visitors take a gradual journey down, into, and across the entire landscape of the September 11 attacks.

...memory, authenticity, scale, and emotion

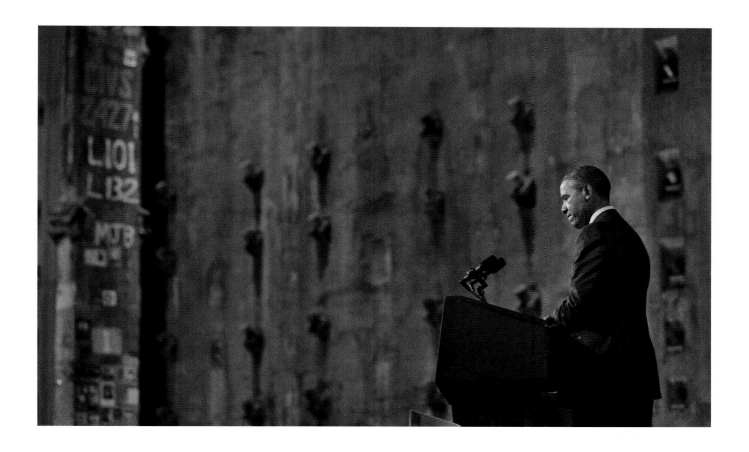

Entering on the eastern edge of the site, one descends seventy feet (21.3 m) to bedrock and walks across to the scarred, sixty-foot-tall (18.3 m) portion of the slurry wall that marks the Trade Center's western boundary. It's a processional experience that invokes mourning and remembrance. The journey delivers a tremendous amount of content, masterfully choreographed and progressively disclosed, that allows visitors to encounter objects and immerse themselves in sensory experiences that don't have an explicit narrative but that nonetheless conjure the entirety of the 9/11 tragedy by the time they reach bedrock.

Traveling from the sun-filled Pavilion to the dim subterranean galleries requires crossing a series of structural and emotional thresholds. "You go from the light into a much more subdued visual environment. It's much quieter, it's darker, your emotions transition. You gather yourself, you adjust to the light, you adjust to the sound, all in this concourse," Davis said. Lighting designer Paul Marantz guided the passage from light to darkness, saying the secret of good museum design is not to "let anybody in too fast, because you would like them to hang around in a middle-light zone long enough for their eyes to adapt to lower light levels."

Lighting a space that is entirely underground presented a challenge. "You have to think about the fact that there's not going to be any daylight down there, but on the other hand, you don't want it to be miserable, dark, and gloomy," Marantz said. To add light, Davis Brody Bond sheathed the undersides of the memorial pools in aluminum, a material that also was used on

During the museum's dedication ceremony on May 15, 2014, President Barack Obama said, "No act of terror can match the strength or the character of our country. Like the great wall and bedrock that embrace us today, nothing can ever break us." Following a six-day period when the museum was open twenty-four hours daily to 9/11 families, survivors. rescue and recovery workers, and others, it opened to the general public on May 21.

179

the façades of the original towers, which once glowed in the afternoon sun. Here, however, they used foamed aluminum, which evokes both a tabernacle's sacred luxe and the rippled patterns made by the falling water of the memorial pools. In a brilliant conceptual move, the light reflected off the twin pools' undersides is the interior's primary light source; it also pays homage to the Twin Towers. "There's a memory of them down at the bottom, underneath the memorial fountains," Marantz said. "There's a coherent idea that what was there and what is there are related."

Arriving at bedrock, visitors stand between the Survivors' Stairs, which represents those who survived, and the repository that holds the unidentified remains of those who did not. On the repository wall, an installation of watercolors honors individuals who died in 1993 and 2001, along with a quotation by Virgil: "No day shall erase you from the memory of time." The repository and a room for victims' families "are not part of the museum, but rather a private space under the authority of the Office of Chief Medical Examiner of the City of New York," Joe Daniels, the National September 11 Memorial & Museum's president and chief executive, said. "The decision to return the remains to the site and locate the repository at sacred bedrock between the two footprints

"a memory of them"...

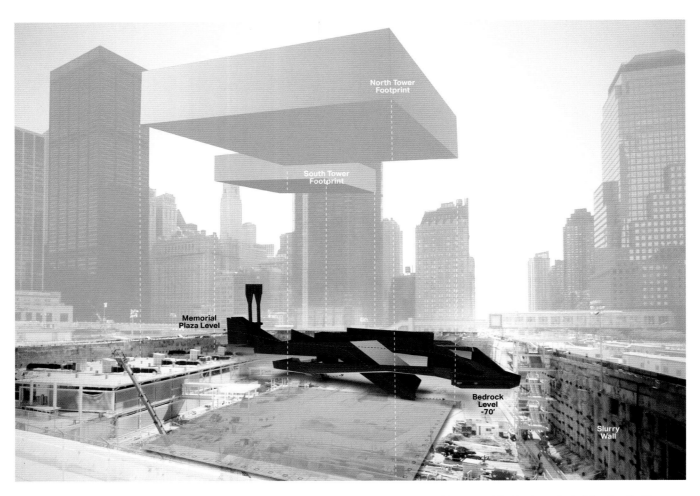

Descent to bedrock is via a wide ramp, recalling the one that recovery and construction workers used for years while clearing and rebuilding the site. The ramp is also a practical means of moving large numbers of people and, with its gentle slope, is ADA-compliant.

180

was made in the earliest stages of the memorial planning process at the request of victims' families."

From the start, the museum staff worked with trauma psychologists "who said that the most important thing you can give to your visitor is choice. Empower them with the ability to decide what they will see, what they're ready to see," said Alice Greenwald, who became the museum's director in 2006 after serving as the associate director of the United States Holocaust Memorial Museum in Washington, D.C. The exhibits had to meet the expectations of the families of the victims, those who were in the city that day, and those who weren't or were too young to understand, while keeping audiences of the future in mind. Another consideration was the different ways in which people absorb content. "Visitors typically fall into three categories: skimmers, strollers, and those who want to dive deeply into the exhibits. By taking a layered approach, designers can speak to all three," said Ann Farrington, who consulted on the exhibition design.

The two primary exhibits include *In Memoriam*, a memorial that pays tribute to the 2,983 men, women, and children who died because of the attacks on February 26, 1993, and September 11, 2001. Its design was a direct response to something a family member said during one of the many planning meetings that

the museum held, which was, "'I'd like to have a sanctum within a sanctum within a sanctum,'" said Tom Hennes of Thinc Design, the lead exhibition designer, who worked with Local Projects, a media design and production firm. *September 11, 2001*, the historical exhibition, consists of three parts: one part concerns events that took place on September 11, 2001, and incorporates artifacts, imagery, testimony, and real-time recordings; a second section circles back to events that led to the attacks; and a third gallery explores the attacks' immediate and ongoing ramifications. Designed by Layman Design, the galleries are dense with physical and digital artifacts that represent only a fraction of the museum's collection. There are too many to take in. Perhaps that multiplicity is the point, conjuring both the enormity of the event and the proliferation of shrines that blanketed the city in the fall of 2001.

"We felt that the trope of this museum was about witness. It was about the shared, collective witness of this event. For that reason, we began our historical exhibition at 8:46, the impact moment of the first hijacked plane into the North Tower. Because that was the point at which most people entered the story," Greenwald said. Bearing witness to the unimaginable, she said, "is the only way to imagine a way beyond it." Ultimately, the goal was to provide "a range of

...2,983 men, women, and children

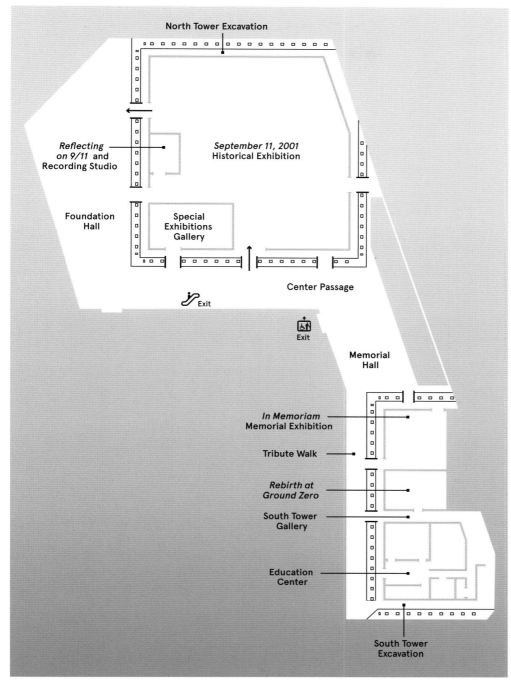

The museum's two core exhibitions are located in the footprints of the North and South towers. Ensuring visitor comfort was a key consideration. One must make a conscious choice to enter the historical exhibition galleries, which hold the bulk of the 9/11 material, much of it disturbing. Interior alcoves that contain potentially upsetting material are similarly labeled with cautionary signage. Early-exit doors allow visitors to leave if they choose. Tissues are available.

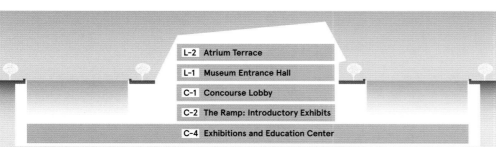

"An emotionally safe encounter with difficult history, experienced through the lens of memory, can inspire and change the way people see the world and the possibility of their own lives."

ALICE GREENWALD National September 11 Memorial Museum Director

"It's a sacred place by virtue of where we are. That's a given."

ALICE GREENWALD

National September 11 Memorial Museum Director

experiences that enable people to regulate the intensity of their own journey and to come as near to the event or stay as distant from it as they need to," Hennes said. "When we feel held or sheltered, the experience is contained; we can open to new things because we're less vulnerable emotionally. The whole museum is what I would term a holding environment, a safe space to explore the edges of our experience." Entering the second segment of the historical galleries, visitors encounter a 7.5-foot (2.3 m) scale model of the Twin Towers, now writ small. As with everything else in the museum, its placement is deliberate. "As soon as you come out of that experience, we present you with a miniature that's whole again," Hennes said. "The goal of that was not only to take a step back and ask why this happened; experientially, the goal was to say, 'You're out of that now. Regroup. You're big, it's small, you're safe.'"

The museum's spaces compress and expand, a time-tested architectural means of moving people forward. However, here that spatiality has a secondary resonance. Most of the 9/11 story is about compression, or collapse. The towers' collapse is the obvious one, but there were other, symbolic collapses of perception in the aftermath—of the United States' invulnerability, of social discourse, of rationality. Countering this was a simultaneous "uncollapse of people working to reinvigorate narrative, reinvigorate dialogue, and reinvigorate the site," as Hennes described it. In Foundation Hall, the museum's culminating space, that sense of expansion reaches its zenith, reinforcing the absence of what was once there. At the same time, the majestic hall inspires pride that is felt to the bones, along with optimism—about recovery, continuity, and the future. ▲

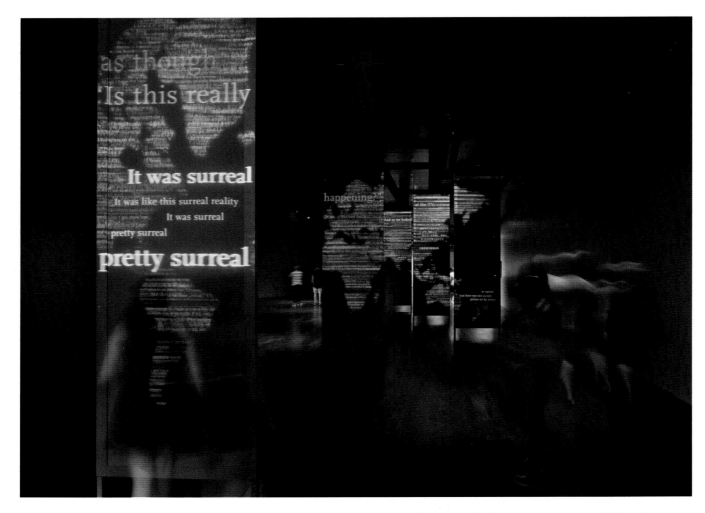

Visitors begin their journey at the *We Remember* exhibit, a darkened corridor in which recorded voices and visual projections convey people's thoughts upon learning of the 9/11 attacks.

...optimism — about recovery, continuity, and the future

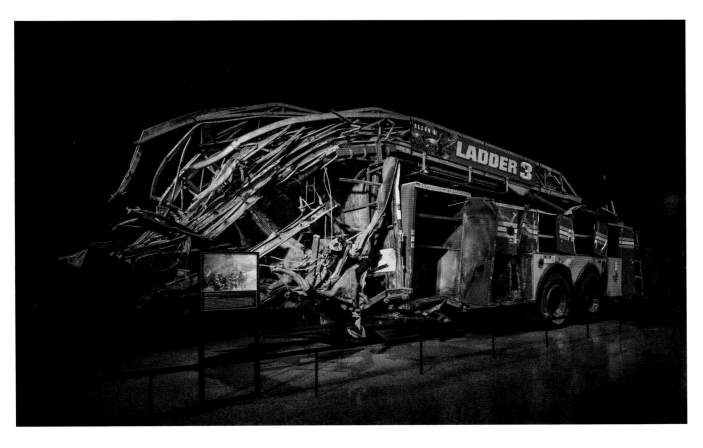

Massive artifacts recovered from Ground Zero, such as this FDNY Ladder Company 3 fire truck, testify to the scale of destruction and to the vastness of the museum's 110,000-square-foot (10,219 m²) interior. Eleven firefighters from that company died inside the North Tower. The truck's front cab was shorn off in the collapse. A message painted on the truck, "Jeff We Will Not Forget You," honors Jeffrey John Giordano, a member of Ladder Company 3. The truck and other oversized artifacts were lowered into the museum via a large hatch on the west side of the north pool.

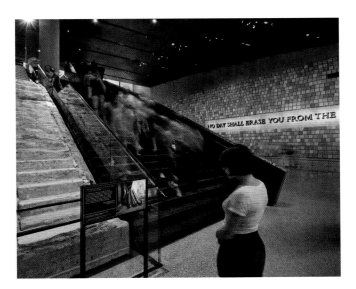

From an overlook in the concourse lobby, one sees the ethereal aluminum underside of the South Memorial pool. On the far wall is a mangled piece of impact steel from the North Tower with a graceful form that recalls the sculpture *Winged Victory of Samothrace*. Embedded in the floor are the remnants of the square box columns that once formed the perimeter of the South Tower.

Descending to bedrock, visitors walk parallel to the Survivors' Stairs, the remnant of a staircase that was originally on Vesey Street at the Trade Center's northern edge, which hundreds used to escape on 9/11. Preserved inside the museum, the stairs allow visitors to experience the same path of travel, albeit under vastly different circumstances. On the back repository wall is a Virgil quote, its letters forged from remnant World Trade Center steel by Tom Joyce, which reads, "No day shall erase you from the memory of time."

Foundation Hall houses the Last Column, a thirty-six-foot-tall (11 m) column that was salvaged from the South Tower. Covered with photographs, mementos, and inscriptions from recovery workers, it was the last load to be removed from Ground Zero on May 30, 2002. Nearby touchscreens allow visitors to explore its markings.

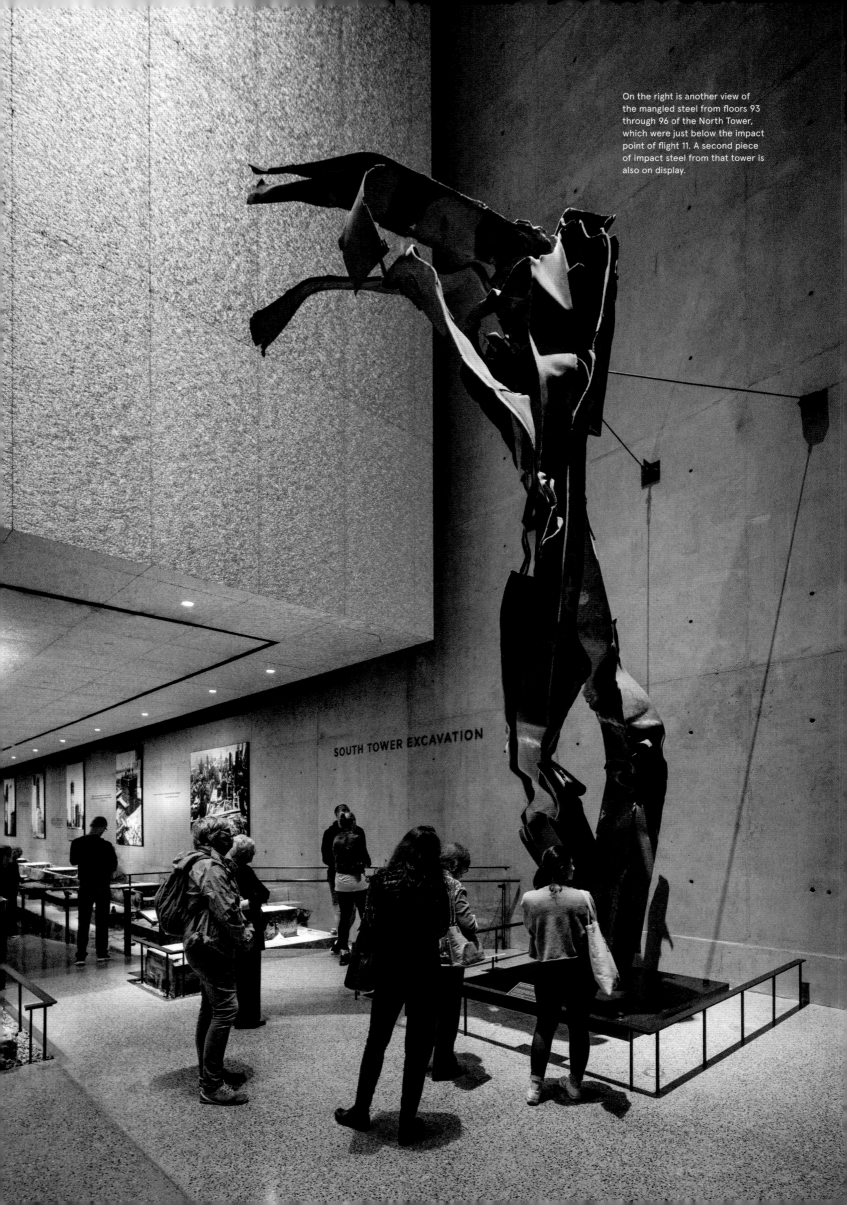

On the right is another view of the mangled steel from floors 93 through 96 of the North Tower, which were just below the impact point of flight 11. A second piece of impact steel from that tower is also on display.

SOUTH TOWER EXCAVATION

Located on the footprint of the South Tower, the *In Memoriam* exhibition is a photographic gallery of the people killed in the 1993 and 2001 World Trade Center attacks. Using touchscreens, visitors can learn more about each person, accessing additional photographs and testimonies, some of which were recorded by StoryCorps, a national oral history initiative. A darkened inner chamber presents visual and audio profiles of individual victims.

What Remained

What was stunning, after the collapse of the largest human-made structures ever destroyed, was how little was left. Within two weeks of the attacks, the Port Authority charged architect Bartholomew Voorsanger of Voorsanger & Associates, Marilyn Jordan Taylor of Skidmore, Owings & Merrill, and Saul Wenegrat, curator of the Port Authority's art collection, with tagging objects that might appropriately be included in an interpretive museum.

Architect Mark Wagner, who worked for Voorsanger and now works for Davis Brody Bond, did most of the tagging, scouring the seven-story mountain of rubble before it was hauled off to Fresh Kills, a 2,200-acre (890.3 ha) landfill on Staten Island. His tags included sections of the broadcast mast from the North Tower, which once loomed almost one third of a mile (0.5 km) over lower Manhattan, crumpled red pieces from Alexander Calder's sculpture *Bent Propeller*, twenty vehicles crushed beyond recognition, PATH station turnstiles—anything that might be of importance in the future narrative of that day. These items were stored at Hangar 17, a vast space at Kennedy International Airport, and some of them eventually were returned and are now on display at the museum.

Wagner went on his gut, selecting pieces that "connected with me as a New Yorker, as an architect, as an artist, as a human being experiencing 9/11." He said that as others learned what he was doing, especially the construction crews, "they'd say, 'Hey, Mark, you have to

come and take a look at this. I'd like you to save this piece of steel.' It might not have meant anything to me, but the point was that it connected with someone, so I would try to save it."

Early on, he tagged a bicycle rack that is now on view at the museum. "I thought it was so poignant that a bike messenger or someone rode their bike to work, locked their bike up on Vesey Street right by 5WTC and then, at the end of the day, could not get it back because they were dead or not coming back," Wagner said. "There was an article in the *New York Post* in January of 2002 that mentioned the bike rack. A week or so later, a guy shows up at Hangar 17 and says, 'I hear you have my bike.' We're like, 'OK, which one is yours?' He took out his key and unlocked the bike and asked, 'What are you going to do with it?' I said it would probably go to a museum or a memorial, something along those lines. He said, 'The bike is pretty banged up; you can keep it, but I want my lock back.' The lock was still in good shape and it was an expensive lock.... That's the way it was. Some things have value to people that they will take home and keep as a remembrance. Others see the value of leaving it for the museum. In this particular case, 'Yeah, leave the bike on the rack. It means more on the rack than it does to me.'"

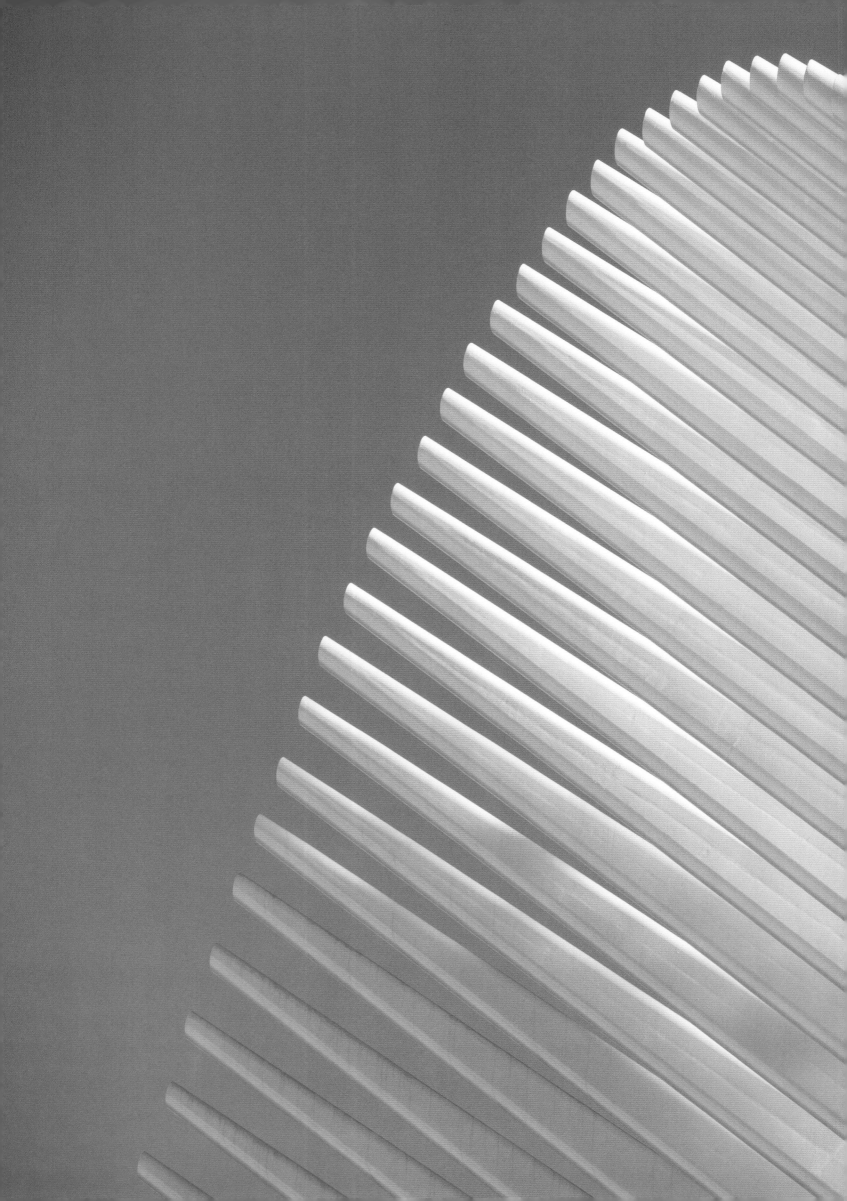

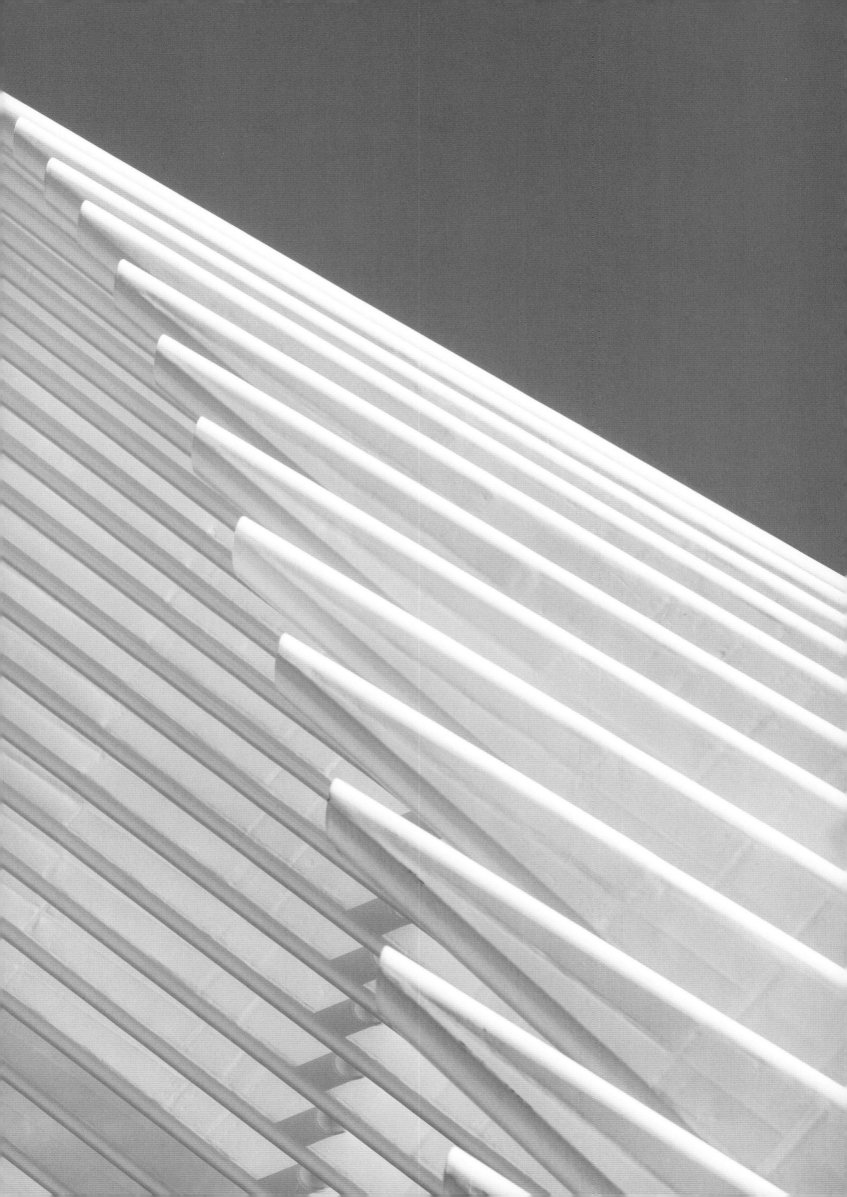

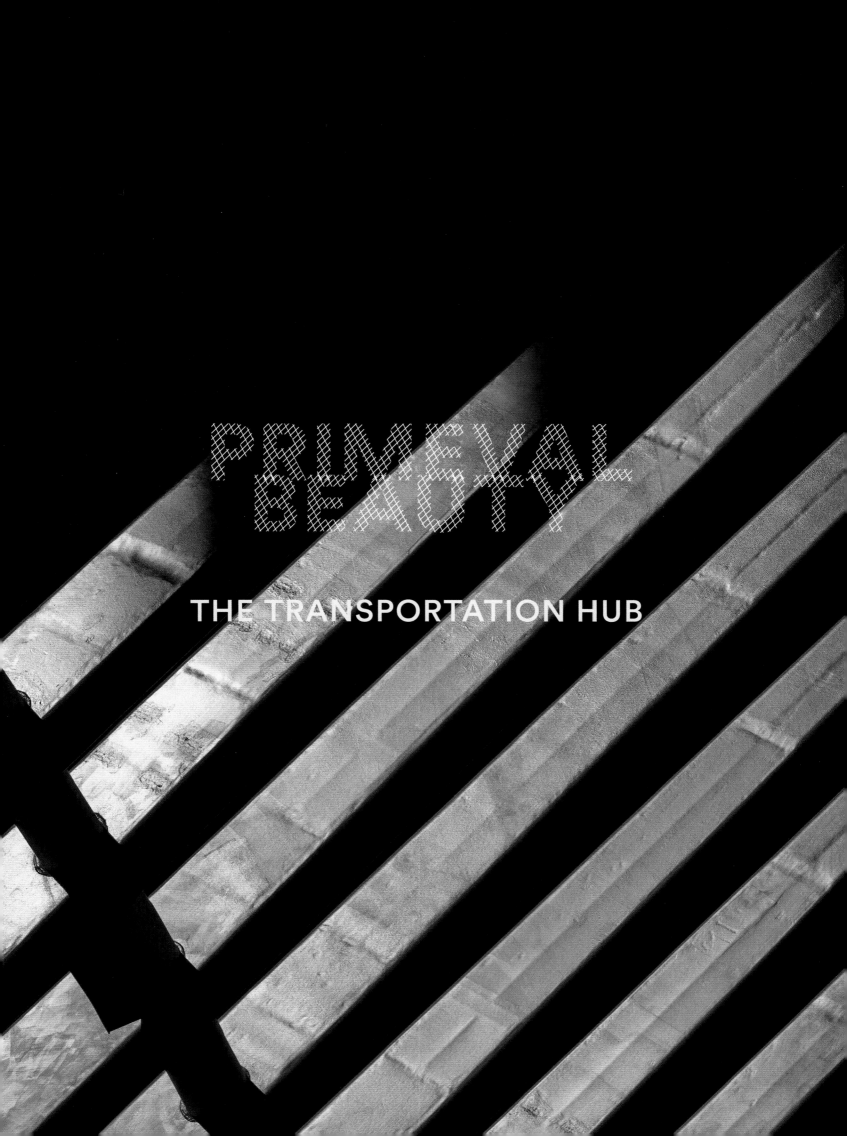

PRIMEVAL
BENGAL

THE TRANSPORTATION HUB

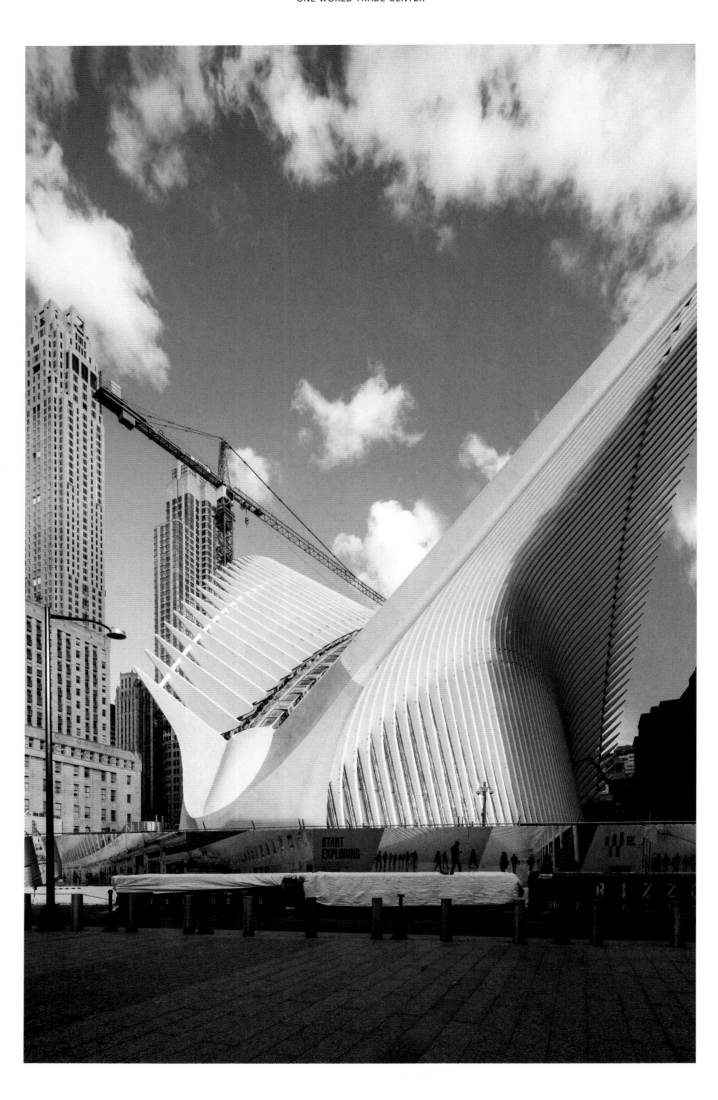

Santiago Calatrava and his ten-year-old daughter, Sofia, stood together at the World Trade Center site in September 2005, just days before construction began on the new transit center that he had designed. To celebrate the structure's avian silhouette, they released two white doves into the air. The doves, as it turned out, were homing pigeons, but no matter. A thrilling metaphor had been made. Since then, debates about whether Calatrava's Transportation Hub looks like a dove in flight—or a dragon, a stegosaurus, or the Pokémon character Nidorino—have continued. To some, the engineering marvel's extended, spiky rafters make it look like a creature from the distant past or the far future.

Calatrava's terminal is a fantastical thing, different in kind from anything else at the Trade Center or in Manhattan. It is the most impressive train station built in the past century, rivaling even Grand Central Terminal. Encompassing 800,000 square feet (74,322.4 m²), it is expected to serve 200,000 daily commuters and millions of annual visitors. It features PATH Hall, the underground station; an extensive network of passageways connecting the Trade Center to multiple subway, train, bus, and ferry lines; and a monumental above-ground hall called the Oculus.

The Oculus is a 365-foot-long (111.2 m) room with 160-foot (48.8 m) ceilings. It is very much a place to see and to be seen, from two upper overlooks or from the encircling mezzanine level. Sunlight pours in from a retractable skylight that runs the length of the

structure. The vaulted space is larger than Grand Central's main concourse, to which Calatrava compares his own atmospheric station. Here, he said, in contrast to Grand Central's celestial ceiling mural, "the sky and the firmament are real."

A hybrid structure, the Oculus takes the form of an arched bridge—not unexpectedly, given the many majestic bridges that Calatrava has designed. It consists of two parallel arches that spring from abutments at grade at Church and Greenwich streets. Vertical elements, 110 of them, dubbed ribs, reach upward 160 feet (48.8 m) to the central skylight. The ribs are tied

Initially, in 2004, Calatrava proposed a lighter, more transparent structure (p. 36). For security reasons, the final design, shown above, has more ribs that are heavier and shorter, and less glazing between them.

larger than Grand Central's main concourse...

to the arches, connecting the upper and lower portal structures. These above-ground vertical elements are tied to the below-grade steel structure, which in turn is planted in bedrock. Most dramatic are the rafters, 114 steel extensions that cantilever out from the arches. They are placed asymmetrically but mirror each other. On the northern side, the rafters are shorter; to the south, they extend to their full length of 140 feet (42.7 m), almost brushing Three World Trade Center.

With its overhead skylight and dramatic converging lines, the interior is a secular cathedral of sorts. Entirely white, either painted white or veneered in pale marble, it elevates the daily commuter experience. The monochromatic palette also pushes comparisons to the skeletal forms that Calatrava is fond of emulating, but they too are an organic expression of the naturalistic geometries and aesthetic logic that mark his work. Every element is exposed and visible. With the exception of the rafters, the Oculus's components are functional, rather than decorative. Its curious beauty arises from that functionality and in the rippling shadows formed by the crisscrossing beams of light it throws.

While the colossal size of the surrounding towers makes them visible from great distances, Calatrava sought a design that, exquisitely detailed and scaled to human beings, would "create a link between you as a person and the rest of the city…. The building is conceived as a piece of art, and I hope people read it like that."

Like all good architects, he has culled the best from others' work and made it his own. His influences include the Catalonian maverick Antoni Gaudí and Finnish-American modernist Eero Saarinen, the latter's influence especially apparent in the rhythmic ribs that enclose the interior of the Oculus. The spirit of local landmarks, particularly the arched portals of the Brooklyn and George Washington bridges, also inspired him. The Transportation Hub alludes to European train stations, with their soaring public spaces that underscore a sense of arrival, and celebrated American train stations, such as Grand Central Station and Union stations in Washington, D.C., and Chicago. Calatrava, who has designed seven railway stations, said that high-speed rail has revitalized Europe's cities. It has also liberated transportation design, providing an expanded "sense of accessibility, transparency, and everyday use…. There's no more heavy façade which you enter like entering into another world. They're much closer to the people, closer to the street."

When addressing the more metaphysical dimensions of his work, Calatrava begins by quoting the architect Le Corbusier—*"L'architecture, c'est une pure creation de l'esprit.'"* He continues, "It's a pure creation of the spirit, and so there is without any doubt, hidden in architecture, in any piece of art, a spiritual dimension. There is another dimension that transcends the material dimension that we can touch. It is sheltering us. It is protecting us from rain, from wind, and it is permitting us to do all kinds of activities. Beyond that also, architecture has the capacity to deliver a message to the people that goes beyond pure function and, without any

194

The Transportation Hub provides connections to eleven subway lines, the PATH line, ferries, and Battery Park City. It includes four platforms and five tracks for PATH trains, underground pedestrian connections, and access to the 9/11 Memorial and all WTC towers.

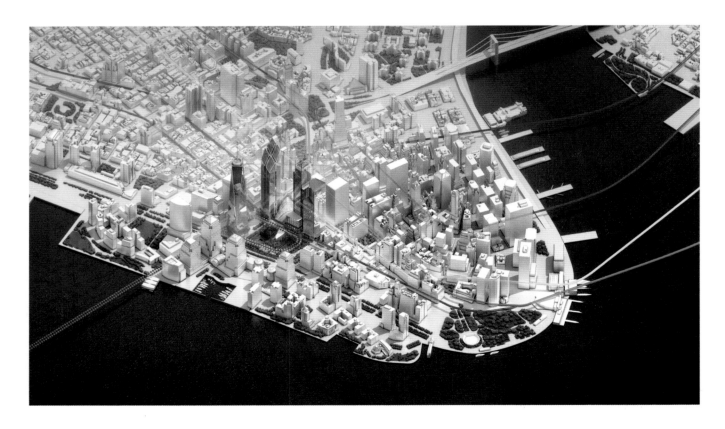

"Imagine there could be places in which you really are grateful to spend ten minutes because they deliver a sense of quality of the space and a sense of quality of the light, and they are telling you that you are an important person as you are commuting from your place to work, and, just because of that, you deserve a space of this quality."

SANTIAGO CALATRAVA

doubt, in the case of Ground Zero and the Transportation Hub, this dimension is present. It is readable."

Originally, the Transportation Hub was to be incorporated into Three World Trade Center, per Libeskind's master plan. Although Calatrava admired that plan, calling it "an inspirational instrument," he wanted a stand-alone structure, the location of which would encroach on the space that Libeskind had set aside for the Wedge of Light, a plaza at Fulton Street that sunlight would illuminate at precisely 8:46 and 10:28 a.m. on September 11. Carla Bonacci, who has worked for the Port Authority for more than thirty years and facilitated the meeting between Calatrava and Libeskind, said that "if they were different people, it might not have turned out as well. They really embraced each other." Calatrava thought "the Wedge of Light was a very beautiful, terrific idea, and I wanted to preserve it and highlight it." He agreed to position the Oculus's long, narrow skylight along the light path that Libeskind had envisioned, subsuming into his design the spirit if not the form of the Wedge of Light.

Underground construction began in 2006. "No one could ever get a sense of all the work we had been doing on the hub," Mark Pagliettini said of the nonstop efforts below ground from 2006 to 2012. According to Pagliettini, who was responsible for delivering the hub for the Port Authority, the biggest engineering and construction challenges involved maintaining service on the PATH and No. 1 subway lines. The temporary PATH station had to be kept operational while portions of the original station were demolished and completely rebuilt. Similarly, by building a massive box around it, the No. 1 subway line kept running. "Thousands of commuters moved through the construction site while it was being built," Pagliettini said, justifiably proud.

Construction involved expanding and deepening the slurry wall along the eastern border and accommodating the site's significant slope. In 2008, in order to complete the memorial by 2011, the hub's design was simplified and the construction sequencing was changed, which incurred delays and tens of millions in additional expenses. Of these, most significant was the

Santiago Calatrava established his reputation as a brilliant innovator with a series of remarkable bridges and rail stations, many in his native Spain. Calatrava is one of a handful of internationally recognized architects, whose designs are characterized by light and lightness, a deft handling of steel and glass, and a preference for soaring structures that evoke birds, vertebrae, and other natural forms. Calatrava wears the hats of architect, engineer, and artist with ease. He uses drawing, painting, and sculpture to uncover a structure's essence and, drawing on all three, imbues his work with a humanist's sensibility. These different ways of understanding are complementary, he said, and "extremely interconnected."

When Calatrava was tapped for the Transportation Hub commission in 2003, he had built only one major structure in the United States, the Quadracci Pavilion (2001) at the Milwaukee Art Museum, which has a winged, retractable roof. He had attracted notice in New York after winning a 1991 design competition to complete the Cathedral of Saint John the Divine. However, his first realized commission in New York was an elegant steel time capsule, dedicated in 2001, that, appropriately, given the many

American commissions that would follow, unfolds like a flower outside the American Museum of Natural History.

The Port Authority conducted a competition to design the Transportation Hub. Anthony Cracchiolo, the Port Authority's former director of capital projects and a longtime fan of Calatrava's work, convinced the agency's then executive director, Joseph Seymour, of the value of working with internationally renowned architects. In July 2003, with a flurry of excitement, the Port announced that Calatrava, working in consultation with the Downtown Design Partnership, a group that included the engineering firms of DMJM Harris and STV, Inc., would design the new terminal. His lyrical design was the first iconic architectural statement to emerge from the rebuilding. In 2012, he won a second World Trade Center commission to design the St. Nicholas National Shrine.

195

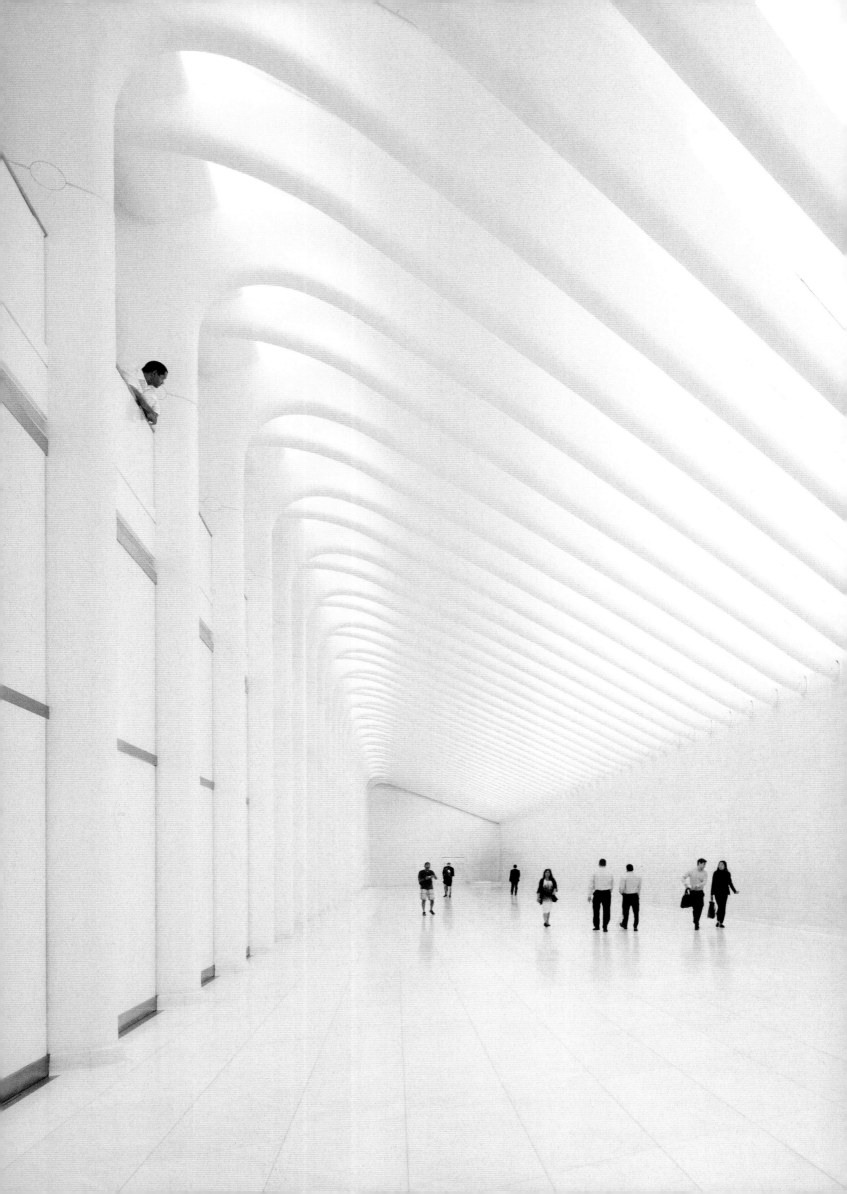

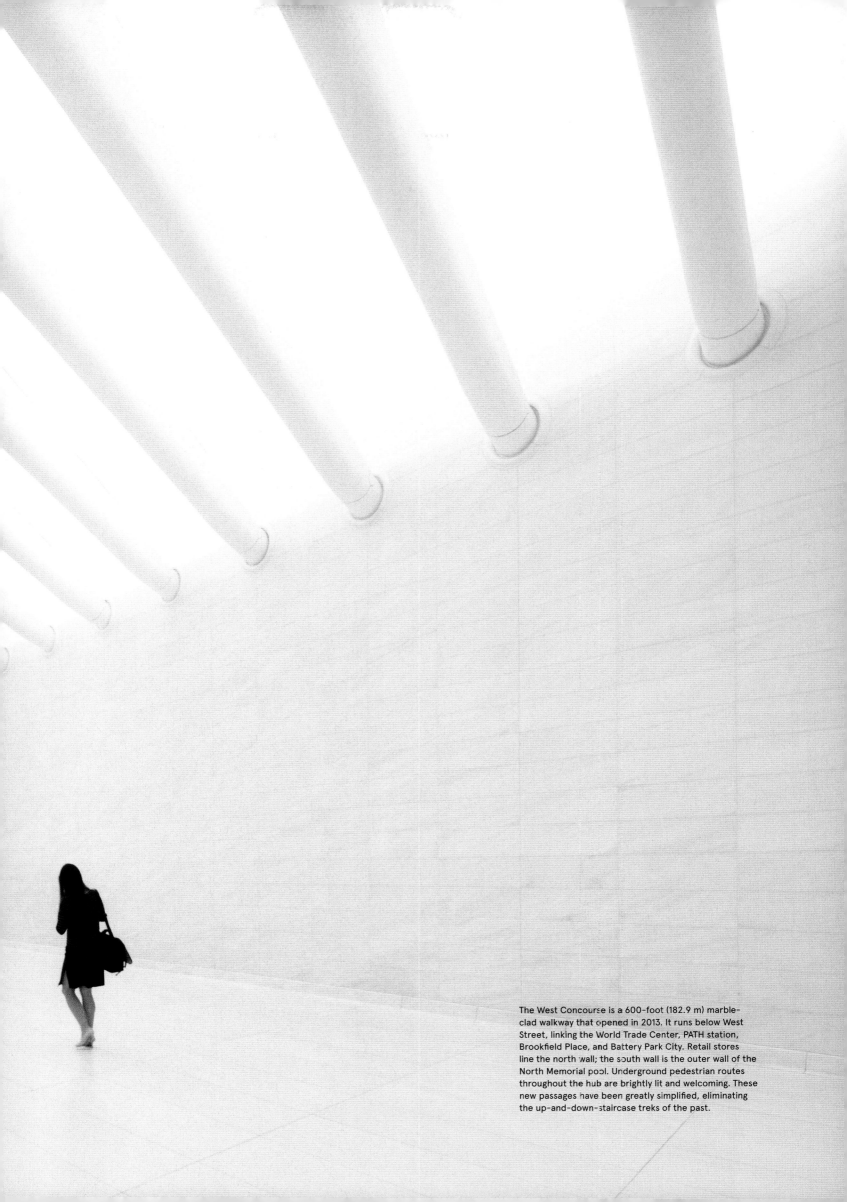

The West Concourse is a 600-foot (182.9 m) marble-clad walkway that opened in 2013. It runs below West Street, linking the World Trade Center, PATH station, Brookfield Place, and Battery Park City. Retail stores line the north wall; the south wall is the outer wall of the North Memorial pool. Underground pedestrian routes throughout the hub are brightly lit and welcoming. These new passages have been greatly simplified, eliminating the up-and-down-staircase treks of the past.

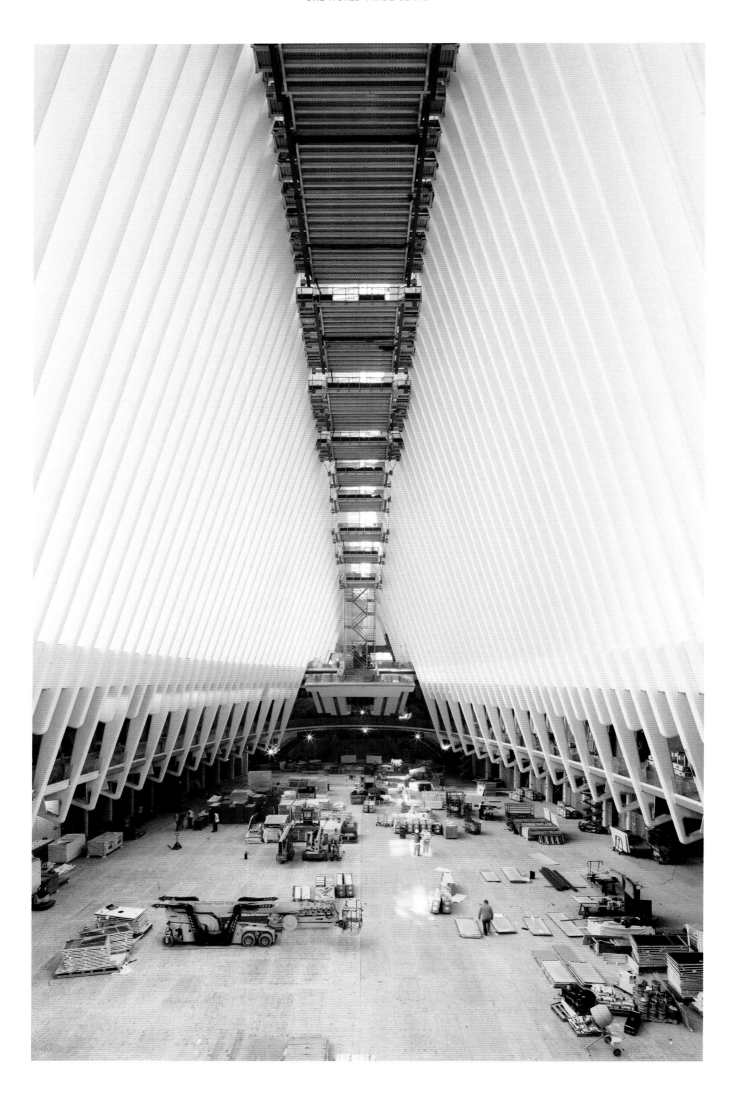

198

The Oculus's upper skylight, which is 200 feet (61.0 m) long and 22 feet (6.7 m) across at its widest point, will be opened on special occasions and each year on September 11. A fully retractable roof was proposed but eliminated due to cost and operational practicalities.

The Italian firm Cimolai, which has worked on several Calatrava structures, fabricated the ribs, arch segments, and rafters in Italy. Additional structural steel was fabricated in Spain, Canada, and the United States. Enclos, an American curtain wall design and engineering company, designed and installed the skylight and glazing between the rafters.

"deckover" solution, which called for building the roof of the plaza first, instead of building from the bottom up. In addition to rebuilding the PATH train station and its platforms, the Port Authority oversaw the construction of the West Concourse, which connects Battery Park City to the World Trade Center. They restored the stations, platforms, and routes for the 1, E, and R subway lines, and built a new connection to the Fulton Street Station. They also juggled the placement of shared underground facilities. One reason Calatrava's structure appears so ethereal is that critical components of its mechanical systems are placed elsewhere on the site, threaded through the structures of Two and Three World Trade Center and the 9/11 Memorial Museum.

A lot of ink has been spilled on the Transportation Hub's cost: about $4 billion, twice the original estimate and slightly more than One World Trade's $3.9 billion price tag, money that many believe the Port Authority should have spent elsewhere. "The airports look the way they do in part because of the Trade Center. The fact is, $8 billion from the airports went there," Patrick Foye, the Port's director, said. The budget swelled, hostage to the rising costs of materials and labor, administration practices, design changes, security enhancements, and the need to complete the memorial by 9/11's tenth anniversary. Extra costs were linked as well to Calatrava's unusual design, which required "labor-intensive building methods and sculptural and curvilinear steel elements that could only practicably be manufactured abroad."

The billions spent in Manhattan have already borne fruit across the Hudson River, in Jersey City, along the PATH train's route, where 24,000 new residential units have been approved or are under construction as of 2015. Questions about the hub's expense will soon evaporate. As the architect Philip Johnson once told me, "Nobody ever asks what the Statue of Liberty cost." Like that landmark, Calatrava's terminal is an object of wonder. On Church Street, looking west, it becomes part of an immense wunderkammer of breathtaking structures seen along the east-west vista: the 9/11 Memorial and its leafy green canopy, Snøhetta's angular Pavilion, the glittering base of One World Trade Center, and, further west, Cesar Pelli's arched glass Winter Garden. It stands as a peer with these neighbors and alongside the great transportation halls of the world. ▲

199

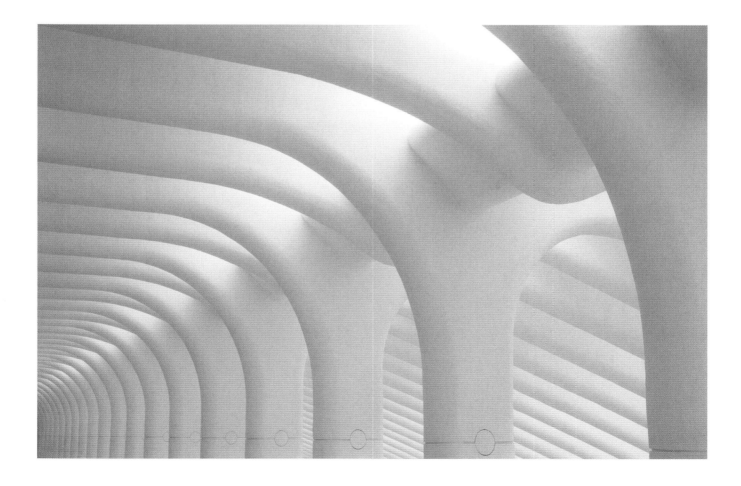

billions spent...

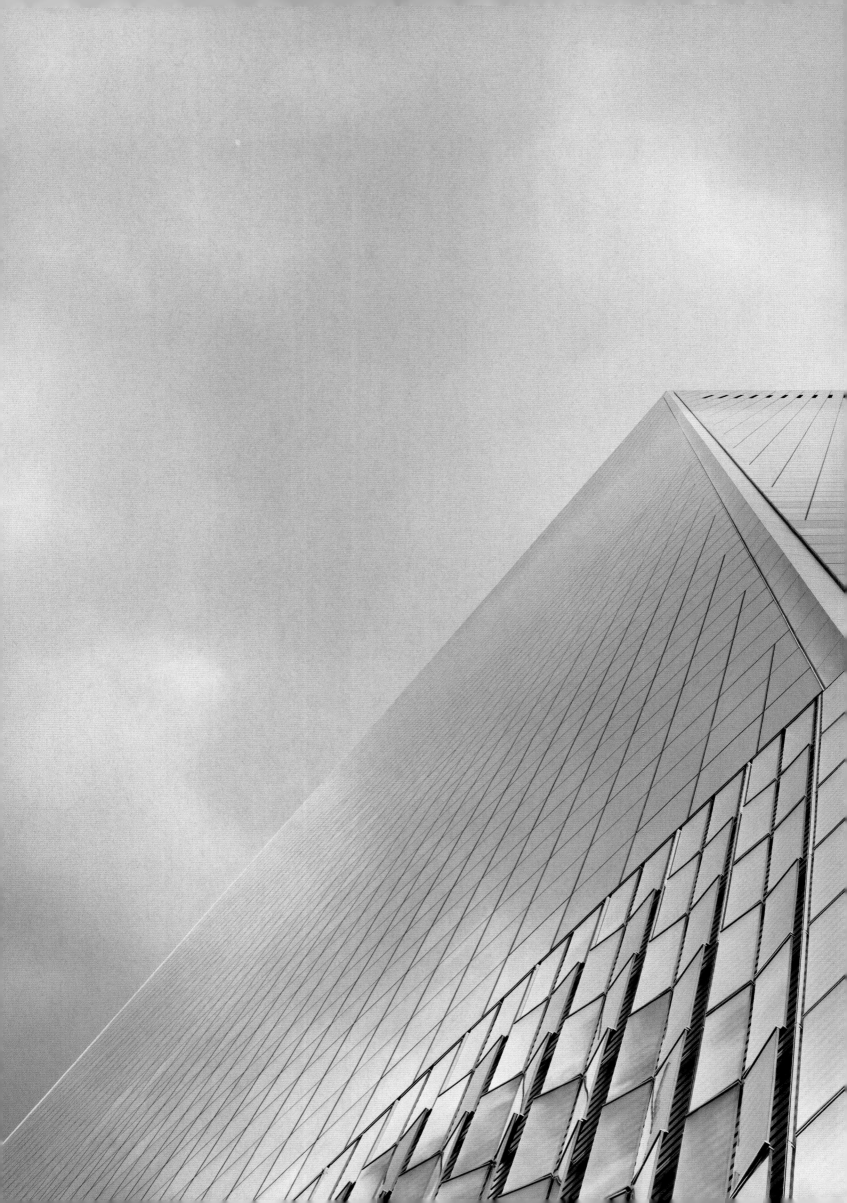

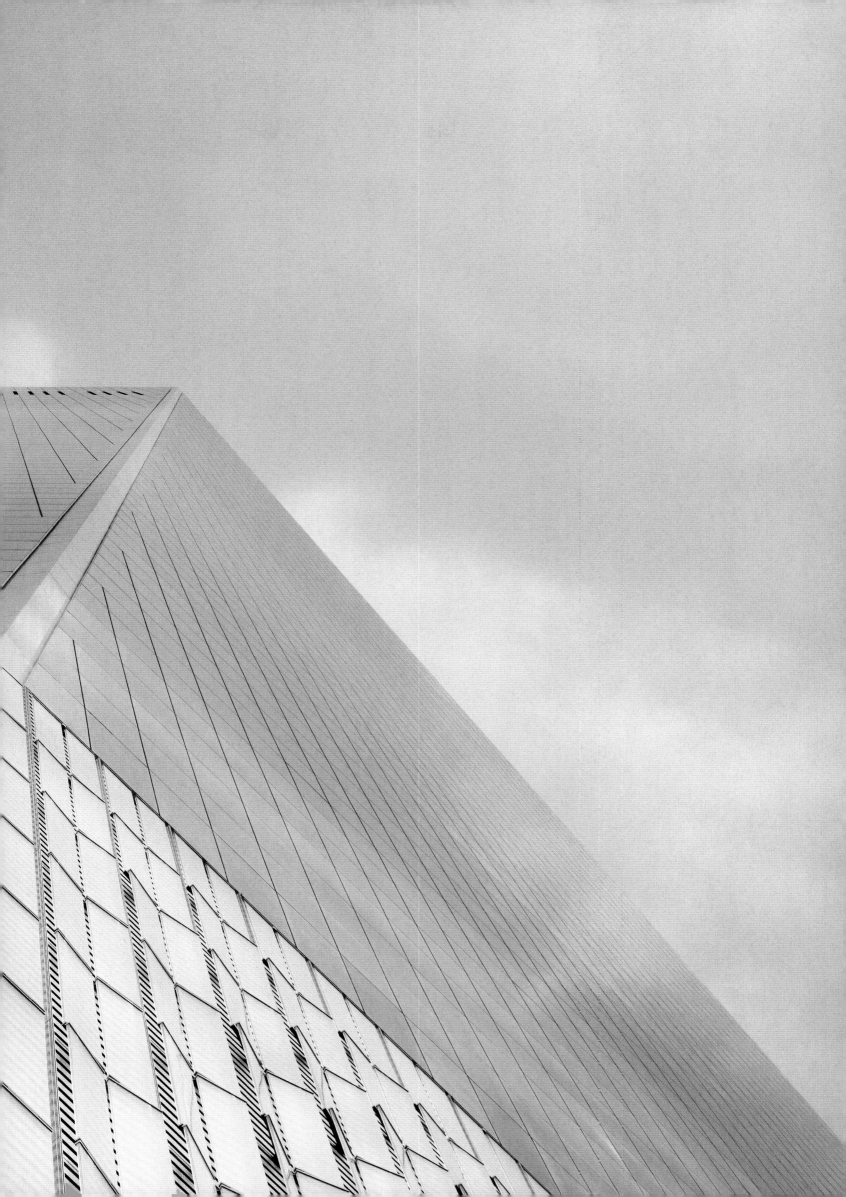

SPIRITUAL LEGACY

ST. NICHOLAS NATIONAL SHRINE

In contrast to his futuristic Transportation Hub design, Santiago Calatrava's luminous St. Nicholas National Shrine mines the distant past for its forms and inspiration. Located just outside the World Trade Center site proper, on the eastern end of Liberty Park, the diminutive Greek Orthodox church offers what the architect describes as a "human-scaled presence in an ensemble of giants." As an urban church, its hospitality includes and welcomes the stranger. The only religious structure at the site, it has a voice in the ongoing debate about the role of religion at Ground Zero.

204

Wisely, Calatrava did not seek to compete with the Trade Center's other signature structures, including his own Transportation Hub, all of them virtuosic displays of technology. Instead, the church is distinguished by its simplicity. His design—a circular domed building bracketed by four towers—combines elements of two landmark churches in Istanbul: the Hagia Sophia, which was the cathedral of the Ecumenical Patriarchate of Constantinople for nearly one thousand years, and the Church of St. Saviour in Chora, also known by its Turkish name, Kariye Camii, which is considered a cultural treasure second only to the Hagia Sophia. St. Nicholas synthesizes the structural, historical, and theological bases of these earlier churches, melding eastern and western symbols. Appropriately, the new church sits on the elevated plinth that links the east and west sides of lower Manhattan.

St. Nicholas's structure is a double-wall construction. The exterior concrete walls are sheathed in glass panels that contain thin sheets of white Pentelic marble. At night, illuminated by LEDs, the marble becomes translucent and glows. During the day, the church appears to have been cut from solid stone. Just over 48 feet (14.6 m) in diameter, the dome is scalloped

with forty ribs. It is supported by the corner towers, which also house ventilation and mechanical systems for the church and lower garage. Fabricated of stone with horizontal bands of subtly contrasting color, the towers recall the striations that are a hallmark of the Chora church. Forty clerestory windows, echoing those at the Hagia Sophia, bring sunlight inside. Clear glass windows on the eastern and western sides invite in additional light. There are no windows on the south side, or on the north side, which overlooks the memorial plaza. The design encourages the act of turning inward, rather than outward, for solace and strength. At night, the church shines like a beacon, its image mirrored and multiplied in the reflective glass skyscrapers that surround it.

Liberty Park's designers masterfully choreographed the park's staircases and pathways with the church's structure and circular forecourt. Its setting, at the end of a vista of flowering trees and meandering paths, reinforces the impression of arriving at a holy place. Climbing the Liberty Street staircase on the west side, one rises to approach the church, a satisfying metaphor for the soul's lifting. Directly in front of the church on Greenwich Street, a cascading staircase offers seating,

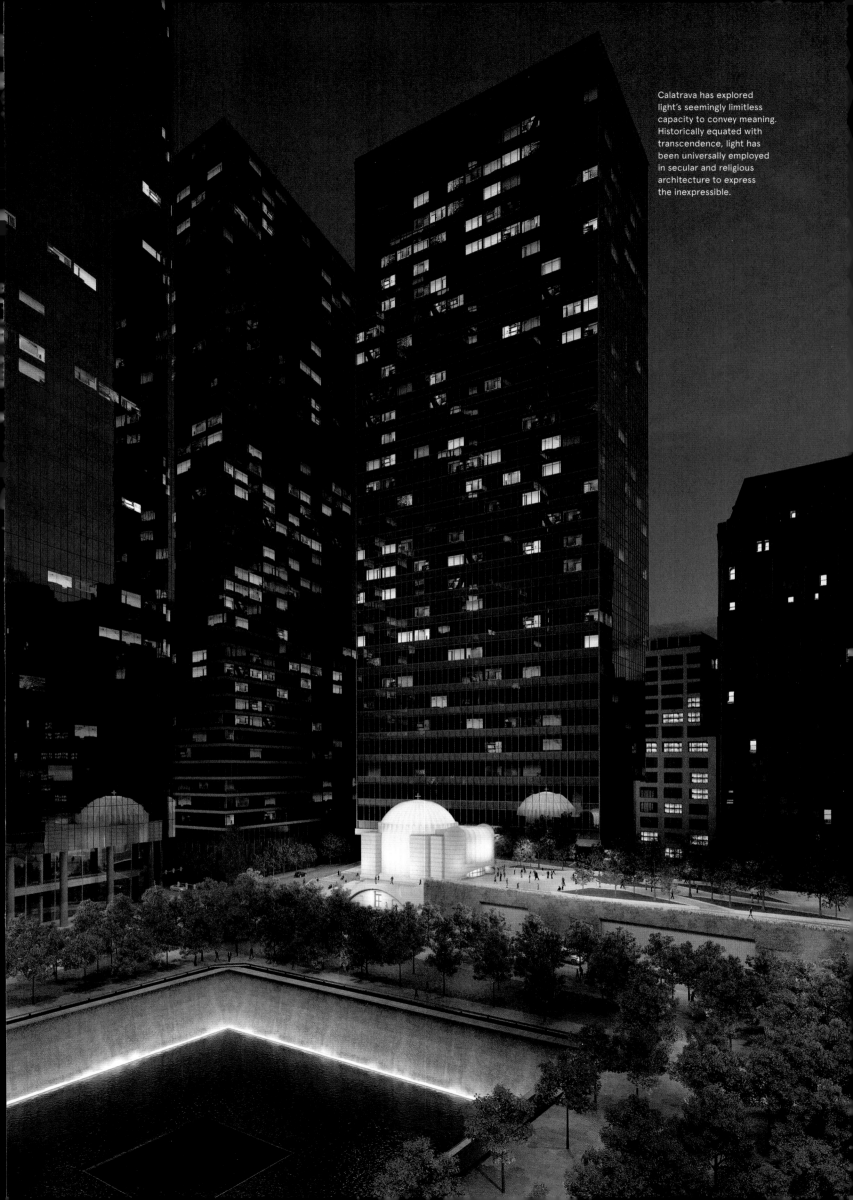

Calatrava has explored light's seemingly limitless capacity to convey meaning. Historically equated with transcendence, light has been universally employed in secular and religious architecture to express the inexpressible.

respite, and a gentle way to be close to a holy place without going inside.

Calatrava felt the church had to be a place for believers and nonbelievers. Inside the entrance, in the exonarthex, visitors can light candles, a practice that is shared by many cultures and faiths. The ceiling here is low, creating a compressed threshold that opens to the narthex and then the central nave, which soars to a height of fifty-two feet (15.8 m). With room for about 200 people, the circular nave is an intimate space, with contemporary seating and furnishings. The layout, however, follows a traditional Orthodox sequence, proceeding from the narthex into the nave and culminating at the iconostasis, an altar screen covered with icons, at the eastern end. The entire church is open to the public, with the exception of the sanctuary, which is reserved for clergy, and private offices.

The church fulfills two roles. It operates as a regular parish, conducting weekly services that follow the canonical liturgical order of the Ecumenical Patriarchate, as well as baptisms, weddings, and ordinations. Secondly, the Greek Orthodox Church of America has designated it a National Shrine, signaling its larger significance. When I discussed the church with Father Alexander Karloutsos, Protopresbyter of the Ecumenical Patriarchate and a Port Authority chaplain, he said, "Everybody knows the word *xenophobia*, a Greek word, which is fear of a stranger. Well, there's another Greek word, *philoxenia*, which is the love of the stranger. This church will be one of philoxenia, and people will always be able to come and be embraced, affirmed, and supported." The parish's interfaith, educational, and cultural programs will be open to all.

Those who brought the new church into being describe it as a "city set on a hill," or as an American Parthenon. The discrepancies of scale between the Parthenon and tiny St. Nicholas are not lost on the archdiocese, but it takes singular pride in the reality that Greek Orthodoxy, a religious super-minority in the United States, has been called to be the sole religious presence at the World Trade Center. Mark Arey, who helped coordinate the design competition, said, "It somehow seems appropriate to me that the path forward should go to a real minority in the culture. Let the minority build it, let the minority share with the majority, and show that there is a place for everybody in our culture."

While St. Nicholas owns the church structure, everything just outside that structure is a public park, which anyone, including the parish, can use. This is noteworthy because of the importance of processionals in Orthodox rites. On Good Friday, the Friday before Easter Sunday, for instance, church members mourn the crucified Christ by carrying a flower-covered coffin through the streets while praying for health and healing. On other occasions, including anniversaries of September 11, church members will process through

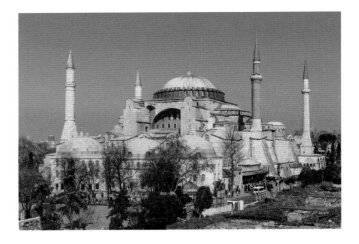

St. Nicholas's dome and interior half-domes were inspired by the Hagia Sophia (532–537), a religious and engineering landmark built in Constantinople, now Istanbul. When that city fell to the Ottoman Turks in 1453, the church was reconsecrated as a mosque and four minarets were added. In 1935, it was decommissioned and made into a museum. Along with Brunelleschi's Duomo in Florence and the Pantheon in Rome, the Hagia Sophia is one of the most influential domed structures of the past two millennia. Its ingenious builders determined that they could put a circular dome atop a square base by using a massive supporting tower at each corner, creating the first true domed basilica.

Liberty Park, icons aloft. The public is welcome to participate. "Freedom of conscience and the fundamental human right of free religious expression," Archbishop Demetrios said, "will always shine forth in the resurrected St. Nicholas Church."

The church's privileged location relative to the overall site was decided after years of litigious conflict. The original St. Nicholas Greek Orthodox Church was founded in 1916 at 155 Cedar Street in a row house that was once a tavern. Greek immigrants had gathered there since 1892; for many Greeks who disembarked at Ellis Island, it was their first stop in America. The church, one of four Christian houses of worship near the World Trade Center, was the only one destroyed on September 11, crushed when the South Tower fell. No one was in the building at the time. A handful of items were salvaged from the ruins. The rest was rubble. The parish lost its most precious possessions—holy relics consisting of bone fragments of Saint Katherine the Great, Saint Sava, and Saint Nicholas—which are now commingled with the ashes of the dead.

Archbishop Demetrios, who leads the Greek Orthodox Church of America, sought to rebuild soon after September 11. Because the Port Authority needed the church's Cedar Street parcel and its air rights for the Vehicle Security Center, the parish agreed to move to a new location. Church representatives sparred with the Port Authority over exactly where the church should be located and how much the authority would contribute to rebuilding. Efforts to proceed were mired for years. Then, in July 2010, excavators unearthed a wooden

...an American Parthenon

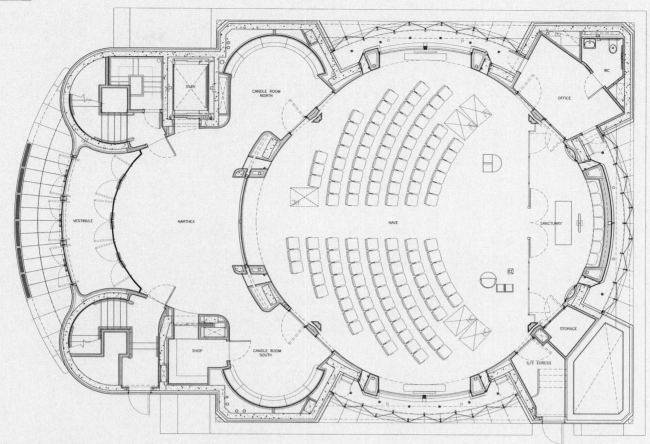

The floor plan is composed of
a profusion of circular forms
braced by four corner towers.

A section drawing shows the rising,
circular volumes of the interior, which
are modeled after those of the Hagia
Sophia. The western façade is a curved,
three-story structure that houses
a nondenominational bereavement
center on the second floor, which is
open to all, and a community room on
the third floor for parish members.

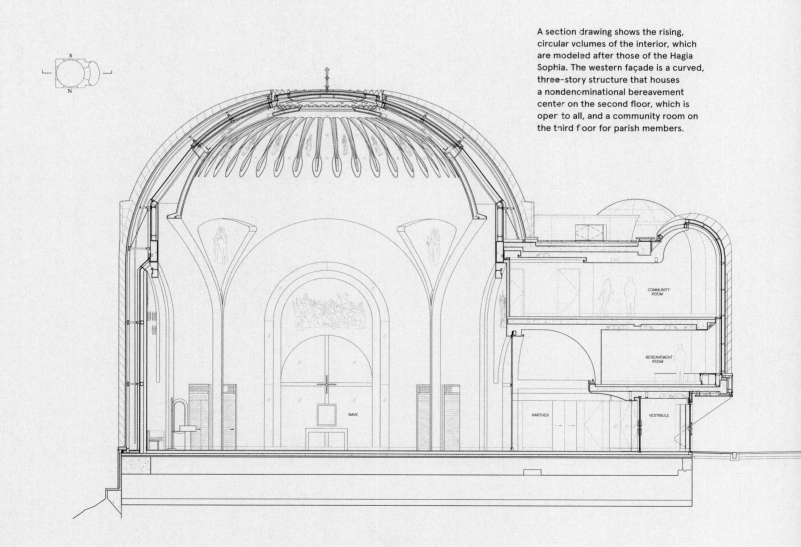

A hand-painted icon of the Zoocochos Peghe (Life-Giving Fountain) was one of a handful of holy objects recovered from the ruins of the original St. Nicholas Church. The work allegorizes the Virgin Mary (the Theotokos, literally "God Bearer") as the wellspring of life. The Virgin and infant Jesus appear above a cascading fountain. Swimming fish in the lower pool indicate that the waters support life and symbolize the graces that flow from Jesus Christ through his mother. The Greek Orthodox Church celebrates the feast of the Life-giving Spring on Bright Friday, the first Friday after Easter Sunday.

An icon of St. Dionysios of Zakynthos, printed on paper, was one of a handful of items recovered from the original St. Nicholas after September 11. Miraculously, the print survived intact, although its silver cover had melted away. The Greek saint is honored for forgiving his brother's murderer.

Archbishop Demetrios, Primate of the Greek Orthodox Church of America, leads 540 parishes, 800 priests, and approximately one and a half million Greek Orthodox Christians in the United States. His commitment to religious freedom for all guided St. Nicholas's rebuilding.

sailing ship built during the late eighteenth century at the very location of the original church, which was named in honor of Saint Nicholas the Wonderworker, the patron saint of travelers, sailors, and wayfarers. Although many of the faithful took the discovery as a sign that the situation would change, negotiations broke down again. To protect its interests, the church sued the Port Authority. Both parties then agreed to an independent engineering study to determine the feasibility of various locations. Finally, a deal was struck in October 2011. The archdiocese swapped its Cedar Street site for the Liberty Street parcel and agreed to a smaller church. The Port Authority bore the expense of constructing the platform and below-ground supports; the church paid for costs from the platform up. From that point, rebuilding moved apace. The archdiocese invited a select group of international firms to compete for the commission, the names of which are protected by a nondisclosure agreement. After months of deliberation, the unanimous choice was Santiago Calatrava.

210

St. Nicholas's design taps into archetypes that have embodied human longing since the first stone was set upon stone. A primary influence was the archetype of the great mother, immortalized at the Hagia Sophia in the *Virgin and Child Enthroned* mosaic. Calatrava painted that image of the Blessed Mother, her son propped on her sturdy knees, followed by an increasingly reductive series of watercolors that yielded the final form of St. Nicholas's dome. Even older is humanity's relationship to Mother Earth, praised by the Greek poet Homer as "Mother of all, eldest of all beings." At St. Nicholas, the image of both woman and earth is conjured by the circle inset into the paved forecourt at the entrance, which delineates a subtly marked ceremonial area. The same diameter as the church's interior space, the circle metaphorically brings the sanctuary outdoors while alluding to cosmological dimensions.

Ancients conceived their temples in relationship to the landscape, aligning them with topographical features, such as mountains, that they believed were endowed with supernatural power. Elevated, illuminated, and the only circular structure at the World Trade Center, St. Nicholas invokes the cosmic center, the primeval point at which heaven and earth connect, which all holy places, whether Mayan temples or Gothic cathedrals, invoke. With its monolithic profile, etched with grooves of the sort that are carved in glacial landforms, the church itself can be read as a sacred mountain. Cut into this mountain is a low, curved entrance, the portal of the hermit's holy cave. The stone veneer that covers the four corner towers is striated. These striations, like rock strata, mark linear time, while the sheltering dome speaks of time outside of time. The church overlooks the memorial pools, themselves inverted iterations of the holy mountain.

In addition to these cosmic allusions, which visitors will intuitively sense, the church is small, scaled to human beings, which gives it an inviting presence. Both beacon and blessing, it anchors the World Trade Center, poetically transmuting its sad past into future hope. Rising amid a vast commercial enterprise, St. Nicholas illuminates eternal, sometimes dissonant truths—us versus them, light versus darkness, wholeness versus brokenness—with forceful simplicity. ▲

...endowed with supernatural power

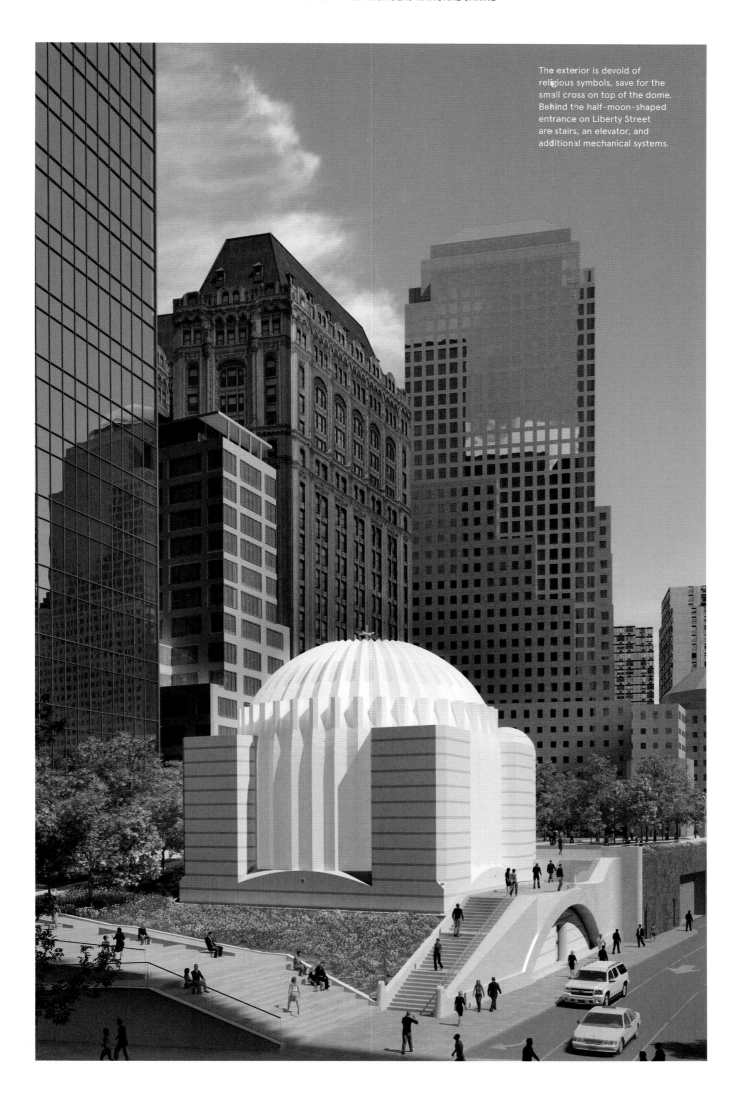

The exterior is devoid of religious symbols, save for the small cross on top of the dome. Behind the half-moon-shaped entrance on Liberty Street are stairs, an elevator, and additional mechanical systems.

As with all his projects, Calatrava's design arose from a richly imaginative period of ceaseless drawing. His watercolors of the *Virgin and Child Enthroned*, a mosaic at the Hagia Sophia, gave form to the new church.

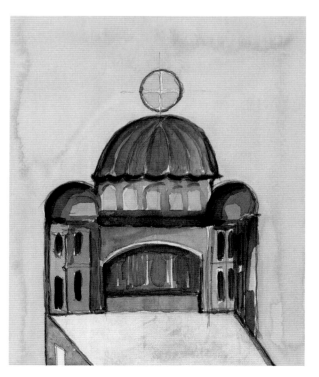
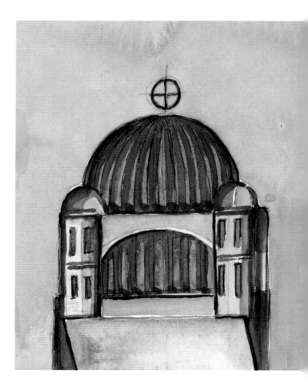

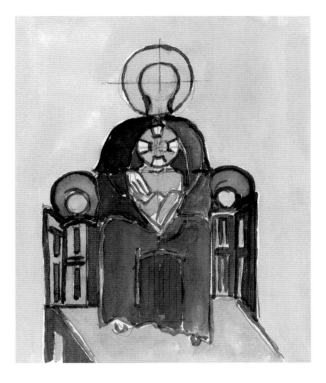

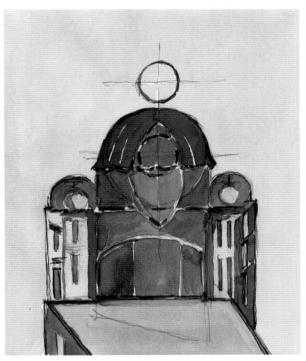

Religion at Ground Zero

Many believe that there should be no religious presence at the Trade Center. Even those who welcome interfaith gatherings say that holding Muslim ceremonies there is still too sensitive an issue. At its heart, the ongoing debate about religion at Ground Zero is a conflict between the sacrosanct belief in individual rights, which dates back to the nation's founding, and the site's exceptional history.

This conflict emerged explicitly in 2010, when Park51, an Islamic mosque and cultural center, sought to build on a location two blocks from Ground Zero and met with divisive acrimony. Many supported the plan, including the Greek Orthodox Archdiocese, which affirmed the mosque's constitutional rights. Once the media and others began referring to the "WTC mosque" and the "victory mosque," a national controversy ignited. Mayor Bloomberg defended Park51, saying, "Our first responders defended not only our city but also our country and our constitution. We do not honor their lives by denying the very constitutional rights they died protecting. We honor their lives by defending those rights—and the freedoms that the terrorists attacked." Shortly after the tenth anniversary of September 11, the mosque opened and, just as quietly, closed.

In July 2014, the Second Circuit Court of Appeals affirmed the right of the 9/11 Memorial Museum to display the Ground Zero Cross, a steel crossbeam that was recovered at the site and that resembles a Latin cross. Mass was said weekly at the cross during the recovery effort, sometimes attracting upward of 300 people, and it became a symbol of hope, faith, and healing for many rescue workers. The ruling cited the landmark 1948 *McCollum v. Board of Education* decision that "for good or for ill, nearly everything in our culture worth transmitting, everything that gives meaning to life, is saturated with religious influences."

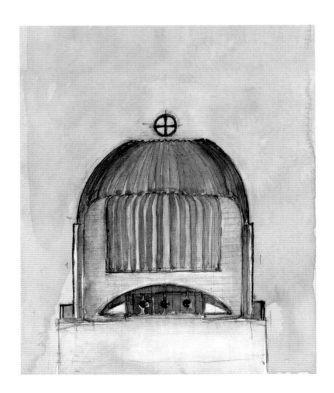

THE NEIGHBORHOOD

4 WORLD TRADE CENTER
3 WORLD TRADE CENTER
2 WORLD TRADE CENTER
LIBERTY PARK

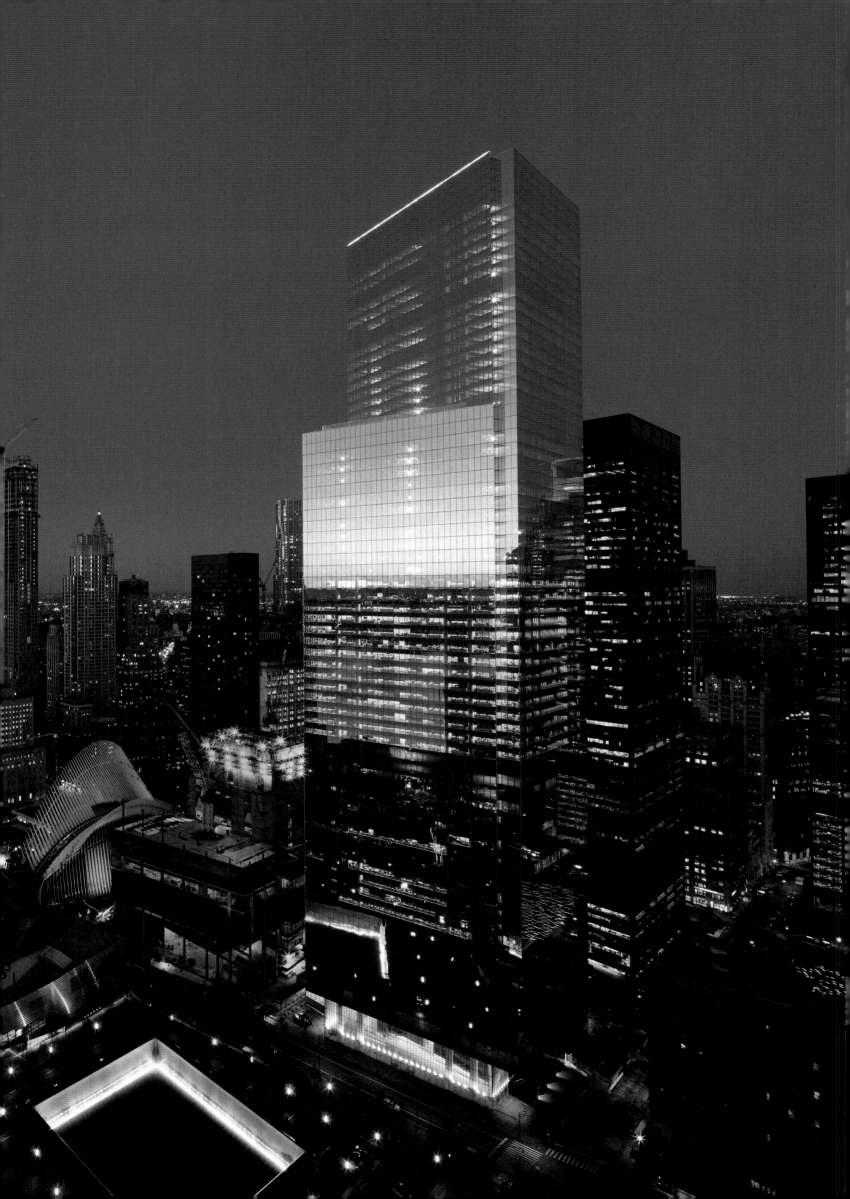

"The city itself merely accommodates a variety of spaces where each individual makes free and selective associations with others, both familiar and strange; the city is a medium through which the individual perceives the outside world. If the architecture that excites us today has to do with investigating qualities of translucency, screening, and the creation of overlapping spaces and visions, this might indicate a sociological trend more than a formal one."

FUMIHIKO MAKI

Space, Territory, Perception, 1997

FOUR WORLD TRADE CENTER

Time magazine partnered with GigaPan in 2013 to create a panoramic photograph from the top of One World Trade Center. A gigapixel in size, the massive image captures views as far as the eye can see. Perhaps the most remarkable sight is hidden in plain view: Four World Trade Center, a 72-story skyscraper, seems to disappear in the photo. Rather than tout its presence, the self-effacing glass tower melts into the sky, reflecting clouds and surrounding buildings. In the photo, the color of the tower is midnight blue, but it is chameleon-like, changing from azure to milky white depending on the weather. Simultaneously set apart from and engaged with the site, the tower arose from Japanese design principles that shaped its quintessential character.

Four World Trade Center was the first new building completed at the World Trade Center, one of five skyscrapers that will eventually encircle the memorial plaza. Designed by the architectural master Fumihiko Maki, the 2013 tower embodies *oku*, a concept of space that Japanese builders have cultivated since ancient times. Rooted in Zen Buddhism, particularly with respect to the transience of all things, *oku* connotes the innermost depth of a building or a place, referring less to measurable distances than to metaphysical and psychological dimensions. Here, *oku* is conjured repeatedly yet subtly in a series of architectural

decisions that invite the individual to engage ever more deeply with the building, the site's recent history, and the primeval past.

The first glimmer of *oku* is apparent from a distance, where the tower seems to disappear into the clouds. When Maki and architect Gary Kamemoto, a director at Maki's firm, saw Ground Zero in 2002, it was still a smoldering pit. Their emotional response to the magnitude of the attacks made them wonder if they should build on the site at all, a reaction that would shape their eventual design. Consequently, when Silverstein Properties commissioned the firm in 2006 to design the tower, Kamemoto said they knew it had to have a "quality beyond that of a commercial high-rise building.... Every single decision always came to this point: that the building should conjure some sense of quietness, serenity, and dignity. We felt that we might be able to make a very strong, positive contribution here to better the place."

It is a three-part invention: the tower's transparent glass base is topped by a parallelogram-shaped body that angles inward at the 57th floor and then rises as a trapezoidal tower. Clad in 11,000 curtain wall units, each consisting of a 5′ × 13′ 6″ high lite with a concealed spandrel section, the tower appears to be made of a single sheet of uninterrupted glass. The lite's outer layer is low-iron glass, which doesn't impart the bluish

the tower seems to disappear...

or greenish tint that a lesser-grade glass would, further emphasizing the tower's ephemerality. Two façade corners, notched from sidewalk to roof, create a shadow that subtly animates the glass envelope.

At midpoint, the tower steps back and points directly at One World Trade Center in a gesture of respect. Located on a corner, diagonally across from One, the tower also marks the place where Libeskind's master plan pivots west. To accentuate this rotation, the designers cut back the trapezoidal floor plate at the 57th-floor terrace. Possibly the best place to see One World Trade Center is from that terrace. If you can tear yourself away from the view and turn around, you also will see One reflected in Four's glass façade, another allusion to realities that extend beyond the physical plane.

In deference to the memorial, the designers eliminated the mechanical louvers, and the noise they emit, on Greenwich Street and placed them instead on the north, south, and east façades. The engineers had to "do gymnastics to get everything off the west face.... We were focused on the impression of the building as it appeared from memorial park. We didn't want to have the mechanical systems, the everyday functions of exhaust and intake, visible on the west façade. We wanted the building to present itself with a certain kind of dignity. Breaking up the surface with louvers would detract from that expression."

Convinced that public places catalyze human connection, Maki emphasizes them in his designs. He has long been a proponent of the increasingly widespread belief that sensitively conceived and beautifully executed designs are not merely "high cultural icing," but a way of caring for others. Designs that are visually delightful, scaled to human proportions, and environmentally sound convey concern for the stranger—the basis of ethical behavior. This life-affirming urbanism is seen in the many gestures of hospitality the tower makes to the wider city. It is reticent yet sociable, contributing to the World Trade Center ensemble while maintaining an individual presence.

Historically, most western city centers were clearly demarcated by a church, municipal buildings, or a rail station. The western-centric model emphasizes the vertical axis between heaven and earth, a sensibility that birthed tall buildings—first cathedrals and, eventually, skyscrapers. Such buildings are beyond human scale and derive a good part of their drama and meaning from that very dissonance in scale. In contrast, cities shaped by *oku* are multilayered compositions with a more passive, flexible determination of boundaries. Their drama is found not in climactic confrontation but in an unfolding realization. Japanese culture privileges these inner depths, beyond that which can be seen. Maki compares this sensibility to peeling away the layers of an onion or opening a package that is wrapped with many different layers, an art form in Japan. Slowly unwrapping an artfully presented package to uncover the treat inside can be as momentous and enjoyable as the treat itself; the journey is as important as the final destination.

The journey into the tower was conceived in four dimensions: the three-dimensional, physical journey from the 9/11 Memorial into the building, combined with the fourth dimension, time. The building changes as one nears it. Abstract from a distance, its carefully conceived detailing comes into focus at street level and continues inside, where its spatial sequencing and rich materials become tangible.

On the western side, the entrances are placed at the north and south corners, set into mini plazas that are carved into the building's footprint. When you enter the building, you walk parallel to the street, a device that Maki uses in nearly all his designs. "You don't turn your back on the street," Kamemoto said. "What happens is people on the sidewalk are walking parallel with you, so you have eye contact. There's a stronger connection between the people within and outside the building, blurring the boundaries between inside and outside."

...conceived in four dimensions

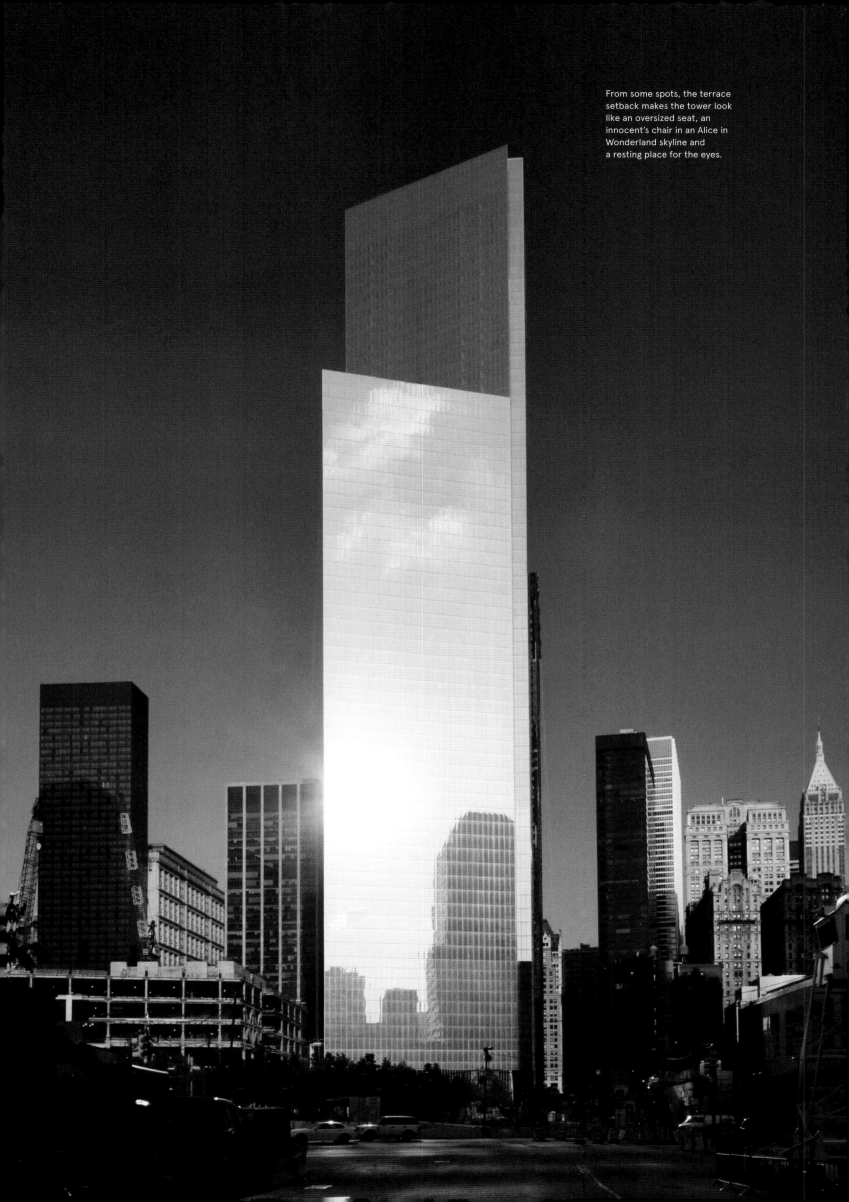

From some spots, the terrace
setback makes the tower look
like an oversized seat, an
innocent's chair in an Alice in
Wonderland skyline and
a resting place for the eyes.

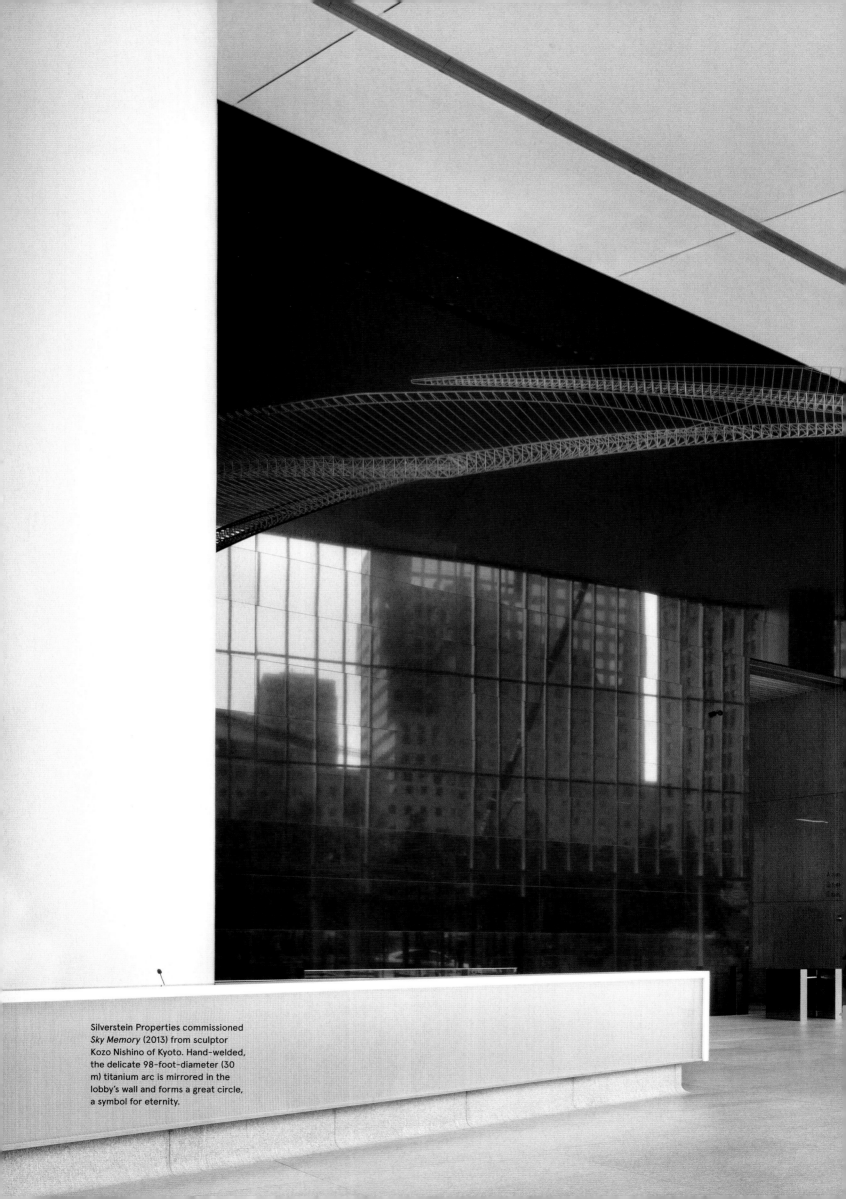

Silverstein Properties commissioned
Sky Memory (2013) from sculptor
Kozo Nishino of Kyoto. Hand-welded,
the delicate 98-foot-diameter (30
m) titanium arc is mirrored in the
lobby's wall and forms a great circle,
a symbol for eternity.

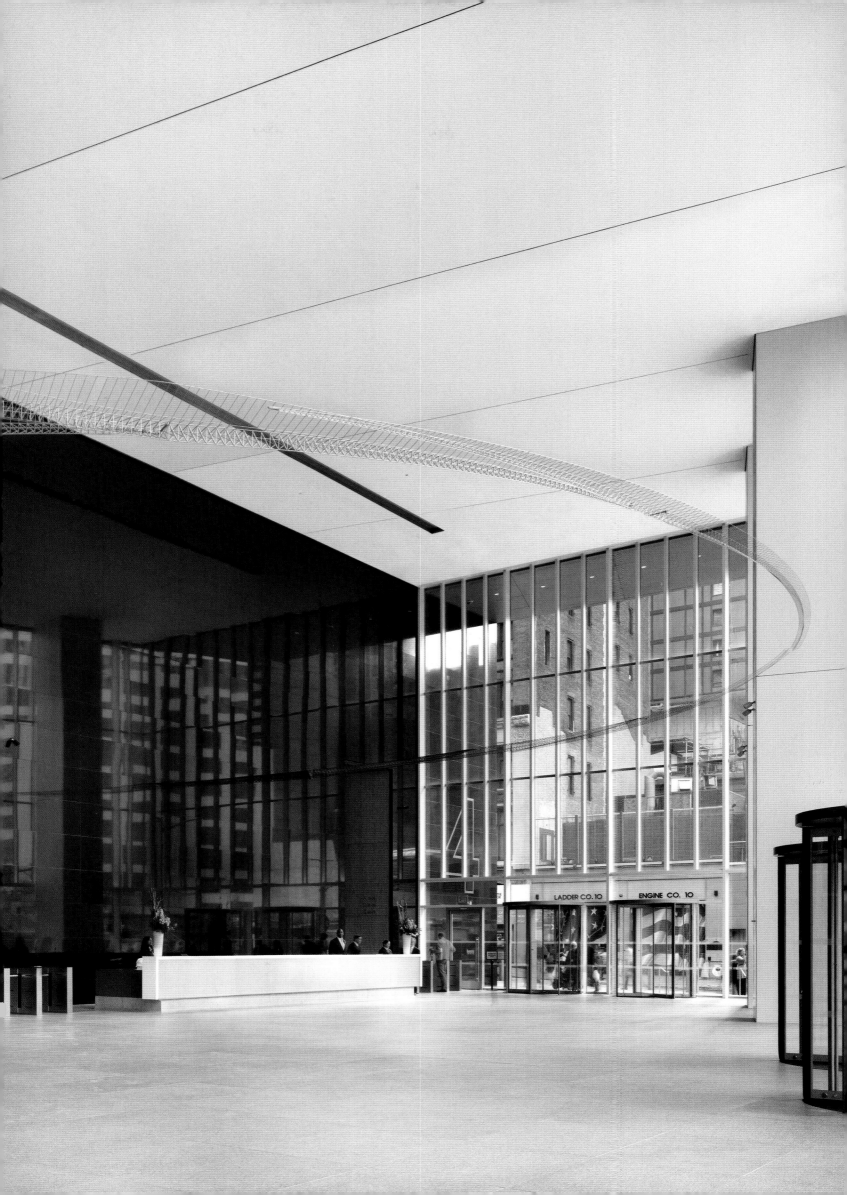

A five-level atrium on Church Street contains spiraling escalators and balconies that access a wide variety of restaurants and shops, enlivening the urban realm. Eataly, a gourmet Italian restaurant and food store, occupies the entire third floor. That floor is a through floor, allowing visitors to walk west and see panoramic views of the memorial plaza.

224

Diana Horowitz has been painting the site's rebuilding from the upper floors of Silverstein's World Trade Center towers since 2007. Her luminous, elegiac oil paintings, such as *World Trade Center Reflecting Pools and Harbor* (2011), capture the extraordinary views and distinctive quality of light downtown.

Inside, the spacious lobby has 47-foot (14.3 m) ceilings and clear glass windows that frame views of the memorial across the street. The main lobby wall is made of fine-grained black granite that, polished to a high sheen, reflects the memorial, the plaza trees, and the viewer in its surface. Seeing a slightly blurred, hypnotic reflection of one's own face juxtaposed with the 9/11 Memorial achieves the same effect that Maya Lin used to create a supremely subjective experience at the Vietnam Veterans Memorial. Here, surrounded on both sides by the actual memorial and its reflection, there is a sense of going back in time—to the events of September 11 and, further, to a time outside of time.

In contrast to the sleek lobby, the elevator corridors partake of primeval beauty. The corridor walls are finished in a honey-colored anigre wood, whose grain recalls the canopies of the memorial trees and reminds visitors of what they've just seen through the front windows. It is coated with seven layers of liquid plastic that protect the wood and impart a mirror-like reflection. Anigre slats on the ceiling recall the sliding screens and roof rafters of traditional Japanese wood construction. Most compelling, however, are three floor-to-ceiling video installations that depict ever-changing scenes of nature on the far walls of each of the corridors. Traveling still deeper, one makes a ninety-degree turn to enter the elevator banks, which are lined in pure white Thassos marble. The walls inside the cars are stainless steel, with an illuminated white ceiling. As one rises up to the office spaces and toward the literal

...going back in time

clouds, the metaphoric journey—from earth (black granite lobby) to wooded nature (elevator corridors) to the sky (white marble elevator banks)—is complete.

To preserve the unsurpassed views of lower Manhattan on the upper floors, the skyscraper's perimeter columns—four sheathed columns, paired in twos—were placed at the edges, which permitted eighty-foot (24.4 m) spans of floor-to-ceiling glass. Structural engineers Leslie E. Robertson and Associates, who also worked on the Twin Towers, accomplished the span, unprecedented in New York City buildings, by using a very deep, eighty-foot (24.4 m) girder. The edge columns are set away from the corners, yielding column-free corners that add to the tower's ethereality. Tishman/AECOM constructed the building. AAI Architects was the architect of record, while Beyer Blinder Belle served in that capacity for the retail portion of the project. Jaros Baum & Bolles provided mechanical and electrical engineering for the tower, and AKF Engineers provided these services for the retail component.

Also on the upper floors, hidden from view, is a sky-high arts colony that has flourished since 2005. Larry Silverstein gave artists—painters, photographers, and filmmakers—workspaces on the raw, unleased floors of Seven and then Four World Trade Center. "There were no expectations from Silverstein for rent or a painting or acknowledgment. Literally, nothing was asked of us. They bent over backward to make things comfortable and easy," said Diana Horowitz, one of the artists who has benefitted from the developer's largesse. Once Seven was fully leased, the artists who were working there, including Horowitz, Jacqueline Gourevitch, Marcus Robinson, and Todd Stone, moved to the upper floors of Four World Trade Center, where they had front-row seats to the hive of construction activity and 360-degree vistas of New York's harbor, rivers, and bridges.

The sensibility implied by *oku* is gaining traction. Technology has untethered presence from place: one need not leave one's living room to take part in a worldwide conversation. Similarly, the city is a unique reality for each person, constructed according to the relationship an individual has with a handful of the places—one's neighborhood, workplace, or favorite bar, for instance—that make up the larger whole. Today, Maki observed, "there are a thousand modernisms for every thousand persons." These multiple, evanescent mental landscapes, rather than physical structure, create the city. In this context, the conceptual thinking behind Four World Trade Center's minimalist design can be better understood. The tower's glass façade both conceals and magnifies what is most essential. Partaking of every passing cloud, it presents an ever-changing face to passersby, all of them peering intently at their cell phones, living in the digital cloud. ▲

225

Fumihiko Maki, seen here in a self-portrait, was born in Tokyo in 1928. He recalls Tokyo as a "great garden city" before U.S. warplanes firebombed it in 1945, reducing sixteen square miles (41.4 km²) in and around the city to ashes and claiming more than 80,000 lives. After studying under Kenzo Tange at Tokyo University, Maki left Japan in 1952, first attending the Cranbrook Academy and then Harvard's Graduate School of Design. He was one of the first Japanese architects to study and work in the United States after World War II. During his extensive travels, the young architect experienced firsthand the relationship between architecture and the city, developing "the notion of an urban order based on a collection of elements," which would guide much of his future work. He was part of the avant-garde Metabolist group, an influential Japanese architectural movement in the 1960s that held that cities were living organisms and should grow organically, propelled by a natural metabolism. After working with Skidmore, Owings & Merrill in New York (1954–1955) and Sert, Jackson and Associates (1955–1958) in Cambridge, Massachusetts, he returned to Tokyo, opening his own firm, Maki and Associates, in 1965. Foremost among his many international distinctions is the Pritzker Prize, architecture's highest honor, which he received in 1993.

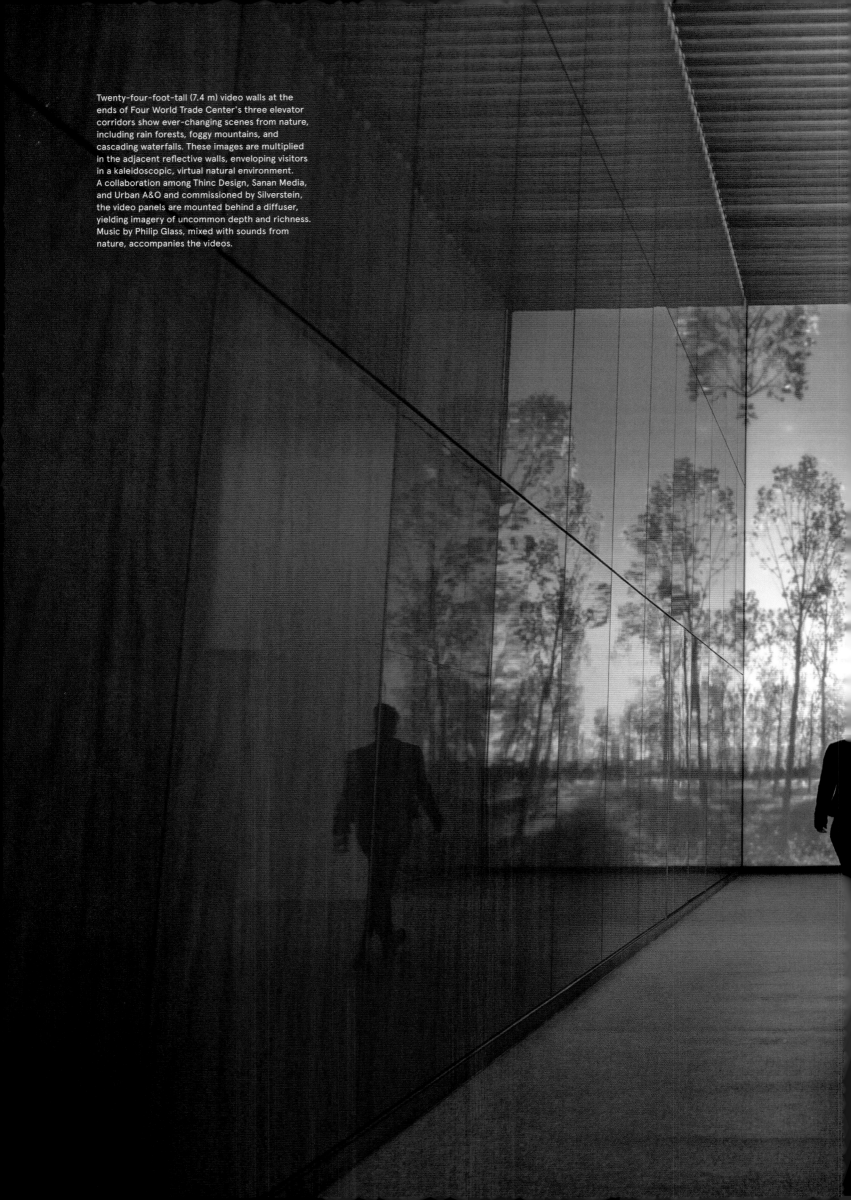

Twenty-four-foot-tall (7.4 m) video walls at the
ends of Four World Trade Center's three elevator
corridors show ever-changing scenes from nature,
including rain forests, foggy mountains, and
cascading waterfalls. These images are multiplied
in the adjacent reflective walls, enveloping visitors
in a kaleidoscopic, virtual natural environment.
A collaboration among Thinc Design, Sanan Media,
and Urban A&O and commissioned by Silverstein,
the video panels are mounted behind a diffuser,
yielding imagery of uncommon depth and richness.
Music by Philip Glass, mixed with sounds from
nature, accompanies the videos.

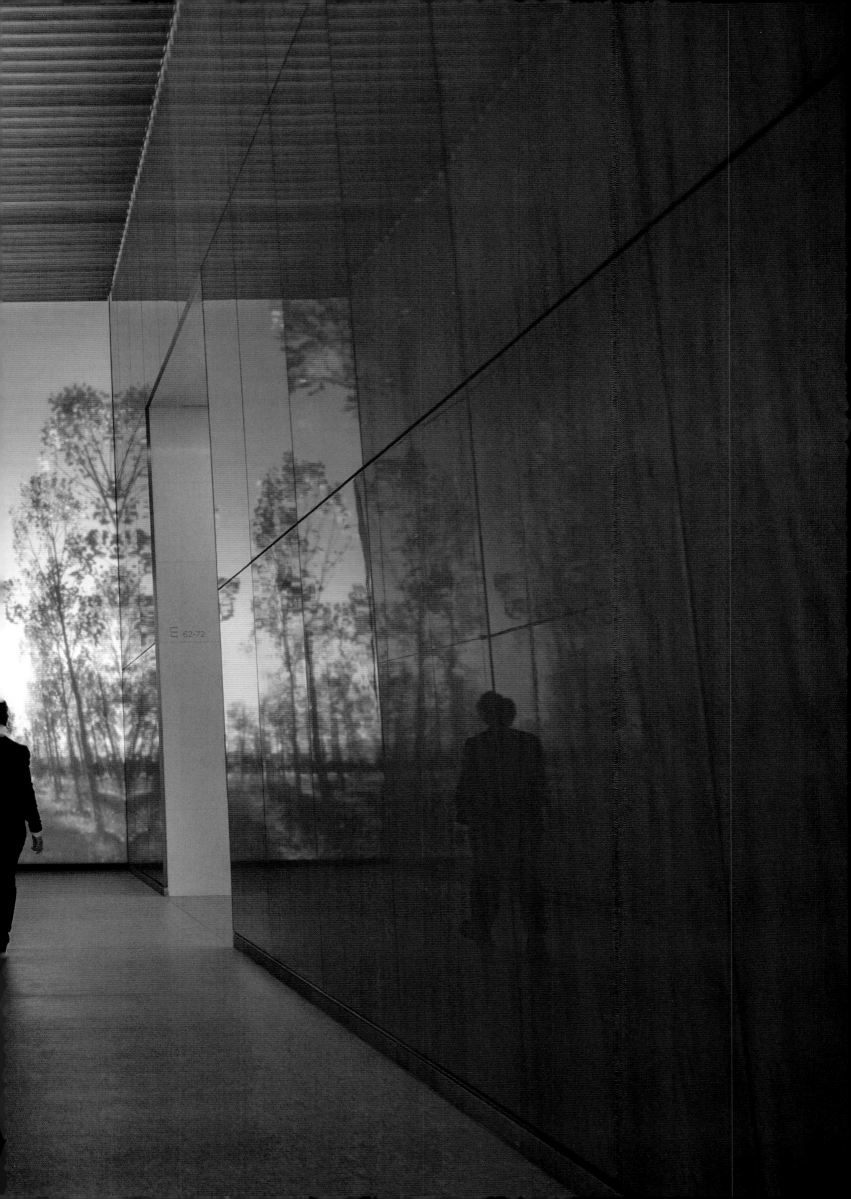

"This is not just any development project—this is the World Trade Center. Yes, we must build it to create jobs and continue the transformative progress downtown and build it so that a completed World Trade Center can realize its full potential as an economic driver for the region. But, just as importantly, we must build it because completing the World Trade Center site is our collective duty."

PATRICK J. FOYE

Executive Director of the Port Authority, addressing the agency's board, April 23, 2014

THREE WORLD TRADE CENTER

Boldly designed by the architect and urbanist Richard Rogers, Three World Trade Center rises eighty stories, a sculptural and steely presence in a neighborhood of sleek glass. A compelling building, whether considered aesthetically or politically, it illuminates the financial considerations that determined the rebuilding of the World Trade Center, and sheds light on how skyscrapers, structures that are particularly vulnerable to the vicissitudes of the economy, are funded. The story of its financing reveals how public and private funding influences large-scale commercial construction, and also offers a rare look into the Port Authority's internal governance.

Architects Rogers Stirk Harbour + Partners designed the tower with a façade layered with steel screens and braces that catch sunlight, reducing the visual bulk of the 2.8 million-square-foot (260,128.5 m²) building. This treatment also allows the public to "read" the building and understand the structural logic of its construction, a hallmark of Rogers's work ever since he designed Paris's no-frills Pompidou Center, or Beaubourg, in 1977 with Renzo Piano, both of them unknown architects at the time. Since then, Rogers has shaped understanding of what makes cities livable— density, lively communal spaces, renewable energy, and access to mass transit—giving early voice to an

urban ethos when there was almost no discourse on the subject. Knighted by Elizabeth II in 1991 and a 2007 Pritzker laureate, Rogers likes to quote an ancient Athenian oath, which young men had to swear to before they became full citizens: "We will leave this city not less, but greater, better, and more beautiful than it was left to us."

On all four sides, the façades are set back, angled, and undercut, so the building becomes progressively more slender as the tower rises to its full height of 1,170 feet (356.6 m). The stepped profile enhances views for tenants on the upper floors and, in a civic gesture, views from the other towers as well. Per the master plan, the building had to complement the memorial precinct. Accordingly, its low, eight-story podium frees up air and light around the plaza. On Greenwich Street, the triple-height glass façade subtly reflects the memorial.

The tower is built around a concrete core, yielding column-free floors with unobstructed views, collaborative work environments, and reduced build-out costs. "The efficiency that comes from column-free space is staggering," said Larry Silverstein, who is developing the property. "We can fit more people with their rear-ends on chairs at desks on each floor in any one of our buildings much more effectively and efficiently than you can in buildings that are fifty, sixty years old, where you have a ton of columns.... Even though the rate per square

228

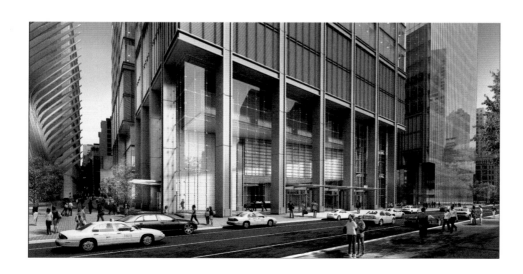

Rising from an eight-story base, the tower houses five trading floors, fifty-four office floors, and eight mechanical floors. With energy costs that are significantly lower than a typical Manhattan office building, it is slated to earn LEED Gold Certification once it opens in 2018. Adamson Associates was the architect of record; WSP USA was the structural engineer.

The glass cable-net façade on Greenwich Street creates a sense of welcome and subtly reflects the adjacent 9/11 Memorial. Inside, the lobby ceilings rise sixty-three feet (19.2 m).

...what makes cities livable

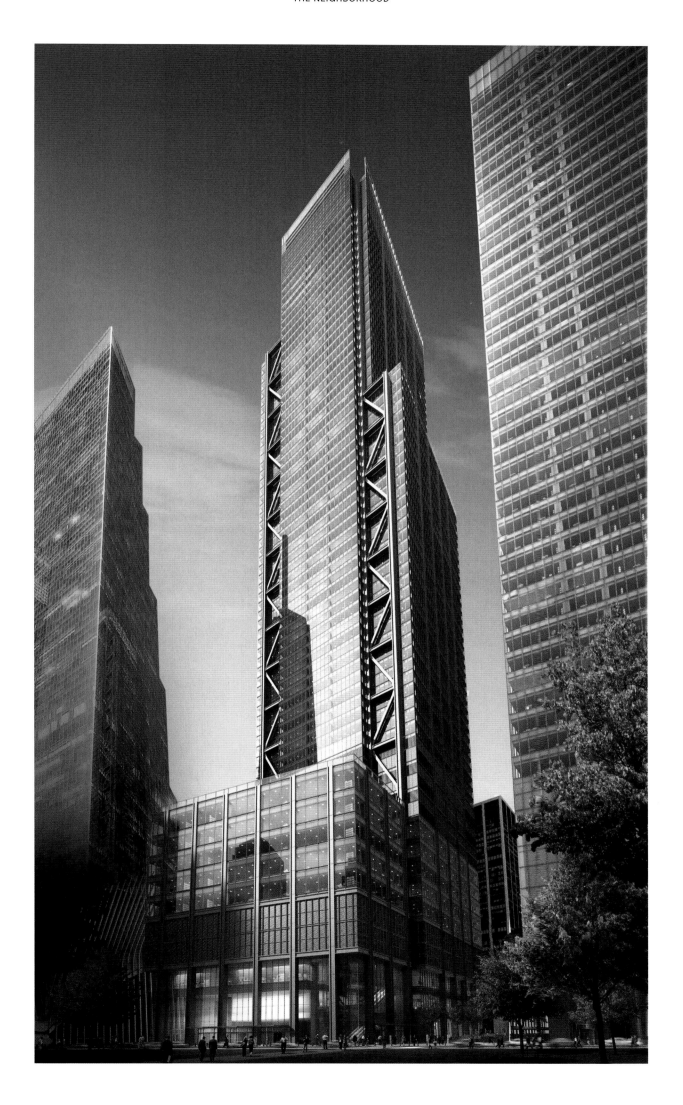

"We rebuilt, we resolved, we learned, and we keep learning."

SCOTT H. RECHLER Port Authority Board Member, 2014

foot is higher, the density is so much greater." Tenants can build out their floors with fewer materials, lowering their construction costs. All Trade Center tenants receive additional economic benefits, including city and state tax incentives and the right to buy electricity for less than it costs elsewhere.

In August 2010, the Port Authority and Silverstein Properties negotiated a deal that allowed the immediate construction of the tower's podium, which was needed to accommodate the Transportation Hub's mechanical systems and other critical infrastructure. Under that agreement, the onus of securing private financing of more than $1.6 billion and finding a tenant to occupy at least 400,000 square feet (37,161.2 m²) of space fell to Silverstein. Once he obtained these private-sector contributions, $600 million in public-sector support from the City and State of New York and the Port Authority would be released for construction and backstop support. Construction then stopped, however, while the Port Authority and Silverstein hammered out how the rest of the building would be paid for. These contentious, highly publicized negotiations took years to conclude.

Then, in December 2013, the media firm GroupM inked a twenty-year lease for nine floors, meeting one of the conditions of the 2010 agreement. Once the building is completed, the firm will move 2,400 employees downtown from midtown. All parties agreed that GroupM's move, the largest tenant relocation in the city in 2013, was a good thing, continuing the leasing surge downtown. However, in light of the changing real estate market, with commercial lending volume down, Silverstein was unable to meet the remaining conditions of the agreement. To move forward, he wanted to restructure the agreement, asking the authority to increase its support from $190 million

to $1.2 billion. With little leasing activity at One and Four World Trade Center, the Port Authority was faced with a difficult decision: stick with the 2010 agreement and lose a significant tenant in GroupM, slowing overall momentum at the site, or restructure the agreement so construction of Three could proceed.

Fanned by the press, which portrayed the developer as looking for yet another handout, Silverstein's request polarized opinions, including those of the eleven members of the Port Authority Board of Commissioners. Proponents of a new deal contended that completing Three World Trade Center was essential to the fortunes of still-fragile lower Manhattan, and one that would ultimately get the Port Authority back to its core mission of regional transportation; the only way to get out of the real estate business, they reasoned, was to have something to sell. Completing Three would also create thousands of jobs and secure new office tenants that would yield future income for the authority. Failure to complete the skyscraper would also wipe out tens of thousands of square feet of retail commitments, which Westfield controlled, depriving the authority of still other income. Critics argued that it made no sense to subsidize a building that would compete for tenants with other nearby buildings, including One World Trade Center, which, at the time, was about half leased. Disgruntled commuters believed that the authority should spend its money on repairing its bus, rail, and airport terminals. Board member Kenneth Lipper agreed, saying, "We are triaging necessary transportation improvements to finance what will be an empty building." The public also weighed in at the board's meetings, with commentaries that ranged from vitriolic denunciations of both agency and developer to pleas on behalf of the union laborers who depended on the site for their livelihoods. Janno Lieber, Silverstein's

...Silverstein's request polarized opinions

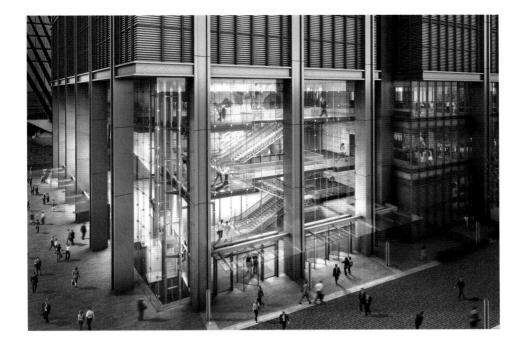

To appeal to New Yorkers, who traditionally prefer shopping at street level, three floors of shops are easily visible and accessible from the sidewalk; two additional retail levels are below ground. There is in-building access to eleven subway lines and the PATH train, a boon in bad weather.

project director at the World Trade Center, regularly attended these meetings. He said that demonizing his organization had "become routine," and that "a lot of what you hear month after month is akin to the sightings of the Loch Ness monster, because the truth is that Silverstein had received after the court battles $4.5 billion and has given $3 billion of that to the Port Authority and the balance has gone into building the buildings. So let us be clear. There is no mystery about where the money has gone."

With the agency's board divided and the public-private hybrid agreement still in its infancy, the decision on Silverstein's request was postponed three times. Scott H. Rechler, a real estate executive and then acting chairman of the Port Authority's board, led the board's efforts to choose between two options: provide a loan guarantee for up to $1.2 billion of financing and in return receive hundreds of millions of dollars in new revenue for the cash-strapped agency, or pursue a public-private hybrid that modified the 2010 agreement but limited the Port Authority's exposure. Opponents argued that it was foolhardy to subsidize the tower when there was a glut of office space. Rechler disagreed, saying that 2014 saw the "biggest recovery of lower Manhattan in over a decade in terms of the velocity of activity—almost four million square feet [371,612.2 m²] of space was leased and two million absorbed, meaning vacant space taken off the market." Silverstein was more succinct: "Glut ain't the case. It's a fiction, not a reality." Moreover, Silverstein pointed out that he was not asking for a subsidy but for a guarantee of debt for $1.2 billion, half the cost of building the tower. Of the octogenarian developer's drive to complete the building, the Port Authority's executive director Patrick Foye said, "Relentlessness is the first characteristic required for success."

Throughout its hundred-year history, the Port Authority has made many of its decisions, especially controversial determinations such as those on Three World Trade Center, under a veil of anonymity in closed executive sessions. Many of its commissioners believed it was time to exercise greater transparency. Consequently, when the board met in June 2014, Rechler did something that, if not unprecedented, was nonetheless extraordinary: he asked each commissioner to vote publicly on the Silverstein matter. A video documenting this vote, and the discussion that attended it, is available online in its entirety. The agency and Silverstein finally reached an agreement on June 25, 2014. The Port Authority agreed to modify the 2010 agreement, releasing to Silverstein $159 million in insurance proceeds and making available up to $80 million that had been committed previously for construction overruns. In return, Silverstein would take back two of the fifteen floors that the authority had leased at Four World Trade Center. Silverstein said he would seek $1.3 billion in private financing and "immediately jump-start vertical construction." True to form, Silverstein began building the remainder of Three the very next day.

Later, Rechler wrote a gutsy article about the deal struck at Three, which he believed signaled a shift in the way the agency conducted its business. No more rubber-stamped deals made behind closed doors. Instead, the Port Authority could craft the best possible outcomes for itself and the region by becoming more open and soliciting input from the board and the public. Months of open debate at the Port Authority concluded with an agreement that struck a balance between the agency's public- and private-sector commitments. The process that led up to it provided the opportunity to show that it was, in Rechler's words, a "new day at the Port Authority and, similarly, a new day down at the Trade Center."

231

"relentlessness is the first characteristic"…

TWO WORLD TRADE CENTER

Two World Trade Center, designed by Bjarke Ingels Group (BIG), is a stack of seven massive glass cubes that morph and step in as they ascend—an ambitious skyscraper that looks wildly inventive from some angles, yet demure from others. BIG's founder, Bjarke Ingels, described the arrangement as "a vertical village of bespoke buildings within the building," one that can be tailored to various uses. When completed in 2020, the asymmetrical tower will stand 1,340 feet (408.4 m) tall and complete the spiral of four skyscrapers that encircle the 9/11 Memorial.

BIG's tower will be built atop a foundation designed by Foster + Partners, the original architects chosen by Larry Silverstein in 2005, when Ground Zero was still in flux. One deduces that Silverstein selected Foster, Rogers, and Maki, a trio of Pritzker laureates, for their flawless track records. And rightly so—there was too much at stake, and too much that remained unknown, to take a chance on a young architect like Ingels.

Fast forward ten years to a Trade Center aloft with glittering towers, tenants, and tourists. Even the announcement that BIG would design Two was a clear sign that this was not business as usual—the news broke on WIRED, a technology blog, rather than in an architectural publication. It was accompanied by a full social-media press that included a three-minute video set to Tchaikovsky and featuring Disney-like touches. In the video, Ingels, with the flick of a finger, draws an outline of a Tribeca warehouse that is seven stories tall. A snap of the fingers, and, voilà, seven cubes waft down and form an eighty-story tower. He makes it look so easy. And that, after fifteen years of laborious progress at the Trade Center, is good news.

Two's design melds the idealism of Daniel Libeskind with the pragmatism of David Childs—and takes advantage of the passage of time. Had it been released in 2005, Ingels's design might not have survived. But as the last of the towers to be erected, it benefits from the trials of those that came before it. What starts out as a grand and uncompromising set of ideas, of course, can become a substantially different reality once it is built. However, the exuberant tower is a bellwether for just how much has changed and will continue to change downtown.

When BIG's design was revealed, Two was little more than the collection of silvery air ducts and other mechanical systems that it houses on behalf of the Transportation Hub. The foundations had been built to accommodate the site's shared infrastructure, but further construction languished after the 2008 recession. Once Two's anchor tenants, Rupert Murdoch's 21st Century Fox and News Corp, signed on, they chose BIG to design spaces that would deliver the large broadcast studios and newsrooms they required. The change in use from financial services to media was ostensibly the reason Foster's design—which many considered the finest of the Trade Center buildings—was bumped.

Still, Silverstein was cautious about embracing Ingels's design. "My first reaction, my second reaction, and my third reaction were: 'Will this work?'" he said. But there was little doubt that the developer would

232

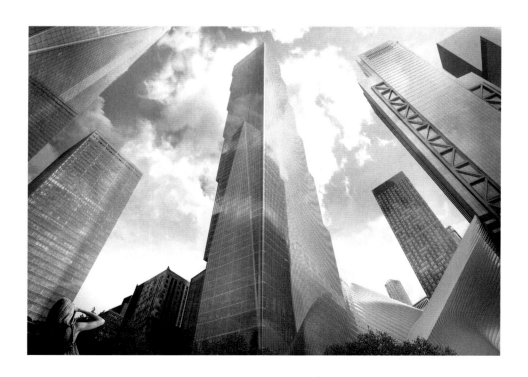

..."a vertical village of bespoke buildings"

Two rises up into the skyline in a series of seven cubes. Tickers underneath the edges of the cubes on the north side enlace the media headquarters with news. Its profile recalls other cuboid structures, particularly Renzo Piano's 2013 design for the Paris Courthouse and SANAA's stacked New Museum of Contemporary Art in the Bowery, completed in 2007. Adamson Associates was the Architect of Record, WSP USA was the structural engineer, and Jaros Baum & Bolles was the mechanical engineer.

To encourage creative collaboration, the high-rise features open work floors, large stairwells that form cascading double-height communal areas, and amenities such as basketball courts, a running track, and screening rooms. "It'll be pretty epic," Ingels said.

Two's planted terraces look down into the mossy churchyard of the venerable St. Paul's Chapel (1766), once a refuge for 9/11 rescue and recovery workers. To preserve the views of the chapel from the memorial plaza, the building is aligned along the Wedge of Light plaza proposed by master planner Daniel Libeskind.

"Your capacity to communicate ideas *is* your hammer and chisel."
BJARKE INGELS 2012

234

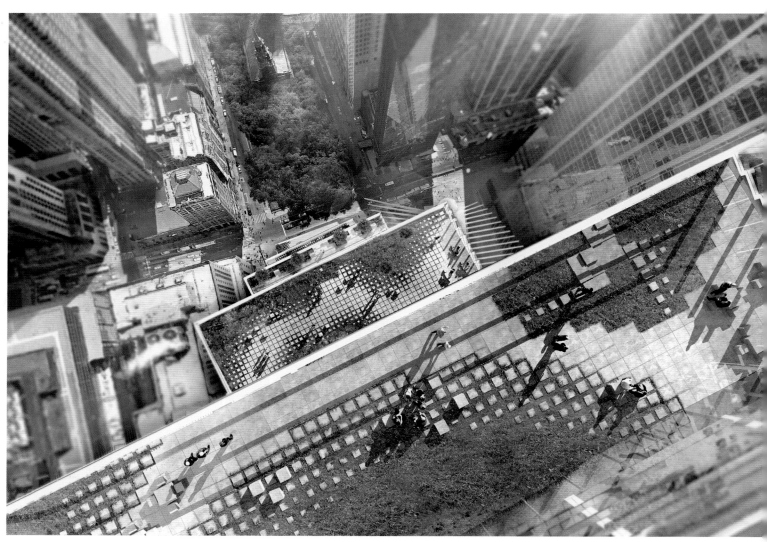

Increasingly, skyscraper amenities include the outdoor spaces that urban tenants prize. BIG's stacked design creates 38,000 square feet (3,530.3 m²) of gardens, lush with greenery and spectacular views of the surrounding cityscape.

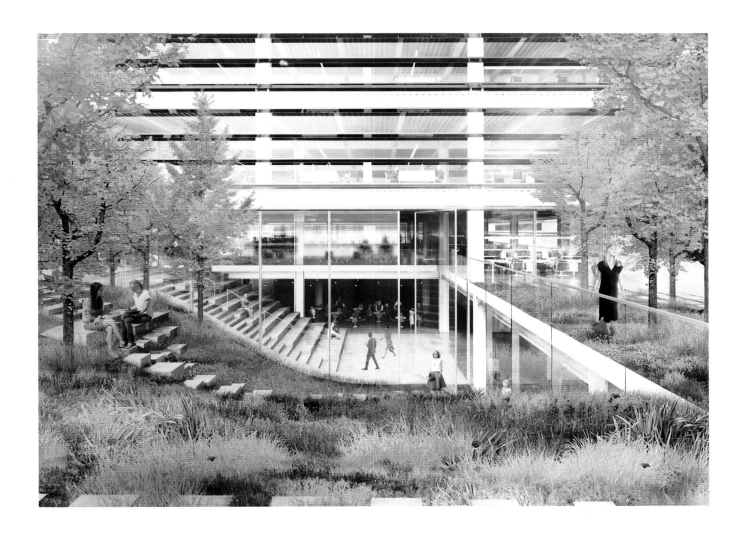

235

approve Murdoch's selection of Ingels, which would cement Silverstein's legacy at the site and bring the rebuilding to a close. The deal also signaled a shift in how skyscrapers are designed: the tenant specified the spaces, which shaped the building, instead of making do with an existing design.

The tower rises in a series of in-and-out steps. On the north face, the cubes project out over the base, their undersides animated with news tickers. On the east side, they step in, a nod to the setbacks of classic 1920s office buildings, yielding six expansive garden terraces. The design creates the optical illusion that Two is leaning toward One World Trade Center, but the tower does not actually lean. "Even though they are not twins [and] they are not identical, they have a sibling relationship going on," Ingels said.

Many of the tower's adjoining floors are open, extending sight lines and allowing people to see colleagues five floors above or below. This configuration undoes "the vertical segregation that normally comes from working on multiple floors"——a solid design

concept, but hardly a new one, having been utilized for decades by architects, most notably by Norman Foster. Yet Ingels's precocious confidence is contagious, and his exploration of the overlap between the pragmatic and the utopian will introduce new audiences to the possibilities of architecture and design.

Within hours of the design's publication, people compared the cubes to a "stairway to heaven," which is how it appears when looking south. A simplistic assessment, but one that speaks to the reality that every building on the site shoulders the task of remembrance. The stairway, which looks capable of rising infinitely higher, recalls the many who took the stairs on 9/11——the firefighters who courageously climbed the Twin Towers and all those who, unable to descend, ascended into eternity. An office building, Two also functions as a memorial, just as One does. But while One bears the weight of the past, Two is free to look to the future. In a fitting final project that will complete the World Trade Center, Ingels's skyscraper invites us to imagine what's next.

the tower does not actually lean...

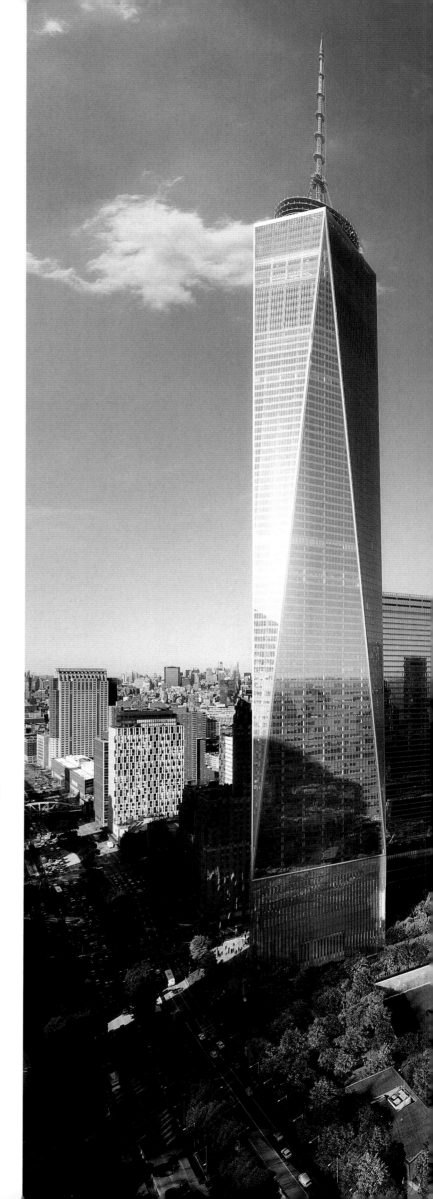

Young, articulate, and telegenic, the Danish architect **Bjarke Ingels** is a self-styled epicenter of fun, having it and poking it. His mantra, "Yes is more," also the title of his 2009 archicomic, a monograph cum manifesto written in comic-book form, synthesizes Mies van der Rohe's modernist dictum, "Less is more," Robert Venturi's postmodernist take, "Less is a bore," and Philip Johnson's quip, "I am a whore." He is a force field of charismatic cool and Icarian swagger. Even his mother calls him Mr. Big. His first completed project in the U.S. was a 2012 installation titled *Times Square Valentine*, which featured a ten-foot-high (3 m) pulsating red heart—an appropriate image, given the love that America has shown BIG's designs in the years since. The architect briefly worked for Rem Koolhaas, whom

he credits for teaching him that buildings must respond to a given circumstance, rather than fit into a predetermined style, before starting his own firm in 2001. He quickly amassed a body of admired work in Denmark, including 8 House, in Ørestad, the profile of which mimics a mountain. He moved to Manhattan in 2010 to oversee his design of VIA 57 West, a pyramidal apartment tower on West 57th Street, developed by the Durst Organization. Another New York City project, the Dryline, is a hybrid storm-barrier-and-park along New York City's riverbanks, built to deter flooding. With English architect Thomas Heatherwick, he is designing Google's new headquarters in Mountain View, California, a climate-proof expanse of sixty acres (24.3 ha) that sits under four glass canopies.

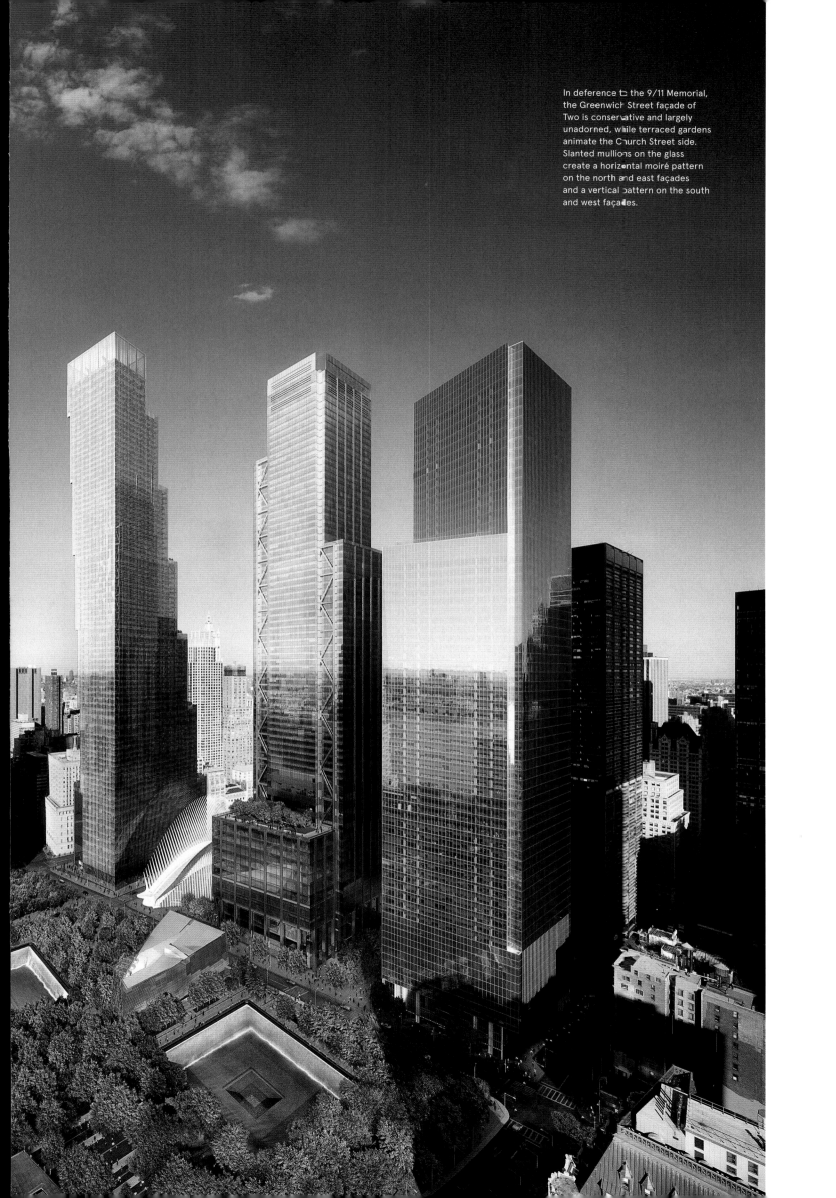

In deference to the 9/11 Memorial, the Greenwich Street façade of Two is conservative and largely unadorned, while terraced gardens animate the Church Street side. Slanted mullions on the glass create a horizontal moiré pattern on the north and east façades and a vertical pattern on the south and west façades.

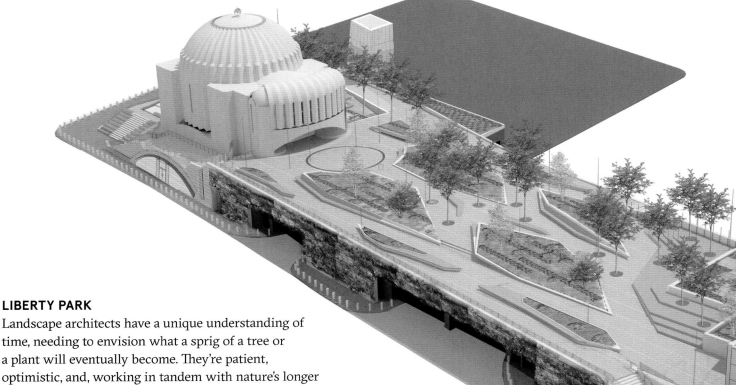

LIBERTY PARK

Landscape architects have a unique understanding of time, needing to envision what a sprig of a tree or a plant will eventually become. They're patient, optimistic, and, working in tandem with nature's longer continuum, often wise. Long-term thinking shaped the design of Liberty Park, a tiny jewel of an oasis that was conceived as a counterpoint to the 9/11 Memorial and a colorful camouflage and green roof for the Vehicle Security Center beneath it. Running the length of Liberty Street, the park is a literal and metaphoric bridge that crosses the West Side Highway, connecting Battery Park City to the rest of lower Manhattan. It is one of the few places offering elevated views of the memorial plaza. Colorful plantings, a variety of places to sit, and numerous pathways invite the community to linger and explore this vibrant spot.

Liberty Park was designed by the Downtown Streetscape Partnership (DSP), a joint venture of AECOM and Jacobs, Inc. Jessica Forse of Jacobs, the engineer of record, managed the DSP team of engineers, architects, and landscape architects. The landscape architectural design was led by Joseph E. Brown, along with Andrew Lavallee and Gonzalo Cruz, all of AECOM, and a team of twenty-five others. Port Authority architect Carla Bonacci, assisted by Christa Rotolo, delivered the park on behalf of the authority, which owns it.

If the park's convivial landscaping is the icing, the cake is its enabling structure: a feat of engineering design that allowed a public park to be built atop the Vehicle Security Center, a state-of-the-art screening checkpoint for all vehicles entering the site and its most security-intensive area. In addition to the site's natural slope, which drops eighteen feet (5.5 m) from east to west, the park had to accommodate the steep drop-off of the spiraling ramp inside the vehicle checkpoint. St. Nicholas, the Greek Orthodox church on the park's eastern end, also had specific ceremonial needs. Further, its design had to work around a number of ventilation shafts that lay on the roof or rose above it. To meet these demands, engineers and landscape designers came up with ingenious solutions, many of them invisible to the unseasoned eye.

Landscape architect Joseph E. Brown described the park as a "lifted landscape" that was designed to express the idea of connection. Initially, the plan was to block foot traffic on the south side of Liberty Street, where the Vehicle Security Center entrances are located, but this was an anathema to the larger goal of restoring street circulation. "Let's get people off that sidewalk and into the park," Lavallee said. "We convinced the Port Authority to cantilever the roof of Liberty Park, extending it like a canopy over the sidewalk." This allowed the garage doors to be recessed and created an upper overlook onto the memorial plaza, which sits about twenty-five feet (7.6 m) below it. Asked how contemplation of the memorial will mesh with the thunder of commercial traffic entering just below, Brown said, "People are immune to street noise in New York City," and, as is often the case, he was right.

Memorial designers Michael Arad and Peter Walker initially dismissed the idea of the park's overlook because they didn't want people looking down at grieving visitors, although several million square feet of office space also have views of the plaza. Arad also felt the memorial's solemnity would be diminished by the Vehicle Security Center's façade, which is directly across the street. In response, the designers built a "living wall," a 300-foot-long (91.4 m) wall of evergreen plants, including periwinkle, pachysandra, and Baltic ivy, which covers the center's northern façade and softens the views south from the memorial. "We chuckled at first when we heard we were going to build a green wall on the north side of the building, because that's a tough place

From above, the 1½ acre (0.6 ha) park looks like a natural landscape, cut by a river of pathways, studded with rocks, that run up to meet St. Nicholas Church, itself a metaphor for a sacred mountain. A 300-foot-long (91.4 m) "living wall" camouflages the Vehicle Security Center's northern façade.

to get plants to thrive," Lavallee said. No matter how beautifully clad, the screening center was going to look like the massive structure it is. "Ultimately, we created a stone base on one end that effectively was the church entrance at the street level. At the other end was the landing for the bridge. Those two masonry bases were the bookends, softened in between with the green wall."

Planters define the park's pathways and subtly direct pedestrian traffic. They have angular, fractal shapes, a nod to the fractured aesthetic of Libeskind's master plan and Snøhetta's Pavilion. These jagged shapes also allow for diagonal movements through the park, making it feel less formal, especially in contrast to the memorial plaza. "We chose not to go with wiggly, dendritic shapes, but with bold shapes that rise and fall," Brown said. "This creates a slight sense of enclosure without making people feel as though they could get lost." To create visual variety, the planters tilt in multiple directions, angled to showcase the garden plantings as one walks in either direction. They also accommodate recycled teak benches with backs to support those with disabilities.

Visitors enter the park from all four corners via a series of staircases and ramps. The grand staircase on Greenwich Street was deliberately placed parallel to the church to direct views north to the site. Composed of stepped terraces with seating, this hospitable staircase

provides a logical meeting spot and also offers a place to decompress after visiting the memorial. In the southwest corner, another series of stepped terraces creates an informal amphitheater setting. It was configured to keep people off a secure area over the Vehicle Security Center; to avoid fencing the area, the designers devised the stepped stairs, which function as a wall and frame a garden full of plantings, another deterrent to foot traffic.

To accommodate St. Nicholas, they placed it atop a stone base so that it appears to be built on a plateau, reminiscent of how churches are sited on Mediterranean hillsides. To avoid making the church feel like an obstruction that people had to walk around, they "wrapped the landscape up to it in some places," and in others allowed pedestrians to walk along the building. Although Calatrava wanted to eliminate the park altogether so his church could sit on a flat plaza, they agreed on a curved forecourt in front of the church. Fortunately, according to Lavallee, these negotiations yielded "an open space of a scale that we didn't have previously in the park."

Placing, sizing, and disguising the five above-ground ventilation shafts that service the lower garage required deft planning. Typically, such shafts are a security nightmare, since people can cause air contamination by throwing things into them. Here they were located with standoff distances of ten to twenty-five feet (3 to 7.6 m) between them and the public. Since the Vehicle Security Center and its exhaust systems were designed before the park, DSP had to work around them. "We pushed and pulled the heights of these vents, twisting their shapes to allow a park to happen.... We were finally able to create standoff and security by wrapping the landscape around them in some places or by lowering the grade around them, the finished grade on the roof, to minimize their height." The designers used strategic cladding to minimize the exhaust towers' visual impact, covering the vent near the West Street crossing, for instance, in the same materials as the bridge so it would appear to be a part of that structure. The two vents by St. Nicholas are clad in matte glass that magnifies the greenery around it. In all cases, Lavallee said, the idea was to make the ventilation shafts "feel like architecture, intentional and not hidden with vines or other silliness."

In many ways, the park represents in a microcosm what is best about New York City — the unexpected moments of delight that occur while walking along its teeming sidewalks. Because it is not possible, or desirable, to prescribe the actions of millions of visitors, and because so many requirements and structures had to be accommodated within a mere sixteen acres (6.5 ha), structural diplomacy was paramount. In this regard, Liberty Park represents a civilized and gracious pause in the overall scheme and is a welcome addition to lower Manhattan. ▲

239

unexpected moments of delight...

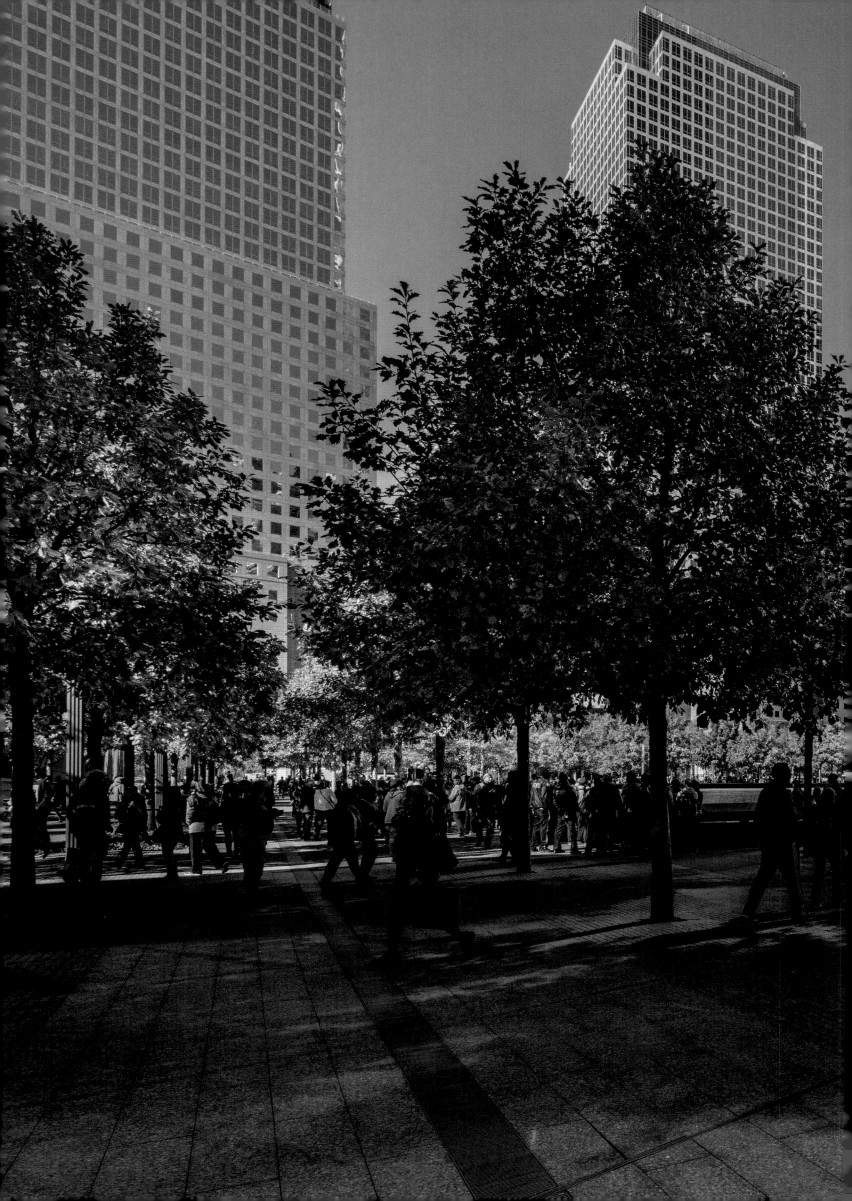

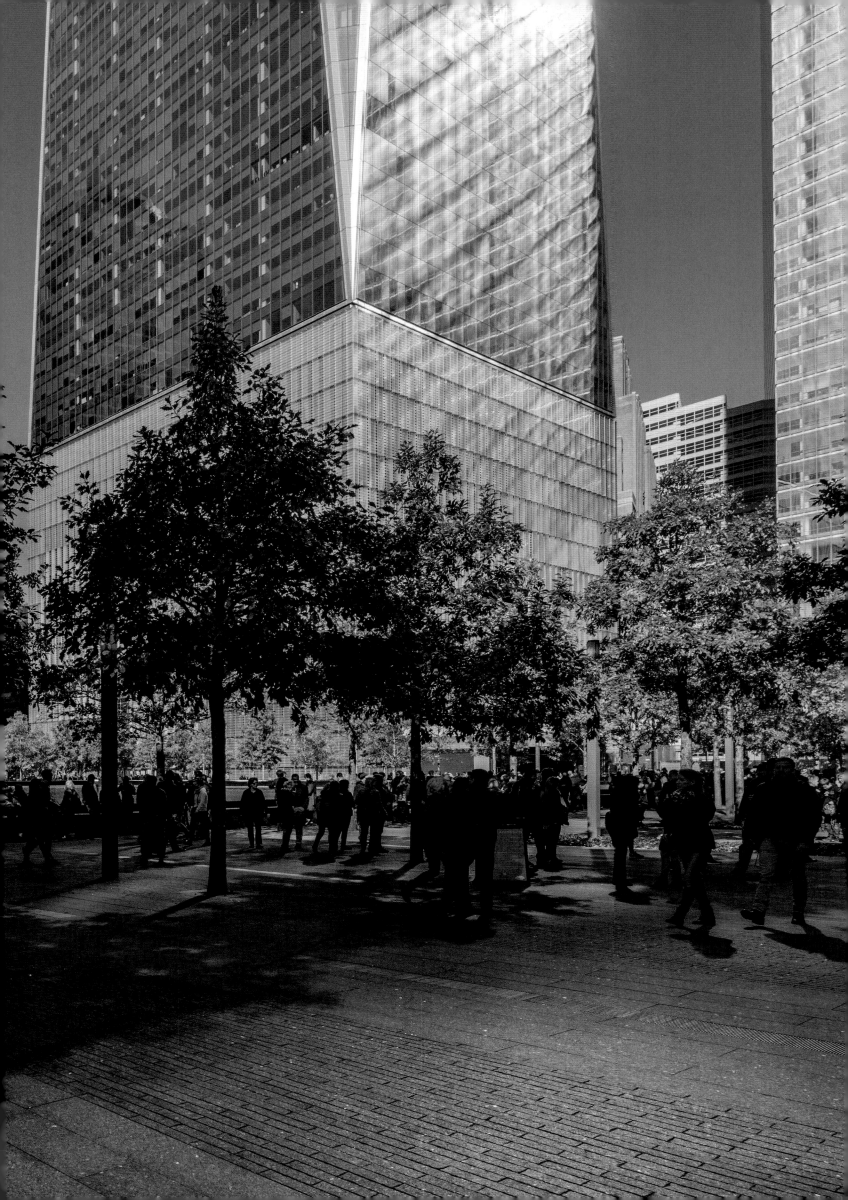

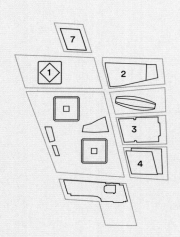

SIXTEEN ACRES

HOSPITALITY, SAFETY, AND SECURITY

On any given day, the World Trade Center plaza is jammed with people, most of them oblivious to the unstinting, largely invisible efforts that have been taken to protect them. The Port Authority's overarching goal was to create public areas that are lively, hospitable, and terrorist-proof and that would "reintegrate this development back into the community. That was first and foremost," says Port Authority architect Carla Bonacci, whose office developed the plaza's overall plan and the materials palette for the streetscape and commercial buildings.

Half of the plaza's sixteen acres (6.5 ha) are devoted to the 9/11 Memorial. The Port Authority and Davis Brody Bond, the associate architect for the National September 11 Memorial & Museum, coordinated with multiple agencies to integrate the underground infrastructure with an aesthetically pleasing experience above ground. The Downtown Streetscape Partners, a joint venture of AECOM and Jacobs, Inc., designed the streetscape elements, street elevations, and the utility infrastructure.

To differentiate it from the rest of the city, the streetscape incorporates elements with a distinctive scale, made of unique materials. This is most evident in the sidewalks, which are twenty-five feet (7.6 m) wide, almost twice as wide as those in the rest of Manhattan, and made of Mesabi Black granite rather than the concrete used elsewhere in the city. These extra-wide walkways, coupled with bollards, sally ports, and guard booths, are security measures but also have the happy benefit of giving pedestrians more room. To integrate the security features, the designers "thought of them as part of the vocabulary of the streetscape furnishings," said landscape architect Andrew Lavallee, who, with Joseph E. Brown, led the streetscape design effort. "We worked hard to ensure that the booths didn't suddenly interrupt the free pedestrian flow. The booths landed on islands, or we bumped out the curbs, so we didn't compromise pedestrian experience for security." Although it was more costly to locate parking spaces and loading docks below the plaza, doing so

significantly improved the appearance and accessibility of the public realm.

Paradoxically, light can only be perceived in the context of darkness, which makes it a potent metaphor for the Trade Center, where contradictory human impulses—to build up or tear down—had to be reconciled. Paul Marantz's zest for both light and darkness has made him one of the most respected practitioners of the ephemeral art of lighting design. Along with his colleagues at Fisher Marantz Stone (FMS), he has lit a large number of architectural projects around the world. The firm's involvement at the World Trade Center dates back to 2002, when they realized the lighting for *Tribute in Light*, the twin beams that shine annually on September 11. They devised lighting for every structure at the Trade Center, with the exceptions of One World Trade Center and the St. Nicholas National Shrine.

The lighting designers had to consider aesthetics as well as security. The plaza needed light sufficient to create a feeling of safety but not so bright that the lighting would compete with the 9/11 Memorial, which is internally lit. Similarly, the tower lobbies along Greenwich Street had to be lit in a way that would not create glare or other impediments to seeing the memorial. FMS developed the plaza lighting with landscape architect Peter Walker, co-designer of the 9/11 Memorial. Each lighting fixture, eight inches (20.3 cm) square, seems to disappear within the allées of trees,

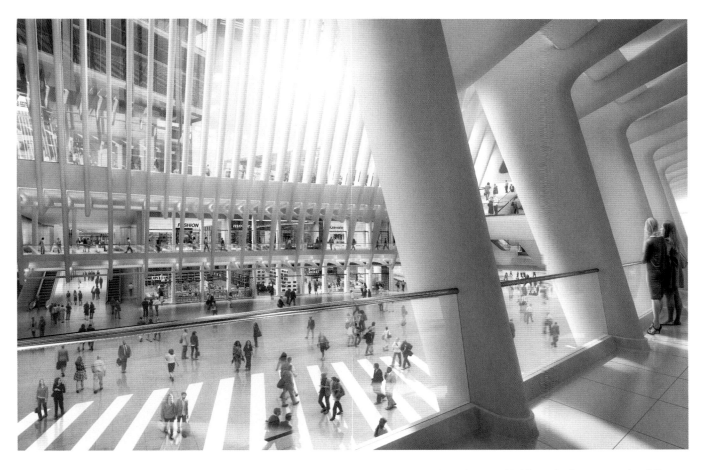

Dozens of stores and restaurants animate the World Trade Center's public spaces. Many, especially those showcased inside the Oculus, are upscale retailers such as Apple and Hugo Boss, but there are a few places where one can buy a toothbrush. Westfield developed the project's retail component.

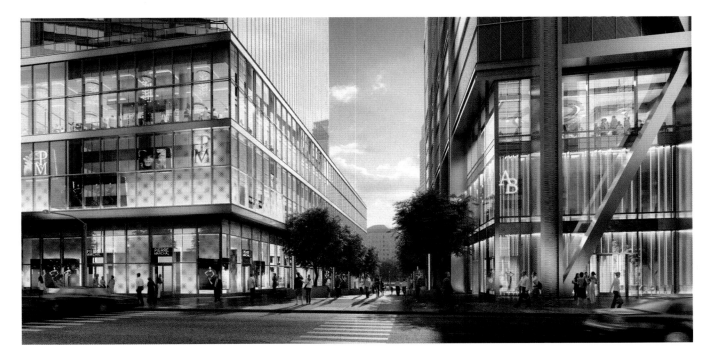

Cortlandt Way, a casualty of the Twin Towers' construction in the 1960s, has been restored, designed by PWP Landscape Architects. Now reserved for pedestrians, the terraced walkway is a primary access route to the memorial. It is paved in Mesabi Black granite, which is also used on the plaza, but here the cobbles are much smaller, in keeping with the street's intimate scale. Signage and lighting are similarly minimal and subdued.

"The minute you begin thinking about light as a material—and it's material in motion, right, it's always moving, lighting is not static—then you begin to think about how you can use it and how you can manipulate it. Then it opens up a whole world."

PAUL MARANTZ Lighting Designer

quietly fitting into the plaza. They cast a warm, horizontal light. "Our mandate was to light the people, not the floor. In other words, we're really interested in what the people are doing, not what the ants are doing," Marantz said of the horizontal beams.

There are no water fountains or trash receptacles on the 9/11 Memorial plaza. While the memorial designers fought for them, they lost the battle. "We had gone to Israel to find a trash can that you couldn't blow up," Walker said, but they "decided not to do them." Trash cans were excluded for two reasons. One, they're a security risk—people can put bombs in them, although various design mechanisms can be used to make doing so harder. The second issue is an aesthetic one: typically, trash receptacles are located in corners, and the last thing anyone wants to see as they approach the memorial or a chic shop is an overflowing trash can. Staff could be hired to empty them, but it's not clear who would be responsible for that cost: the Port Authority controls the overall site, the Memorial Foundation maintains the memorial plaza, and New York City owns the sidewalks, which each World Trade Center property owner is expected to maintain.

Safety and security concerns determined the location and number of public amenities. Restrooms are available at the Transportation Hub, inside the fare zone, and, for ticket holders, at the 9/11 Memorial Museum. Additional facilities will be located inside the retail areas of Two and Three World Trade Center. There are none on the memorial plaza, an example of thinking that is blind to the needs of families, the elderly, and the pregnant. Perhaps it is a good thing that one cannot

buy a cup of coffee on the plaza, either. New York City Planning also did away with bike racks, a step backward for green transportation. These basic needs fell between the cracks largely because they were outside of the Port Authority's usual purview and the authority did not have the internal resources to take on the Department of City Planning and other agencies.

SAFETY

Questions about World Trade Center security are rife because of its unique history and the sheer numbers there on any given day. Thousands of people flow in and out daily, arriving on foot, via subways and trains, or in buses, cabs, and cars. Hundreds of trucks make daily deliveries. Somehow, in the midst of this constant flux, the Port Authority has to get inside the heads of garden-variety pickpockets, teenage pranksters, and those with darker motives. The World Trade Center integrates comprehensive protective materials and technologies. The extent of these measures, delineated in classified documents, has been shared with very few. To quantify the Port Authority's efforts in another way: From the 2015 operating budget of $2.9 billion, "we'll probably spend a number like $800 million (including capital spending) on security, a shockingly high number, but given the demands of the 9/11 world, not surprising," Patrick Foye said.

"We are, without question, a target," said Joe Dunne, a 32-year veteran of the NYPD and its first deputy commissioner on September 11, and the Port Authority's former chief of security. His comment echoed those expressed by many entrusted with public

247

Visible protective measures include street bollards, sally ports, inspection booths, and raptors, such as those pictured here at the western end of Vesey Street.

thousands of people flow in and out daily...

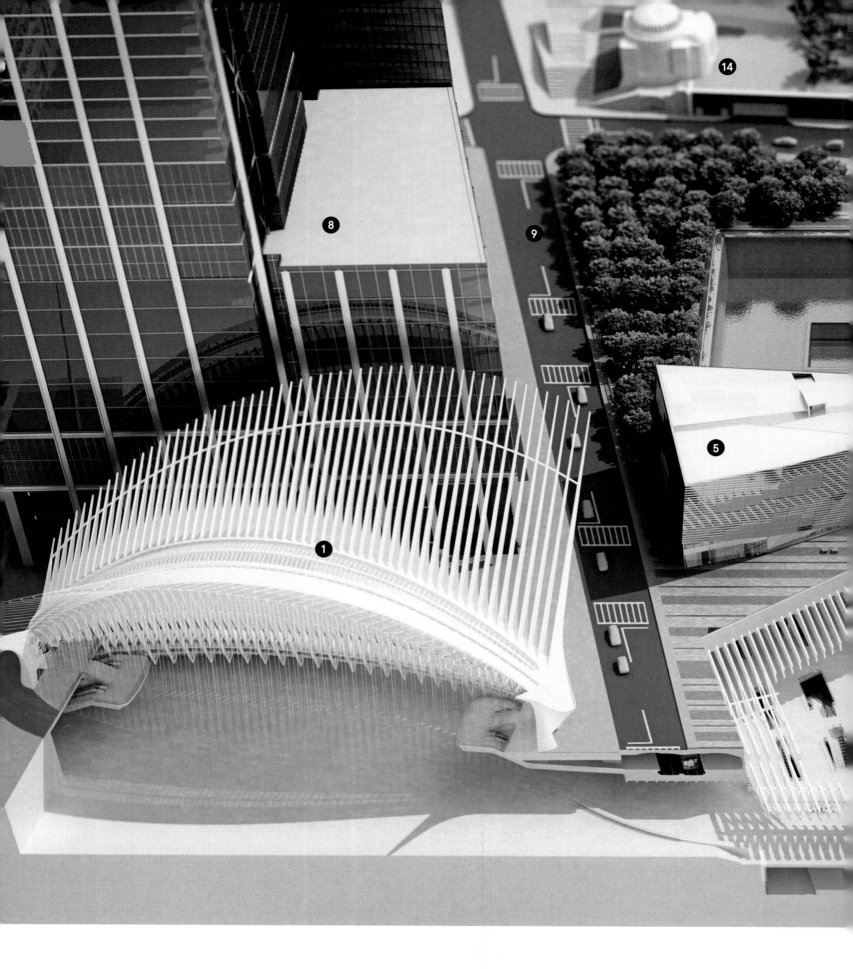

"The Port Authority has left no stone unturned, no expense spared, no effort too much to secure the site."

DOUG FARBER Director, World Trade Center Security

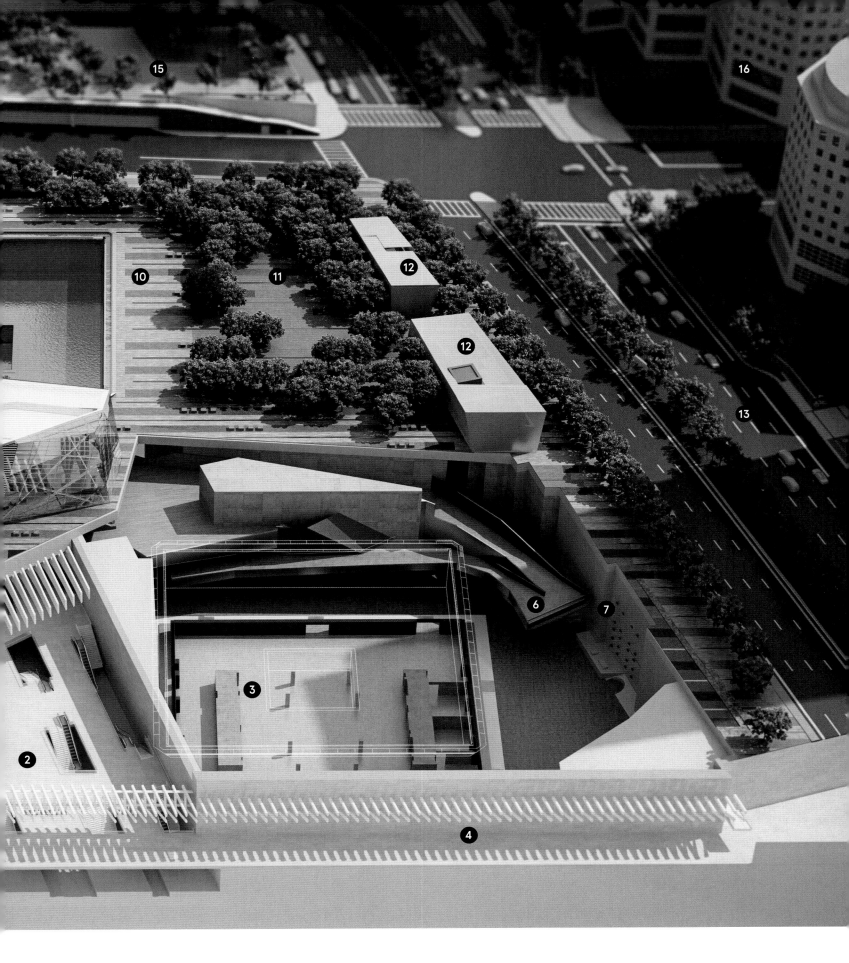

An invisible world exists underground. There, each structure depends on its neighbors—one building's roof is another's floor. The nine major WTC structures, along with the No. 1 subway and PATH train lines, are interdependent and form a Rubik's Cube of shared foundations, utilities, and mechanical systems. This graphic illustrates the interaction of some elements beneath the plaza. Additional underground infrastructure includes the Vehicle Security Center, roadways, loading docks, and parking areas.

1	Transportation Hub Oculus	9	Greenwich Street
2	PATH Hall	10	9/11 Memorial South Pool
3	9/11 Museum North Tower footprint	11	9/11 Memorial Plaza
4	West Concourse	12	West Vent Structures
5	9/11 Museum Pavilion Entrance	13	West Street (West Side Highway)
6	9/11 Museum ramp	14	St. Nicholas National Shrine
7	Slurry wall	15	Liberty Park
8	3 World Trade Center	16	Brookfield Place

"We have to live our lives, we have to conduct business, we have to do it as fearlessly as possible, and the public has to understand that the police and those people who are responsible for their security are doing as much as they can to keep them safe and secure."

JOE DUNNE Chief Security Officer (2012–2014), Port Authority

safety in an age of terrorism. Furthermore, One World Trade Center's distinction as the tallest tower in the nation makes it an "attractive nuisance," as Dunne called it, "for crackpots and daredevils." The media is culpable too. If there's so much as a sneeze at the site, if a teenager manages to sneak through a hole no bigger than a manila envelope and get to the top of the tower, the story appears instantly in the press, egging on other would-be trespassers.

To avoid employing Draconian tactics that would inhibit business or enjoyment of the campus, as security personnel call the site, the Port Authority has taken a multilayered approach to safety. The Port Authority Police Department (PAPD) is 1,800 strong, with sworn police officers that have dual jurisdiction in New York and New Jersey. Their primary partners at the Trade Center include the New York Police Department (NYPD), the Fire Department of New York (FDNY), and private security guards. Each tower has its own internal security that is commensurate with any Class A office high-rise, as does the National September 11 Memorial & Museum. Beyond that, the PAPD has local, state, federal, and international partners in a vast intelligence community that shares real-time information and expertise.

When the site was rebuilt, Greenwich and Fulton streets were reopened, which was considered a win for planners and a boon for the neighborhood. However, it also raised new security issues and apprehensions that the area would have the uninviting appearance of a fortress. Fears that bulky, obstructive security measures would trump urban planning have been largely alleviated. Street curbs are lined with steel bollards, the waist-high barrier posts that cropped up around many buildings after 2001, that reduce automobile traffic by nearly half and free up the street for pedestrians and cyclists. The Authority worked to make the area as accessible as possible within the confines of security demands.

Vehicular explosive devices are the main concern. Through traffic is restricted on all streets that cross the site. Private cars can enter but are limited to those who are enrolled in the Trusted Access Program (TAP), which allows vehicles to be checked and registered before

gaining access. Credentialing and screening of TAP-enrolled vehicles takes approximately forty seconds; they take longer for those not enrolled. Passenger cars enter and exit through eight sally ports on the north and south sides, which bar cars without clearance from entering.

Commercial trucks, vans, and tour buses enter through the Vehicle Security Center, a state-of-the-art screening checkpoint designed by Liberty Security Partners, which runs the length of the Trade Center's southern border. Trucks and their contents are inspected there via a variety of technologies, typical of those used by Customs to examine cargo arriving at ports and borders, before proceeding to the underground loading docks, where trucks undergo further inspections. As at the sally ports, the trucks' license plates trigger the TAP, permitting entry only to preauthorized vehicles with confirmed appointments. Perhaps the best indication of the level of security measures taken

…"crackpots and daredevils"

underground is Liberty Park, the public park on top of the screening center.

In an age when a kid in a coffee shop can use a smartphone to hack a bank thousands of miles away, cyber security is a global problem. Not only teenagers have phones, however. "Someone once asked me what my best security tool was, and I said my phone—the ability to pick up the phone and collaborate with subject matter experts within the security industry," said Doug Farber, who heads World Trade Center security for the Port Authority. To manage risk, Farber coordinates the authority's efforts with dozens of agencies that gather constant intelligence. They include the NYPD, a major partner; the Department of Homeland Security; the Joint Terrorist Task Force, a federal investigative body composed of FBI agents and police officers; and the NYPD's Lower Manhattan Security Initiative, a consortium of downtown businesses and public agencies.

The primary local authority defending against terrorist attacks is the NYPD. Air, land, and sea initiatives are part of a massive citywide security program meant to send one message: Don't mess with New York City. "We're the number-one target in the country," said former police commissioner Ray Kelly, speaking of Manhattan. To protect the lives of New Yorkers and tens of millions of visitors annually, sophisticated technology has been designed specifically for the NYPD's counterterrorism efforts, which is shared with its partners, including the PAPD. Artificial intelligence, combined with three thousand surveillance cameras located citywide, can track a range of potential threats, from an unattended package to all those, for instance, wearing red shirts that

day. Called the "ring of steel," after a similar program in London, these NYPD surveillance initiatives are intended to look closely, too closely in the opinion of some, at aberrant street activity.

Experts typically speak of CBR—chemical, biological, radiological—defenses that can detect, literally, a molecule of biological matter and provide rapid amelioration. Sensors installed around the site are part of a larger citywide program run by the NYPD and the Department of Homeland Security to detect biological agents, pathogens that potentially can grow, as opposed to toxic chemicals, such as those produced by car exhaust. The World Trade Center towers also incorporate radiation detectors. Additionally, license plate readers, called LPRs, are in constant use for all of lower Manhattan, defined as the area below Canal Street. Collected information is compared against international databases of known terrorists, other criminals, persons of interest, and the rest of us mere mortals. You may want to think twice before parking in that spot.

Psychological hurdles remain for many, especially those, like Joe Dunne, who were there when the original towers fell. "I heard all the sad stories about the last words, and last messages, and what was said that day to one another, and what projects they were in the middle of doing in homes," he said. "These stories, they're pretty much embedded in my heart." He, the PAPD, the NYPD, and scores of others have expended herculean efforts to create a site that is hospitable to remembrance, culture, and commerce—and one that is as safe as possible. ▲

251

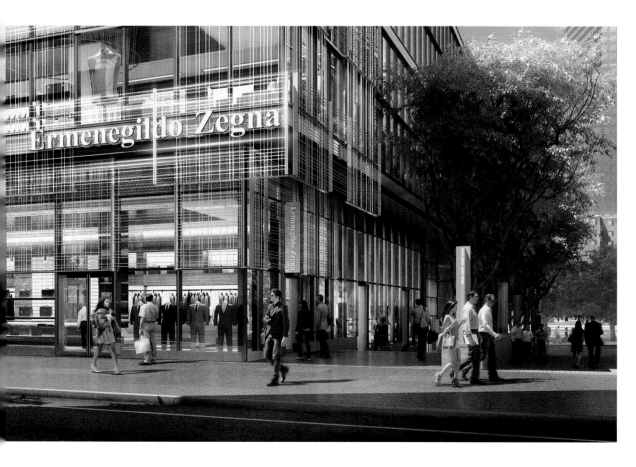

To maintain the dignity of the 9/11 Memorial, shops on the lower levels of Two, Three, and Four World Trade Center are located on Church Street.

AFTERWORD

Many declared the skyscraper dead in the wake of September 11. A quick tour d'horizon, however, shows that the past decade has been the most productive ever in terms of tall buildings: more skyscrapers have been built since 2001 than were built in the century preceding it. That abundance of office space determined the fortunes of the four skyscrapers at the World Trade Center, and, in the case of Two and Three World Trade Center, their construction schedules as well. The Manhattan market for large, state-of-the-art office buildings also has reorganized itself by price rather than an allegiance to a particular geography, with real estate forces vying in three locations—downtown, around Grand Central, and west of Penn Station.

One World Trade Center, the locus of downtown development, has a timeless design that, untethered from trends, will serve its tenants and the city for decades to come. It is all too easy to miss the subtleties of its understated but nuanced profile. For all of its dominant physical presence, much unseen is also here. The notion of restraint in an urban setting is lost in today's "experience economy," which is marked by exuberant, highly individualistic architectural statements. Ultimately, One is a response to how the individual perceives it rather than a statement about itself. Its simplicity emphasizes and encourages individual engagement. In contrast, the original towers deflected both engagement and reflection. It is also true that the new tower has been erected at a time when many do not want to put any effort into such encounters, preferring the quick visual equivalent of Instagram, rather than grappling with simplicity, which takes commitment and time.

Beyond aesthetics, the building had to resolve a broad spectrum of structural, political, and financial issues, some of which still have not been made public. Much like their tower, which cloaks its audacity behind an elegant façade, the architects have chosen not to defend the building from its critics. That urbane reserve is a hallmark of Skidmore, Owings & Merrill, but, more to the point, the architects don't believe it needs defending. David Childs passionately believes in the "inevitability" of its design. He's mum on the compromises that had to be made, several of which, one suspects, were excruciating.

Even before it opened, the tower's design was widely criticized. Critics damned it as compromised or, at best, conservative, calling it "monomaniacal," "a shyscraper," "a shell of the original vision," "a prime specimen of capitalist realism," "a bold but flawed giant" that was "only worthy of an indifferent shrug." This minute sampling does not begin to suggest the strafing of every person, company, and organization responsible for the tower, including its designers, its developers, the Port Authority, and the public, with its omnipresent fears and questionable taste. As James Joyce famously said in a different context, "Here comes everybody."

Architects, notably, have been more sparing in their criticism, and, in that highly competitive field, not necessarily because of professional courtesy. Most firms would have jumped for a shot at this commission. Through grim experience, they have some inkling of what it took to negotiate the morass, more than a decade long, of red tape, design changes, delays upon delays, and the inevitable restrictions of time and money. This in addition to responding to seemingly unquenchable expectations and meeting the tower's complex structural demands and unprecedented (literally, as in, never done before) security parameters.

One World Trade Center and every other structure on the site hold our impossible wish: to have back everyone who was lost on September 11. Of all the challenges that the World Trade Center has had to face, perhaps the biggest one is exorcising the ghosts of the structures that it replaced. The site is so vested with memories, sorrow, and ambition that no building could meet the layers of expectation laid on it. Heated debates about the choices made continue. The World Trade Center is too new, still a work in progress, to judge its ultimate coherence as a project, though without a doubt a new downtown is emerging. New York, as is its nature, has already turned its attention to other buildings and concerns, shifting the hard spotlight away from the Trade Center. Now it will be free to grow into itself. Two World Trade Center, originally designed by Foster + Partners, will be designed by Bjarke Ingels Group. Plans to build a fifth tower just south of Liberty Street, where the Deutsche Bank Building once stood, are in flux. Also still to come is a performing arts center. Such a place, free to focus on creativity unencumbered by commercial demands, will provide the last piece of this noble puzzle.

...cloaks its audacity behind an elegant façade

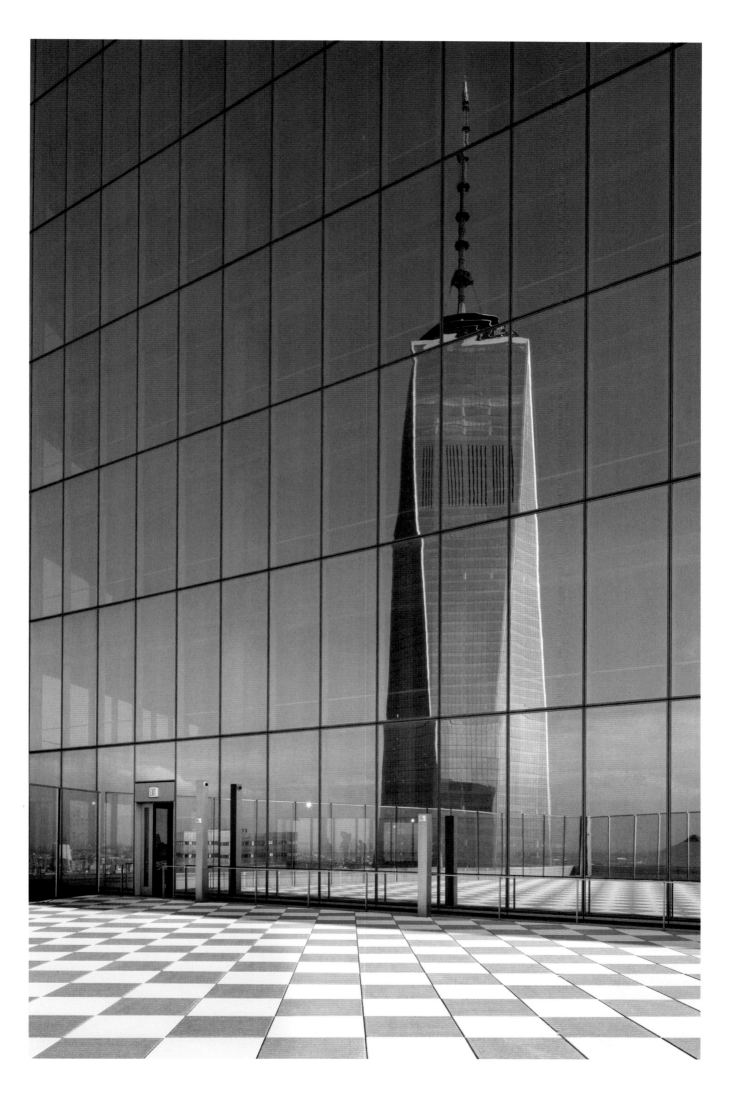

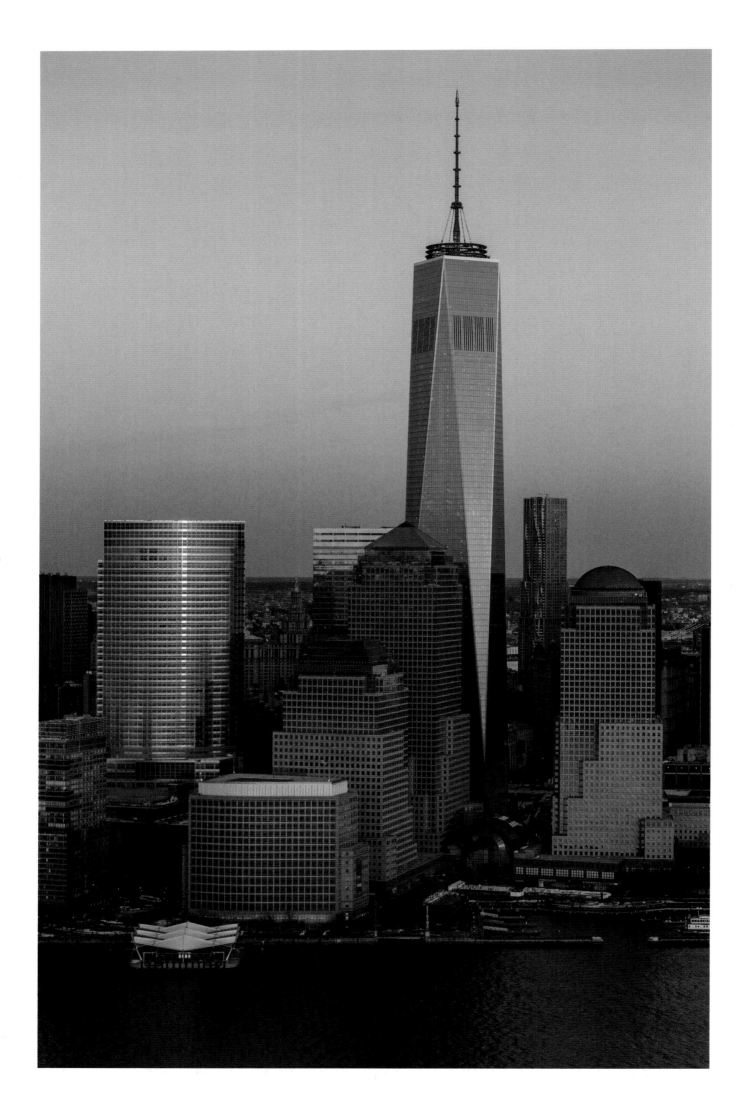

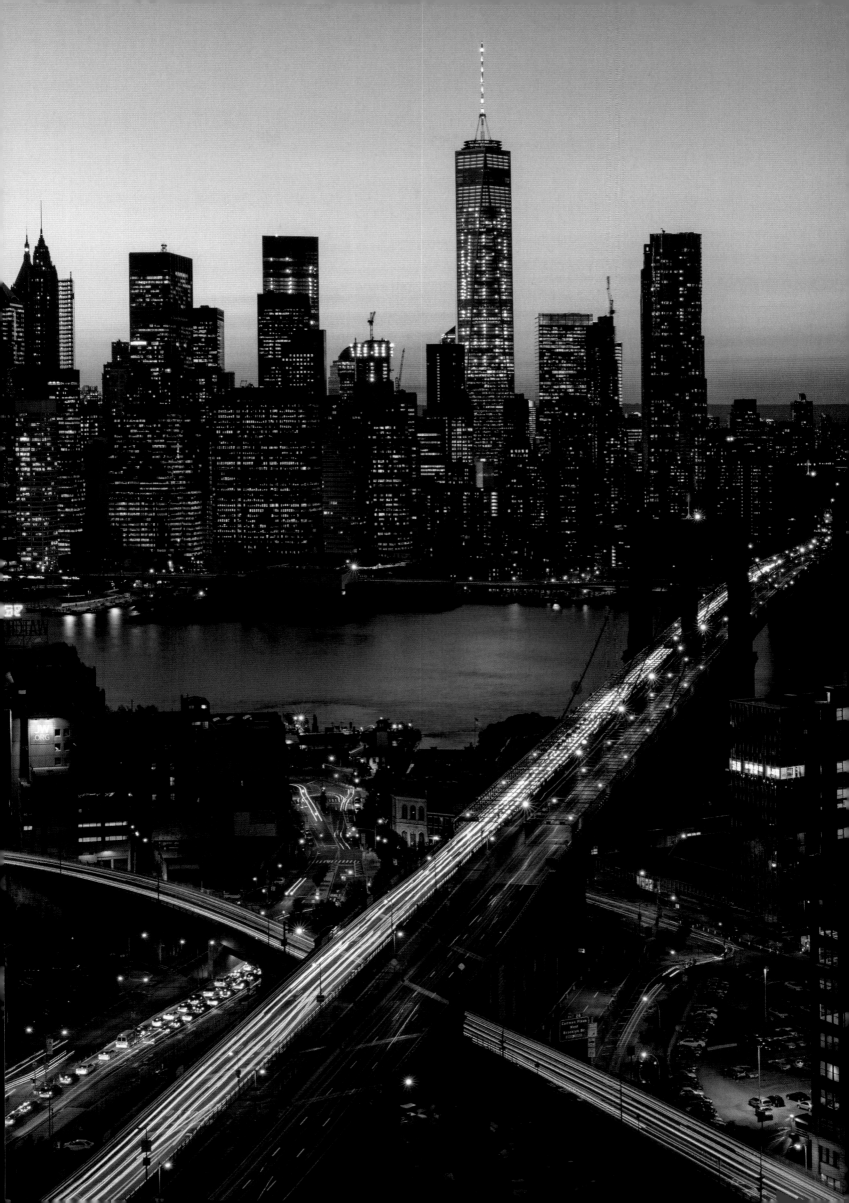

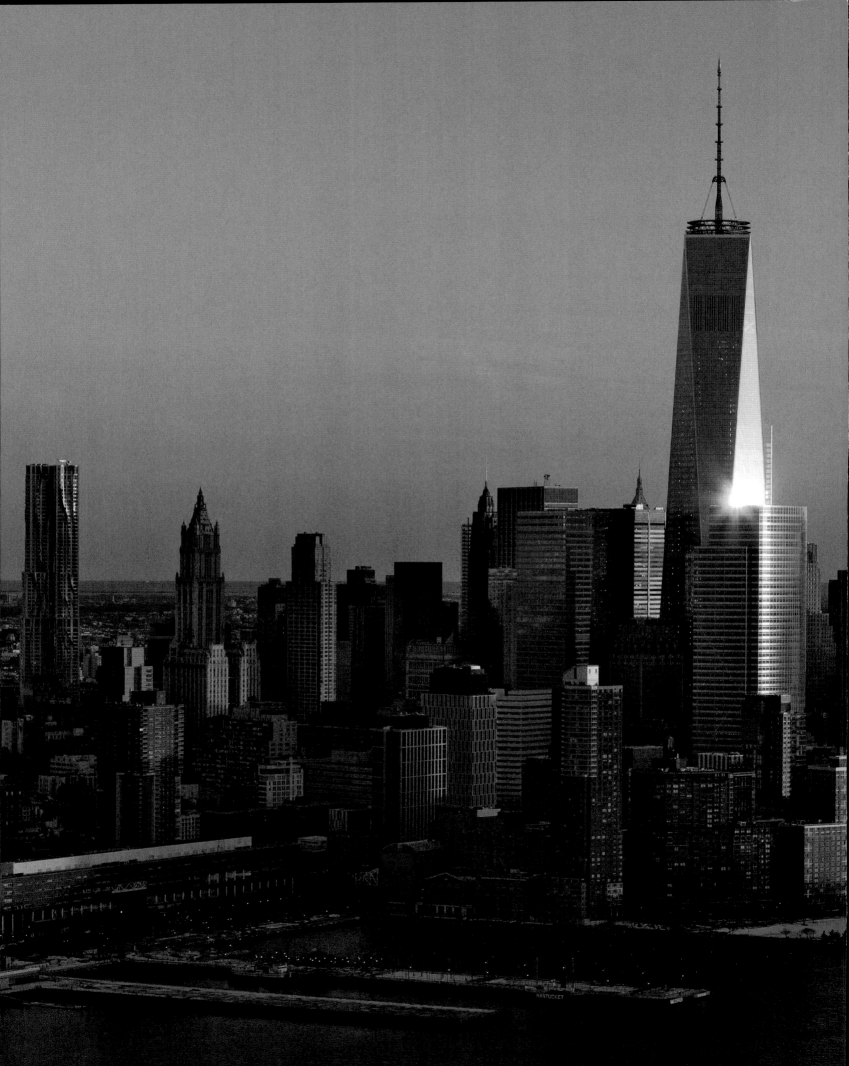

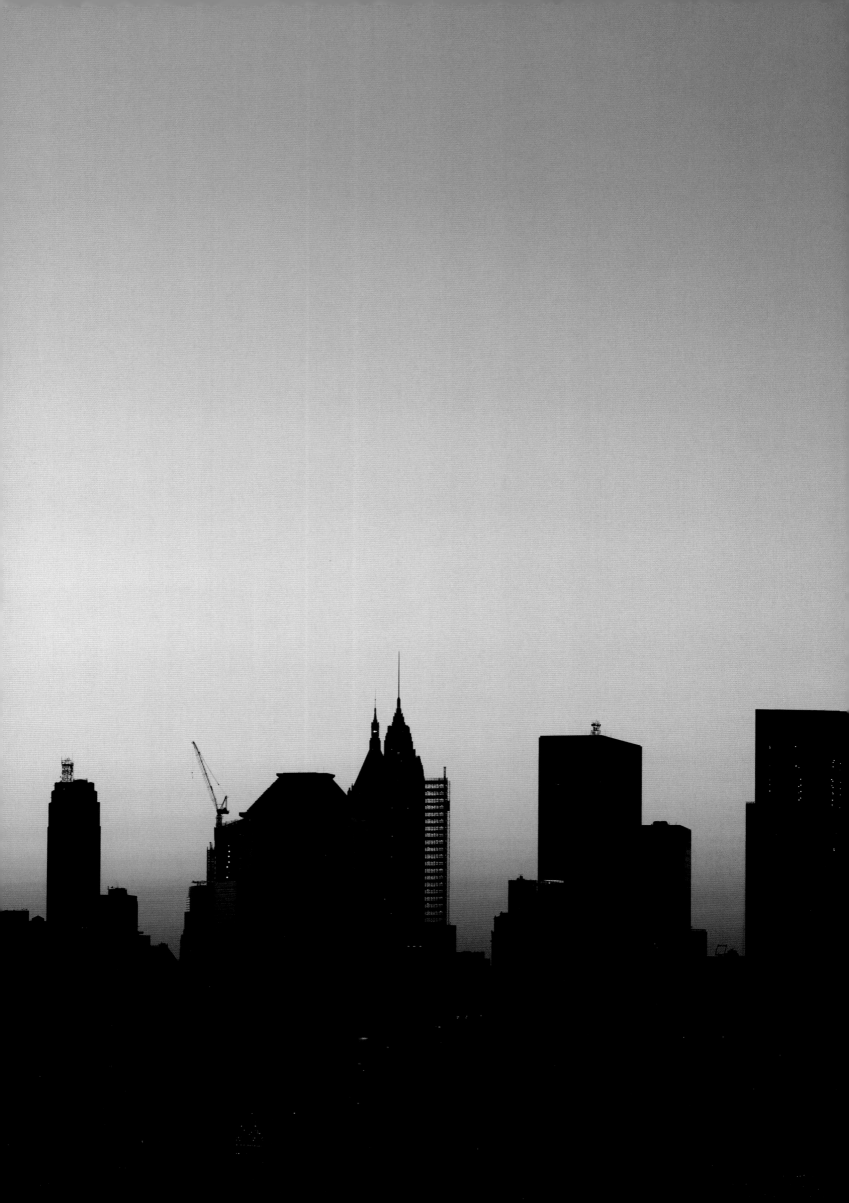

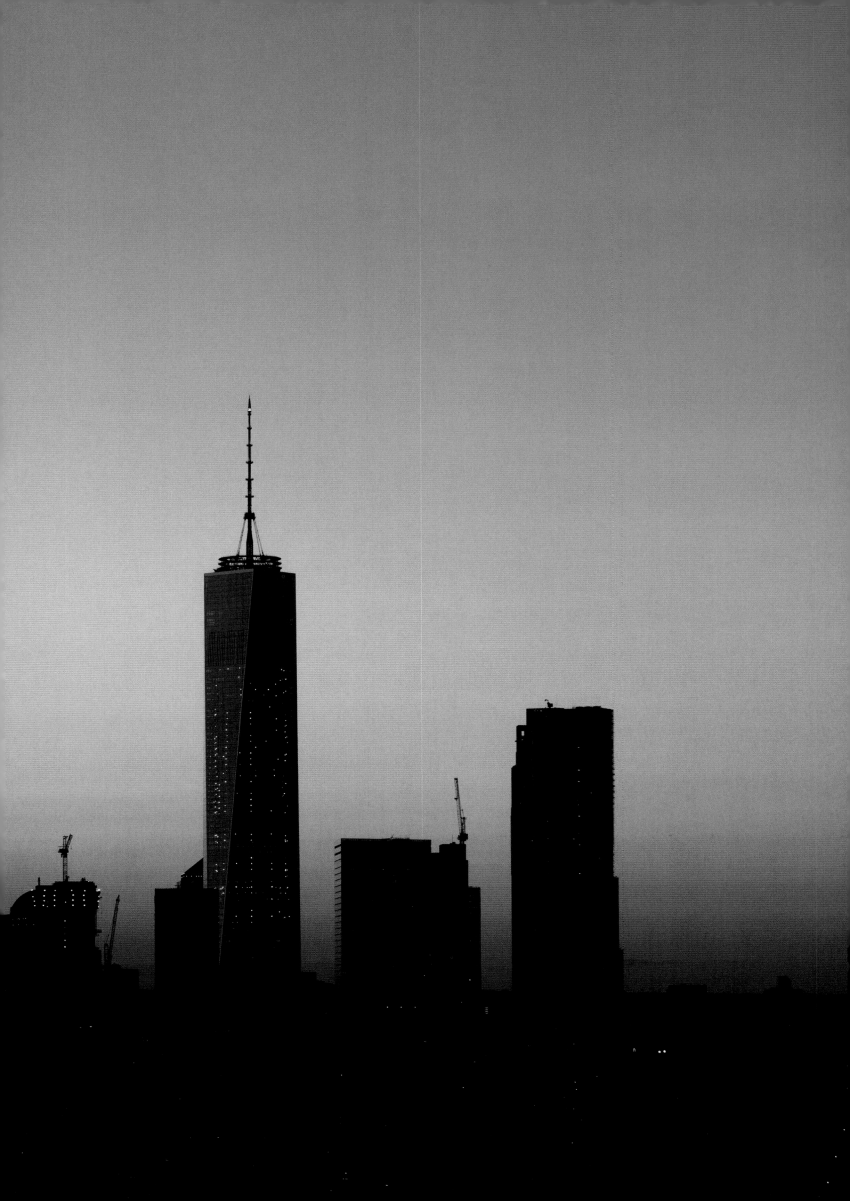

ACKNOWLEDGMENTS

Foremost, I am indebted to those interviewed for speaking candidly and often profoundly about the World Trade Center and its larger role in the life of the city. Their remarks are the lifeblood of this book. Of that large and generous group, some deserve particular thanks. Patrick Foye of the Port Authority proved the book's bedrock, being the first to see its potential and, in all practical ways, make it a reality. Thank you, Pat. Steve Plate, who directs the efforts of everyone working at the Trade Center and is quite possibly the busiest person on earth, always made time to answer my questions. Scott Rechler, vice chairman of the authority's Board of Commissioners, dissected with patience and good cheer the complex financial agreements that shaped the World Trade Center. Chris Ward, the Port Authority's former executive director, blew a breath of fresh air into the entire enterprise. Many other Port Authority employees helped me in dozens of ways. I am grateful for Port spokesperson Erica Dumas's skilled, timely, and generous editorial support. Architect Carla Bonacci read several chapters with her good, seasoned eye. Mike Donovan gave expert help, as did Chi Ling Moy, who tirelessly ferreted out photographs from the past decade. John Ma and Veronica Rodriguez lent their support and legal acumen. Rudy King, ostensibly my minder, became much more than that over the past years, and I am thankful for his integrity and friendship.

David Childs and T. J. Gottesdiener of SOM, along with Ken Lewis, Nicole Dosso, and their staff, assisted in accurately documenting their tower design. SOM provided multiple interviews, a careful reading of the text, and photographs. There simply are not enough words to thank David Childs, who is unfailingly helpful, wise, and kind. Jeff Holmes, formerly of SOM, enriched the text with his fine aesthetic sensibility and invaluable historical perspective. Another beautiful mind, Ahmad Rahimian of WSP USA, who directed One's structural engineering, was a source of inspiration and ongoing assistance. Many thanks to Dave Checketts for his hospitality and for sharing his memories of his father, a World War II veteran. I'm lucky to have caught a bit of the magic dust that Phil Hettema spreads around the world. Santiago Calatrava was extraordinarily generous, sharing his singular vision and resources. Michael Arad, Steven Davis, Alice Greenwald, Tom Hennes, Lynn Rasic, and Peter Walker expanded my understanding of the design and premise of the National September 11 Memorial & Museum and, beyond that, what it takes to engage the public imagination. I was gladly swept into Daniel Libeskind's tornadic energy, and I thank him for his insights. Paul Marantz turned on quite a few light bulbs. The irreplaceable Larry Silverstein put this project into the greater context of Manhattan's real estate history and extended, along with Dara McQuillan, hospitality and editorial support.

One summer day in 2014, a group of us gathered on the roof of One World Trade Center. Our number included my agent, Cathy Hemming, whose clear vision rivals the long vistas from the top of the tower, and, from Little, Brown, Reagan Arthur, Heather Fain, Carrie Neill, and Michael Sand, who championed my work from the start. Their willingness to don hard hats and boots that day and at other times since then is a good metaphor for their zest and devotion, which brought this book to life. I am grateful to my editor, collaborator, and friend, Michael Szczerban, for expertly shaping the text with a light but firm hand; to Garrett McGrath, for many wonderful and helpful conversations; to the eagle-eyed Kathryn Rogers; and to Peggy Freudenthal, for her generosity and precision. Matthew Bannister, Darren Tuozzoli, Johnny Petley, Gustav Liliequist, Gabor Cseh, and others at DBOX infused the book's design with their unique gifts. I thank Ted Goodman for creating the index and for our camaraderie over the years. Gretchen Bank, Sarah Celentano, and Sherry Segers provided meticulous research assistance and interview transcriptions. Dale Wilhelm, dear friend and colleague, helped me select photographs and bolstered me with her unwavering belief in this book. My love and heartfelt thanks to Elizabeth Abbott, Leslie Cecil, Regina Clarkin, Laurie Foos, Danette Koke, Kerry Novick, and Lily Prigioniero for the wellspring of their friendship.

Milton Glaser, whose graphic genius changed the way we see the city, loaned his "I Love New York More Than Ever" poster, the first image I acquired for this book—a very good omen indeed. Many others followed, generously lending the imagery that enlivens these pages, notably Joe Woolhead, Nicola Evans, James Ewing, Evan Joseph, and Port Authority photographers Michael Mahesh and Victor Nordstrom. Marshall Gerometta and Daniel Kieckhefer, living databases of all things supertall, contributed facts, figures, and friendship. David W.

260

BE GENEROUS. YOUR CITY NEEDS YOU. THIS POSTER IS NOT FOR SALE.

261

Dunlap's writings on the World Trade Center over the past decade have been both muse and benchmark. John McPhee reminded me that a notebook can surpass the talents of a tape recorder when conducting an interview. Roger Rosenblatt of capacious mind and heart provided decisive help. I acknowledge the support of SUNY Purchase and the New York State United University Professions. I also acknowledge a National Endowment for the Humanities Public Scholar award, which supported the completion of this book and a digital continuation and expansion of the book online. Any views, findings, conclusions, or recommendations expressed in this book do not necessarily reflect those of the National Endowment for the Humanities.

This book is dedicated to my parents, Robert and Dolores Dupré, with thanks for their love, unstinting support, and abundant wisdom. My siblings kept it real and warm. If a book can be compared to a building, then my beloved sons, Brendan and Emmet, are surely the foundation, as well as the windows and doors, of this endeavor.

I owe thanks to many for their contributions, including these fine people: Mark Arey, The Hellenic Initiative; Alice Bloom; James Carpenter and Ben Colebrook, James Carpenter Design Associates; Marty Carver, CTBUH; Marc Colella, AECOM; Melissa Coley, Brookfield Properties; Brian Cury, Lisa Kelly, and the EarthCam team; Amanda de Beaufort and Zoë Seibel, Studio Libeskind | New York; Andrew S. Dolkart; Amy C. Dreher, National September 11 Memorial & Museum; Joan Falk; Ann Farrington; Caitlin Foye; Linda Figg; John Gallagher, Mercury; Eric Gelfand, Legends; Christy Gray; Dolores Hayden, Yale University; Anthony Hayes; Diana Horowitz; Ann Kilbourne; Yumi Kori; Carl Krebs, Lourdes Hazelton, and Andre Pause, Davis Brody Bond; Elizabeth Harrison Kubany, SOM; Raymond Lee; David Long; Frank Lorino and Danielle de Lopez, Santiago Calatrava New York; Mike Marcucci; Vasileios Marinis, Yale University; Christina Mathews, Beyer Blinder Belle; Beth and Ed Matthews; Cathleen Medwick; Creighton Michael; Dean Motter; Rebecca Oling, SUNY Purchase; Project Rebirth; Helen and Brian Rafferty; Kaya Sanan, Sanan Media; Slinkachu; Erica Stoller/ESTO; David Sundberg/ESTO; Father Nathanael Symeonides, Greek Orthodox Archdiocese of America; John Treat; Eddie Walsh; Laura Wexler, Yale University; Carol Willis, The Skyscraper Museum; and, always, all the Wahines.

ONE WORLD TRADE CENTER PROJECT CREDITS

LEADERSHIP

The Port Authority of New York & New Jersey
Patrick J. Foye, Executive Director
Steven Plate, Deputy Chief of Capital Planning/Director of World Trade Center Construction
Beth Wolfowitz, Acting Director, World Trade Center Redevelopment

The Port Authority of New York & New Jersey Executive Directors
Christopher O. Ward (2008–2011)
Anthony E. Shorris (2007–2008)
Kenneth J. Ringler Jr. (2004–2007)
Joseph J. Seymour (2001–2004)
Ronald Shiftan (interim, 2001)
Neil D. Levin (March 2001– Sept. 11, 2001)

The Port Authority of New York & New Jersey Deputy Executive Directors
Deborah L. Gramiccioni (2013–2015)
William Baroni Jr. (2010–2013)
Susan Bass Levin (2007–2010)
James P. Fox (2004–2007)
Michael R. DeCotiis (2002–2004)
Ronald Shiftan (1998–2002)

Governors of New York
Andrew Cuomo (2011–present)
David Paterson (2008–2010)
Eliot Spitzer (2007–2008)
George E. Pataki (1995–2006)

Governors of New Jersey
Chris Christie (2010–present)
Jon Corzine (2006–2010)
Richard Codey (2004–2006)
James E. McGreevey (2002–2004)
Donald DiFrancesco (2001–2002)
Christine Todd Whitman (1994–2001)

Mayors of New York City
Bill de Blasio (2014–present)
Michael R. Bloomberg (2002–2013)
Rudolph W. Giuliani (1994–2001)

Chair, The Port Authority of New York & New Jersey
John J. Degnan (2014–present)
David Samson (2011–2014)
Anthony R. Coscia (2003–2011)
Jack G. Sinagra (2001–2003)
Lewis M. Eisenberg (1995–2001)

Vice Chair, The Port Authority of New York & New Jersey
Scott H. Rechler (2011–present)
Henry R. Silverman (2007–2011)
Charles A. Gargano (1995–2007)

The Port Authority of New York & New Jersey Board of Commissioners, 2001–present
Richard H. Bagger
Virginia S. Bauer
Bruce A. Blakeman
Michael J. Chasanoff
Anthony R. Coscia
Kathleen A. Donovan
Lewis M. Eisenberg
Christine A. Ferer
Angelo J. Genova
Stanley E. Grayson
Fred P. Hochberg
H. Sidney Holmes III
Charles Kushner
George R. Laufenberg
Kenneth Lipper
Jeffrey H. Lynford
David S. Mack
William J. Martini
Jeffrey A. Moerdler
Basil A. Paterson
Alan G. Philibosian
Raymond M. Pocino
Bradford J. Race Jr.
Rossana Rosado
James P. Rubin
Anthony J. Sartor
William Schuber
Anastasia M. Song
David S. Steiner
James Weinstein

The Durst Organization
Douglas Durst, Chairman
Jonathan (Jody) Durst, President
Thomas Duffe, Vice President and Director of Construction
Tony Tarazi, Senior Project Manager
Robert Becker, Director, OWTC
Jordan Barowitz, Director of External Affairs
Gary M. Rosenberg Esq., Rosenberg & Estis

Silverstein Properties
Larry A. Silverstein, Chairman
John "Janno" Lieber, President, World Trade Center Properties
David Worsley, Head of Construction, World Trade Center
Dara McQuillan, Chief Marketing Officer

PROFESSIONAL CREDITS

Owner/Developer: The Port Authority of New York & New Jersey
Owner's Representative: STV Inc.
Developer: The Durst Organization
Original Developer: World Trade Center Properties, LLC/ Silverstein Properties, Inc.
Leasing: The Port Authority of New York & New Jersey; The Durst Organization; Cushman & Wakefield, Inc.

Architect
Skidmore, Owings & Merrill LLP (SOM)
David M. Childs, FAIA, Design Partner
T. J. Gottesdiener, FAIA, Managing Partner
Kenneth A. Lewis, AIA, Managing Director
Carl Galioto, FAIA, Technical Design Partner (2004–2009)
Jeffrey Holmes, AIA, Associate Design Partner (2003–2008)
Nicholas Holt, AIA, Technical Director
Nicole Dosso, AIA, Senior Technical Architect
Julie Hiromoto, AIA, Project Manager
Frank E. Mahan, AIA, Senior Design Architect

Structural Engineers
Structural Engineer of Record: WSP USA
Ahmad Rahimian, Ph.D., P.E., S.E., F.ASCE, Director of Building Structures
Silvian Marcus, P.E., Director of Building Structures
Jeff Smilow, P.E., Director of Building Structures
Yoram Eilon, P.E., Senior Vice President
Oded Abir, P.E., Associate
Frank Mannino
Mihaela Cismigiu
Sam Perel, P.E.
Marc Collela
Anthony Tarantino, P.E.
Charles Guerrero, Vice President, Director of CADD Operations
Anthony Cazzola, Senior BIM Coordinator
Bram Nanandhan, Senior BIM Coordinator
Evangeline Durham, Structural BIM Technician
Structural Engineer (spire/cable net wall): Schlaich Bergermann und Partner
Structural Engineer (below-grade structure): Leslie E. Robertson Associates
Protective Design Engineer: Weidlinger Associates
MEP Engineer/Sustainability: Jaros Baum & Bolles, Inc.
Vertical Transportation: Steven Kinnaman & Associates
Civil and Transportation Engineer: Philip Habib & Associates
Geotechnical Engineer: Mueser Rutledge Consulting Engineers
Façade Consultant: Vidaris, Inc.
Wind Analysis: Rowan Williams Davies & Irwin Inc.

Main Contractor
Tishman/AECOM Construction Corp.

One World Observatory
Developer: Legends
Observatory Experience Design, Production, and Installation: The Hettema Group
Overall Project Architect: Montroy Andersen DeMarco
Observatory Facility Design: The Hettema Group and Montroy Andersen DeMarco
Observatory Construction: RM Construction

SOM Consultants
Acoustics: Cerami & Associates
Broadcasting: Metropolitan Television Alliance
Code Consultants: Code Consultants, Inc.
Collaborating Artist (spire): Kenneth Snelson
Digital Animations: Screampoint
Digital Visualizations: DBOX; SWIM; Qubdesign; aexen; The Seventh Art; by-encore
Exhibition: Ralph Appelbaum Associates
Façade Maintenance: Citadel Consulting/Lerch Bates
Consulting
Landscape Architects: Mathews Nielsen Landscape Architects; PWP Landscape Architecture
Lighting: Claude R. Engle
Lighting (Podium): Scott Matthews with Brandston Partners Inc.
Models: Radii Inc.; Saleh & Dirani; Bill Wunder
Pedestrian Traffic Modeling: Booz Allen Hamilton
Photography (model): Jock Pottle/ ESTC
Photography (building): James Ewing; Iwan Baan
Security: Ducibella Venter & Santore; Weidlinger Associates
Signage: Pentagram
Sustainability Consultants: Viridian; Steven Keppler & Associates

SUPPLIERS, MANUFACTURERS, AND CONSULTANTS

Steel Manufacturers
Tower and below-grade steel: ArcelorMittal International (Luxembourg); Nucor Yamato (AR); ArcelorMittal (PA)
Spire steel: Timken Company; Vallourec Tubes; ArcelorMittal

Structural System
Steel fabricator (below grade): Banker Steel Company
Steel fabricator (above grade): DCM Erectors Inc. (US)
Steel erector: DCM Erectors Inc. (US)
Steel spire: ADF Group Inc.
Custom concrete mix: Eastern Concrete Materials, Inc.; Empire Transit Mix Inc.; Quadrozzi Concrete Corp.
Concrete contractor (foundation): The Laquila Group Inc.
Concrete contractor (superstructure): Collavino Construction Company

Concrete Manufacturers and Suppliers
Cement manufacturers
 Lafarge North America
 Lehigh Cement Company
 Essex Cement Company LLC
 CEMEX USA/Hidalgo
Fly-ash manufacturers
 Separation Technologies, LLC
 Mineral Resources Technologies, Inc., a CEMEX Company
Blast furnace slag suppliers
 Holcim US Inc.
 Lafarge North America
Aggregate
 Coarse aggregate: New York Sand & Stone; Tilcon New York Inc.
 Fine aggregate: Roanoke Sand & Gravel Corp.; East Coast Mines & Materials Corp.
Concrete admixtures
 Foundation: The Euclid Chemical Company; Grace Construction Products
 Superstructure: BASF Construction Chemicals; Sika Corp.

Concrete formwork
 System and accessory supplier:
 EFCO Corp.
 Shoring supplier: Engineered
 Devices Corp.
Reinforcing steel and accessories
supplier
 Barker Steel LLC, a Harris Rebar
 Company
 DYWIDAG-Systems International
 SAS Stressteel, Inc.
Rebar supports and accessories
 Meadow Burke
 Erico
 Dayton Superior

Cladding
Curtain wall: Benson Industries, Inc.
Insulating glass units: Viracon
Glass: Guardian Industries
Podium: Permasteelisa North
 America
Podium glass fins: Interpane
Podium glass-fin processor: Bischoff
 Glasstechnik AG
Stainless steel corners: Pohl Inc. of
 America
Lobby glass walls: APG International
Exterior wall sealant: Dow Corning

Interior Finishes
Stone installation: Port Morris Tile &
 Marble Corp.
Lobby stone (Larissa White Marble):
 Savema S.P.A.
Lobby stone (Mesabi Granite): Cold
 Spring Granite
Podium stone: Mount Airy Granite
Marble quarry: Franchi Umberto
 Marmi

Electrical Contractors
Five Star Electric Corp.

Lighting
Spire: Barbizon Lighting Company
Podium LED lighting: Philips Color
 Kinetics
Beacon fabricator: Kammetal
Beacon light fabricator: Syncrolite

Conveyance
Elevators/escalators: ThyssenKrupp
 Elevator America
Elevator cabs: National Elevator Cab
 & Door Corp.

Plumbing
WDF, Inc.

Additional Suppliers
Carpentry: Component Assembly
 Systems
Fire protection: Rael Automatic
 Sprinkler Co., Inc.
Fireproofing: Grace
Firestopping: Hilti USA
Fuel cells: UTC Power, a United
 Technologies Company
Lumber: Feldman Lumber
Mechanical: ASM Plumbing
 and Heating
Millwork: Bauerschmidt & Sons
Ornamental metal: Airflex
 Industrial, Inc.
Turnstiles: Kouba Systems, Inc.
Waterproofing: Jobin Waterproofing
 Corp.

Additional Contributors
Arnold & Porter
ARUP Communications
Battle McCarthy/London
Block & Associates

Cini-Little International Inc./
 New York
Clean Air Communities
Community Board No. 1
Connelly McLaughlin & Woloz
Edelman Arts
Edgett Williams Consulting
 Group, Inc.
Edison Properties, LLC
Green Order, NY
Hanson Professional Services Inc.
HNTB Corp.
Lawrence Berkeley National
 Laboratory
Lower Manhattan Development
 Corporation
New York City Department of City
 Planning
New York City Department of
 Transportation
New York State Department of
 Transportation
New York State Energy Research and
 Development Authority
Northeast States Center for a Clean
 Air Future
Richard Harris Podolsky, Ph.D.
TransSolutions
University of Illinois—Urbana-
 Champaign
University of Western Ontario
U.S. Department of Energy
Wachtell, Lipton, Rosen & Katz
Steven Winter Associates, Inc.
Young Clark & Associates

PROJECT TEAMS

Port Authority Team
Alan Reiss, Deputy Director, WTC
 Construction
Thomas O'Connor, Deputy Director,
 WTC Construction
Brian Hegarty, Program Director,
 WTC Construction
Ron DeVito, Assistant Director, WTC
 Construction
Michael Mahesh, Senior Engineer/
 Photographer
Solange Osorio, Executive Assistant
 to the Director

STV Project Management Team
Milo Riverso, Project Executive
John McCullough, Project Executive
Bruce Fox, Project Executive
Eduardo del Valle, Director of Design
Bruce Gombos, Design Manager
Mike Flaherty, Director of Field
 Operations
Sassan Manii, Project Manager
Julie Valerio, Project Manager
Thales Savas, Project Manager
Jacqueline Mascoli, Project Manager
Miquel Verhagen, Project Manager
Mark Sheehan, Project Manager
Robert Dries, Field Manager
Ted Gardner, Field Manager
Stephanie Dreher, Project Engineer
Michael Cafiero, Project Engineer

Louis Berger Group Program
Management Team
Michael Donovan, P.E.,
 Program Director
Steve Hill, Senior Program Manager
Michael Hessemer, P.E., Assistant
 Program Manager
Jason Tirri, Assistant Program
 Manager
Mark Hamilton, Assistant Program
 Manager

Steve Weeks, Senior Cost Engineer
Chi Ling Moy, Communications
 Manager
Jason Brown, Senior Scheduler
Victor Nordstrom, Graphics &
 Network Support/Photographer
Julie Sullivan, Executive
 Administrative Assistant
Jacqueline Alleyne, Document
 Control Manager
Celeste Albanese, Administrative
 Assistant
Ed Orlando, Cost Program Manager

Tishman/AECOM
Construction Team
Jean P. Arboleda
Marc S. Becker
Antoine T. Bernard Jr.
Lawrence J. Bourguet
Carolyn Caranante
Angela M. Canterbury
Joseph Capone Jr.
Bilal Capri
Tammy Cossean
Donna DePaolo
John A. Di Capua
Tara L. Doyle
Kevin T. Flynn
Lucia Giron Nanne
Jeffrey A. Holmes
Adam C. Jones
Steven J. Martinez
Charlette M. Pellot
Michael Pezzuto
Michael Pinelli
Katrina E. Pratt
Eduard Prom
Flora M. Ramos
Joseph A. Ricco
Dion L. Rivera
Hector E. Rodriguez
Marla Rothlein
Charles J. Sperling
Andrew K. Syvertsen
Michael D. Tomechko
Brian D. Troast Jr.
Vitaly Tropp
Dennis Valeri
Michael T. Vitelli

SOM Team, 2005–present
Steven Abel
Ajmal Aqtash
Angelo Arzano
John Ashton
Nabil Awad
Reiner Bagnato
Jonathan Baker
Lucia Bartholomew
Jennifer Bernell
Charles Besjak
Jessica Buckley
Natalie Carlson
Pamela Casella
Sophia Cha
David Chalmers
Wilson Chao
Nancy Cheung
Sung Ik Cho
James Cifuentes
Monica Coghlan
Alexandra Cuber
Mihai Craciun
Evan Cronly
Jonathan Dans
George De Brigard
Serge Demerjian
Owen Detlor
Andrew Donaldson
Balsam El-Ariss
Julia Ellinwood
Lick Fai
Peter Fajak
Michelle Falce

Manolo Figueroa
Joerg Flachowsky
Brent Fleming
Simon Frommenwiler
Babak Ghezelayagh
Amber Giacomelli
Richard Goodstein
David Gwinn
Catherine Haley
Gary Hansen
Aarij Hashimi
Raymond Hidalgo
Eric Ho
Olivia Holub
Ya-Ching Hsueh
Alfred Huang
Makida John-Baptiste
Matthew Jull
Neil Katz
Michael Kim
Russell Kim
Soerynn Kim
Nizam Kizilsencer
Matthieu Klein
Coin Koop
Christian Kotzamanis
Elizabeth H. Kubany
Wendy Lam
Louis Lee
Sang-Won Lee
Sophia Lee
Herbert Lynn
Arry Zi Mai
Donald Marmen
Lois Mazzitelli
Leo Molino
David Nguyen
Yuj Nishoka
Sara Ocampo
Kate Occhipinti
Christopher Olsen
Jocelyn Oppenheim
Sheryl Oring
Katherine Park
Alex Patterson
Mark Peterson
Simone Pfeiffer
Anna Pieczara
Gene Pyo
Dena Qaddumi
Benjamin Reich
Nicole Robertson
David Rodriguez
Diana Rodriguez
Rob Rothblatt
Jacob Rothman
Frank Ruggiero
Virginia Sanchez
Louise Sanseverino
Rashid Saxton
Sven Schroeter
Felix Scull
Fulay Senolsun
Ellen Shakespear
Anastasia Shimchick
Jim Simmons
Jeremy Singer
Shridhuli Solanki
Jeeun Song
Matt Stephenson
Dong Sun
Christoph Timm
Richard Tyler
Manola Ufer
Kathryn Van Nelson
Irene Vogt
Dan Weaver
Ross Wimer
Andrea Wong
Yeng Wu
Eill Wunder
Jaewoong Yi
John Zils
Teresa Zix

264

TRADE UNIONS THAT BUILT THE WORLD TRADE CENTER

International Brotherhood of Boilermakers, Iron Ship Builders, Blacksmiths, Forgers & Helpers
Boilermakers Local Lodge 5

United Brotherhood of Carpenters
Carpenters Local Union 20
Carpenters Local Union 45
Carpenters Local Union 157
Millwright and Machinery Erectors
 Local Union 740
Carpenters Local Union 926
Timbermen and Dockbuilders
 Local Union 1556
Resilient Floor Coverers Local
 Union 2287

International Brotherhood of Electrical Workers
Electrical Workers Local Union 3

International Union of Elevator Constructors
Elevator Constructors Local Union 1

International Association of Heat and Frost Insulators and Allied Workers
Heat and Frost Insulators and Allied
 Workers Local Union 12
Heat and Frost Insulators Local
 Union 12a

International Association of Bridge, Structural, Ornamental and Reinforcing Iron Workers
Iron Workers Local Union 40
Lathers Metallic Local Union 46
Derrickmen and Riggers Local
 Union 197
Iron Workers Local Union 361
Ornamental Iron Workers Local
 Union 580

Laborers' International Union of North America
Blasters, Drill Runners and Miners
 Local Union 29
Concrete Workers District
 Council 16
Cement and Concrete Workers
 Local Union 6-A
Cement and Concrete Workers
 Local Union 18-A
Cement and Concrete Workers
 Local Union 20
Asbestos, Lead and Hazardous
 Waste Laborers Local Union 78
Construction and General Building
 Laborers Local Union 79
Building Concrete, Excavation and
 Common Laborers Local Union
 731
Pavers & Roadbuilders District
 Council, Laborers Local
 Union 1010

International Union of Operating Engineers
Operating Engineers Local Union 14
Operating Engineers Local
 Union 15, 15a, 15b, 15c, and 15d
Operating Engineers Local Union 30
Operating Engineers Local Union 94
Operating Engineers Local
 Union 825

International Union of Painters and Allied Trades
Painters District Council 9
Metal Polishers Local Union/8a
Painters Structural Steel
 Local Union 806
Glaziers Local Union 1281
Drywall Tapers Local Union 1974

Operative Plasterers' and Cement Masons' International Association of the United States and Canada
Plasterers Local Union 262
Cement Masons Local Union 780

United Association of Journeymen & Apprentices of the Plumbing & Pipefitting Industry of the United States & Canada
Plumbers Local Union 1
Steamfitters Local Union 638

United Union of Roofers, Waterproofers and Allied Workers
Roofers and Waterproofers Local
 Union 8

Sheet Metal Workers' International Association
Sheet Metal Workers Local Union 28
Sheet Metal Workers Local Union 137

International Brotherhood of Teamsters
Teamsters Local Union 282
Private Sanitation Local Union 813
Teamsters Local Union 814

International Union of Bricklayers and Allied Craftworkers
Bricklayers Local Union 1
Tile, Marble and Terrazzo B.A.C.
 Local Union 7

Service Employees International Union
Union Local 32BJ

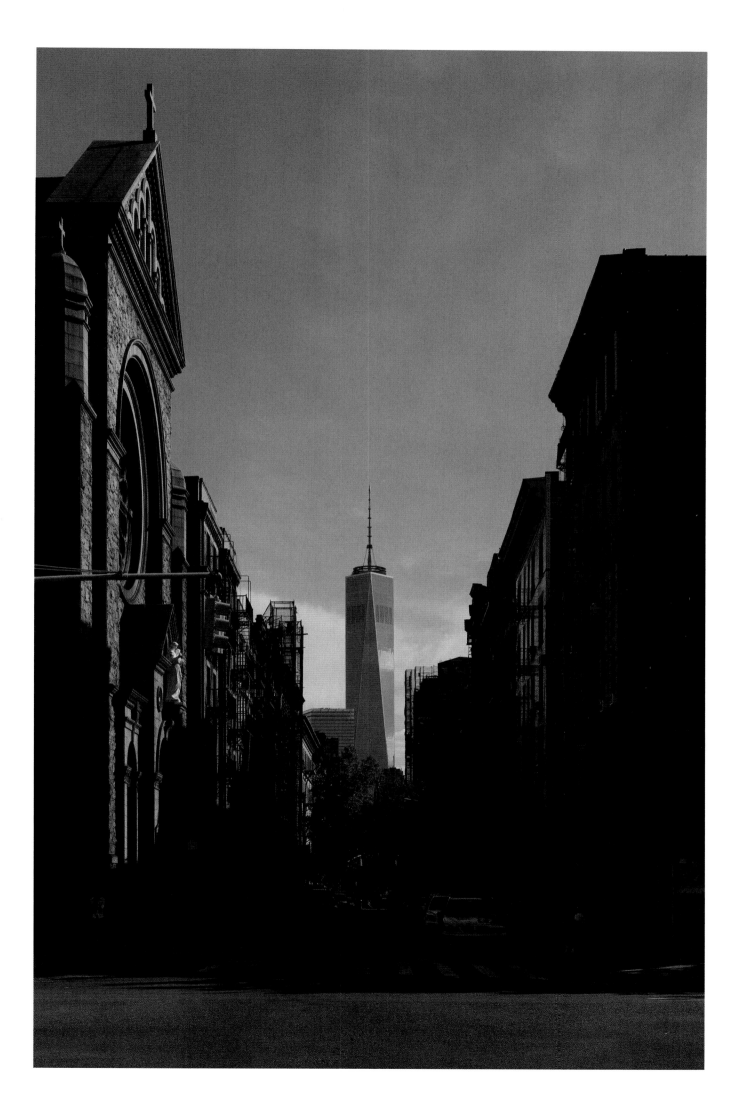

SOURCES

The Port Authority of New York and New Jersey provided me with unfettered access to their site, employees, suppliers, and archives. It was a privilege to be the only author given such access. These eyewitness accounts represent critical documentation—made while the interviewees were working actively on the project and not recollected in hindsight—that will augment the work of future scholars. The bulk of the text is culled from these accounts, construction documents, and other agency reports.

INTERVIEWS CONDUCTED (2003–2007; 2013–2015)

The Port Authority of New York & New Jersey: Patrick J. Foye, Executive Director; Scott H. Rechler, Vice Chairman, Board of Commissioners; Steven Plate, Director, World Trade Center Construction; Kenneth J. Ringler Jr., Executive Director (2004–2007); Christopher O. Ward, Executive Director (2008–2011); Carla Bonacci, Assistant Director, World Trade Center Site and Infrastructure Project Development, World Trade Center Construction; Michael Kraft, Senior Program Manager, World Trade Center Construction; Joseph P. Dunne, Chief Security Officer; Doug Farber, Chief of Security, World Trade Center; Mark Pagliettini, Assistant Director, World Trade Center Transportation Hub; and Erica Dumas and Rudy King, Media Relations

Skidmore, Owings & Merrill (SOM): David M. Childs, Consulting Design Partner; T. J. Gottesdiener, Managing Partner; Kenneth A. Lewis, Managing Director; Nicole Dosso, Technical Director; Jeffrey Holmes, Associate Design Partner (2003–2008); Carl Galioto, Technical Partner (2004–2009); and Elizabeth Harrison Kubany, firm spokesperson

Structural Engineering: Ahmad Rahimian, Chief Executive, and Yoram Eilon, Senior Vice President, WSP USA; Jon Galsworthy, Principal and Wind Engineering Director, Rowan Williams Davies & Irwin, Inc.; and Michael Stein, Managing Director, Schlaich Bergermann.

Tishman/AECOM: Daniel Tishman, Chairman and CEO; and Michael Pinelli, General Superintendent

Legends: David W. Checketts, Chairman and Chief Executive; John Urban, Legends Attractions; and Phil Hettema, The Hettema Group, Design, One World Experience

Silverstein Properties: Larry A. Silverstein, Chairman; and Dara McQuillan, Chief Marketing Officer

The Durst Organization: Douglas Durst, Chairman; Jonathan Durst, President; Thomas J. Duffe, Vice President and Director of Construction; Tony Tarazi, Senior Project Manager; Jordan Barowitz, Director of External Affairs; and Gary M. Rosenberg Esq., Rosenberg & Estis

Barbizon Electric Company: John Gebbie, Business Development Manager; and Benjamin Tevelow, Systems Technician

Benson Industries: Ryan Kernan, Project Manager; and Robyn Ryan, Project Coordinator

DCM Erectors: Kevin Murphy, Kevin Scally, Tom Hickey, and Mike O'Reilly

Eastern Concrete: Steve Jackson, Area Manager

Claude R. Engle, Lighting Consultant: Claude R. Engle III

The National September 11 Memorial & Museum: Joe Daniels, President and Chief Executive Officer; Alice Greenwald, Director; Lynn Rasic, Executive Vice President, External Affairs & Strategy; Michael Arad, 9/11 Memorial Designer; Peter Walker, 9/11 Memorial Designer; Steven M. Davis, Davis Brody Bond, Architect of the 9/11 Memorial Museum; Mark Wagner, Associate Partner, Davis Brody Bond; Craig Dykers, Snøhetta, Architect of 9/11 Memorial Museum Pavilion; Tom Hennes, Thinc Design, Lead Installation Designer, 9/11 Memorial Museum; and Ann Frank Farrington, Exhibition Consultant, 9/11 Memorial Museum

St. Nicholas National Shrine: Father Alexander Karloutsos, Protopresbyter of the Ecumenical Patriarchate, Greek Orthodox Archdiocese of America; and Mark Arey, The Hellenic Initiative

AECOM: Joseph E. Brown; and Andrew Lavallee

Maki & Associates: Gary Kamemoto, Director; and Osamu Sassa, Consulting Project Architect

Additional interviews: Santiago Calatrava, Architect, Transportation Hub and St. Nicholas National Shrine; James Carpenter, James Carpenter Design Associates, 7 World Trade Center; DBOX, Digital Visualizations; Michael Gericke, Pentagram; Diana Horowitz, Artist, 4 and 7 World Trade Center; Daniel Libeskind, World Trade Center Master Plan; Barbara Littenberg, Peterson/Littenberg; Carol Willis, Director, The Skyscraper Museum

BIBLIOGRAPHY

Blais, Allison, and Lynn Rasic. *A Place of Remembrance: Official Book of the National September 11 Memorial.* Washington, D.C.: National Geographic Society, 2011.

Chanin, Clifford, and Alice M. Greenwald, eds. *The Stories They Tell: Artifacts from the National September 11 Memorial Museum: A Journey of Remembrance.* New York: Skira Rizzoli, 2013.

Darton, Eric. *Divided We Stand: A Biography of the World Trade Center.* New York: Basic Books, 2011.

Downtown-Lower Manhattan Association, Inc. *World Trade Center: A Proposal for the Port of New York.* Jan. 27, 1960.

Glanz, James, and Eric Lipton. *City in the Sky: The Rise and Fall of the World Trade Center.* New York: Times Books / Henry Holt, 2004.

Goldberger, Paul. *Up from Zero.* New York: Random House, 2005.

Greenspan, Elizabeth. *Battle for Ground Zero.* New York: Palgrave Macmillan, 2013.

Maki, Fumihiko. *Nurturing Dreams: Collected Essays on Architecture and the City.* Cambridge, MA: MIT Press, 2008.

Mollenkopf, John, ed. *Contentious City: The Politics of Recovery in New York City.* New York: Russell Sage Foundation, 2005.

Mysak, Joe, with Judith Schiffer. *Perpetual Motion: The Illustrated History of the Port Authority of New York & New Jersey.* Los Angeles: General Publishing Group, 1997.

Nobel, Philip. *Sixteen Acres: Architecture and the Outrageous Struggle for the Future of Ground Zero.* New York: Metropolitan Books, 2005.

Principles for the Rebuilding of Lower Manhattan. New York: New York New Visions, 2002.

Robins, Anthony W. *The World Trade Center.* New York: Thompson & Columbus, 2011.

Saint Nicholas Greek Orthodox National Shrine at Ground Zero: The World Trade Center. Privately published, unpaginated, 2013.

Stephens, Suzanne. *Imagining Ground Zero: Official and Unofficial Proposals for the World Trade Center Site.* New York: Rizzoli, 2004.

MOMENT FRAMED SCHEME

TRUSSED SCHEME

W O R L D T R A D E C E N T E R | **T O W E R O N E** | CANTOR SEINUK GROUP | SCHLAICH BERGERMANN | **March 22, 2005**
WTC PROPERTIES, LLC, AN AFFILIATE OF | | | | SCALE: NTS
SILVERSTEIN PROPERTIES, INC. | SKIDMORE, OWINGS & MERRILL LLP | JAROS BAUM & BOLLES | BATTLE MCCARTHY | **ASK-1007**

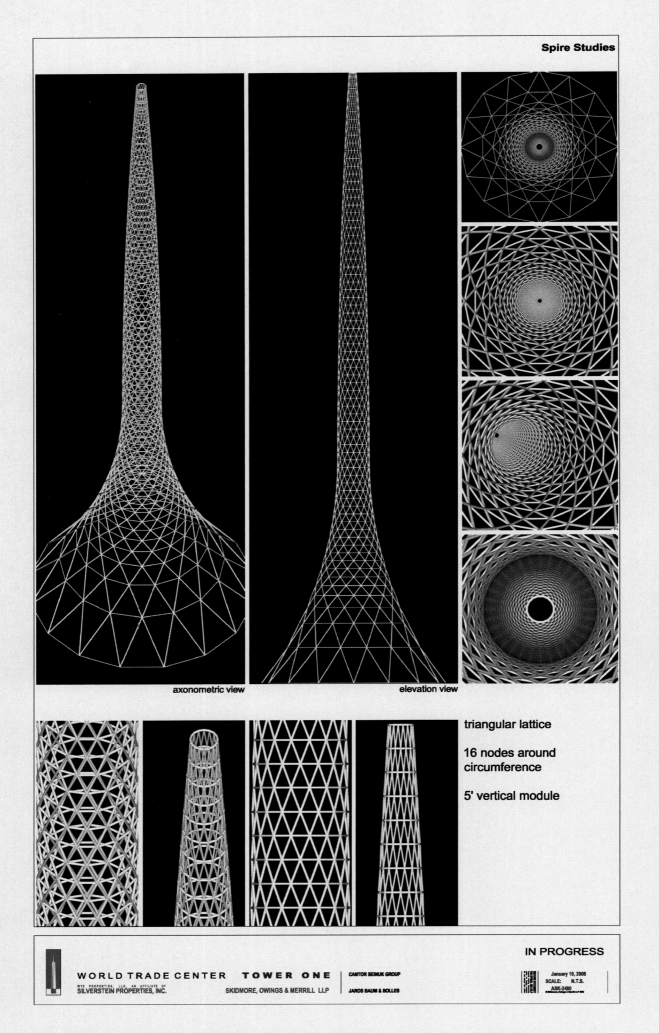

axonometric view

elevation view

triangular lattice

16 nodes around circumference

5' vertical module

IN PROGRESS

WORLD TRADE CENTER **TOWER ONE**
WTC PROPERTIES, LLC, AN AFFILIATE OF
SILVERSTEIN PROPERTIES, INC.

SKIDMORE, OWINGS & MERRILL LLP

CANTOR SEINUK GROUP

JAROS BAUM & BOLLES

January 19, 2006
SCALE: N.T.S.
ASK-2480

Various 2006 studies of the radome that would sheathe One World Trade Center's spire show the intricate triangular geometries of the structure the architects had envisioned.

NOTES

INTRODUCTION
Page

5 More than 26,000 workers: Steven Plate, Director, World Trade Center Construction, The Port Authority of New York & New Jersey. Interview, Feb. 6, 2014.

5 "single largest contributor to construction spending": Patrick Foye, Executive Director of the Port Authority, interview, June 5, 2015.

6 "different layers of objectives": David Childs, Chairman Emeritus and Consulting Design Partner, SOM, interview, Apr. 1, 2014.

9 "to-ing and fro-ing": Daniel Libeskind, AIA, Designer, World Trade Center Master Plan, interview, July 25, 2014.

9 Since its opening, people: Steve Cuozzo, "Public Has Embraced Gorgeous New World Trade Center," *New York Post*, Dec. 21, 2014.

10 In exchange for relieving: Joe Mysak with Judith Schiffer, *Perpetual Motion: The Illustrated History of the Port Authority of New York and New Jersey* (Santa Monica, CA: General Publishing Group, 1997), 163–64.

10 "In addition to the national": Foye, interview, June 24, 2014.

10 In the years that followed: Christopher O. Ward, Executive Director (2008–2011) of the Port Authority of New York & New Jersey. Interview, Nov. 18, 2014.

10 usually it would regroup: Scott H. Rechler, Vice Chairman, Board of Commissioners, The Port Authority, interview, July 1, 2014.

10 The idea, floated in 2002: Thomas J. Lueck. "McGreevey Calls Trade Center Land Swap Unlikely." *New York Times*, Aug. 22, 2002.

10 The constant turnover: Since the mid-1970s, New York's governor has selected the Port Authority's executive director, and New Jersey's governor has recommended the chair of the Board of Commissioners. It was further agreed in 1995 that New Jersey's governor would select a deputy executive director, who would share managerial responsibility with the New York–appointed executive director.

10 according to a special evaluatory panel: The Special Panel on the Future of the Port Authority, *Keeping the Region Moving. A Report Prepared for the Governors of New York and New Jersey.* Dec. 26, 2014.

10 Their 2014 report: Ibid., 10.

10 "The agency for the last couple": Rechler, interview, May 21, 2015.

11 "It's a positive, self-reinforcing cycle": Rechler, interview, May 21, 2015.

12 "executive director": Foye stepped down as executive director on Nov. 19, 2015.

12 "account for more than 128,200 jobs": The Rudin Center for Transportation Policy and Management at NYU and Appleseed. "SURPRISE! The World Trade Center Rebuilding Pays Off for the Port Authority—and the Region." Report. Oct. 29, 2015.

12 "he had a lease": Kenneth J. Ringler, Jr., Executive Director (2004–2007), The Port Authority of New York & New Jersey. Interview, June 24, 2015.

12 "because of the site's importance": Foye, interview, June 5, 2015.

12 "deliberate, strategic, and quite successful": The Rudin Center for Transportation Policy and Management at NYU and Appleseed. "SURPRISE! The World Trade Center Rebuilding Pays Off for the Port Authority—and the Region." Report. Oct. 29, 2015. This study asserts that the outlook for the World Trade Center is bright and that the Port Authority and Silverstein Properties made a sound investment in its redevelopment. The Port is likely to recoup 98.6 percent of its rebuilding costs by 2019; by 2020, the agency's WTC net operating income will be an estimated $177 million. Between 2002 and 2020, the Port/Silverstein investment will have directly and indirectly supported more than 198,700 person-years of work in the region, an average of more than 10,400 full-time-equivalent jobs per year; provided nearly $19.4 billion in wages; and generated $43.9 billion in regional economic output (all figures in 2015 dollars). For decades to come, the WTC will generate major tax revenues for New York City and State and, to a lesser extent, New Jersey. The benefits extend beyond economic impact: the WTC has transformed lower Manhattan, attracting new businesses and residents and allowing a vibrant cultural community to thrive downtown.

12 "While real estate development": Foye, interview, June 24, 2014.

12 joint venture with the Westfield Group: "World-Class Retail Coming to World Trade Center under Joint Venture between Port Authority & Westfield Group." Port Authority of New York & New Jersey press release, Feb. 9, 2012.

12 The authority's 2013 agreement with Legends: "Nationally Renowned Legends Hospitality Chosen to Develop and Operate Three-Story Observation Deck atop One World Trade Center." Port Authority of New York & New Jersey press release, Mar. 20, 2013.

12 "challenge of divestiture": Rechler, interview, May 21, 2015.

GROUND ZERO: COMPETING VISIONS
Page

22 The stark, unadorned date: Christopher Bonanos, "9/11, Name of." *New York Magazine*, Aug. 27, 2011.

22 Architect Rick Bell plants: Michael Gericke, Pentagram, interview, May 22, 2014.

22 "a marathon race": Plate, interview, Feb. 6, 2014.

22 New York New Visions: New York New Visions' partners included the Infrastructure Task Force of the New York City Partnership; the Real Estate Board of New York; the Civic Alliance; observers from the Department of City Planning; and participants from Community Board 1, the Manhattan and Bronx Borough Presidents' Offices, and the Alliance for Downtown.

23 "We've got to think": "Text of Mayor Giuliani's Farewell Address," *New York Times*, Dec. 27, 2001.

23 it is soon covered: For those whose loved ones' remains had yet to be recovered, erecting the platform was seen as premature, and their resentment was exacerbated by the announcement within days of its opening that, for crowd-control purposes, access would be by ticket only. Although free, tickets had to be picked up at the South Street Seaport—a twenty-minute hike away; the more cynical understood the ticket location as an attempt to entice people to visit other parts of the city where tourism had all but evaporated.

23 Max Protetch mounts: Philip Nobel, *Sixteen Acres: Architecture and the Outrageous Struggle for the Future of Ground Zero* (New York: Metropolitan Books, 2005), 95. *A New World Trade Center: Design Proposals* exhibit was on view from January 17 to February 17, 2002, at the Max Protetch Gallery, New York City. In association with *Architectural Record* and others, the gallery exhibited sixty drawings, models, and photographs submitted from architects around the globe. The show traveled to the National Building Museum in Washington, breaking all attendance records, and then took on a political dimension, representing the United States at the Venice Biennale in September 2002, before the Library of Congress acquired it.

25 "help build consensus": New York New Visions, *Principles for the Rebuilding of Lower Manhattan* (New York: New York New Visions, 2002).

25 Installed in a parking lot: *Tribute in Light* was conceived by John Bennett, Gustavo Bonevardi, Richard Nash Gould, Julian Laverdiere, and Paul Myoda and realized by Fisher Marantz Stone (FMS), who also designed the National September 11 Memorial & Museum lighting. Originally produced by the Municipal Art Society and Creative Time, in collaboration with the Battery Park City Authority, *Tribute in Light* is now directed by the National September 11 Memorial & Museum. FMS's first task was to source

lights that were powerful enough to be visible. They found 7,000-watt xenon searchlights in Las Vegas and did a test run of the installation there. Since even a slight misalignment would distort the beams, FMS stationed people in the five boroughs and New Jersey to report back on the alignment; eventually, they realized they could align the lights to the surrounding towers.

26 much of what BBB proposes: Paul Goldberger. *Up from Zero* (New York: Random House, 2005), 93. In writing about the public agencies' struggles to meet their obligations, Goldberger deemed the hiring of BBB a miscalculation. Thanks to Gehry's Bilbao Museum and other expressive structures that had sprung up in the previous decade, the public had come to expect architecture to make iconic statements, not merely be a placeholder for real estate.

26 "Listening to the City": Two Listening to the City meetings were held at the Javits Center, on July 20 and 22, 2002. An additional eight hundred people participated online between July 29 and August 12. The forums, sponsored by the LMDC and the Port Authority, were organized by the Civic Alliance to Rebuild Downtown New York, a planning coalition of eighty-five organizations. Additional support was received from the Center for Excellence in New York City Governance at the Robert F. Wagner Graduate School of Public Service at New York University, the Regional Plan Association, the Pratt Institute's Center for Community and Environmental Development, the New School's Milano Graduate School, and America*Speaks*.

26 "It was a town meeting": Robert Campbell, "Rigid Ideas Hinder Plans of WTC Site." *Boston Globe*, July 28, 2002, L1.

26 Critics, however, attacked: Michael Sorkin, "Critique," *Architectural Record* 190, no. 9 (Sept. 2002): 67.

26 The public and the press deemed: The Civic Alliance, *Listening to the City: Final Report*, September 24, 2002.

26 "People were exposed": Barbara Littenberg, Peterson/Littenberg, interview, June 10, 2014.

26 "It looks like Albany": Civic Alliance, "Listening to the City."

26 the LMDC regroups and issues: Lower Manhattan Development Corporation, "Request for Qualifications: Innovative Designs for the World Trade Center Site," Aug. 19, 2002.

27 the "Don't Rebuild. Reimagine" issue: More than a lineup of architectural beauty contestants, the plans, Muschamp insisted, were on par with the urban ambition evident in Vienna, Tokyo, Rotterdam, and other foreign cities. He admitted that the publication deadline didn't allow the team to focus on a number of critical issues that had to be addressed, including sustainable design, transit links, and underground retail. In fact, these were necessary accommodations that would ultimately play a key role in shaping the final site. The invited architects included Stephen Cassell and Adam Yarinsky of Architecture Research Office; Henry N. Cobb; Peter DePasquale; Todd Fouser, Reuben Jorsling and Sean Tracy of FACE Design; Alexander Gorlin; Zaha Hadid; Rem Koolhaas, Dan Wood, Joshua Ramus, and Office for Metropolitan Architecture; Koning Eizenberg Architecture; Maya Lin; Pablo Lorenzo-Eiroa; structural engineer Guy Nordenson; Enrique Norton and Bernardo Gómez-Pimienta of TEN Arquitectos; David Rockwell; Lindy Roy; and Hernan Diaz Alonso of Xefirotarch. Also included were Peter Eisenman, Charles Gwathmey, Steven Holl, Richard Meier, Frederic Schwartz, and Rafael Viñoly, all of whom were invited to submit proposals to the LMDC's "Innovative Design Study," issued on September 26, 2002.

27 Designed by Diana Balmori and Pentagram: Balmori and Pentagram worked in collaboration with the Skyscraper Museum, the New York Historical Society, New York New Visions, the Port Authority, and others. A year later, a second Viewing Wall that pictured the history of lower Manhattan since colonial times opened on the southern border.

28 *New York Magazine* publishes seven: Joseph Giovannini, "Rising to Greatness." *New York Magazine*, Sept. 16, 2002. The magazine published plans by architects Peter Eisenman, Zaha Hadid, Thom Mayne, William Pedersen, Wolf Prix, Lebbeus Woods, and Carlos

Zapata that accommodated the LMDC's guidelines but did not make functionality a "primary premise." Instead, they prescribed "curative doses of the beautiful, the poetic, the sublime."

29 The LMDC selects: The seven teams included Foster and Partners; Peterson/Littenberg Architecture and Urban Design; Studio Daniel Libeskind; Think Design (Shigeru Ban, Frederic Schwartz, Ken Smith, Rafael Viñoly), which presented three schemes; a consortium formed of Richard Meier & Partners, Eisenman Architects, Gwathmey Siegel & Associates, and Steven Holl Architects with engineers Craig Schwitter/Büro Happold; and United Architects (Greg Lynn Studio, UN Studio, Foreign Office Architects, Reiser + Umemoto, Kevin Kennon, Imaginary Forces). The team composed of SOM, SANAA, Field Operations, Tom Leader Studio, Inigo Manglano-Ovalle, Rita McBride, Jessica Stockholder, and Elyn Zimmerman withdrew from consideration; SOM team members Michael Maltzan Architecture and Neutelings Riedijk withdrew from their team in mid-December shortly before the proposals were made public.

29 the puzzle eludes the public's: Edward Wyatt, "Visions for Ground Zero: Overview; 7 Design Teams Offer New Ideas for Attack Site," *New York Times*, Dec. 19, 2002.

30 In a nine-page letter: Larry Silverstein, letter to John C. Whitehead, Chairman, Lower Manhattan Development Corporation, Jan. 31, 2003.

34 "astonishingly tasteless": Herbert Muschamp, "Balancing Reason and Emotion in Twin Towers Void," *New York Times*, Feb. 6, 2003.

34 "between the promise of birth": Steve Cuozzo, "Leader of the Pack: Think Team Proposes Right Kind of Rebuilding," *New York Post*, Feb. 3, 2003.

35 Silverstein calls a press conference: "Designs for Three World Trade Center Towers Unveiled," Silverstein Properties press release, July 7, 2003.

35 "Precisely because architecture": Libeskind, interview, June 17, 2003.

36 The joint city-state agency: "Governor and Mayor Name Lower Manhattan Redevelopment Corporation," LMDC press release, Nov. 29, 2001. Additional inaugural board members were Roland W. Betts, Paul A. Crotty, Lewis M. Eisenberg, Dick Grasso, Robert M. Harding, Sally Hernandez-Pinero, Thomas S. Johnson, Edward J. Malloy, E. Stanley O'Neal, Billie Tsien, Carl Weisbrod, Madelyn Wils, Deborah C. Wright, and Frank G. Zarb.

36 From the outset, the LMDC's ability: Lynne B. Sagalyn, "The Politics of Planning the World's Most Visible Urban Redevelopment Project," in *Contentious City: The Politics of Recovery in New York City*, edited by John H. Mollenkopf (New York: Russell Sage Foundation, 2005), 24.

36 In April 2002, the agency: The firms included Beyer Blinder Belle (BBB); Peterson/Littenberg; architects SOM; planners Cooper, Robertson & Partners; and engineers Parsons Brinkerhoff.

36 They ultimately selected: Goldberger, *Up from Zero*, 93.

36 LMDC issued an open Request: Lower Manhattan Development Corporation, "Request for Qualifications: Innovative Designs for the World Trade Center Site," Aug. 19, 2002.

36 Proposals had to accommodate: Littenberg, interview, June 10, 2014. Garvin derived the redevelopment guidelines for the Trade Center largely from New York New Visions' prescient document "Principles for the Rebuilding of Lower Manhattan" and was assisted by Peterson/Littenberg, an architecture firm that had prepared an award-winning master plan for lower Manhattan in 1994. The LMDC program also required provision of a central transportation hub to link subway, PATH, and future airport lines; cultural and civic amenities such as parks, museums, performing arts and educational facilities; and the rebuilding of St. Nicholas Orthodox Church.

36 "make lower Manhattan a destination": *Sixteen Acres*, directed by Richard Hankin, DVD (New York: Tanexis Productions, 2012).

36 More than one hundred thousand people: The Winter Garden

exhibition was open to the general public from December 20 until February 2, 2003.

36 "The designs are polar opposites": Quoted in Paul Goldberger, "Designing Downtown," *New Yorker*, Jan. 6, 2003.

36 the LMDC announced two finalists: Suzanne Stephens, *Imagining Ground Zero: Official and Unofficial Proposals for the World Trade Center Site* (New York: Rizzoli, 2004), 66.

36 the LMDC selected Libeskind's proposal: Alex Garvin and Stuart Lipton, "Effect: Delivering Change," *RSA Journal* 151, no. 5510 (Jan. 2004): 44. Accused of holding closed-door meetings, the LMDC in fact had established nine advisory councils composed of 211 members that met more than fifty times to consider all the issues before selecting Libeskind's master plan on February 27, 2003. Twenty-two public hearings were also held, in every borough and the tristate area.

36 "I may just be a hick": Quoted in Nobel, *Sixteen Acres*, 175.

37 the "Thanksgiving Accord": World Trade Center Design and Site Plan Agreement and Exhibits, Nov. 24, 2004.

EVOLUTION OF THE TOWER'S DESIGN

Page

43 The leases they had signed: Martin C. Pedersen, "In Praise of Guarded Optimism," *Metropolis Magazine*, Mar. 2004.

43 Silverstein commissioned SOM: Larry Silverstein, interview, Apr. 10, 2014. When Silverstein offered Childs the entire site, Childs demurred, saying the project would be "much more dynamic, much more attractive" if different architects designed each tower. Silverstein recalls David saying, "Honestly, you should not, you should not, as much as I'd love to have it, you should not offer it to me, because that would be a mistake and not in everybody's best interest." "[David] was very placid, very calm, and, obviously, very deliberate. It was a wonderful moment in time. I looked at him and said, 'I couldn't have a better friend.' " Childs said that Silverstein "loves to tell that story because he was so shocked. Here's an architect giving away work, [but] I don't care how good an architect you have, the imposition of one hand would not be as enlightening as having multiple hands."

43 "Dan, if I'm gonna have": Quoted in Nobel, *Sixteen Acres*.

43 "We spent quite a few months": T. J. Gottesdiener, Managing Partner, SOM, interview, Mar. 13, 2014.

44 "You're experiencing a certain meaning": Libeskind, interview, July 25, 2014.

44 "the issues of the families": Ibid.

44 Childs "is a gem": Silverstein, interview, Apr. 10, 2014.

44 a "mission he was entrusted": David M. Childs, correspondence with the author, Jan. 29, 2015.

44 Childs could give Silverstein: Nicolai Ouroussoff, "The Power Broker Yearns to Be Cool," *New York Times*, Feb. 20, 2005.

44 Their approaches were fundamentally at odds: Goldberger, *Up from Zero*, 188.

44 devised an internal cable system: David Childs, interview, Mar. 13, 2014. Structural engineer Guy Nordenson assisted in the development of this design.

44 This scheme was developed: Jeffrey Holmes, interview with the author, Feb. 13, 2015.

44 Pataki, frustrated that things: Deborah Sontag, "The Hole in the City's Heart," *New York Times*, Sept. 11, 2006. By all accounts, the governor deemed the World Trade Center a strategic backdrop for the upcoming Republican National Convention in Manhattan in August 2004 (his presidential bid would fail). But, as Sontag reports, his leadership was criticized widely as "erratic, risk-averse and lacking vision."

44 The governor told the LMDC: Edward Wyatt, "Officials Reach Agreement on Rebuilding Downtown," *New York Times*, July 16, 2003.

44 Pataki surprised everyone: Nobel, *Sixteen Acres*, 223.

44 That design survived until 2005: Ward, interview, Nov. 18, 2014.

48 "A lot of people talked about": Libeskind, interview, July 25, 2014.

48 the right to develop One and Five: In 2003, Silverstein selected French architect Jean Nouvel to design Five World Trade Center, and he relinquished his rights to develop the tower in 2006. Construction is on hold.

48 "Did we think it was fair?": Quoted in Nobel, *Sixteen Acres*.

48 "Silverstein is the one who said": Ward, interview, Nov. 18, 2014.

48 "It was the best teaching": Silverstein, interview, Apr. 10, 2014.

49 "America didn't lose its freedom": Ward, interview, Nov. 18, 2014.

49 he cares deeply about what: David M. Childs, conversation with the author, Dec. 31, 2014.

50 "This is my World Trade Center": Erica Dumas, Spokesperson, The Port Authority of New York & New Jersey. Interview, June 5, 2015.

52 "The slurry wall speaks": Libeskind, interview, June 17, 2003.

53 Constructing a concrete diaphragm: Henry Petroski, "Big Dig, Big Bridge," *American Scientist* 92 (2004): 317.

53 these walls were stabilized further: Scott Raab, "The Foundation," *Esquire*, Sept. 5, 2003.

53 below-grade structural slabs were installed: George J. Tamaro, "Holding Up," *Civil Engineering* 73 (2003): 62–67.

53 Tamaro worked with other foundational engineers: Mueser Rutledge consulted with other stakeholders besides the Port Authority, including Battery Park City Authority, Brookfield Properties, the state of New York, and Metropolitan Transit Authority, who were responsible for other structures that depended on the efficacy of the slurry walls.

53 "mud map": Marc Colella, Senior Associate, WSP USA. Correspondence, Nov. 6, 2015.

53 The slurry walls were fortified: Ahmad Rahimian, Chief Executive, WSP USA, interview, Apr. 17, 2014.

THE INFLUENCE OF SEVEN: SEVEN WORLD TRADE CENTER

Page

58 "One of the great attributes": James Carpenter, James Carpenter Design Associates, interview, May 15, 2014.

58 "The subtext of everything": Kenneth A. Lewis, Managing Director, SOM, interview, Apr. 11, 2014.

61 "We had to do something": Silverstein, interview, Apr. 10, 2014.

61 "Larry, we've got thirteen": Childs, interview, Mar. 13, 2014.

61 For 7 World Trade: Holzer's lobby installation scrolls quotations about Manhattan in a loop that is about thirty-six hours long. It includes lines from American poets such as Elizabeth Bishop, Langston Hughes, Walt Whitman, and William Carlos Williams, and from songwriter Woody Guthrie and essayist E. B. White. When the installation is viewed at an angle, the wall's acid-etched surface causes the text to transform into a luminous volume of white light.

62 SOM made life safety: Gottesdiener, interview, Mar. 13, 2014.

62 Silverstein was actively involved: Carl Galioto, interview, Dec. 31, 2014.

63 "We were collaborative": Peter Walker, Principal, PWP Landscape Architects, interview, Oct. 30, 2014.

63 Even the tenant leases are green: "Mayor Bloomberg Announces First Ever Lease For Commercial Office Space That Contains Groundbreaking Language That Incentivizes Energy Efficiency." Mayor Michael R. Bloomberg Office press release (109–11), Apr. 5, 2011. Silverstein Properties and the law firm of WilmerHale, a 7 World Trade Center tenant, were the first to adopt the green lease language crafted by the Mayor's Office of Long-Term Planning and Sustainability.

63 the harmony of a "jazz quartet": David W. Dunlap, "A First Look at Freedom Tower's Neighbors" *New York Times*, Sept. 8, 2006.

INTO THE BLUE: DESIGNING ONE WORLD TRADE CENTER

Page

69 "serenity amongst all the cacophony": Childs, interview, Apr. 1, 2014.

70 Its nuances become more apparent: Jeffrey Holmes, Associate Design Partner, SOM, interview, Oct. 10, 2014. Holmes spent a

lot of time studying American artists such as Donald Judd, Dan Flavin, and Richard Serra, whose minimalist work — composed of boxes, neon tubes, or twists of steel, respectively — creates a rich experience. A simple box becomes interesting, Holmes said, once you begin to consider its relationship to the room or to the proportions of the human body. "It's no longer about the box; it's about the interaction with it."

70 "It's difficult to say": Childs, interview, Apr. 1, 2014.

70 "Suddenly, it clicked": Childs, interview, Mar. 13, 2014.

70 "a stick of butter": Ibid.

70 the depth of a typical city block: Each side of the Twin Towers was 207 feet 2 inches (63.1 m) long.

71 buildings that express permanence and social purpose: John M. Bryan. *Robert Mills: America's First Architect* (New York: Princeton Architectural Press, 2001), 246.

71 "a front door": Childs, interview, Mar. 13, 2013.

72 He told Ward: Ward, interview, Nov. 18, 2014.

72 "a centralized decision-making group": Ibid.

72 Ward established a steering committee: The World Trade Center (WTC) Steering Committee included representatives from key WTC stakeholders: the Port Authority of New York & New Jersey and its Board of Commissioners; the Federal Transit Administration; the City of New York; the National September 11 Memorial & Museum; Silverstein Properties, Inc.; the Metropolitan Transportation Authority; the New York State Department of Transportation; and the Lower Manhattan Development Corporation.

72 "Not to be cynical": Ward, interview, Nov. 18, 2014. Ward said, "The only way we could bring them all to the table was by saying that the memorial would be done. Then you could say to them, 'Tough shit, while that's important and we're struggling with that, this is the priority.' … It cut through so many competing self-interests that it allowed, finally, some management control. Otherwise, it was like the scene in *Lawrence of Arabia* when the Bedouin tribes are in fucking Damascus and they're all screaming at each other. Once they knew the memorial was going to be delivered, they had to take a backseat because that was driving the schedule." Additionally, with some difficulty, the authority got out of the contract with the consortium of Skanska, Fluor, Granite, and Bovis, which was building everything except Silverstein's buildings. "We [then] went to competitively bid packages, which allowed us to deliver schedule and budget far more effectively and direct work in a more focused way."

72 It set forth schedules and budgets: The Port Authority of New York & New Jersey, *World Trade Center Report: A Roadmap Forward*, Oct. 2, 2008, 3.

73 "SOM nixed this design": Tony Tarazi, Senior Project Manager, Durst Organization, quoted in David W. Dunlap, "1 World Trade Center Is a Growing Presence, and a Changed One," *New York Times*, June 12, 2012.

73 "approachable, friendly, light": Gottesdiener, SOM, interview, Apr. 1, 2014.

73 "We set the mood": Claude R. Engle III, founder, Claude R. Engle, Lighting Consultant, interview, Mar. 10, 2014.

79 As the Port Authority saw it: The Port Authority of New York & New Jersey, Board of Commissioners meeting minutes, Aug. 5, 2010, 31.

79 they awarded the Durst Organization: "Port Authority Finalizes Agreement with Durst Organization for Equity Membership in One WTC," Port Authority of New York & New Jersey press release, Aug. 5, 2010.

79 The Durst Organization's portfolio: In some ways, Durst was a surprising choice. Earlier, in February 2007, Durst and Anthony E. Malkin, another powerful New York real-estate agent, took out full-page ads in New York newspapers. The open letter, written by the Continuing Committee for a Reasonable World Trade Center and addressed to the Port Authority and Governor Eliot Spitzer, called for a halt to One World Trade Center's construction. Despite

the "understandable rush to demonstrate New York's resilience after 9/11," the letter criticized the "frenetic redesign of the tower after the NYPD's security review." As designed, the tower would be "extraordinarily expensive to build," and, in any case, as the most valuable building on the site, it should have been built last to capitalize on the successes of the other buildings. The tower was "far too important an undertaking to be mired by inefficient planning, hasty design, or occupancy by government agencies paying sub-market rents." This was not the first family effort to stop construction at the Trade Center. As reported by R. W. Apple Jr. in the April 1, 1964, edition of the *New York Times*, Durst's father, Seymour B. Durst, and Malkin's grandfather Lawrence Wien had formed the Committee for a Reasonable World Trade Center in 1964 to protest the original Twin Towers, which they believed would flood Manhattan with unneeded office space and undermine the real estate market.

79 The firm's long game: Erin Carlyle, "Sky Scrappers: World Trade Center Is a Risk for Everyone Involved — Except the Durst Family," *Forbes*, July 21, 2014, 68.

79 "The view is what's going": Durst, interview, June 30, 2014.

79 As one incentive, the Port Authority: Charles V. Bagli, "Condé Nast Will Be Anchor of 1 World Trade Center," *New York Times*, May 17, 2011.

79 they "did not negotiate anything": Ward, interview, Nov. 18, 2014.

79 Ward addressed their concerns: Ibid.

79 Less predictably, Condé Nast's: Ibid.

81 automated systems cannot properly clean: Adam Higginbotham, "Life at the Top," *New Yorker*, Feb. 4, 2013.

82 They are equipped with: In 2012, Hurricane Sandy flooded two of One World Trade Center's basement levels and destroyed three costly, state-of-the-art fuel cells. The cells, which generate electricity with very little pollution, have yet to be replaced.

82 they constructed an "exemplar space": Ken Lewis, interview, Apr. 11, 2014.

82 "Some of them, quite frankly": Dan Tishman, Chairman and CEO, Tishman/AECOM, interview, June 16, 2014.

83 "a value engineering effort": The Port Authority of New York & New Jersey, Board of Commissioners meeting minutes, Aug. 5, 2010, 27.

83 "result in net economic benefit": Ibid., 44.

83 That equation later changed: Douglas Durst, Jonathan (Jody) Durst, Thomas Duffe, Tony Tarazi, and Jordan Barowitz, Durst Organization; Gary M. Rosenberg, Rosenberg & Estis, interview, June 30, 2014.

83 the "Port decides": Ibid.

83 "We don't cut costs": Ibid.

83 "We would have designed": Michael Stein, interview, Oct. 10, 2014.

83 the radome would increase: Jon Galsworthy, Principal and Wind Engineering Director, RWDI, interview, Sept. 26, 2014. At several different stages of design, RWDI analyzed the spire structure, testing it with and without the radome. According to Galsworthy, those tests revealed that "the radome actually resulted in the spire vibrating quite a bit. Without the radome, the wind just passes through the spire structure."

83 cited the radome's cost: James Panero, "A Beacon Diminished," *Wall Street Journal*, Sept. 20, 2013.

83 DCM/Solera, in turn subcontracted: Tara Taffera, "U.S. Suppliers Do the Design Work but Overseas Company Gets the Job for Portion of One World Trade Center," *USGlass News Network*, Mar. 31, 2009.

83 invested "high seven figures": Ibid.

83 The Chinese glass was brittle: Charles V. Bagli, "Feature at Trade Center Is Halted after $10 Million," *New York Times*, May 11, 2011.

83 Durst emailed SOM: Durst, interview, June 30, 2014.

83 "SOM rose to the occasion": Ibid.

83 "shimmering skirt": Holmes, interview, Oct. 10, 2014.

83 "It was going to be something": Peter Walker, Principal, PWP Landscape Architects, interview, Oct. 30, 2014.

84 "an exemplar for large-scale": The Port Authority, LMDC, and New York State Energy Research and Development Authority developed *Sustainable Design Guidelines Reference Manual for World Trade Center Redevelopment Projects*. Acknowledging the project's scale and extended time frame, as well as the reality that much on the site could not be defined simply as a "building," it urged "whole systems thinking." Densely detailed and nearly five hundred pages long, the manual was published in March 2005 as a supplement to an earlier set of guidelines.

84 "Sustainability wasn't limited": Lewis, interview, Apr. 22, 2014.

84 the event forced a move: Simon Lay, "How World Trade Center Affected Tall Building Life Safety Design: Fire Engineering," *CTBUH Journal* 3 (2011): 39.

84 "The most critical question": Galioto, interview, Dec. 31, 2014.

84 "Should one or more columns fail": Gottesdiener, interview, Mar. 13, 2014.

84 "a process of listening": Ibid.

84 "never been a major fire": Galioto, Dec. 31, 2014.

85 "Pre-9/11, it was a very": Childs, interview, Mar. 13, 2014.

86 "there's a requirement for buildings": Ibid.

86 In the past, it was assumed: Gottesdiener, interview, Mar. 13, 2014.

87 "What we can deal with": Quoted in *Science Illustrated* 4, no. 2 (Mar.–Apr. 2011): 36.

87 Childs made an emotional appeal: "CTBUH Affirms One World Trade Center Height," Council on Tall Buildings and Urban Habitat press release, Nov. 12, 2013.

STRONG AND TRUE: ENGINEERING ONE WORLD TRADE CENTER

Page

92 Greater Security Demands: Yoram Eilon, P. E., Senior Vice President, WSP USA, interview, June 18, 2015.

94 "Dan Tishman and the Tishman team": Gottesdiener, interview, Mar. 13, 2014.

94 a series of recommendations: Based on its WTC investigation, the National Institute of Standards and Technology issued recommendations that impact thirty-seven specific standards, codes, and practice guidelines. The final 2008 NIST report covered eight categories: increased structural integrity, enhanced fire performance, new methods of passive fire protection, improved active fire protection, improved building evacuation, improved emergency response, improved procedures and practices, and education and training. See the complete list of recommendations at http://www.nist.gov/el/disasterstudies/wtc/wtc_recommendations.cfm.

94 the steel perimeter and concrete core: Ahmad Rahimian and Yoram Eilon, "Rising to the Top," *Modern Steel Construction*, Feb. 2014.

94 decision was made early: Nicole Dosso, Technical Director, SOM, interview, Apr. 1, 2014.

94 One World Trade Center's foundation: Ahmad Rahimian and Yoram Eilon, "The Rise of One World Trade Center," Thomas C. Kavanagh Memorial Structural Engineering Lecture, Pennsylvania State University, Apr. 3, 2014.

98 "We immediately began laying": Michael DePallo, Director and General Manager, PATH, quoted in The Port Authority of New York & New Jersey, *World Trade Center Progress Newsletter*, Feb. 2010, 2.

98 The flooding was caused: Jerrold Dinkels, Srinath Jinadasa, and Raymond Sandiford, "Restoring PATH," *Civil Engineering* 73, no. 7 (July 2003): 56–61.

98 the solution "in a remarkable way": Tishman, interview, June 16, 2014.

98 Architect Nicole Dosso: Dosso, interview, Apr. 1, 2014. Dosso's father worked in New York City water and subway tunnels, and he would sometimes take her five hundred feet below ground when she was a young girl. Consequently, she said, wearing a hard hat and walking construction sites had become second nature.

98 first large-scale use: Nicole Dosso, correspondence with the author, June 5, 2015. SOM and Autodesk partnered to beta-test Revit on OWTC.

98 "There were multiple parties": Ibid.

98 "We were not dealing": Ibid. Dosso recalls coordinating the "J line wall" between the One World Trade Center and the Memorial sites in 2007. "We sat in a room with forty people trying to coordinate five openings, which should have taken a half hour to an hour. It took days, weeks, to get everybody to agree how those openings would be located and placed and how the infrastructure then would wrap with somebody else's building, and negotiating something that should've been 'Okay, here are the openings, here's what I need to get through the wall, and so on.' It really became an exercise in and of itself."

98 For the structural steel: Rahimian and Eilon, *Modern Steel Construction*, 23.

99 "Every structure interacts": Galsworthy, interview, Sept. 26, 2014.

99 "Inefficiency in the design": Lewis, interview, Apr. 22, 2014.

101 "It's the only reliable method": Galsworthy, interview, Sept. 26, 2014.

101 "anything Mother Nature": Ryan Kernan, Project Manager, Benson Industries. Interview, May 14, 2014.

101 What shapes motion perception: Melissa D. Burton, Kenny C. S. Kwok, Peter A. Hitchcock, and Roy O. Denoon, "Frequency Dependence of Human Response to Wind-Induced Building Motion," *Journal of Structural Engineering* 132, no. 2 (Feb. 2006): 296. Response to building movement arises from multiple psychological and physiological factors and varies widely from person to person.

101 "become an obstruction": Rahimian, interview, Apr. 17, 2014.

HIGH STEEL: BUILDING ONE WORLD TRADE CENTER

Page

109 "Everyone had to dance": Craig Dykers, AIA, Founding Partner, Snøhetta, interview, Apr. 1, 2014.

109 "we slowly and methodically broke": Plate, interview, June 5, 2014.

109 "We use this as a tool": Michael Kraft, Senior Program Manager, World Trade Center Construction, interview, June 30, 2014.

109–10 A state-of-the-art enterprise: Plate, interview, Feb. 6, 2014.

110 Plate was joined: Dan Tishman said his father realized there was a significant flaw in the construction industry: Owners "didn't engage a constructor until the project had been completely designed and everything was done and then looked to the constructor for a price. Then the battle started between the owner and the contractor." Tishman, interview, June 16, 2014.

110 game of chess: Tishman, interview, Mar. 26, 2014.

110 Before construction of the superstructure: Nadine Post, "Tower Crews Get Royal Treatment," *Engineering News-Record* 267, no. 5 (Aug. 15, 2011).

112 "I knew I would never": Tishman, interview, June 16, 2014.

112 Four of the lead ironworkers: Field Supervisor Kevin Murphy, Foreman Kevin Scally, Connector Tom Hickey, and Connector Mike O'Reilly, Local 40 Ironworkers employed by DCM Erectors, interview, Mar. 25, 2014.

112 Four cranes were used: Two Favco 760 internal climbing cranes, a Manitowoc 16000 Crawler Crane, and a Manitowoc 18000 Crawler Crane were used to erect the podium. The ironworkers also erected, "jumped," and dismantled a creeper crane that Collavino Construction, the concrete contractor, used to lift the material to build the concrete core.

113 Kahnawake and Aquasasne: Ralph Gardner Jr. "What's Old Is New Again." *Wall Street Journal*, Feb. 4, 2015.

114 once the glaciers retreated: Rhoda Amon," Shifting Sands and Fortunes," *Newsday*, Mar. 30, 1998.

114 "There were actually four": Steve Jackson, Area Manager, Eastern Concrete, interview, June 11, 2014.

117 "You're dealing with": Kernan, interview, May 14, 2014.

117 His father, John L. Tishman: John L. Tishman, "Construction

Management, a Professional Approach to Building," Robert B. Harris Inaugural Lecture, Center for Construction Engineering and Management, University of Michigan, Apr. 13, 1988. This landmark talk concerned the benefits of coordinating the efforts of the owner, construction manager, and architect from a project's outset. A radical departure from traditional ways of building, this approach let design and construction proceed simultaneously, resulting in major time and cost savings.

CONSTRUCTION TIMELINE: ONE WORLD TRADE CENTER

Page

123 After protracted legal battles: Sagalyn, "Politics of Planning the World's Most Visible Urban Redevelopment Project," 59. When Silverstein bought the original WTC lease, he had obtained insurance from two dozen insurers in the amount of $3.55 billion "per occurrence." After September 11, there were legal questions about the meaning of "occurrence." Did the attacks constitute one or two events? The answer determined whether there would be a single payout or one twice as large.

123 The largest single insurance: Charles V. Bagli, "Insurers Agree to Pay Billions at Ground Zero," *New York Times*, May 24, 2007.

127 "Uncertainty is expensive": The Port Authority of New York & New Jersey, *World Trade Center Report: A Roadmap Forward*, Oct. 2, 2008, 21.

129 at the 9/11 Memorial Museum: After praying at the 9/11 Memorial and greeting family members and rescue workers, Pope Francis descended into Foundation Hall at the museum. Standing before the slurry wall, its symbolic power never more evident, he presided over a multifaith ceremony of great breadth and power. Religious leaders said prayers in sacred tongue and in English. The three Abrahamic faiths were bridged in a striking visual tableau when Rabbi Elliot J. Cosgrove shook hands with Imam Khalid Latif, with Francis standing just behind them. The Pope called for peace: "We can and must build unity on the basis of our diversity of languages, cultures, and religions, and lift our voices against everything which would stand in the way of such unity. Together we are called to say 'no' to every attempt to impose uniformity and 'yes' to a diversity accepted and reconciled." With haunting emotion, Cantor Ari Schwartz sang the Kaddish, a Jewish prayer in honor of the deceased. As he ended, with repeated supplications for peace—Ya'aseh shalom, Ya'aseh shalom, Shalom aleinu (May He make peace, May He make peace, Peace for us)—Jews, Catholics, Muslims, and others chimed in softly. In that unforgettable moment, full of grief and hope, a secular museum became a holy temple.

131 "The workers knew": Plate, interview, Feb. 6, 2014.

133 May 19: The American Institute of Architects also awarded "Architect of Healing" medals to Julie Beckman, Robert I. Davidson, Ridgely Dixon, Craig Dykers, Ronald E. Fidler, Christopher Fromboluti, Keith Kaseman, Daniel Libeskind, Craig A. Morgan, Paul Murdock, and Mary Oehrlein. In addition, more than 130 architects received AIA Presidential Citations for their roles in rebuilding Ground Zero.

SEE FOREVER: ONE WORLD OBSERVATORY

Page

145 One World immerses guests: Phil Hettema, The Hettema Group, interview, Apr. 2, 2014.

146 "A view is power": Justin Davidson, "What You're Really Seeing from the 100th Floor of One World Trade Center," *New York Magazine*, May 31, 2015.

146 Meeting the public's expectations: David W. Checketts, Chairman and Chief Executive, Legends, interview, June 5, 2014.

148 Those effects were developed: The Hettema Group worked with these firms on elements of the One World experience: Blur Studio (Sky Pod), Mousetrappe (Voices of the Building), Réalisations, Inc. (See Forever Theater), Stimulant (Welcome Lobby), and Local Projects (City Pulse).

148 That interactive spirit guided the design: Doug Barnes, "Phil Hettema—from Disneyland to Universal to the World!," MiceChat Podcast, Oct. 12, 2013.

REMEMBRANCE: THE NATIONAL SEPTEMBER 11 MEMORIAL & MUSEUM

Page

164 He had few commissions: Arad worked for Kohn Pedersen Fox, notably on the ICC Tower in Hong Kong, before joining the Design Department of the New York City Housing Authority in 2003, where he had the opportunity to work on community projects, such as police stations. In 2004, he joined Handel Architects as a partner.

165 "five or six things": Walker, interview, Oct. 30, 2014.

165 "It's almost entirely spatial": Ibid.

165 "think longer before": Ibid.

166 Walker describes as a "harness": Ibid.

166 begun more than thirty years ago: Alexander Cooper and Stanton Eckstut, with the landscape architects Hanna/Olin and overseen by Amanda Burden of the Battery Park City Authority, included the riverfront esplanade, now 1.2 miles long, in their 1979 master plan for Battery Park City.

166 "from the first minute": Paul Marantz, FIALD, Founding Partner and Consulting Design Principal, Fisher Marantz Stone, interview, Oct. 29, 2014.

166 "We want the names above": Quoted in Sontag, "The Hole in the City's Heart."

166 The powerful Coalition: Joe Hagen, "The Breaking of Michael Arad," *New York Magazine*, May 22, 2006.

167 Arad suspected that moving: Ibid.

167 A thirteen-member jury: Jury members were Paula Grant Berry, 9/11 Memorial board member, whose husband died in the 2001 attacks; Susan K. Freedman, president of the Public Art Fund; Vartan Gregorian, president of the Carnegie Corporation of New York; Patricia Harris, first deputy mayor of New York City; Maya Lin, architect of the Vietnam Veterans Memorial in Washington, D.C.; Michael McKeon, former communications director for New York governor George Pataki; Julie Menin, chairperson of Community Board 1; Enrique Norten, architect and principal of TEN Arquitectos; Martin Puryear, sculptor; Nancy Rosen, art adviser; Lowery Stokes Sims, curator of Museum of Arts and Design; Michael Van Valkenburgh, landscape architect; and James E. Young, professor at the University of Massachusetts. In addition to Arad, the seven memorial competition finalists were *Dual Memory* by Brian Strawn and Karla Sierralta; *Garden of Lights* by Pierre David with Sean Corriel and Jessica Kmetovic; *Inversion of Light* by Toshio Sasaki; *Lower Waters* by Bradley Campbell and Matthias Neumann; *Passages of Light: The Memorial Cloud* by Gisela Baurmann, Sawad Brooks, and Jonas Coersmeier; *Suspending Memory* by Joseph Karadin with Hsin-Yi Wu; and *Votives in Suspension* by Norman Lee and Michael Lewis.

170 "I really felt for him": Walker, interview, Oct. 30, 2014.

170 What emerged was the idea: Michael Arad, 9/11 Memorial Designer, Handel Architects, interview, Nov. 3, 2014.

170 Arad began to explore: Arad, interview, May 8, 2015. Arad's initial competition proposal did not address the placement of the names. After winning the competition, however, he suggested that the names be placed in meaningful ways, an idea that the LMDC quashed. Arad said it was "the only time I broke down and cried." The plan to place the names randomly resulted in a lot of negative publicity for the memorial overall and very little fund-raising for a two-year period. Once it was decided to place the names in nine groups, organized by geographic location, Arad again took up the idea of "meaningful adjacencies" within those nine groupings, which is how the names are now arranged. Arad praised Bloomberg's "tremendous leap of faith. No typical politician would have given us the opportunity to implement this idea."

170 In June 2009, the 9/11 Memorial: Allison Blais and Lynn Rasic,

A Place of Remembrance: Official Book of the National September 11 Memorial (Washington, D.C.: National Geographic Society, 2011), 165.

170 "It was a very emotionally charged": Arad, interview, Nov. 3, 2014.

170 "The fact that I'm taking": Ibid.

172 "We recognized one thing": Dykers, interview, Apr. 1, 2014.

173 "searing fragment of ruin": Philippe de Montebello, "The Iconic Power of an Artifact," *New York Times*, Sept. 25, 2001.

173 They looked "manageable": Mark Wagner, AIA, Associate Partner, Davis Brody Bond, interview, Oct. 20, 2014.

173 "We couldn't control": Dykers, interview, Apr. 1, 2014.

178 There were fears that: David W. Dunlap, "Governor Bars Freedom Center at Ground Zero," *New York Times*, Sept. 29, 2005.

178 "why I fought hard": Dykers, interview, Apr. 1, 2014.

178 "They're very, very realistic": Ibid.

178 "It's where you realize": Steven Davis, FAIA, principal, Davis Brody Bond, and architect of the 9/11 Memorial Museum. Interview, Oct. 14, 2014.

178 were protected under Section 106: For a history of the Section 106 process, see Clifford Chanin and Alice M. Greenwald, eds., *The Stories They Tell: Artifacts from the National September 11 Memorial Museum: A Journey of Remembrance* (New York: Skira Rizzoli, 2013).

179 Paul Marantz guided the passage: Marantz, interview, Oct. 29, 2014.

179 The repository and a room for victims': Joe Daniels, President and Chief Executive Officer, National September 11 Memorial & Museum. Correspondence with the author, Nov. 24, 2014.

180 staff worked with trauma psychologists: Greenwald, interview, Sept. 23, 2014.

180 The exhibits had to meet: The museum's dedication took place on May 15, 2014, in Foundation Hall. About seven hundred guests attended the solemn ceremony, which was simulcast on the memorial plaza. Michael R. Bloomberg, chairman of the National September 11 Memorial & Museum, introduced President Barack Obama. The president's comments were followed by those of past and present political leaders whose careers were shaped by September 11, including New York governor Andrew Cuomo, New Jersey governor Chris Christie, New York City mayor Bill de Blasio, former New York governor George Pataki, former New Jersey governor Donald DiFrancesco, and former New York City mayor Rudolph Giuliani. First Lady Michelle Obama, former president Bill Clinton, and former secretary of state Hillary Rodham Clinton were in attendance. First responders, 9/11 family members, and survivors spoke, as did recovery workers from the FDNY, NYPD, and the Port Authority Police Department. Rhonda LaChanze Sapp, a Broadway singer who lost her husband, Calvin Gooding, on September 11, sang "Amazing Grace."

180 "Visitors typically fall into": Ann Frank Farrington, Exhibition Consultant, 9/11 Memorial Museum, interview, Sept. 18, 2014.

180 "I'd like to have a sanctum": Tom Hennes, Thinc Design. Lead installation designer, 9/11 Memorial Museum. Interview, Nov. 4, 2014.

180 "We felt that the trope": Greenwald, interview, Sept. 23, 2014.

180 Bearing witness to the unimaginable: "The National September 11 Memorial Museum Is Open to the Public," 9/11 Memorial Museum press release, May 21, 2014.

181 "An emotionally safe encounter": Quoted in "The Completion of the National September 11 Memorial Museum Upholds Commitment to Honor, Educate and Remember the History," National September 11 Memorial & Museum press release, May 14, 2014.

182 "It's a sacred place": Alice Greenwald, National September 11 Memorial Museum Director, interview, Sept. 23, 2014.

187 landfill on Staten Island: Elizabeth Royte, "New York's Fresh Kills Landfill Gets an Epic Facelift." *Audubon Magazine* 117, no. 4 (July–Aug. 2015): 48–58. Fresh Kills, once verdant marshlands, was established as a landfill by 1948. Although closed prior to September 11, 2001, it was reopened after that date because of the urgent need to move debris off the World Trade Center site and set up a working station to sift through tons of wreckage in the search for human remains. In 2003, Field Operations, the architectural firm behind the High Line, won a competition to restore Fresh Kills into a biologically diverse urban oasis.

187 stored at Hangar 17: Before the 9/11 Memorial Museum opened, the Port Authority stored as many as 1,284 objects at Hangar 17. Since then, most of the artifacts have found homes, donated to 1,500 organizations nationwide and around the world.

187 Wagner went on his gut: Wagner, interview, Oct. 20, 2014.

187 As others learned: Ibid.

PRIMEVAL BEAUTY: THE TRANSPORTATION HUB

Page

193 "the sky and the firmament": Andrew Rice, "A Glorious Boondoggle: Will the New WTC Station Permanently Taint Santiago Calatrava's Career?," *New York Magazine*, Mar. 9, 2015.

194 "create a link between you": Ibid.

194 "sense of accessibility": Ibid.

194 "L'architecture, c'est": Ibid.

195 "Imagine there could be places": Santiago Calatrava, interview, July 7, 2014.

195 "if they were different people": Carla Bonacci, Assistant Director of Infrastructure and Product Development, World Trade Center Construction, The Port Authority of New York & New Jersey. Interview, June 30, 2014.

195 "the Wedge of Light": Calatrava, interview, July 7, 2014.

195 "No one could ever get": Mark Pagliettini, Assistant Director, WTC Transportation Hub, The Port Authority of New York & New Jersey, interview, July 18, 2014.

195 "Thousands of commuters": Ibid.

195 These different ways of understanding: Calatrava, interview, July 7, 2014.

195 The Port Authority conducted: Goldberger, *Up from Zero*, 181.

199 "The airports look the way they do": Foye, interview, June 5, 2015.

199 Extra costs were linked: David W. Dunlap, "How Cost of Train Station at World Trade Center Swelled to $4 Billion," *New York Times*, Dec. 2, 2014. The price tag also rose in response to a tsunami of political demands, not the least of which were the presidential ambitions of Governor Pataki, who supported the Metropolitan Transportation Authority's desire to keep the No. 1 subway line running during construction—at a cost of at least $355 million to the Port Authority—so as not to anger commuters from Staten Island, largely Republican, who ferried to Manhattan and then used that subway line.

199 The billions spent: Andrew Rice, "A Glorious Boondoggle."

SPIRITUAL LEGACY: ST. NICHOLAS NATIONAL SHRINE

Page

204 "human-scaled presence": Santiago Calatrava, "A Monument to the Human and Divine," in *Saint Nicholas Greek Orthodox National Shrine at Ground Zero: The World Trade Center* (Privately published, unpaginated, 2013).

204 elements of two landmark churches: Calatrava, interview, July 7, 2014.

204 a cascading staircase: Archbishop Demetrios, Primate of the Greek Orthodox Church of America, conversation with the author, Sept. 25, 2015.

206 "love of the stranger": Fr. Alexander Karloutsos, Protopresbyter of the Ecumenical Patriarchate, interview, July 17, 2014.

206 a "city set on a hill": Mark Arey, "The City Set on a Hill Cannot Be Hidden," *Orthodox Observer*, Dec. 2013, 5.

206 "It somehow seems appropriate": Arey, interview, July 21, 2014.

206 "Freedom of conscience": "Port Authority and Greek Orthodox Archdiocese Announce Agreement on Rebuilding of St. Nicholas Greek Orthodox Church," The Port Authority of New York & New Jersey press release, Oct. 14, 2011.

206 A handful of items were salvaged: The items recovered at St.

Nicholas were a paper icon of St. Dionysios of Zakynthos; a hand-painted icon of the Zoodochos Peghe (Life-giving Fountain); a copper bell; melted candles; a silver candle holder; two books, a copy of the Holy Bible and a history of the Ecumenical Patriarchate; and several hand-embroidered velvet altar covers. These are displayed at the new church.

206 Church representatives sparred: Eliot Brown, "City News: Greek Church to Be Rebuilt at WTC Site," *Wall Street Journal*, Oct. 15, 2011, A19.

206 Efforts to proceed: The Port Authority of New York & New Jersey, *World Trade Center Report: A Roadmap Forward*, Oct. 2, 2008. This report identified the primary issues to be resolved before the mired rebuilding efforts downtown could proceed. Chief among them was coming to an agreement with the Archdiocese.

206 The original St. Nicholas: *Saint Nicholas Greek Orthodox National Shrine at Ground Zero*.

210 Both parties then agreed: The four-month study was led by Peter Lehrer, a renowned construction expert, who worked on the project on a pro bono basis with Director of World Trade Center Construction Steven Plate and independent engineers Gorton & Partners and McNamara/Salvia, Inc.

210 The Port Authority bore: David W. Dunlap, "Way Is Cleared to Rebuild Greek Orthodox Church Lost on 9/11," *New York Times*, City Room blog, Oct. 14, 2011.

212 Calatrava's design arose: Micol Forti, "The Metamorphoses of the Space between Sign and Function," in *Santiago Calatrava: The Metamorphoses of the Space, exhibition catalogue* (Vatican City: Edizioni Musei Vaticani, 2014), 24.

213 Many supported the plan: Mark Arey, "A Tale of Three Churches: Part 2," Orthodox Observer, Feb.–Mar. 2014, 5.

213 a national controversy ignited: See Elizabeth Greenspan, *Battle for Ground Zero* (New York: Palgrave Macmillan, 2013), for a thoughtful discussion of the Park51 battle. In addition to the Greek Orthodox Archdiocese, supporters included the United Jewish Federation of New York, September 11 Families for a Peaceful Tomorrow, and Community Board 1.

213 "Our first responders defended": Text of New York mayor Michael Bloomberg's speech, *Wall Street Journal*, Aug. 3, 2010.

213 Shortly after the tenth anniversary: In 2014, developer Sharif El-Gamal said he planned to build an Islamic museum and residential tower at the location.

213 to display the Ground Zero Cross: *American Atheists v. Port Authority of New York and New Jersey* (13-1668).

213 Mass was said weekly: Sally Jenkins, "9/11 Memorials: The Story of the Cross at Ground Zero," *Washington Post*, Sept. 8, 2011.

THE NEIGHBORHOOD

Page

219 *Time* magazine partnered: To commemorate the rebuilding of the World Trade Center, *Time* partnered with GigaPan, a tech startup based in Portland, Oregon, and founded by former NASA and Carnegie Mellon University researchers. The firm creates panoramic photographs that combine digital images with billions of pixels into one, highly detailed image. To make the 360-degree interactive image of views seen from One World Trade Center's topmost point, the team anchored a Canon 5D Mark II camera with a 100-mm lens to a jib anchored just below the beacon at the top of the tower's spire. On September 28, 2013, working over a five-hour span, they captured 567 pictures that were then stitched together digitally into a single massive—and zoomable—image of views in all four directions. The photograph is accessible at http://time.com/world-trade-center/#a-view-reborn.

219 *oku* connotes the innermost: Brendon Levitt, "Veiled Sustainability: The Screen in the Work of Fumihiko Maki," *Places: Forum of Design for the Public Realm* 17, no. 2 (Summer 2005): 76–81.

219 Their emotional response: Gary Kamemoto, Director, Maki & Associates. Interview, Oct. 22, 2014.

219 Kamemoto said they knew: Ibid.

220 The engineers had to: Osamu Sassa, Consulting Project Architect, Maki & Associates, interview, Sept. 30, 2014.

220 Convinced that public places: *Media Kit Announcing the 1993 Pritzker Architecture Prize Laureate* (Los Angeles: The Hyatt Foundation, 1993), 10.

220 He has long been a proponent: Yuriko Saito, "The Moral Dimension of Japanese Aesthetics," *Journal of Aesthetics & Art Criticism* 65, no. 1 (January 2007): 93.

220 This life-affirming urbanism: Blair Kamin, "Ground Zero's Gentle Giant," *Chicago Tribune*, Nov. 5, 2013.

220 cities shaped by *oku*: Fumihiko Maki, "The Japanese City and Inner Space," in *Nurturing Dreams: Collected Essays on Architecture and the City*, by Fumihiko Maki (Cambridge, MA: MIT Press, 2008), 165.

220 Maki compares this sensibility: Fumihiko Maki, "Japanese City Spaces and the Concept of Oku," *Japan Architect* (1979): 52.

225 "There were no expectations": Diana Horowitz, painter, interview, Sept. 29, 2014. Horowitz has been painting at the World Trade Center since 1985, first from the observation deck of the South Tower and then, as part of the Lower Manhattan Cultural Council's World Views program, from the upper floors of the North Tower. After September 11, Horowitz took her easel to Brooklyn and other parts of the city. She works at Four World Trade Center five or six days a week. Asked about the advantages of working from this particular perch, she said that "the paintings I've done there are the biggest I've ever done. Canvases of that size wouldn't have been possible if I wasn't able to leave my things there. It allowed me to do justice to the scale of the site."

225 The sensibility implied by *oku*: Fumihiko Maki, "My City: The Acquisition of Mental Landscapes," in Fumihiko Maki, *Nurturing Dreams*, 91.

225 Today, Maki observed: Fumihiko Maki, "Modernity and the Present," in Fumihiko Maki, *Nurturing Dreams*, 256.

225 Fumihiko Maki, seen here: Fumihiko Maki, *Nurturing Dreams*, 29.

228 "We will leave this city": Richard Rogers. *Cities for a Small Planet* (New York: Basic Books, 2008): 16.

228 Since then, Rogers has shaped: Edwin Heathcote, "Urban Warrior: Richard Rogers and 'Inside Out,'" *Financial Times*, July 19, 2013.

228 "We can fit more people": Larry Silverstein, interview, Apr. 10, 2014.

230 Once the building is completed: Charles V. Bagli, "First Business Tenant Is Set for a Trade Center Building," *New York Times*, Dec. 23, 2013. GroupM is one of the many media, technical, and creative companies flocking to an area historically dominated by banks and financial services.

230 All parties agreed: The current migration of media firms to the downtown area recalls an earlier era, when lower Manhattan was the nation's news hive in the nineteenth century and reporters cranked out stories for the city's daily papers—the *Herald, Sun, Tribune, World, Journal*, and *Times*—from offices along Newspaper Row, a group of buildings across from City Hall Park, just blocks from the World Trade Center.

230 he wanted to restructure: Charles V. Bagli, "Developer Reaches Deal to Finish 80-Story Tower," *New York Times*, June 25, 2014.

230 Failure to complete: Steve Cuozzo, "3 WTC Gets a Boost: Leasing Spurt Improves Silverstein's Chances," *New York Post*, June 23, 2014.

230 Critics argued: Charles V. Bagli, "Developer's Skyscraper Is Focus of Latest Dispute at Rebuilt Trade Center," *New York Times*, Mar. 16, 2014.

230 "We are triaging": Quoted in Joe Nocera, "The Real Port Authority Scandal," *New York Times*, Apr. 21, 2014.

230 The public also weighed in: Margaret Donovan spoke on behalf of the Twin Towers Alliance, a nonprofit citizens watchdog group; Paul Fernandes, chief of staff of the Building and Construction Trades Council of Greater New York, spoke on behalf of the local affiliates of fifteen national and international unions. Port

Authority of New York & New Jersey Board of Commissioners, committee meeting video, Apr. 23, 2015.

231 "a lot of what you hear": Ibid.

231 the decision on Silverstein's request: Daniel Geiger, "Deal Eyed to Restart Work on 3 WTC," *Crain's New York Business*, June 23, 2014.

231 Rechler disagreed: Rechler, interview, July 1, 2014.

231 "Glut ain't the case": Silverstein, interview, Apr. 10, 2014.

231 "Relentlessness is the first": Foye, interview, June 24, 2014.

231 A video documenting this vote: The Port Authority of New York & New Jersey, Board of Commissioners, committee meeting video, June 25, 2015.

231 "immediately jump-start vertical": Quoted in Bagli, "Developer Reaches Deal."

231 Later, Rechler wrote a gutsy article: Scott Rechler, "WTC Deal Signals a New Port Authority," *Newsday*, June 25, 2014.

231 Months of open debate: Scott Rechler, correspondence with the author, Aug. 19, 2014.

231 "new day at the Port Authority": Rechler, interview, July 1, 2014.

232 "a vertical village": Nikolai Fedak, "Interview: Bjarke Ingels on New Design for 200 Greenwich Street, AKA Two World Trade Center," New York YIMBY, June 11, 2015.

232 Even the announcement: Goldberger, "How 2 World Trade Center Was Redesigned Exactly for Rupert Murdoch's Media Empire." *Vanity Fair*, June 10, 2015.

232 It was accompanied: Andrew Rice, "Revealed: The Inside Story of the Last WTC Tower's Design," *Wired*, June 9, 2015.

232 The foundations had been built: Andrew Rice, "Big Deal," *Wired*, Sept. 28 2015. Piggybacking the new skyscraper onto Foster's foundation created structural problems, especially in the lobby and the lower floors, which had to be engineered to shift the tower's weight onto the preexisting supports.

232 Once Two's anchor tenants: The two companies signed a nonbinding but detailed letter of intent with Silverstein Properties on June 2, 2015.

232 "My first reaction": Quoted in Rice, "Revealed: The Inside Story of the Last WTC Tower's Design."

232 But there was little doubt: Rice, "Revealed: The Inside Story of the Last WTC Tower's Design."

233 Its profile recalls other: David Brussat, "BIG copies the future!" *Architecture Here and There* blog, June 12, 2015.

234 "It'll be pretty epic": Quoted in Rice, "Revealed: The Inside Story of the Last WTC Tower's Design."

234 "Your capacity to communicate": Ian Parker, "High Rise," *New Yorker*, Sept. 10, 2012.

235 The deal also signaled: Goldberger, "How 2 World Trade Center Was Redesigned Exactly for Rupert Murdoch's Media Empire."

235 On the east side: Ibid.

235 "Even though they are not twins": Quoted in Sara Pepitone, "When Larry Met Bjarke...," *Commercial Observer*, June 17, 2015.

235 "the vertical segregation": Bjarke Ingels, "Interview with Charlie Rose." *Charlie Rose*, PBS, New York. June 16, 2015.

236 Even his mother calls him: Parker, "High Rise."

237 the Greenwich Street façade is conservative: Andrew Rice, "Big Deal." Two's critics include Douglas Durst, whose firm developed One World Trade Center and commissioned BIG to design VIA 57 West. "I'm very disappointed in Bjarke's design," Durst said of the orientation of Two's stepped gardens. "He turned his back on [One]. Not even metaphorically. It's very disrespectful." Although Durst still thinks Ingels is a genius, Rice writes that a "cynic might say the developer has an interest in minimizing competition as he attempts to lease his own World Trade Center building." Justin Shubow, president of the National Civic Art Society, wrote that to build a tower "seemingly on the verge of collapse at the site of the former World Trade Center goes beyond bad taste; it constitutes gross negligence. Two World Trade Center, like the three nearby towers at the site, ought to look as permanent and stable as possible." Shubow, "Towering Infernal," *Weekly Standard*, Sept. 21, 2015.

238 a "lifted landscape": Joseph E. Brown, FASLA, AECOM, interview, Aug. 4, 2014.

238 "Let's get people off": Andrew Lavallee, FASLA, AECOM, interview, Aug. 8, 2014.

238 initially dismissed the idea: Ibid.

238 "We chuckled at first": Ibid.

239 "We chose not to go": Brown, interview, Aug. 4, 2014.

239 they "wrapped the landscape": Ibid.

239 Placing, sizing, and disguising: The ventilation towers are located next to the pedestrian bridge, one at the corner of West and Cedar streets, two immediately south of the church adjacent to the future Tower 5, and one embedded in the church itself.

239 located with standoff distances: The ventilation shafts' profiles were also determined by the way air moves around the different skyscrapers in the area; changing the size or height of any given vent required a costly airflow analysis of the entire district. Additionally, every time a park element was moved, the walkways had to be redesigned to make the vents as unobtrusive as possible.

239 "We pushed and pulled": Lavallee, interview, Aug. 8, 2014.

SIXTEEN ACRES: HOSPITALITY, SAFETY, AND SECURITY
Page

244 The Port Authority's overarching goal: Bonacci interview.

244 To integrate the security features: Lavallee, interview.

244 The plaza needed light sufficient: Ibid. For human beings to feel secure, lighting does not have to be extremely strong, just strong enough. Originally FMS was asked to provide five-foot-candle lighting on the plaza, a foot-candle being a unit of light intensity. However, because this is New York, where "there's plenty of light floating around loose in the air" FMS was allowed to use half-foot-candle lighting. Marantz took Robert Ducibella, a Port Authority security consultant to various parks in the city, including Bryant Park, "the best corollary place to downtown because it's surrounded by tall buildings. . . . We put a light meter in the middle of the Bryant Park lawn, and it measured half a foot-candle." Ducibella agreed it was sufficient and waived the five-foot-candle requirement.

247 "The minute you begin thinking": Marantz, interview, Oct. 29, 2014.

247 "We had gone to Israel": Walker, interview, Oct. 30, 2014.

247 There are none on the memorial: There have been numerous failed attempts to install self-cleaning automated toilets in Manhattan. In 1992, JCDecaux, a French advertising company, installed six restrooms that were removed after a four-month testing period; Cemusa, a Spanish advertising company, won a contract in 2008 to install twenty units, but only three, one of which is in Manhattan, have been installed thus far.

247 "we'll probably spend": Foye, interview, June 24, 2014.

250 "We have to live our lives": Joseph Dunne, Chief Security Officer, Port Authority of New York & New Jersey. Interview, June 24, 2014.

250 Fears that bulky, obstructive security: David Dunlap, "With Security, Trade Center Faces New Isolation," *New York Times*, May 16, 2013.

250 The Authority worked: Erica Dumas, Spokesperson, The Port Authority of New York & New Jersey, correspondence with the author, Jan. 13, 2015.

250 Credentialing and screening: The City of New York Police Department, "World Trade Center Campus Security Plan. Statement of Findings," Aug. 26, 2013.

251 "Someone once asked me": Doug Farber, Chief of Security, World Trade Center, Port Authority of New York & New Jersey. Interview, July 8, 2014. A thoughtful man who takes long pauses before speaking, Farber began his career in the Secret Service in 1997, working as a specialist in the Technical Security division during the Clinton, Bush, and Obama administrations. His job required

detecting environmental, chemical, and physical threats to the White House's occupants at home and abroad.

251 "We're the number one target": *60 Minutes* interview with Ray Kelly, Sept. 25, 2011.

AFTERWORD
Page

252 The Manhattan market: Carol Willis, Founder and Director, The Skyscraper Museum, interview, Dec. 30, 2014. While some question whether that much commercial space is needed, many developers are betting yes and leveraging pricing and location to their advantage. At one time banking and financial services were concentrated in the Wall Street district, but after the Second World War banks and other large corporations began to migrate to the newer buildings in midtown. Downtown office space expanded in the 1970s with the completion of the Twin Towers and then again

with the development in the late 1980s of the World Financial Center, now Brookfield Place, in Battery Park City.

252 Critics damned it as compromised: Michael Kimmelman, "A Soaring Emblem of New York, and Its Upside-Down Priorities," *New York Times*, Nov. 30, 2014, A1; Banksy, unpublished op-ed piece, posted online, Oct. 27, 2013, http://banksy.co.uk; Zachary M. Seward, "The Failure of One World Trade Center," *Quartz*, Nov. 3, 2014; Michael Sorkin, "Ground Zero Sum," *The Nation*, July 22–29, 2013; Blair Kamin, "One World Trade Center 'a Bold but Flawed Giant,'" *Chicago Tribune*, Oct. 18, 2014; Aaron Betsky, "Spireless Wonder," *Architect*, Aug. 13, 2012.

252 performing arts center: Robin Pogrebin. "Design Team Named for Performing Arts Center at World Trade Center Site," *New York Times*, Nov. 20, 2015. REX, a Brooklyn-based architecture firm, will design the WTC PAC, with Davis Brody Bond as executive architect.

IMAGE CREDITS

Front Matter Endpapers: DBOX/ plans by Skidmore, Owings & Merrill; vi: © Skidmore, Owings & Merrill; vii: © Skidmore, Owings & Merrill; xii–xiii: © James Ewing/ OTTO **Introduction** 2–3: © DBOX/ architecture by Robert A. M. Stern Architects, Fumihiko Maki, BIG, Skidmore, Owings & Merrill, and Pei Cobb Freed & Partners; 11: © Port Authority of New York & New Jersey (PANYNJ); 12: © PANYNJ; 13: © DBOX/architecture by Skidmore, Owings & Merrill, BIG, and Fumihiko Maki; 14–15: © The Council on Tall Buildings and Urban Habitat; **Ground Zero: Competing Visions** 19: © PANYNJ; 21: Courtesy Laura Kurgan; 22: Andrea Booher/ FEMA News Photo; 23T: Andrea Booher/FEMA News Photo; 23B: Foreign Office Architects/Farshid Moussavi, Alejandro Zaera Polo; 24T: Carlos Brillembourg/Carlos Brillembourg Architects; 24B: © Hariri & Hariri; 25L: Barry Yanowitz; 25R: © PANYNJ; 26: Beyer Blinder Belle Architects & Planners LLP; 27T: © Rafael Viñoly Architects; 27B: Courtesy of Pentagram; 28T: Andrea Booher/FEMA News Photo; 28B: Kohn Pedersen Fox; 29T: © Peterson, Littenberg Architecture and Urban Design/Photo: Jock Pottle; 29B: © DBOX/architecture by Richard Meier, Peter Eisenman, Charles Gwathmey, and Steven Holl; 30: Foster + Partners; 31: Courtesy Rafael Viñoly Architects; 32–33: © Daniel Libeskind; 34T: © Torsten Seidel, courtesy of Studio Libeskind; 34B: © Studio Libeskind; 34R: © Daniel Libeskind; 35: Courtesy Michael Arad; 36T: © Archimation, courtesy Studio Libeskind; 36B: © PANYNJ; 37T: Project Rebirth; 37B: © Studio Libeskind; **Evolution of the Tower's Design** 42: © Skidmore, Owings & Merrill; 45: © Studio Libeskind; 46L: © Miller Hare, courtesy Studio Libeskind; 46R:

Courtesy of Guy Nordenson and Associates/Photo: Jock Pottle. The Museum of Modern Art, Collection Number: 494.2005; 47L: Courtesy Skidmore, Owings & Merrill/© Jock Pottle; 47R: © Skidmore, Owings & Merrill/DBOX; 48: Courtesy Silverstein Properties, Inc.; 49T: Courtesy Skidmore, Owings & Merrill/© Greg Betz; 49B: © Stefan Ruiz, courtesy Studio Libeskind; 50–51: © DBOX/architecture by Pei Cobb Freed & Partners, Skidmore, Owings & Merrill, BIG, Santiago Calatrava, Rogers Stirk Harbour + Partners, and Fumihiko Maki; 53L: © Archimation, courtesy Studio Libeskind; 53C/53R: © PANYNJ; **The Influence of Seven** 61: Courtesy Silverstein Properties, Inc./Photo: Joe Woolhead; 62T: Courtesy Silverstein Properties, Inc./Photo: Joe Woolhead; 62B: James Carpenter Design Associates; 63: Courtesy Silverstein Properties, Inc./Photo: Joe Woolhead; **Into the Blue** 70: © Skidmore, Owings and Merrill; 71: Photo: David Iliff, License: CC-BY-SA 3.0; 73: © 2015 Nicola Lyn Evans/WSP|Parsons Brinckerhoff; 76: ThyssenKrupp Elevator/Scott Lahmers; 78: © James Ewing/OTTO; 79: The Durst Organization; 80: © Skidmore, Owings & Merrill; 81: © PANYNJ; 82T: Library of Congress, Historic American Engineering Record/ Photo: Jack Boucher and Jet Lowe; 82B: Courtesy Silverstein Properties, Inc./Photo: Joe Woolhead; 86: © PANYNJ/Photo: Victor Nordstrom; 87: © 2015 Nicola Lyn Evans/ WSP|Parsons Brinckerhoff; 88–89 © 2015 Nicola Lyn Evans/WSP|Parsons Brinckerhoff; **Strong and True** 95: © James Ewing/OTTO; 96: © PANYNJ/Photo: Michael Mahesh; 97: © DBOX/architecture by Skidmore, Owings & Merrill; 99: Rowan Williams Davies & Irwin Inc. (RWDI); 103T: © PANYNJ; 103B: © PANYNJ; 103R: © 2015 Nicola Lyn Evans/ WSP|Parsons Brinckerhoff; **High Steel** 107–108: © PANYNJ/Photo: Michael Mahesh; 110: © PANYNJ; 113: © PANYNJ/Photo: Victor Nordstrom; 115: © PANYNJ/Photo: Victor Nordstrom; 116: © PANYNJ; 117T: © PANYNJ; 117B: Michael

Falco; 118–119: Courtesy of Brian Cury, Founder of EarthCam, Inc., © EarthCam, Inc.; **Construction Timeline** All images © PANYNJ, with these exceptions: 4/27/06: Courtesy Silverstein Properties Inc./Photo: Allan Tannenbaum; 6/28/06: Courtesy Skidmore, Owings & Merrill; 5/23/06, 7/26/06, 9/11/11, 6/25/12, 5/10/13: Courtesy Silverstein Properties, Inc./Photo: Joe Woolhead; 2/15/14, 3/26/14, 5/21/14: Judith Dupré; 7/28/14: Michael Rieger/FEMA News Photo; 10/18/14: Courtesy Greek Orthodox Archdiocese of America/Photo: Dimitrios Panagos; **See Forever** 147T: Photo: Evan Joseph, courtesy of The Hettema Group; 152–159: Evan Joseph Images/AirPhotosLIVE; **Remembrance** 163: Photo: Joe Woolhead, Courtesy 9/11 Memorial; 165T: © PANYNJ/Photo: Victor Nordstrom; 165B: Michael Arad, 2003; 166: © PANYNJ; 167: Courtesy Michael Arad; 170T: © PANYNJ; 170B: PWP Landscape Architecture; 172L: Courtesy of Davis Brody Bond LLP; 173T: © PANYNJ; 174: Photo: Ofer Wolberger, Courtesy 9/11 Memorial; 175: Courtesy of Davis Brody Bond LLP; 178: Snøhetta; 179: Official White House Photo by Pete Souza; 180: Courtesy of Davis Brody Bond LLP; 181: Thinc Design; 182: Thinc Design, Photo: Tom Hennes; 183BL: Thinc Design, Photo: Tom Hennes; 183BR: Thinc Design, Photo: Tom Hennes; 187: Thinc Design, Photo: Tom Hennes; **Primeval Beauty** 193: © PANYNJ; 195: Dimitri Kasterine; **Spiritual Legacy** 205: © 2014 Santiago Calatrava LLC. All rights reserved.; 206: Arild Vågen; 207: © 2014 Santiago Calatrava LLC. All rights reserved.; 210: Courtesy Greek Orthodox Archdiocese of America; 211: © 2014 Santiago Calatrava LLC. All rights reserved.; 212–213: © 2014 Santiago Calatrava LLC. All rights reserved.; **The Neighborhood** 221: Courtesy Maki and Associates/ Photo: Tectonic; 222–223: © Bednorz-Images 2015; 224T: Courtesy Maki and Associates; 224B: © Diana Horowitz; 225: Courtesy Maki and Associates; 226–227: © 2015 Sanan Media; 228–232:

Courtesy Silverstein Properties, Inc.; 233: © DBOX/architecture by BIG; 234–235: Courtesy Silverstein Properties, Inc.; 236L: Courtesy Bjarke Ingels Group (BIG)/Image by Thomas Loof; 236R: © DBOX/ architecture by Skidmore, Owings & Merrill, Pei Cobb Freed & Partners, BIG, Santiago Calatrava, Rogers Stirk Harbour + Partners, and Fumihiko Maki; 238–239: Downtown Streetscape Partnership, a joint venture of AECOM and Jacobs; **Sixteen Acres** 245T: © DBOX for Westfield Corporation, architecture by Santiago Calatrava; 245B: © DBOX for Westfield Corporation; 247: © PANYNJ; 250–251: © DBOX for Westfield Corporation; **Afterword** 253: © Bednorz-Images 2015; **Back Matter** 261: Milton Glaser; 264: Top row, L–R: International Brotherhood of Boilermakers; Cement & Concrete Workers District Council; Cement & Concrete Workers, Local 6A; Cement & Concrete Workers, N.Y. City & Vicinity, Local Union 18A; Elevator Constructors Union No. 1 of New York & New Jersey. Second row, L–R: Local 12 NYC Heat & Frost Insulators; Courtesy of the IBEW; International Brotherhood of Teamsters; International Union Painters and Allied Trades; Courtesy Cement & Concrete Workers District Council. Third row, L–R: Operative Plasterers' and Cement Masons' International Association; International Union of Operating Engineers; Millwright and Machinery Erectors, Local Union 740; New York City & Vicinity District Council of Carpenters; Operative Plasterers' and Cement Masons' International Association. Bottom row, L–R: International Associat on of Bridge, Structural, Ornamental and Reinforcing Iron Workers. Sheet Metal Workers International Association; United Associat on; United Union of Roofers, Waterproofers and Allied Workers; 267–268: © Skidmore, Owings & Merrill. 285: Slinkachu/ Andipa Gallery.

INDEX

The London-based artist Slinkachu has created provocative photographic vignettes in cities around the world that juxtapose miniature figures against immense backdrops. *Skyscraping* shows one such figure, winged and hopeful, confronting Manhattan's skyline.

This book was designed by DBOX and printed and
bound by APS in China.

The text face is GT Sectra, designed by Marc
Kappeler (Moiré), Dominik Huber (Moiré) and Noël
Leu (Grilli Type), issued by Grilli Type.

Headlines are set in Circular, designed by Laurenz
Brunner and issued by Lineto.

The subhead, caption, and quote face is
Aperçu, designed by The Entente and issued by
the Colophon Foundry.

dbox.com